THE MIGRANT'S
TIME

CLARK
STUDIES
IN THE
VISUAL
ARTS

THE MIGRANT'S
TIME

Rethinking Art History and Diaspora

Edited by Saloni Mathur

Sterling and Francine Clark Art Institute
Williamstown, Massachusetts

Distributed by Yale University Press, New Haven and London

This publication was conceived by the Research and Academic Program at the Sterling and Francine Clark Art Institute. A related conference, "Art History and Diaspora: Genealogies, Theories, Practices," was held 25–26 April 2008 at the Clark. For information on programs and publications at the Clark, visit *www.clarkart.edu.*

Produced by the Publications Department of the Sterling and Francine Clark Art Institute
225 South Street, Williamstown, Massachusetts 01267

Curtis R. Scott, *Director of Publications and Information Resources*
David Edge, *Graphic Design and Production Manager*
Dan Cohen, *Special Projects Editor*
Katherine Pasco Frisina, *Production Editor*
Michelle Noyer-Granacki, *Publications Intern*
Carol S. Cates, *Layout*
Audrey Walen, *Copy Editor*

Printed by Howard Printing, Inc., Brattleboro, Vermont
Distributed by Yale University Press, New Haven and London
P. O. Box 209040, New Haven, Connecticut 06520-9040
www.yalebooks.com/art

Printed and bound in the United States of America
10 9 8 7 6 5 4 3 2 1

Title page and divider page illustration: Subodh Gupta (Indian, born 1964), *Everything Is Inside* (detail), 2004. Taxi, bronze, 108 ⅝ x 63 ¾ x 41 in. (276 x 162 x 104 cm). © Subodh Gupta

Library of Congress Cataloging-in-Publication Data

The migrant's time : rethinking art history and diaspora / edited by Saloni Mathur.
 p. cm.—(Clark studies in the visual arts)
 A related conference, "Art History and Diaspora : Genealogies, Theories, Practices," was held
Apr. 25–26, 2008 at the Clark Art Institute, Williamstown, Mass.
 Includes bibliographical references.
 ISBN 978-1-935998-03-7 (Clark pbk : alk. paper)—ISBN 978-0-300-13414-8 (Yale pbk : alk. paper)
1. Emigration and immigration in art. 2. Art and globalization. 3. Art—Historiography. I. Mathur,
Saloni. II. Sterling and Francine Clark Art Institute. III. Title: Rethinking art history and diaspora.

N8217.E52M54 2011
701'.03—dc22

 2011016609

Contents

Part Three: Modes of Engagement

Introduction

Saloni Mathur

The title of this volume, *The Migrant's Time*, is borrowed from a brief but discerning article by the historian and social theorist of modern South Asia, Ranajit Guha, first published in 1998 and reprinted here as the opening contribution. "To belong to a diaspora . . . ," Guha reflected in the first sentence of his essay, "I wrote down those words and stopped." What is the nature of this belonging? Who and what constitutes a diaspora? And, what alternative possibilities and modes of community might exist? In other words, Guha begins by interrupting and interrogating any complacent reception of the notion of diaspora, instead presenting us with more questions than answers in the far-reaching set of reflections that follow on the vexed cultural processes of migration and belonging. For Guha, the question of belonging is not just a spatial problem involving the geographic discrepancy between "here" and "there," it is also the occasion of a "temporal maladjustment," involving the "tragic disjunction" between past and present. The creative overcoming of such complexity requires obtaining a "toehold in the living present," or finding a place of "matching coordinates" within the great disparities of the social field that may finally be claimed as "our time." Guha's phrase, "the migrant's time," therefore refers both to the unsettling temporality of the experience of the migrant and announces unequivocally that his or her time has come: the present and future we must learn to inhabit is, in Guha's terms, *the migrant's time*.

This volume, the eleventh in the Clark Studies in the Visual Arts series, takes as its point of inspiration and departure the idea that the time of the migrant has also arrived in relation to the visual arts. Not only has the theme of migration increasingly emerged as a dominant subject matter of art, the varied mobilities of our contemporary world have radically reshaped art's conditions of production, reception, and display. In the essays that follow, the notion of migration resonates with a variety of other categories and concepts that float around discussions of culture that are international in spirit: diaspora, exile, globalization, hybridity, migration, mobility, multiculturalism, transnationalism, the nomad. These terms, each of them internally contested and much debated, seem less to provide a stable ground of investigation than to signal a broad constellation of intellectual concerns with respect to the accelerating and uncertain conditions of human dis-

placement and transplantation in the modern era. This volume will not pretend to settle the confusion resulting from this proliferating vocabulary; nor will it aspire to pin down or define a project for a presumably coherent aesthetic emerging from the mix, like the "art of diaspora" or the "art of migration." Instead, it proceeds with caution in the face of such categories, and seeks nevertheless to attempt to take seriously how the so-called "mobility turn," an emergent paradigm within the social sciences, has come to bear in a number of powerful ways upon a range of practices, both material and intellectual, belonging to the visual arts.[1]

The Migrant's Time: Rethinking Art History and Diaspora thus seeks to critically explore the increasing universality of the conditions of global migration and interdependence, and examine the relationships of art practice, art history, and art criticism to this normative reality, past and present. The essays that follow inhabit, rethink, and depart from existing perspectives in transnational or diaspora studies in order to develop empirical and theoretical directions that go beyond some of the current frameworks, which appear at times to have stiffened from overuse. In the broadest sense, they explore the relationship of the visual arts to the forms of subjectivity produced by migration and displacement in the modern era; the role of art and architecture in challenging or consolidating the conditions of globalization and its histories; and the implications of a world that is understood as *both* inextricably interconnected and mercilessly blocked by the politics of barriers and boundaries for historiography, writing, and the narratives of art history. How have experiences of migration and mobility found expression in the artistic and critical practices of the visual arts, and how do we grasp the new cultural assemblage generated by the conditions of relentless human mobility in the present?

It is useful to recall that Raymond Williams too saw the phenomenon of migration as constitutive of modernism when he argued for an account of the émigré in his development of a "fully responsible" cultural studies paradigm. Williams pointed to the example of Guillaume Apollinaire—born Wilhelm Apollinaris de Kostrowitzki—to show how the "sociology of metropolitan encounters and associations between immigrants" was crucial to *both* the formal innovations, breaks from tradition, and kinds of radical consciousness that led to the formation of the avant-garde *and* the processes at stake in the inevitable absorption of the avant-garde into the dominant culture of the succeeding period.[2] In other words, for Williams and other thinkers, most notably Edward Said, whose account of the artist Mona Hatoum follows Guha's essay in this volume, the question of migra-

tion stands at the core of modernism's capacity to construct new political spaces, which are nonetheless precarious and dialectically positioned in relation to the forces of assimilation and normalization. In such thinkers, the privileging of the migrant does not imply a celebration or affirmation of that which is nomadic, nor does it present the migrant as a trope that is automatically synonymous with a space of resistance in cultural terms. Rather, the field of human and societal relationships brought into view through the paradigm of the migrant is more ambivalent and indeterminate; it represents some of the most difficult forms of entanglement and separation resulting from our collective condition, the unsettling crises of dislocation and non-belonging, and the necessity of searching for alternative connections to communities of inhabitation over space and time.

In fact, the migrant in Ranajit Guha's essay is not "nomadic" in the Deleuzian sense: he does not arrive in order to leave again, he travels and searches for a way to stay.[3] Guha is thus more concerned with the ethical or moral question of *connecting* to a dynamic community from the point of view of the newcomer and the problem of the limits of translation where the Other is concerned; the place where alienation and estrangement become painfully intensified, where people "intersect, but do not coincide." Guha's account thus speaks to some of the existential crises generated by the migrant's "temporal maladjustment," namely, the confrontation with the "daunting openness and indefiniteness" of a society differentiated in synchronic terms, which is to him as promising as it is disconcerting. If the shift in Guha's essay from a spatial account to one that is fundamentally temporal is in keeping with a diachronic approach to society as a historically intertwined space, it also reasserts the temporality of the migrant against the long history of suppression and rejection of the "time of the Other." This is the process that Johannes Fabian identified in 1983 as "the denial of coevalness,"[4] namely, the construction of alterity through temporal distance: a paradigm that persists in a great deal of museological, anthropological, and ethnographic representations, as in the famously ill-fated "affinities" show at The Museum of Modern Art in New York. In Guha's terms, this is also one of the great challenges of "our time": the synchronization of a field of vastly different temporalities, the reshaping of a colonial paradigm to serve a shared, yet unequal, heterogeneous present, and the realignment of a community's past, present, and future, which constitutes, in his words, "the fabric of its life."

Admittedly, Guha's essay, with its personal, uncertain, almost whimsical tone, is not particularly representative of his larger scholarly oeuvre, which has

been seminal to the study of postcolonial society and history.[5] One objective in revisiting the piece, despite its having been for the most part overlooked in the visual arts, is to drop some alternative ideas into the discipline of art history with the hope of creating a ripple or two. Edward Said's luminous engagement with the work of contemporary artist Mona Hatoum is republished here in the same spirit. It is significant that Said's reflections on Hatoum's work, written for her 2000 exhibition at the Tate Gallery in London, was—with the exception of his collaboration with the photographer Jean Mohr for the book *After the Last Sky*—the only time he engaged with a visual artist. In a 1998 interview with W. J. T. Mitchell, another contributor to the present volume, Said, known for his astonishing erudition, admitted to feeling panicked and "somewhat tongue-tied" in the face of painting, photography, sculpture, and curating.[6] Said claimed to respond to visual forms—the paintings of Goya and Picasso, the photographs of Palestinians, the work of Mona Hatoum—intensely and intuitively, but without the comfort of a known narrative or philosophical scheme: they corresponded more to "what I was feeling," he stated; "I couldn't formulate what the response even was."[7] In other words, Said seemed to be deeply moved, as Mitchell noted, by the "unknowability" of visual art forms.

And yet, Said's account of Hatoum's installation of disorienting objects from everyday life was perhaps one of the most lucid and beautiful articulations of that which he situated at the painful core of the Palestinian condition, namely, its contested relationship to space, territory, geography—its cultural politics of exile and displacement. Said saw in the world of Hatoum's inhospitable domestic forms, which set aside their "normal" functions (like rest, sleep, or just being at home), that "familiarity and strangeness are locked together in the oddest way, adjacent and irreconcilable at the same time." Thus was exile "figured and plotted" in the objects she created:

> Her works enact the paradox of dispossession as it takes possession of its place in the world, standing firmly in workaday space for spectators to see and somehow survive what glistens before them. No one has put the Palestinian experience in visual terms so austerely and yet so playfully, so compellingly and at the same moment so allusively. . . .

Significantly, what Said saw in Hatoum's contorted everyday objects echoed some of the poignancy and passion of his own lifelong sense of dislocation, and his exemplary efforts to confront and alter the "uniquely punishing destiny" of the Palestinian people. Indeed, one of the most prescient themes to emerge from Said's body of scholarly work has been the question of the creative potential of a migrant or exilic consciousness for the cultural forms of the twentieth century. It is a theme that underlies many of his major theoretical contributions, like the notions of "worldliness" or "secular criticism," or the "contrapuntality" of cultural texts. The condition of being physically or metaphorically "out of place," the title of his memoir of 2000, was also central to Said's understanding of the role of the intellectual, and his purposeful vision of academic life.[8] The need to inhabit a relation at odds with the orthodoxies of society, to "speak truth to power,"[9] to avoid and oppose the "thumping language of national pride, collective sentiments, group passions":[10] these were the responsibilities of the humanities and of intellectuals, more broadly, and they remained inseparable for Said from the critical possibilities that migration had (and could) produce.

Thus, in the first two essays in this book, albeit in very different ways, Guha and Said go to the heart of the displacement, slippage, interruption, and alienation that stem from the conditions of human mobility in the world and signal the need for intellectuals to respond creatively. They also remind us that migration is far from a uniform or evenly shared experience. Instead, they point toward a vast landscape of cultural and political differentiation in which the confrontation between mobility and immobility, in the form of the stateless refugee, the undocumented worker, the persecuted exile, the homeless or the poor, becomes one of the most daunting challenges of "our time." They also push at the limits of representation of these varied forms of migrant experience by noting the radical alterity and potential collisions between "others" that are born out of the flight paths of cultures in motion. In this way, the migrant comes to symbolize the essential problem of humanity's coexistence, while representing the most radical challenges to the lived realities of multicultural society on the ground. Given the unyielding nature of these cross-cultural interactions, very little in the world today, these authors seem to say, remains untouched by the forces put into play by the inexorable dialectics of migration in our time.

The essays that follow represent a wide range of intellectual responses to such insights, and they point in a variety of ways to the necessity of integrating

the thematics of migration into the critical practices of art historical research. For example, in his account of Robert Scott Duncanson, the African American landscape painter who travelled to Europe and Canada in the nineteenth century, Kobena Mercer underscores the challenge of writing a dialectically situated historiography of art. Significantly, Mercer begins his essay with a "mini-genealogy" of the concept of diaspora as it entered cultural studies through the work of James Clifford, Paul Gilroy, and Stuart Hall, and he at least partially locates his historiographic agenda within the dialectical terms afforded by this concept. However, Mercer also notes that art history has responded inadequately to such a conceptual model, and he writes: "art history has been oblivious to the interactive dialectic of cross-cultural borrowing—the give-and-take of expropriation and appropriation as a back-and-forth process that constitutes one of the basic conditions of modernity in the visual arts." For Mercer, the discipline's tendency toward a "presentist" understanding of intercultural exchange might be corrected by "erasing and rewinding" the art historical narratives of the past two centuries. Such a project is undertaken in substantive ways in the four volumes that Mercer has recently edited for the MIT Press series Annotating Art's Histories.[11] In his account of Duncanson's painting for this volume, Mercer suggests a way to uncover the "asymmetrical code sharing" that signals the beginnings of a possible African American art history. Encoded in Duncanson's handling of the sublime, Mercer argues, was a subtext related to race and slavery in America, one that contrasted sharply with the triumphant equation between nature and national identity in the landscape painting of the Hudson River School.

The idea of "rewind and replay" also captures something of the methodological spirit of the essays by May Joseph and Richard Powell that follow. The predominance of black men on the cosmopolitan stage is questioned and challenged by the latter in his account of Donyale Luna, the pioneering African American fashion model who moved to Europe in 1965. As Powell suggests, Luna's life recalls some of the complexities of Josephine Baker at an earlier moment, except that she lived in the era of civil rights and the rise of feminism and the women's movement. Yet the art critic Robert Hughes's description of Luna as reminiscent of "a living sculpture by Giacometti" also betrays some of the enduring legacies of primitivism in spite of the vanguard spirit of her career. Powell's emphasis on the paradoxes of her life, her short-lived success, and her eventual fate resonates with the field of alienation and difference articulated by both Guha and Said. Powell writes: "Caught between the insinuating effects of racial/cultural

renunciation, sexual stereotype, and, to a great extent, the seduction of her own image, Luna's response, ironically, was to wear the mask and, in the manner of one of Giacometti's skeletal sculptures, to become a negligible component of life, hovering between existence and nothingness."

May Joseph, by contrast, is concerned with rewinding and replaying the broader story of the twentieth century avant-garde, and she revisits this landscape of aesthetic innovation as a tactile "field of intimacies between Europe and its colonies." Joseph's account of the avant-garde's formation within a global modernity moves self-consciously away from a formal inquiry and toward one that is decidedly contextual or conjunctural. The archive that she undertakes to recover is made up of "fraught exchanges," "chance meetings," "urban jostlings," and "transcontinental sojourns," all of which contribute to a history of the avant-garde as "an intricate global network of arrivals and departures, thefts and exchanges, influences and rejections, circulations and still points." Nevertheless, her awareness of the discrepancies and discontinuities at stake, such as in the persistent time lag between the cultures of metropole and colony, also allows her to place limits on the revolutionary ethos associated with modernism's decolonizing subject. "Embedded within the narrative of the avant-garde," Joseph thus reminds us, is also "its teleological limit."

The opening essay of the second section of this volume, by W. J. T. Mitchell, acknowledges and takes as its point of departure *both* the thematic of migration in the visual arts *and* the migratory nature of visual forms. "Migration as a topic engages all the inherent dialectics of the image, and exacerbates them," observes Mitchell. In his essay, concerned with images of "illegalized immigration," Mitchell explores the convergence of the realm of images, where images themselves are "on the move" within the arena of migration and the discursive contexts of the law. Mitchell proceeds to examine the image of the alien in specific science fiction accounts, contrasting the novels of Octavia Butler with an analysis of the feature-length movie, *District 9*, before turning his attention to two documentary films that respond to the crisis of arbitrary checkpoints, policed road blockages, and militarized border crossings in Gaza and the West Bank. At the end of the essay, Mitchell juxtaposes these images with a long-term conceptual performance art project in Paris by the Cuban artist, Tania Bruguera, to point to the creative role that images can have in relation to illegalized immigration, that is, "to set out hypotheses, possibilities, and experimental scenarios for a world of open borders and universal human rights."

Two other essays in this section, by Jennifer A. González and Esra Akcan, expand upon the elusive and ethically difficult project of bringing into representation the subjectivity and specific angle of vision of the subaltern, marginal, or illegalized migrant. González highlights this problem in her account of the 2007 video installation, *Western Union: Small Boats,* by the experimental filmmaker, Isaac Julien, which depicts in a disturbing way the deadly traffic of African migrants to Europe across a lyrically rendered Mediterranean Sea. González points to a jarring aspect of Julien's piece: the filmmaker's unexpected edits and visual juxtapositions which abruptly reposition and demand from the viewer an exploration "of the dreamscape of the migrating subject." If this raises the philosophical question of the ethical limits of representation, it also gives rise to another pertinent question. González hints (at least implicitly) at a new form of accountability on the part of contemporary art: "Why have so few visual artists addressed the politics of migration from the psychological, internal state of the migrant?" The necessity of grasping the elusive consciousness of the migrant and confronting the forms of alterity and social distance this entails is also highlighted by Esra Akcan, an architectural historian, who turns to the IBA initiative, a German reconstruction and renewal project that sought during the 1980s to rebuild Kreuzberg, a rundown neighborhood of Turkish migrants in Berlin (described by the media as "the German Harlem"). Akcan examines how Berlin's so-called "foreigner problem" was articulated and confronted through the built environment. Her account of the Portuguese architect Alvaro Siza's historic social housing project in the furthest reaches of East Kreuzberg foregrounds the complex themes of integration and segregation at the level of human dwelling and physical inhabitation, and raises the challenge of the social gulf embodied by the Pritzker Prize–winning architect's off-site relationship to the Turkish migrants who occupied his buildings.

In the last essay in this section, Stanley Abe expresses a different kind of investment in the notion of images and objects as themselves on the move. Abe's investigation takes the provocative form of a return to James Clifford's conception of the "art-culture system," which was an influential proposal to understand the global movement of non-Western art objects as they migrated across the various institutions and spaces of meaning for art (museums, markets, galleries, etc.). Abe observes that the kinds of mobilities conceived by Clifford in 1986 when he published this schema, like the "demotion" of an Impressionist painting to the Gare d'Orsay train station, did not represent the great democratization of the art object or transformation of the culture of the masterpiece that Clifford and others

had perhaps hoped for and projected. While Abe acknowledges that his account of Clifford's "missteps" has the advantage of historical distance, he also notes that Clifford's vision "caught in the 1980s . . . seems less familiar and more inaccessible with each passing year." In revisiting the questions of mobility and movement that were at the heart of Clifford's influential schema, Abe reminds us that the object of the system itself—the present—is also a moving target.

The present is the primary concern of the third and final section of the volume, which offers several critical perspectives on contemporary art's dramatic turn toward an increasingly international and multi-sited global stage. In the opening essay, Nikos Papastergiadis draws attention to the bewildering nature of transformations to the conceptions, definitions, locations, and parameters of contemporary art: "Where does art begin and end?" he asks. In the absence of a fixed object, Papastergiadis proposes the concept of "assemblage" to harness the shape-shifting forms of encounter between artists and their different contexts (for instance, "refugees"). He also extends the argument he has developed elsewhere that mobility is "central to the artistic imaginary and aesthetic production," and thus constitutes a new prism for comprehending contemporary art.[12] In doing so, Papastergiadis further raises the question of the role of criticism, and asks if it is necessary for art—and implicitly, art criticism—at this historical juncture "to produce a kind of understanding that is distinctive from other social, creative, and critical encounters?"

Sustaining a healthy skepticism, Miwon Kwon recalls in her essay the kinds of constraints and challenges that identity politics in the 1990s produced for the institutions and discourses of contemporary art, and she questions the relationship between these formations and the internationalist spirit that characterizes the present. Does the current climate represent "a diminishment, a narrowing down of potential meaning of a work, or is it an opening up of its meaning?" she asks. Kwon examines a 2009 exhibition at the Los Angeles County Museum of Art, titled *Your Bright Future: 12 Contemporary Artists from Korea*, as symptomatic of the trend toward a global contemporary art that is frequently celebrated as transcendent of national boundaries. However, Kwon also shows how this curatorial aspiration existed in tension with the national frame of "Korean art" that underlay the exhibition. Thus, the occasion signaled, in her terms, "a complex and at times frustrating meeting of different expectations, competencies, and access to contemporary art, on the one hand, and Korean cultural history and language, on the other." Kwon eventually turns to the back cover of the exhibition catalogue

where the translation of the twelve artists' Korean names into the Roman alphabet reflected a compendium of different possibilities, choices, and professional strategies made by each individual, consciously or not. Embedded within this roster of names "without a shared standard of translation or perhaps too many standards colliding at once," Kwon suggests, is *both* the cultural evidence of an uneasy negotiation with the power structures of contemporary art *and* a certain "mutability, mobility, and flow" that is a potential asset to the field.

The issues of translation and inscription highlighted by Kwon persist in the remaining contributions to this section—by Nora A. Taylor, Aamir R. Mufti, and Iftikhar Dadi—who offer detailed engagements with three contemporary artists: Jun Nguyen-Hatsushiba, Zarina Hashmi, and Shirin Neshat, respectively. What these accomplished artists appear to have in common, in spite of enormous differences between their practices, is that they simultaneously highlight and erase the national and geopolitical frames that have crucially shaped their aesthetic concerns. It is a gesture that is increasingly emblematic of the moment, expressing the will toward that toehold of "matching coordinates" that Guha viewed as a necessity of "our time." In her account of Nguyen-Hatsushiba, an artist of mixed Japanese and Vietnamese heritage, Taylor notes the artist's paradoxical formation through migration and displacement, on the one hand, and the professional success obtained in his adopted country of residence, Vietnam, on the other. Like Kwon, Taylor points to the kinds of slippages and elisions that occur through curatorial trends in contemporary art that place value on national identity in the name of diversification. By citing the conceptions of identity that are also internal to Vietnam, Taylor makes visible some of the trajectories that entangle an artist *before* their arrival at the international biennale, as it were, or prior to their moment of interpellation onto contemporary art's global stage. These issues become most salient in Nguyen-Hatsushiba's recent, highly ambitious project, *Breathing is Free: 12,756.3*, in which the artist is running a distance equivalent to the diameter of the earth over the course of a decade. Taylor views the project in part as an extension of Nguyen-Hatsushiba's earlier work, which thematized the plight of Vietnamese refugees as a metaphor for fleeing or deportation. However, this daunting physical and psychic performance also challenges all manner of spatial and temporal assumptions about art; thus what Taylor sees in this radical, unpredictable work-in-progress is an artist asserting his vocational prerogative to "imagine what cannot be imagined."

The difference between Nguyen-Hatsushiba's extreme physical perfor-

mance and the impeccable formal economy of Zarina Hashmi's woodcut prints could not be more dramatic. However, the printmaking practice of this New York–based artist of South Asian origin known by her first name, the subject of Aamir Mufti's essay, embodies a similar politics of displacement and homelessness. For Mufti, such an art is not merely the sign of a cosmopolitan consciousness; rather, it is concerned, in a more profound sense, "with the foundational unlivability of modern modes of life." By drawing from Hannah Arendt's analysis of statelessness as a symptomatic experience of the modern era, one that emerges paradoxically from the establishment of the nation-state as a normative political form in the nineteenth and twentieth centuries, Mufti explicates the profound meanings of "house," "home," and "homeland" in Zarina's minimal architectural footprints and her abstracted renderings of maps of such places as Baghdad, Jenin, New York, and Srebrenica. In dialogue with the art of Mona Hatoum, and Edward Said's account of her work in this volume, Mufti argues that Zarina's practice "invites a new mode of planetary or worldly understanding of the history of violence, uprooting, and homelessness in the modern era," one that is deeply connected to the question of language.

The role of language is highlighted yet again in the final essay of the volume, by Iftikhar Dadi, who examines the series of photographs titled *Women of Allah*, produced by the New York–based artist of Iranian origin, Shirin Neshat. Dadi situates this series from the mid-1990s in relation to ongoing debates about Muslim women and the veil, as well as the visual landscape of the post-9/11 U.S.-led "war on terror." He argues that certain elements of Neshat's images, in particular her use of Islamic calligraphy overlain on the body, encourage an allegorical reading, a claim that is given theoretical substance through Dadi's account of the debates around allegory and third world literature generated by Frederic Jameson's influential thesis.[13] Part of the power of these images, according to Dadi, is the way in which they highlight seemingly incommensurable entities that nevertheless coexist and construct an "imminent yet unnameable global visual sphere." In pointing to the uses of Urdu or Persian in artists like Hashmi and Neshat, scripts that are generally undecipherable to the Indo-European language traditions of Europe and North America, both Dadi and Mufti demonstrate the role of language in simultaneously repudiating Orientalist conventions and inviting, significantly, from their Western art publics, in Mufti's terms, "an exploration of the mutual translatability of heterogenous cultural positions" within the new circuits of a globalized world.

To return, then, to my opening questions: How have experiences of migration and mobility found expression in the practices of the visual arts? And how do we grasp the new cultural assemblage generated by the relentless conditions of human mobility in the present? The essays collected here can be seen to offer a far-reaching, interdisciplinary, and open-ended set of possibilities in response. They are exploratory, provisional, diverse, and unprescriptive. They are not intended to fix a theoretical agenda or devise a single methodological plan. Rather, they bring a range of conceptual resources to bear on the transformations to society and its expressive forms that the figure of the migrant has come to invoke. The entanglements of intertwined histories and futures; the ethics of coexistence and connecting to community; the articulation of more fluid notions of self and society; the construction of a new ground for identity itself: these are the issues opened up and made essential through a consideration of the dialectics of migration in our time. How these ideas might enable or restrict the knowledge practices of the visual arts, or serve earlier periods of art historical inquiry like the ancient or premodern fields, remains, of course, to be seen. Nonetheless, these essays show how the discipline might stand to benefit from a critical engagement with the tropes of migration. It appears that the migrant's time has finally come. And in this moment of simultaneous arrival and departure, of door opening and bringing what was outside in, there is surely something for art history to gain.

1. See, for example, Peter Adey, *Mobility* (London and New York: Routledge, 2010); John Urry, *Mobilities* (Cambridge, UK: Polity Press, 2007), and *Sociology Beyond Societies: Mobilities for the Twenty-First Century* (London and New York: Routledge, 2000).

2. Raymond Williams, *The Sociology of Culture* (New York: Schocken Books, 1982), 84.

3. See the discussion of Deleuze and Guattari's "Treatise on Nomadology," in Murat Aydemir and Alex Rotas, eds., "Introduction," in *Migratory Settings* (New York and Amsterdam: Rodopi, 2008), 7–31.

4. Johannes Fabian, *Time and the Other: How Anthropology Makes its Object* (New York: Columbia University Press, 2002).

5. Some major works by Ranajit Guha include *History at the Limit of World-History* (New York: Columbia University Press, 2002); *Elementary Aspects of Peasant Insurgency in Colonial India* (Durham, NC: Duke University Press, 1999); *Dominance without Hegemony: History and Power in Colonial India* (Cambridge, MA: Harvard University Press, 1997); *A Subaltern Studies Reader*, ed. (Minneapolis:

University of Minnesota Press, 1997); *A Rule of Property for Bengal: An Essay on the Idea of Permanent Settlement* (Durham, NC: Duke University Press, 1996); *Selected Subaltern Studies*, ed. with Gayatri Spivak (Oxford and New York: Oxford University Press, 1988).

6. W. J. T Mitchell and Edward Said, "The Panic of the Visual: A Conversation with Edward Said," *Boundary 2*, vol. 25, no. 2 (Summer 1998): 11–33.

7. Ibid., 17.

8. Edward Said, *Out of Place: A Memoir* (New York: Vintage, 2000).

9. Edward Said, "Speaking Truth to Power," in *Representations of the Intellectual: The 1993 Reith Lectures* (New York: Vintage Books, 1994), 85–102; see also Paul A. Bové, ed., *Edward Said and the Work of the Critic: Speaking Truth to Power* (Durham, NC and London: Duke University Press, 2000).

10. Edward Said, *Reflections on Exile and Other Essays* (Cambridge, MA: Harvard University Press, 2000), 177.

11. See the following titles in the MIT Press's Annotating Art's Histories: Cross-Cultural Perspectives in the Visual Arts series edited by Kobena Mercer: *Cosmopolitan Modernisms* (2005); *Discrepant Abstraction* (2006); *Pop Art and Vernacular Cultures* (2007); *Exiles, Diasporas, Strangers* (2008).

12. Nikos Papastergiadis, *Modernity as Exile: The Stranger in John Berger's Writing* (Manchester, UK: Manchester University Press, 1993); *Dialogues in the Diaspora: Essays and Conversations on Cultural Identity* (London: Rivers Oram Press, 1998); *The Turbulence of Migration* (Cambridge, UK: Polity Press, 2000); and *Complex Entanglements: Art, Globalisation, and Cultural Difference*, ed. (London: Rivers Oram Press, 2004).

13. Frederic Jameson, "Third World Literature in the Era of Multinational Capitalism," *Social Text* 15 (Fall 1986): 65–88.

PART ONE

MAPPING MIGRATION

The Migrant's Time

Ranajit Guha

To belong to a diaspora . . . I wrote down those words and stopped. For I was
not sure one could belong to a diaspora. Belonging is predicated on something
that is already constituted. Would the first migrant then remain excluded for
ever from a diaspora? Who constitutes a diaspora anyhow? And what is it after
all? Is it a place or simply a region of the mind—a mnemic condensation used to
form figures of nostalgia out of a vast dispersal? Or is it nothing but the ruse of
a beleaguered nationalism to summon to its aid the resources of long-forgotten
expatriates in the name of patriotism? Well, I don't know—not yet in any case.
So, to start with let me stay close to the essential connotation of the term as a
parting and scattering and say that to be in a diaspora is already to be branded by
the mark of distance. Somewhat like being an immigrant, but with a difference.
The latter is distantiated from the community—the people or the nation or the
country or whatever the name of the community—where he finds himself more
often than not as an unwelcome guest. From the moment he knocks on his host's
door, he is one who has come in from the outside. The diasporan as a migrant is,
on the contrary, someone who has gone away from what once was home—from
a motherland or a fatherland. In this case, unlike the other, the function of
distance is not to make an alien of him but an apostate. An apostate, because,
by leaving the homeland, he has been unfaithful to it. Since there is no culture,
certainly not in South Asia, which does not regard the home as the guardian and
propagator of values associated with parenthood to the extent of investing the
latter with a sanctity akin to religiosity, desertion amounts to transgression. The
migrant, even the involuntary one washed offshore by circumstances beyond
his control, has therefore broken faith and is subjected to judgments normally
reserved for apostasy.

 I speak of apostasy in order to highlight the intensity of the moral strictures
heaped by their compatriots on those who have gone away. The disapproval could
be nationalistic or familial in rhetoric and the defector condemned for weakening
in that fidelity which makes for good citizenship and kinship. Whichever the
idiom in which it is expressed, its object is nothing less than the violation of some
sacrosanct codes. These are codes of solidarity and exchange, alliance and hostility,

love of neighbors and fear of strangers, respect for tradition and resistance to change—all of which help a population to form a community through mutual understanding. Presupposed in every transaction between its members, these are in effect codes of belonging by which they identify themselves and recognize each other. To violate these by going away, by breaking loose from the bonds of a native world is to be disowned and bring down on oneself the harsh sentence: "You no longer belong here; you are no longer one of us."

The voice in which such a sentence is pronounced is that of the first-person plural speaking for an entire community from a position entrenched within it. What is within is *here*—a place the migrant will not be entitled to call his own. The displacement is made all the more poignant by the paradox that it corresponds to no distantiation in time. For it is stapled firmly to an accentuated and immediate present cut off from a shared past by the adverbial force of "no longer." A sharp and clean cut, the dismissal leaves its victim with nothing to fall back on, no background where to take umbrage, no actual communitarian links to refer to. For it is in their everyday dealings with one another that people in any society form such links in a present which continually assimilates the past to itself as experience and looks forward at the same time to a future secure for all. The loss of that present amounts, therefore, to a loss of the world in which the migrant has had his own identity forged. Ousted temporally no less than spatially, he will, henceforth, be adrift until he lands in a second world where his place will seek and hopefully find matching coordinates again in a time he, like others, should be able to claim as "*our* time."

A diaspora's past is, therefore, not merely or even primarily a historiological question. It is, in the first place, the question of an individual's loss of his communal identity and his struggle to find another. The conditions in which that first identity was formed are no longer available to him. Birth and kinship which gave his place in the first community the semblance of so complete a naturalness as to hide its man-made character, are now of little help to him as an alien set apart by ethnicity and culture. Birthmarks of an originary affiliation, these are precisely what make it hard for him to find a toehold in that living present where a communal identity renews itself as incessantly in the day-to-day transactions between people as it is promptly reinforced by a common code of belonging. For everything that appertains to such a code is framed in time. Indeed belonging in this communitarian sense is nothing other than temporality acted upon and thought—and generally speaking, lived—as being with others in shared

time, with sharing meant, in this context, as what is disclosed by the community to its constituents as temporal. One has simply to listen to the discourse of belonging to realize how pervasive such temporalisation is in all that people say or otherwise indicate to each other about good and bad times, about work and leisure, about how it was and how it might turn out to be, about being young and growing old, and more than anything else about the finitude of life in being born and dying. This is not only a matter of some linguistic compulsion requiring the grammar of a language to insist on the aspectual category of verb phrases in an utterance. More fundamentally, this is an existential question of being in time. There is no way for those who live in a community to make themselves intelligible to each other except by temporalizing their experience of being together.

Temporalization such as this has, of course, all the strands of past, present and future inextricably woven into it. However, the migrant who has just arrived stands before the host community only in the immediacy of the present. This is so because, from the latter's point of view, whatever (if anything) is known about his past and presumed about his future, is so completely absorbed in the sheer fact of his arrival that, as an occurrence in time, it is grasped as a pure externality, mediated neither by what he was nor by what he will be. Yet there is nothing abstract about this. Quite the opposite seems to be the case. For, it has the concreteness of a sudden break with continuity, or more appropriately, if figuratively speaking, that of a clinamen which disturbs the laminar flow of time to create a whirlpool for the strangeness of the arrival to turn round and round as a moment of absolute uncertainty, a present without a before or an after, hence beyond understanding. Of course it will not be long before the latter recovers from the shock of suddenness and takes hold of the occurrence by interpretation—that is, by such codes as may assign it a meaning in terms of one or any number of alterities ranging from race to religion. All of which, again, will be phrased, much as was the very last sentence of rejection addressed to the migrant on the point of departure from his native land, thus: "You don't belong here." Wanting as it is in the adverbial phrase "no longer," this interdicts rather than rejects. However, like that other sentence, this too will be uttered unmistakably within a nowness.

How come that the now sits on guard at the gate of the host community as well? It does so because, as Heidegger says, "Belonging-somewhere (*Hingehörigkeit*) has an essential relationship to involvement."[1] Belonging to a community is no exception, for it involves being with others in the everyday life of an ordinary world. Since the now is the mode in which everydayness articulates

mostly and primarily, it serves as the knot that ties together the other strands of a community's temporal bonding. The past is gathered into this knot and the future projected from there as well. The now is, therefore, the base from which all the distantiating strategies are deployed against the alien as the one who stands outside the community's time—its past of glory and misery, its future pregnant with possibilities and risks, but above all its present charged with the concerns of an authentic belonging.

Nothing could be more acute as a predicament for the migrant who personifies the first generation of any diaspora. Participation in the host community's now, that is, a moment of temporality made present as today, is an indispensable condition of his admission to it. Yet, as one who has just arrived from the outside, he is, by definition, not admissible at all. For he has nothing to show for his present except that moment of absolute discontinuity—the foreshortened time of an arrival—which is conspicuous precisely by its exclusion from the today of the community at whose threshold he has landed. Not a little of the complexity and pathos of the diasporic condition relates to this very impasse.

At this point it would be convenient for us perhaps simply to go round this difficult and embarrassing moment and allow our narrative a small, almost imperceptible jump in order to move on to that firm ground where the migrant, washed and fed and admitted already to his new community, awaits assimilation as either a mimic or a misfit, depending on the degree of his resistance to that always painful and often humiliating process. But let us not be tempted by this option. Let us continue a little longer with our concern for the impasse in which, literally, he finds himself: stranded between a world left behind and another whose doors are barred, he has nowhere to go. Homeless and with little hope left for anything but one last chance, he has all his orientation and comportment taken over by anxiety.

That is a mood notorious for its unsettling effect. It shakes him out of the groove of an immediate and unbearable present and makes him ready to summon the experience of what he has been for an encounter with the indefiniteness of what lies ahead. In other words, it is anxiety which enables him to look forward to his own possibilities, helps him to mobilize the past as a fund of energies and resources available for use in his project to clear for himself a path which has the future with all its potentiality on its horizon. A difficult path opened up by the tragic disjunction of his past and present, it lies across that now from which he has been excluded so far and posits him there by the logic of that very crossing.

Thus, the migrant has situated himself at last. But he is far from assimilated yet. For the everydayness of his new situation and that of the host community's intersect, but do not coincide. There is a mismatch which will serve for a field of alienation from now on with differences read along ethnic, political, cultural and other axes. This non-coincidence puts a new spin on the problem of the migrant's time. Why does his now resist absorption in that of his adopted community? Because it is constituted differently from the latter. For the now of any time whatsoever arises from the connectedness of the present with the past and the future. It inherits and projects, and in that dual function, integrates to itself all that is specific to a culture as it has formed so far and all that will determine its quality and character in time to come. A community's now is, therefore, not just one of a series of identical moments arranged in a steady succession. Aligned by its connectedness and colored by the specificities of its overdeterminations, the moment of its time a community experiences as now is necessarily different from that of any other.

This is why switching communities is in every instance the occasion of a temporal maladjustment which, however, is grasped by common sense, not for what it is, but as the failure of one culture to slot smoothly into another. There is nothing particularly wrong with this interpretation except that it makes a part stand in for the whole. For what is cultural about this phenomenon is already entailed in the temporal and follows directly from it. Thus, to cite an all too familiar example, the difference in attitudes to clock time ascribed often so readily to religious distinctions is perhaps much better explained in terms of the differing temporalities which connect a community's understanding of its own past, present and future in a manner unlike another's.

The migrant, too, is subjected to such misinterpretation in the host community once he has been admitted to it. For the connectedness of time which makes up the fabric of its life is not and cannot be the same as in the one he has left behind. As an immigrant—with the prefix *im* to register the change in his status as one kept no longer waiting outside—the sense of time he brings with him is the child of another temporality. The myriad relationships it has for its referent relations to his own people, its traditions and customs, its language, even the environment of his native land—set it clearly apart from those that inform such relationships in the community where he finds himself. His attempt to get in touch with the latter and involve himself in the everydayness of being with others is, therefore, fraught inevitably with all the difficulties of translation between

accents, inflexions, syntaxes and lexicons—between paradigms, for short. All that is creole about a culture is indeed nothing other than evidence of its creative overcoming of such difficulty.

It is not uncommon for the necessary inadequacy of such translation to be diagnosed wrongly as nostalgia. The error lies not only in the pathological suggestion it carries, but primarily in its failure to understand or even consider how the migrant relates to his own time at this point. Driven on by anxiety, he has only the future in his horizon. "What is going to happen to me? What should I do now? How am I to be with the others in this unfamiliar world?" These are all cogitations oriented towards what is to come rather than ruminations about what has been so far.

Lacking as he does the kind of support and understanding one finds in one's native community, he is entirely on his own with no hinterland for retreat but only a prospect which faces him with its daunting openness and an indefiniteness which is as promising as it is disconcerting. All that is in him, and makes him what he is, is caught now—at this moment—in an inexorably forward drift. What he has been so far is also caught in that drift, but not as dead baggage towed along by a force not its own. On the contrary, it is itself constitutive of that headlong movement carrying him forward. In that movement the past does not float passively as a chunk of frozen time, but functions as experience both activated by and invested in the force of a precipitation. There is nothing in it of any desperate effort at finding what has been lost, but only an ongoing current in which the past is integral to the present.

The alignment of the migrant's past with his predicament in the flow of his being towards a future occurs, therefore, not as a process of recovery but of repetition. Far from being dead that past has remained embedded in its time fully alive like a seed in the soil, awaiting the season of warmth and growth to bring it to germination. As such, what has been is nothing other than a potentiality ready to be fertilized and redeployed. It anticipates the future and offers itself for use, and through such use, renewal as the very stuff of what is to come.

That is why the migrant's present, the moment of that tide in which his future-oriented past is being carried along, draws attention to itself invariably as the figure of an ambiguity. For at any such moment, he still appears to speak in the voice of the community where he was born to his first language, even as he is so obviously picking up the language of the other community where he is about to find a second home. In all other respects of his comportment as well—the way

he dresses, works, eats, speaks, and generally conducts himself in his everyday relationship with others—he mixes idioms and accents and is typecast as one who defies translation, hence understanding.

Our first migrant is, therefore, in a temporal dilemma. He must win recognition from his fellows in the host community by participating in the now of their everyday life. But such participation is made difficult by the fact that whatever is anticipatory and futural about it is liable to make him appear as an alien, and whatever is past will perhaps be mistaken for nostalgia. He must learn to live with this doublebind until the next generation arrives on the scene with its own time, overdetermining and thereby reevaluating his temporality in a new round of conflicts and convergences.

This essay was originally published in *Postcolonial Studies* 1, no. 2 (1998): 155–60. Spellings and punctuation have been edited to follow American style.

1. Martin Heidegger, *Being and Time*, trans. John Macquarrie and Edward Robinson (Oxford: Basil Blackwell, 1987), 420.

The Art of Displacement: Mona Hatoum's Logic of Irreconcilables

Edward W. Said

Consider the door handle's place as you stand before the entrance to a room. You know that as you reach forward, your hand will move unerringly to one side or another of the door. But then you don't encounter the handle, curl your fingers around it, and push forward because . . . it has actually been placed two feet above your head in the middle of the door, perched intransigently up there where it eludes your ready grasp, cannot fulfill its normal function, and does not announce what it is doing there. From that beginning dislocation others necessarily follow. The door may be pushed open on only one of its hinges. You must therefore enter the room sideways and at an angle but only after your coat or skirt is caught and torn by a nail designed to do that every time the room is entered. Inside, you come upon a carpet of undulating curves, which on close examination reveal themselves to be intestines frozen into plastic stillness.

The kitchen to your right is barred by minuscule steel wires strung across the door, preventing

Fig. 1. Mona Hatoum (Lebanese, b. 1952), *Home*, 1999. Wood, stainless steel, electric wire, lightbulbs, computerized dimmer switch, amplifier, speakers. Table: 3 ft. 6 ⁵/₁₆ in. × 6 ft. 6 in. × 2 ft. 4 ⁷/₈ in. (77 × 198 × 73.5 cm). Moderna Museet Stockholm

entrance. Gazing through those wires you see a table covered with colanders, large metal spoons, grinders, sifters, squeezers, and egg beaters, connected to each other by a wire that ends up connected to a buzzing lightbulb that flutters off and on disturbingly at random intervals (fig. 1).

A bed in the left corner is without a mattress, its legs akilter in a grotesque rubbery wilt (fig. 2). A mysterious tracing of white powder forms a strange symmetrical pattern on the floor beneath the bare metal springs of a baby's crib next to it. The television set intones a scramble of jumbled discursive sounds,

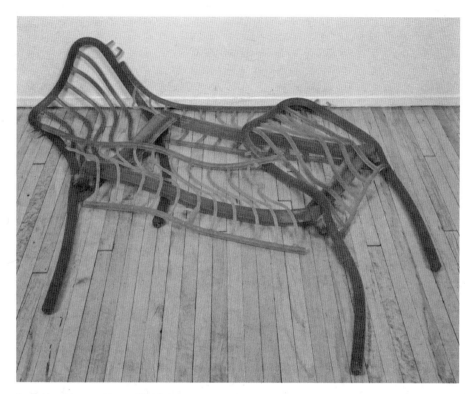

Fig. 2. Mona Hatoum, *Marrow*, 1996. Rubber, 12 × 45 × 57 in. (30.5 × 114.5 × 149 cm). Courtesy Alexander and Bonin, New York

while a camera imperturbably emits animated images of an unknown person's innards. All this is designed to recall and disturb at the same time. Whatever else this room may be, it is certainly not meant to be lived in, although it seems deliberately, and perhaps even perversely to insist that it once was intended for that purpose: a home, or a place where one might have felt in place, at ease and at rest, surrounded by the ordinary objects which together constitute the feeling, if not the actual state, of being at home. Next door, we find a huge grid of metal bunks, multiplied so grotesquely as to banish even the idea of rest, much less actual sleep (fig. 3). In another room, the notion of storage is blocked by dozens of what look like empty lockers sealed into themselves by wire mesh, yet garishly illuminated by naked bulbs.

An abiding locale is no longer possible in the world of Mona Hatoum's art which, like the strangely awry rooms she introduces us into, articulates so fundamental a dislocation as to assault not only one's memory of what once

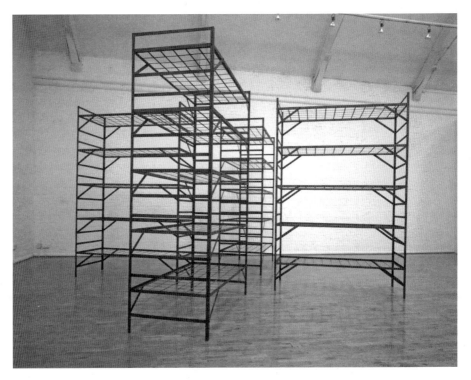

Fig. 3. Mona Hatoum, *Quarters*, 1996. Mild steel, 108 $^{7}/_{16}$ × 203 $^{1}/_{8}$ × 203 $^{1}/_{8}$ in. (275.5 × 516 × 516 cm). Courtesy White Cube

was, but how logical and possible, how close and yet so distant from the original abode, this new elaboration of familiar space and objects really is. Familiarity and strangeness are locked together in the oddest way, adjacent and irreconcilable at the same time. For not only does one feel that one cannot return to the way things were, but there also is a sense of just how acceptable and 'normal' these oddly distorted objects have become, just because they remain very close to what they have left behind. Beds still look like beds, for instance, and a wheelchair most definitely resembles a wheelchair: it is just that the bed's springs are unusably bare, or that the wheelchair leans forward as if it is about to tip over, while its handles have been transformed either into a pair of sharp knives or serrated, unwelcoming edges (fig. 4). Domesticity is thus transformed into a series of menacing and radically inhospitable objects whose new and presumably non-domestic use is waiting to be defined. They are unredeemed things whose distortions cannot be sent back for correction or reworking, since the old address is unreachably there and yet has been annulled.

This peculiar predicament might be characterized, I think, as the difference between Jonathan Swift and T. S. Eliot, one the great angry logician of minute dislocation unrelieved by charity, the other the eloquent mourner of what once was and can, by prayer and ritual, be restored. In their vision, both men begin solidly, unexceptionally from home: Lemuel Gulliver, Swift's last major persona, from England; the narrator of Eliot's poem "East Coker" sets out from home as a place "where one starts from." For Gulliver the passage of time culminates in a shipwreck after which he fetches up on a beach, tied down by tiny ropes affixed to his hair and body, pinioned to the ground, immobilized by six-inch humanlike creatures whom he could have wiped out by his superior strength but can't because (a) he is unable to move and (b) their tiny arrows are capable of blinding him. So he lives among them as a normal man except that he is too big, they too small, and he cannot abide them any more than they can him. Three disconcerting voyages later, Gulliver discovers that his humanity is unregenerate, irreconcilable with decency and morality, but there is really no going back to what had once been his home, even though in actual fact he does return to England but faints because the smell of his wife and children as they embrace him is too awful to bear. By contrast, Eliot offers a totally redeemable home after the first one expires. In the beginning, he says, "houses rise and fall, crumble, are extended, are removed, destroyed." Later, however, they can be returned to "for a further union, a deeper communion / Through the dark cold and the empty desolation." The sorrow and loss are real, but the sanctity of home remains beneath the surface, a place to which one finally accedes through love and

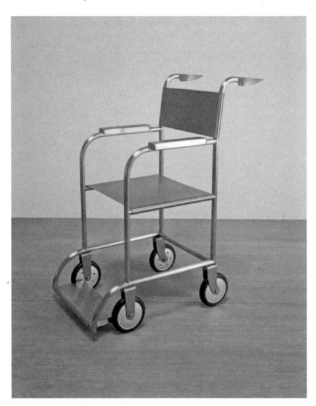

Fig. 4. Mona Hatoum, *Untitled* (*Wheelchair*), 1998. Stainless steel and rubber, 38 1/8 × 19 3/4 × 33 1/8 in. (97 × 50 × 84 cm). Courtesy White Cube

prayer. In "Little Gidding," the last of the elegiac Four Quartets ("East Coker" is the second), Eliot borrows from Dame Julian of Norwich the line "all manner of thing shall be well" to affirm that after much sorrow and waste, love and the Incarnation will restore us to a sense of "the complete consort dancing together," a vision that shows how "the fire and the rose are one."

By contrast with Eliot, Swift's profanity is incurable, just as the dissociation of Gulliver's sense of homely comfort can never be made whole or what it once was. The only consolation—if it is one—is the ability he retains to detail, number, and scrupulously register what now stocks his state of mind in his former abode. Hyppolite Taine called Swift a great businessman of literature, someone to whom objects no matter how peculiar and distorted can be carefully placed on a shelf, in a space, in a book or image. In Mona Hatoum's relentless catalogue of disaffected, dislocated, oddly deformed objects, there is a similar sense of focusing on what is there without expressing much interest in the ambition to rescue the object from its strangeness or, more importantly, trying to forget or shake off the memory of how nice it once was. On the contrary, its essential niceness—say, the carpet made of pins, or the blocks of soap pushed together to form a continuous surface onto which a map is drawn with red glass beads—sticks out as a refractory part of the dislocation. A putative use value is eerily retained in the new dispensation, but no instructions, no 'how-to' directions are provided: memory keeps insisting that these objects were known to us, but somehow aren't any more, even though memory clings to them relentlessly. There is nothing of Eliot's scared discipline here. This is a secular world, unpardoned, and curiously unforgiving, stable, down-to-earth. Objecthood dug in without a key to help us understand or open what seems to be locked in there. Unsurprisingly then, *Lili (stay) put*, is the name of one of Hatoum's brilliantly titled works.

Her work is the presentation of identity as unable to identify with itself, but nevertheless grappling the notion (perhaps only the ghost) of identity to itself. Thus is exile figured and plotted in the objects she creates. Her works enact the paradox of dispossession as it takes possession of its place in the world, standing firmly in workaday space for spectators to see and somehow survive what glistens before them. No one has put the Palestinian experience in visual terms so austerely and yet so playfully, so compellingly and at the same moment so allusively. Her installations, objects, and performances impress themselves on the viewer's awareness with curiously self-effecting ingenuity which is provocatively undermined, nearly cancelled, and definitively reduced by the utterly humdrum,

Fig. 5. Mona Hatoum, *Doormat*, 1996. Stainless steel pins, nickel plated pins, glue, and canvas, 1 ¼ × 28 × 16 in. (3 × 71 × 40.5 cm). Courtesy Modern Collections

local, and unspectacular materials (hair, steel, soap, marbles, rubber, wire, string, etc.) that she uses so virtuosically. In another age her works might have been made of silver or marble, and could have taken on the status of sublime ruins or precious fragments placed before us to recall our mortality and the precarious humanity we share with each other. In the age of migrants, curfews, identity cards, refugees, exiles, massacres, camps, and fleeing civilians, however, they are the uncooptable mundane instruments of a defiant memory facing itself and its pursuing or oppressing others implacably, marked forever by changes in everyday materials and objects that permit no return or real repatriation, yet unwilling to let go of the past that they carry along with them like some silent catastrophe that goes on and on without fuss or rhetorical bluster (fig. 5).

Hatoum's art is hard to bear (like the refugee's world, which is full of grotesque structures that bespeak excess as well as paucity), yet very necessary to see as an art that travesties the idea of a single homeland. Better disparity and dis-

location than reconciliation under duress of subject and object; better a lucid exile than sloppy, sentimental homecomings; better the logic of dissociation than an assembly of compliant dunces. A belligerent intelligence is always to be preferred over what conformity offers, no matter how unfriendly the circumstances and unfavorable the outcome. The point is that the past cannot be entirely recuperated from so much power arrayed against it on the other side: it can only be restated in the form of an object without a conclusion, or a final place, transformed by choice and conscious effort into something simultaneously different, ordinary, and irreducibly other and the same, taking place together: an object that offers neither rest nor respite.

Originally published in *Mona Hatoum: The Entire World as a Foreign Land* (London: Tate Gallery Publishing, 2000), 7–17. Illustrations as shown above have been selected by the editor; corresponding figure references have been added to the text. Spellings and punctuation have been revised to follow American style.

Erase and Rewind: When Does Art History in the Black Diaspora Actually Begin?

Kobena Mercer

On 30 May 1861, Robert Scott Duncanson hired Pike Opera House in Cincinnati as the first stop in an international touring exhibition of two large-scale pictures, *Land of the Lotus Eaters* (fig. 1) and *Western Tornado*. He announced his itinerary to the *Daily Cincinnati Gazette*, which reported that the *Lotus Eaters* would be on display for just one week, "after which it will be taken to Canada." The exhibition received such acclaim that it was extended for over a month, during which time another local journalist enthused: "It has been the steady determination of the artist, Mr. Duncanson, to take it to Europe at an early day, where, too, we are safe in prognosticating it will remain, for the wealthy connoisseurs of that hemisphere will not suffer such a gem of art to recross the Atlantic."[1] After travelling to Toronto in November 1861, whereupon he made a brief return to Ohio, Duncanson arrived in Montreal in September 1863, where he resided for two years before setting sail for Europe in summer 1865. Reaching his goal, *Lotus Eaters* was first shown in Dublin and then in Glasgow prior to being exhibited in London in

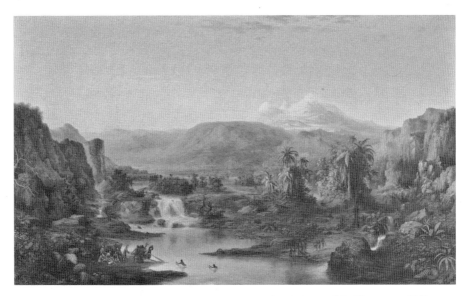

Fig. 1. Robert Scott Duncanson (American, 1821–1872), *Land of the Lotus Eaters*, 1861. Oil on canvas, 52 $^{3}/_{4}$ × 88 $^{5}/_{8}$ in. (134 × 225.1 cm). Collection of His Royal Majesty, the King of Sweden

1866, where Duncanson stayed for a year before returning to Cincinnati to set up a new studio on Fourth Street.

In making his journey across the Black Atlantic, Duncanson shared company with other nineteenth-century African American artists who undertook similar voyages. At the age of twenty, Mary Edmonia Lewis departed from Boston to Italy in 1865, living an expatriate life in Rome up to her death in 1911. While Lewis made frequent return visits to the United States, Henry Ossawa Tanner chose to settle permanently in Paris, where he lived from 1894 to 1937. Their lives and works confirm Paul Gilroy's thesis that diaspora identities are shaped by experiences of travel and migration that question the territorial claims of the nation-state as the primary basis of collective belonging.[2] Previous historical studies, however, have entirely misinterpreted the Atlantic crossings of the first generation of African American painters and sculptors as assimilative quests for acceptance within the white art establishment. There is another feature that Tanner, Lewis, and Duncanson share in common, namely the striking paucity of black imagery in their work: in a corpus of one hundred sixty-two landscape paintings, Duncanson only once produced a representation of black subject matter. Earlier studies regarded this absence of manifest blackness as evidence of the artist's renunciation of his identity, whereas I see it as an opportunity to explore the historical conditions under which diaspora identities reveal their constructed character as subject positions that are brought into being through the dialogical principle.

Derived from the Greek, "diaspora" combines the verbs for "to sow" or "to disperse" with the preposition for "over." This gives us a word that applies to a population forcibly separated from its place of natal origin, thereby scattered and dispersed into the world under conditions of exile and fragmentation. In the social sciences, William Safran identifies four key features of diasporas: enforced dispersal as a result of involuntary migration, a conflicted relationship to the receiving societies in which members of such a population are constituted as demographic minorities, lateral communication between two or more sites of dispersal, and finally, the elaboration of myths of return to the homeland.[3] Cultural studies contributed to the contemporary remodeling of the diaspora concept by adding two crucial emphases. As Gilroy makes clear, in "Diaspora, Utopia, and the Critique of Capitalism"—chapter five of his 1987 publication, *There Ain't No Black in the Union Jack*—there has been a political shift away from the centrist orientation of the pan-Africanist search for "roots" that had envisaged a literal return to unitary origins in favor of a post-nationalist conception of imagined community that

offers a utopian alternative in which collective affiliations open up de-centered "routes" in the circulatory networks of popular culture.[4] Hence, in his view of vernacular culture as a site of social antagonism, Gilroy stresses the mobility of signifying elements that are appropriated against the grain of what he calls "ethnic absolutism." His approach parallels James Clifford's notion of traveling culture in which the meaning of material artifacts is modified by the manner in which elements move through the Art-Culture System, and finds further elaboration in Stuart Hall's 1990 essay "Cultural Identity and Diaspora," which was directly informed by innovative artistic practices in Black British film and photography.[5]

The principle point of this mini-genealogy is to observe that it has taken the best part of twenty years for the conceptual innovations associated with diaspora studies to enter the field of art history. On one hand, it is entirely understandable that ideas and methods that appear new to the discipline are received with an attitude that seeks to find a one-to-one correspondence with artistic practices that are equally new. What results, in my view, is the problem of presentism, whereby the deep historical past is threatened with erasure by virtue of the heightened attention given to the contemporary. On the other hand, having initiated a project that has resulted in the four-volume Annotating Art's Histories series, I have an appreciation of the length of time it takes to actually produce new knowledge.[6] As a character remarks in James Baldwin's 1978 novel, *Just Above My Head*, "diaspora wasn't made in a day."[7] To put it another way: what is most intriguing about the reconceptualization of diaspora is that it overturns the short-term calculus of multicultural inclusionism so as to recast the entire story of modernism and modernity in an altered light. We are, in fact, only now beginning to grasp the contradictory entanglement of multiple modernisms that were cast in shadow for the first eighty years of the twentieth century by the monologic assumption that there was only *one* story to tell about the relationship between modern art and modernity and only *one* way to tell it. Indeed, I would go so far as to say that the tendency to interpret concepts of globalization, hybridity, and cross-culturality as though they belong exclusively to the contemporary moment is not just a case of looking through the wrong end of the telescope, but that institutionally sanctioned narratives are preserved intact when "difference" is misperceived as a novelty that only arises in the present.

Toward the end of his career, the philosopher Mikhail Bakhtin distinguished between "great time" and "small time." In light of this distinction, we can fully understand why postcolonial scholars argue that globalization began

circa 1492.[8] It is in cross-cultural encounters with others that Europeans become self-consciously aware of the West as a bounded identity. For my part, Bakhtin's dialogical methods provide the most revealing mode of ekphrasis through which to understand how artistic production in the African diaspora actually begins. Blasted out of one historical continuum into another by "the commercial deportation of slavery," as the Caribbean novelist George Lamming put it, the ex-Africans who had been variously named the Akan, Mende, Yoruba, or BaKongo peoples found themselves in the process of becoming Negro, with no choice in the matter, on account of their status as slaves.[9] Seizing opportunities that constantly differentiated the symbolic forms and linguistic norms imposed by their masters —whether English, Portuguese, French, or Dutch—the process of Western acculturation was transformed into a two-way dialectic of transculturation. Amid the interdependent entanglements of self and other, the diaspora subject discovers that, as Bakhtin put it:

> The word in language is half someone else's. It becomes "one's own" only when the speaker populates it with his own intention, his own accent, when he appropriates the word, adapting it to his own semantic and expressive intention. Prior to this moment of appropriation, the word does not exist in a neutral or impersonal language . . . but rather it exists in other people's mouths, in other people's contexts, serving other people's intentions: it is from there that one must take the word and make it one's own.[10]

Pictures, paintings, and sculptures put forward as objects for aesthetic contemplation are very different from words in poems, novels, or speech, which is to say that the optical metaphor of "race" creates enduring resistance to mutual recognition among African and European subjects. Bakhtin concluded his preceding statement by adding, "not all words for just anyone submit easily to this appropriation." As we observe the *longue durée* in which the self-naming of diaspora subjects passes from Negro through Colored to Black, we readily agree that appropriation in language "is a difficult and complicated process."[11] But how much more so is it when we translate this concept into the visual? If black subjects had no choice but to interact with the demographic majority among whom they were scattered and dispersed, black artists likewise had to respond to representations of race that preceded their entry into the West. It is at this point that we encounter the struc-

tural condition of *asymmetrical code sharing* that forms the very basis of African American art history. What black artists come up against as they enter the fine arts in the late eighteenth century is the sheer force of "the gaze" that perceives the black individual as an object but that cannot see blacks as agents or subjects of representation in their own right. As Sander Gilman reveals in his 1975 essay "The Figure of the Black in German Aesthetic Theory," there is not a single European philosopher—from Edmund Burke and Gotthold Lessing to Johann Herder and Immanuel Kant—who does not have something to say about blackness as they formulate their competing definitions of beauty.[12] At issue is self-definition by antithesis, which made blackness-as-alterity central to Enlightenment rationality. Once we shift perspective to ask what this construction of reality meant from the point of view of black subjects—let us bear in mind that African American art began in the 1790s when the Baltimore limner Joshua Johnston produced portraits of Maryland families who had prospered in the city's maritime trade—we encounter the fact that the symbolic meaning of blackness never actually belonged to blacks themselves; it was always already expropriated as a Western signifier of absolute difference. In Newtonian optics, whiteness absorbs all other colors on the spectrum of light, whereas blackness is what results from its absence. Each of the philosophers Gilman discusses were captivated by the case presented in 1728 by London surgeon William Cheselden, who restored sight to a boy by removing his cataracts. Observing the boy's emotional reactions to light and dark, Cheselden wrote that, "seeing by Accident a Negroe woman, he was struck with great Horror at the Sight."[13] The equation between blackness and fear that was sedimented in the dominant order of racist visuality was only truly denaturalized—that is to say, drawn out into conscious intellection—when Frantz Fanon put forward a psychoanalytical account of the gaze in *Black Skin, White Masks*, first published in 1952 in France. In a point-by-point reversal, which doubles over Cheselden's scene, Fanon describes the shock of non-recognition he experienced as he walked the streets of Lyon and was stopped in his tracks by a child who cried out, "Look, a Negro! . . . Mama, see the Negro! I'm frightened!"[14] We readily understand that by issuing an epistemological break with representation as verisimilitude, Western modernism overturned the dominant order of visuality that had held sway ever since the advent of Renaissance monocular perspective: how recently, then, by a logic of delayed action or *nachträglichkeit* have we come to understand the resistance to knowing—the ego's *méconnaissance*—that was historically maintained by the optical polarity of race.

Prior to Fanon, W. E. B. DuBois evoked the metaphor of the veil to describe the visuality through which the Negro was constructed in American national culture while, writing at the same time as Fanon, Ralph Ellison proposed the term "invisibility," but the key word it seems to me is "oblivion," for it refers to something that was never seen in the first place.[15] Much ink has been spilled on the subject of the gaze, but Lacan's definition points toward an impersonal structure that is not possessed by anyone but which functions precognitively to determine what can and cannot be seen as intelligible from within the field of vision.[16] My point is twofold: art history has been oblivious to the interactive dialectic of cross-cultural borrowing—the give-and-take of expropriation and appropriation as a back-and-forth process that constitutes one of the basic conditions of modernity in the visual arts—and such oblivion is itself double-sided. Modernist formalism was entirely complicit with the colonial gaze, for the cross-cultural could only be admitted into its visual order when it was sequestered within the primitive, the folkloric, or the ethnographic. But as Michele Wallace pointed out in her 1990 keynote essay on "The Problem of the Visual in Afro-American Culture," the privilege that black scholars bestow upon literary texts in the realm of high culture and upon music and the performing arts in popular culture also adds to the oversight of the aesthetic intelligence produced in the realm of the black visual arts.[17]

Excluded from the formalist narratives of progress that dominated institutional accounts of modernism from the 1940s to the 1970s, the historiography of the diaspora's visual arts is thus distorted as a separatist story that mostly reproduces highly conservative methods of narration: diachronic sequencing that implies a line of descent from Joshua Johnston onward downplays the synchronic interactions that all black artists and art movements have had with other artists, patrons, and audiences, and it also encourages biographical reductionism that minimizes the contextual conditions in which artistic intentions are formed.[18]

Taking another look at historical materials previously overlooked because of their apparent absence of any transparent or immediately legible manifestation of blackness, my second point—as we return to Duncanson and his international tour of the *Land of the Lotus Eaters*—is to argue that the inscription of diaspora subjectivity among African American artists of the nineteenth century takes place below the threshold of the visual. In the subtextual allegories and semantic indirection by which their individual choices served to accentuate the artistic utterances they produced within the prevailing codes of romantic landscape, neoclassical

sculpture, and painterly realism, respectively, Duncanson, Lewis, and Tanner were initiating a call-and-response dialogue with representations of black life produced by white American and European artists. When we consider the visual construction of "the Negro" that dominates this period, we understand that the unconscious structure of fear and desire elicited by the supremacist gaze was precisely what each was seeking to escape as they embarked upon journeys in search of an "elsewhere." Their Black Atlantic travels were thus shaped by the patterns of utopian flight and dystopian aversion that Gilroy identifies in the push-and-pull factors motivating those literary and political voyages that generated a counter-discourse of black internationalism in the nineteenth century.

As a self-taught artist, Duncanson gained access to fine art production through an apprenticeship in the family trade of house painting and carpentry established by his father, the son of a mulatto slave from Virginia. Based in Cincinnati, he began to exhibit from 1842 onward as a member of the free colored population that had legal protection under Ohio law. Supported by abolitionist patrons such as Reverend Charles Avery, whose 1848 commission led Duncanson to sketch from direct observation, and Nicholas Belmont, who required a French classical landscape for the murals he commissioned in 1850–52, Duncanson enjoyed an integrated position in the profession—he had a studio adjoining that of William Sonntag and first visited Europe in 1853 when he undertook a grand tour of Italy in Sonntag's company, with a letter of introduction written by Longworth and addressed to Hiram Powers in Florence. The absence of human figures may be seen as one of the ways in which the landscape genre enabled Duncanson to gain entry into the market, but as he draws upon successive paradigms of American landscape painting—the picturesque, the pastoral, the sublime—there are two distinct modes of subtextual inscription that introduce an element of double-voicing into key works within his corpus. Equations between national identity and the untamed wilderness of the American hinterland were encouraged by the Hudson River School led by Thomas Cole, and the Ohio Valley School followed suit, though Duncanson broke away from this patriotic codification of the natural terrain in subtle and indirect ways.

Blue Hole, Flood Waters, Little Miami River (fig. 2) frames three diminutive figures in the manner of the picturesque, although Duncanson's choice of topography carries a pointedly indexical undertow. Within the clandestine geography of the Underground Railroad—in which Cincinnati played a pivotal role—it is crucial to know that the confluence of the Ohio and Little Miami

Fig. 2. Robert Scott Duncanson, *Blue Hole, Flood Waters, Little Miami River*, 1851. Oil on canvas, 28 ¹/₂ × 41 ¹/₂ in. (72.4 × 105.4 cm). Cincinnati Art Museum. Gift of Norbert Heermann and Arthur Helbig

rivers was "a favored escape route for fugitive slaves"[19] and that "the slave, George Washington McQuerry, who escaped in 1849 and eventually settled in . . . Miami County, Ohio, was well-known among blacks in that region."[20] In 1854, Duncanson declared, "I have made up my mind to paint a great picture, even if I fail."[21] While initially considering John Bunyan's *Pilgrim's Progress* as a source, as this had inspired Cole's last work, he switched allegiances to the sublime paradigm then being advocated by Asher Brown Durand and Frederick Edwin Church. Although *Western Tornado* and *Prairie Fire* of 1861 are now lost, a slightly later work, *Waiting for a Shot* (1869), indicates how the sweeping vistas of the Midwest provided the topographical setting for Duncanson's turn toward the sublime.

The cataclysmic theme suggested by *Western Tornado* and *Prairie Fire* had already featured in earlier works such as *Time's Temple* (1854) and *Ruins of Carthage* (1854), evoking the transience of civilization in the face of nature's destructive power, but as he turned to Lord Alfred Tennyson's 1832 poem "The Lotus Eaters" as inspiration for his "great picture" in December 1860, when the Civil War was

imminent, Duncanson's approach toward the sublime took on inescapably political implications. Completed in May 1861, after hostilities commenced, the *Land of the Lotus Eaters* isolates the moment in Homer's *Odyssey* in which Ulysses and his army, returning from their victory in Troy, succumb to the narcotic lotus leaf that is offered to them by the dark-skinned inhabitants of an Arcadian idyll (fig. 3).

Adhering closely to the poem, Duncanson retains the compositional template of an idealized classical landscape sectioned into a three-point zigzag pattern that directs the eye from foreground incident through mid-range volume to a rear plane suffused with light. The miniscule presence of the Caucasian figures grouped at center-left heightens their intoxicated passivity even as the drama of contrasting scale amplifies the otherworldly grandeur of lush foliage, tropical palms, waterfalls, and remote mountains. As Joseph Ketner suggests, what appears to be fanciful escapism conceals a potent political subtext for "the narcotic-induced apathy of Ulysses's soldiers reflects a contemporary criticism that the South had grown complacent and dependent on slave labor to support its economy and luxurious standard of living."[22] Looking closer at the encoding of its subtextual allegory, in the moment in which it was conceived, the implication is that, just as Ulysses revealed the vulnerability of ancient Greece as an imperial nation, so the United States, having grown complacent from the wealth created by its slaves, faces an impending catastrophe in which its nationhood is threatened by the consequences of the South's luxurious indolence in the past. On the visible surface, we behold a scene of blissful

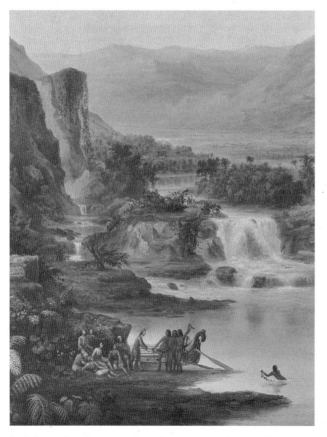

Fig. 3. Robert Scott Duncanson, *Land of the Lotus Eaters* (detail), 1861

Fig. 4. Frederic Edwin Church (American, 1826–1900), *Heart of the Andes*, 1859. Oil on canvas, 66 ¹/₈ × 119 ¹/₄ in. (168 × 302.9 cm). The Metropolitan Museum of Art, New York. Bequest of Margaret E. Dows, 1909

Fig. 5. Robert Scott Duncanson, *Pompeii*, 1855. Oil on canvas, 21 × 17 in. (53.3 × 43.2 cm). Smithsonian American Art Museum, Washington, D.C. Gift of Dr. Richard Frates

contentment, but roiling beneath the seductive artifice is a prophetic forewarning of the cataclysm about to engulf the nation as a result of its past dependence on slavery. Whereas Church's *Heart of the Andes* (fig. 4) articulated "the vast extent of the sublime wilderness that Americans assumed was their domain through Manifest Destiny,"[23] Duncanson disarticulates triumphalist equations of natural terrain and national identity by encoding a transposition in the order of time.

The classical landscape tradition locates the utopian realm of Arcadia in the prelapsarian *past*, but the metonymic logic of his allegorical subtext is directed toward a dystopian *future* in which American Manifest Destiny leads to civil war and ruination. Were we to superimpose *Lotus Eaters*'s overall compositional structure onto *Pompeii* from 1855 (fig. 5)—depicting the ruins of ancient Rome as a slave-owning society since destroyed by the eruption of Mount Vesuvius—the center-left figure group coincides exactly with the placement of the two miniscule figures pointing to cryptic signage on a stone tablet after the manner of Poussin's *Et In Arcadia Ego* (1637–39). The substitutive transposition of prophetic forewarning over the site of archaic devastation confirms Duncanson's handling of the sublime as a deliberative product of intentional double-voicing that accentuates a counter-politics of semantic indirection.

Where utopia literally means "no such place," Duncanson's palms—also seen in *Arcadian View* (fig. 6)—do not suggest a direct reference to the diaspora's lost African origin (even though palms carry such connotations in nineteenth-century European painting) so much as they act as enigmatic signifiers of an exotic "elsewhere" that cannot be represented directly. Gilroy places strong emphasis on semantic indirection in musical forms such as spirituals: he describes a "politics of transfiguration" in which utopian strivings were "steeped in the idea of a revolutionary or eschatological apocalypse — the Jubilee."[24] Insofar as the "concept of Jubilee emerges in Black Atlantic culture to mark a special break or rupture in the conception of time defined and enforced by the regimes that sanctioned bondage,"[25] we may detect a resonant echo between Gilroy's notion of "the slave sublime" and the allegorical mode of inscription that Duncanson achieved through his subtextual encoding of political prophecy beneath the emphatically exotic "non-place" that was presented to the beholder on the otherworldly surface of the *Lotus Eaters*'s synthetic artifice.

Alfred Tennyson invited the artist to visit him on the Isle of Wight, saying, "Come whence it may, your landscape is delightful; and though not quite my lotus land, is a land in which one loves to wander and linger."[26] By then, British

Fig. 6. Robert Scott Duncanson, *Arcadian View*, 1867. Oil on canvas, 28 ³/₄ × 52 in. (73 × 132.1 cm). Manoogian Collection

audiences were aware of the *Lotus Eaters*, as it had been reproduced in a small book, *Testimonies of Slavery*, published in 1864 by Reverend Moncure Conway, an Ohio slave owner turned abolitionist who edited the *Cincinnati Dial.* Reporting that Duncanson "has been invited to come to London by . . . the Duchess of Sutherland and the Duchess of Essex, who will be his patrons," Conway struck a note of incredulity when he described the encounter of artist and poet: "Think of a negro sitting at table with Mr. and Mrs. Alfred Tennyson, Lord and Lady of the Manor, and Mirror of Aristocracy, and so forth."[27]

We should note that the abolitionist support Duncanson received in Britain was fully in line with the philanthropic patronage given to the Fisk University Jubilee Singers, who toured the United Kingdom in 1871 and 1873 under the sponsorship of the Earl of Shaftesbury. As a result of his contacts, *Western Tornado* was purchased by actress Charlotte Cushman as a gift for the Duchess of Sutherland (who was Mistress of the Robes to Queen Victoria); today *Land of the Lotus Eaters* is owned by the King of Sweden. Having met with Duncanson while visiting the South Kensington Museums in 1866, it is significant that Conway touched upon the sublime *sotto voce*, and even hinted at the intertext of art and music in his small book of 1864, wherein he wrote:

My belief is that there is a vast deal of high art yet to come from that people in America. Their songs and hymns are the only original melodies we have, and one of the finest paintings which I have ever seen is a conception of Tennyson's *Lotos-eaters* [sic] painted by a Negro.[28]

One final instance of double-voicing: based on sketches produced during a return trip to Scotland in 1870, where he was a guest of the Duchess of Argyll, *Ellen's Isle, Loch Katrine* (fig. 7) alludes, in part, to Ellen Douglas, the female protagonist in Sir Walter Scott's epic poem of 1650, *The Lady of the Lake*. Duncanson's painting depicts the actual topography of the island that Scott refers to, which was part of the Highland estate owned by the Duchess, herself an abolitionist. Learning that one of her previous guests was Senator Charles Sumner of Boston, an advocate of emancipation, Duncanson made a gift of the painting upon his return to the United States. One historian suggests that, "the imagery of boats crossing the water . . . represented . . . the passage to freedom over the River Jordan to heaven referred to in slave songs."[29] Where such a reading tends to force its way through the picture plane, as if to finalize one definitive mean-

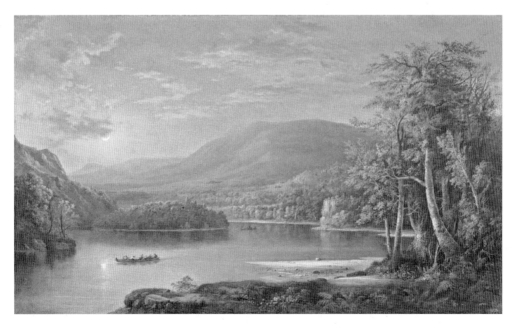

Fig. 7. Robert Scott Duncanson, *Ellen's Isle, Loch Katrine*, 1871. Oil on canvas, 28 1/2 x 49 in. (72.4 x 124.5 cm). Detroit Institute of Arts. Gift of the Estate of Ralzemond D. Parker

ing, the hermeneutics of the Black Atlantic lay out a wider canvas in which to recognize the far-reaching differences made by small acts of dialogism. As Gilroy notes, Frederick Douglass "acquired his new post-slave surname from the pages of Sir Walter Scott's *The Lady of the Lake*."[30] Sharing the same textual source as Duncanson, Frederick Douglass chose a double "s" in the spelling of his name. As a sign of the foundational act of self-naming that speaks to new practices of freedom, the dialogic production of such doubleness marks out one of the ways in which diaspora consciousness made its presence felt within the prevailing order in which Western visuality was defined.

1. *Daily Cincinnati Gazette*, 30 May 1862, 2, and *Cincinnati Daily Inquirer*, 7 June 1861, 2; cited in Joseph D. Ketner, *The Emergence of the African American Artist: Robert S. Duncanson, 1821–1872* (Columbia: University of Missouri Press, 1993), 112–13.

2. Paul Gilroy, *The Black Atlantic: Modernity and Double Consciousness* (Cambridge, MA: Harvard University Press, 1993).

3. William Safran, "Diasporas in Modern Societies: Myths of Homeland and Return," *Diaspora* 1 (1991): 83–99.

4. Paul Gilroy, *There Ain't No Black in the Union Jack: The Cultural Politics of "Race" and Nation* (London: Hutchinson, 1987).

5. James Clifford, *Routes: Travel and Translation in the Late Twentieth Century* (Cambridge, MA and London: Harvard University Press, 1997), 17–47; Stuart Hall, "Cultural Identity and Diaspora," in *Identity: Community, Culture, Difference*, ed. Jonathan Rutherford (London: Lawrence and Wishart, 1990).

6. Kobena Mercer, ed., *Exiles, Diasporas, and Strangers*, Annotating Art's Histories: Cross-Cultural Perspectives in the Visual Arts (Cambridge, MA: MIT Press, 2008).

7. James Baldwin, *Just Above My Head* (New York: Dell, 1978), 532.

8. Mikhail Bakhtin, *Speech Genres and Other Late Essays*, ed. Michael Holquist and Caryl Emerson (Austin: University of Texas Press, 1986), 4.

9. George Lamming, *The Pleasures of Exile* (London: Allison and Busby, 1984), 37.

10. Mikhail Bakhtin, *The Dialogic Imagination*, ed. Michael Holquist (Austin: University of Texas Press, 1981), 293–94.

11. Ibid., 294.

12. Sander Gilman, "The Figure of the Black in German Aesthetic Theory," *Eighteenth Century Studies* 8 (1975): 373–91.

13. Ibid., 375. William Cheselden, "An Account of some Observations made by a young Gentleman, who was born blind, or lost his sight so early, that he had no Remembrance of ever having seen, and was couched between 13 and 14 Years of Age," *Philosophical Transactions of the Royal Society* 35 (1727–28), 447–48.

14. Frantz Fanon, *Black Skin, White Masks* (1952; New York: Grove Press, 1967), 112.

15. See W. E. B. DuBois, *The Souls of Black Folk* (New York: Signet Classics, 1903), 45, and Ralph Ellison, *Invisible Man* (Harmondsworth, UK: Penguin, 1952).

16. Jacques Lacan, *The Four Fundamental Concepts of Psychoanalysis* (Harmondsworth, UK: Pelican, 1977), 67–119.

17. Michele Wallace, "Modernism, Post-Modernism, and the Problem of the Visual in Afro-American Culture," in *Out There: Marginalization and Contemporary Culture*, ed. Bruce Ferguson, et al. (New York: New Museum of Contemporary Art; Cambridge, MA: MIT Press, 1990).

18. See Kobena Mercer, "Diaspora Aesthetics and Visual Culture," in *Black Cultural Traffic*, ed. Harry J. Elam Jr. and Kennel Jackson (Ann Arbor: University of Michigan Press, 2005), 141–61, and Kobena Mercer, "Iconography After Identity," in *Shades of Black: Assembling Black British Arts of the 1980s*, ed. Ian Baucom, et al. (Durham, NC: Duke University Press, 2005), 49–58.

19. Romare Bearden and Harry Henderson, *A History of African American Artists: From 1792 to the Present* (New York: Pantheon, 1993), 27.

20. Sharon Patton, *African American Art* (New York and London: Oxford University Press, 1999), 85.

21. Robert S. Duncanson to Julius R. Sloan, 21 Aug. 1854, cited in Ketner, *Emergence of the African American Artist*, 76.

22. Ketner, *Emergence of the African American Artist*, 91.

23. Ibid., 90.

24. Gilroy, *Black Atlantic*, 56.

25. Ibid., 212.

26. Sir Alfred Tennyson in the *Montreal Herald*, 8 Feb. 1864, cited in Ketner, *Emergence of the African American Artist*, 154.

27. Conway cited in Bearden and Henderson, *History of African American Artists*, 35.

28. Ibid., 34.

29. Ketner, *Emergence of the African American Artist*, 175.

30. Gilroy, *Black Atlantic*, 58.

Globalization, Modernity, and the Avant-Garde

May Joseph

> Start the forgetting machine.
> —Aimé Césaire

Shock

It is a strange time to be in the business of performance. Reality is stranger than fiction and the everyday more surreal than the theater. Shock after 9/11 takes on a new intensity. After March 11, 2004, a fresh horror.[1]

Shock is the neural snap of modernity. It is the short-circuiting of perception. Shock is Galileo's gasp as he peers through the telescope the first time. It is Columbus's surprise. Shock is Vasco da Gama's exhilaration at the discovery of the sea route to India. It is the startled horror of that modern performer, the slave Gustavo Equiano in middle-passage, aboard the slave ship. Shock is the scandal of Alfred Jarry's *Ubu Roi*, belting "*merdre!*" across the Theatre de l'Oeuvre in the Paris of 1896. It is also the synaptic arrest of the imperial bayonet. The gory first blood of the shock troops of battle. Shock catapults the modern. Shock is the avant-garde.

Historically, shock is synonymous with the fracturing of the modern sensorial field. It embodies the shift from the medieval to the modern. It is Walter Benjamin's startled Angel of History flailing backward, face aghast.[2] Shock shapes the earliest theorizing of perceptual modernity in its many dimensions. Modern shock is the ricochet of Hiroshima and Nagasaki. It is the spasmodic contortion of imperial violence. This history of shock implodes with the World Trade Center and the U.S. strategy of "shock and awe" unleashed on Baghdad. After Hiroshima and Nagasaki, shock is not ethically possible. As Jean-Francois Lyotard suggests, shock is a simulated echo, disconnected from the political.[3] Scandal is irrelevant. The avant-garde—a logic of Cartesian space shattered into fractals, fragmented in time and space.

Arrested Visuality

> The western front's interminable trench warfare . . . created a bewildering landscape of indistinguishable, shadowy shapes, illuminated by lightning flashes of blinding intensity, and then obscured by phantasmagoric, often gas-induced haze. The effect was even more visually disorienting than those produced by such nineteenth-century technical innovations as the railroad, the camera, or the cinema. When all that the soldier could see was the sky above and the mud below, the traditional reliance on visual evidence for survival could no longer be easily maintained.
>
> —Martin Jay[4]

Acrid, sulphurous with the stench of the shock troops of battle, World War I is often invoked as the crucible of the modern sensibility. An urtext of shock, its neural distortions and arrested visuality triggered by mustard gas, the first nerve agent of chemical warfare, this war is also the last brutal performance of tangible hand-to-hand combat in the Western world. It marks that chasm before the sanitized madness of the bomb. Our modernity is forged out of this blinding intensity and gas-induced haze whose lesser-known scenarios include the colonial theaters of war outside Europe's borders. Headless torsos. Severed hands. Burnt limbs. Flayed bodies. A Picasso or Dalí? Or the French torture chambers of Hanoi and Algiers?

An itinerant wandering into the somatic adventures of the historical avant-garde dredges the mutations these encounters generated, frequently outside the language of the visual. It presents a volatile mise-en-scène of sensations catalyzed by colonizer and the colonized. These perceptions impinge on the modern imagination in ways that are startlingly direct and often inarticulable. Their immediate and raw sphere of exchange forces open concerns of politics and aesthetics that incorporate the body. Between the street and the stage, the everyday and the performed, the discursive distortions and leaps offer a glimpse into the inchoate yet distinctively new experiences of being modern that unfold at the juncture of differing sensoriums—simultaneously Western and non-Western.

Embodied Knowing

> The fundamental assumption behind the various movements of the avant-garde in the arts . . . was that relations between art and society

had changed fundamentally, that old ways of looking at the world were inadequate and new ways must be found. This assumption was correct. . . . However . . . in the visual arts this has not been achieved, and could not have been achieved, by the projects of the avant-garde.

—Eric Hobsbawm[5]

In *The Decline and Fall of the Twentieth-Century Avant Gardes*, Eric Hobsbawm elaborates upon Walter Benjamin's argument that painting and sculpture, the legitimate arts of the nineteenth century, could no longer capture the sensibility of the new era. Hobsbawm writes, "among all the arts, the visual ones have been particularly handicapped . . . they have patently failed . . . the project was abandoned, leaving behind avant-gardes which became a subdepartment of marketing, . . . 'the smell of impending death.'"[6] Hobsbawm's historical reading of the interface between the technological and the corporeal underscores the increasing pertinence of the tactile in emerging notions of the modern. The emergent new technologies of photography, film, architecture, and design, he argues, better express the changing tempo of the times. Their means of expression resonate with the escalation of speed and the compression of time. These mediums capture the dislocation of modern individualism in the nations of Europe and their extended empires.

The decline of painting and sculpture as avant-garde mediums in the age of technology in Hobsbawm's analysis is superceded by the realm of the tactile. While the body itself falls outside his concerns, the corporeal hovers as a critical arena of innovation gestured to by references to the opera and theater. The arts Hobsbawm privileges are those that shift the sense of the tactile into the sphere of mechanical reproduction, such as design and advertising, most effectively embodied by the London subway map of the 1930s. As an innovative realization of the new aesthetic, the London Underground map embodies the junction between the visual, the tactile, the mechanical, and the technological. For him, it incorporates abstract minimalist design into a functionalist object that is utilitarian and democratic, an aspect crucial to the emerging aesthetic of the modern.

This heady seduction of technology and its attending logic of progress implied by the "machine age" is implicitly grounded in the uneasy global scenario of colonialism, slavery, and imperialism. Writing in 1949 in the manifesto for Socialism or Barbarism, a radical political group of left-wing intellectuals in Paris, Cornelius Castoriadis writes: "The struggle for colonies became the main expression of the antagonisms between various monopolies and imperialist na-

tions . . . in which the "advanced" capitalist countries could indulge in the direct and brutal appropriation of wealth and . . . they could sell their products."[7] These imminently tactile theaters of violence with their technologies of guns and torture become as relevant to the imagination of the avant-garde as the technologies of glass and steel fetishized by the Futurists and later by Hobsbawm. It is the voyeuristically visceral that draws European travelers like Eugène Delacroix and later Charles Baudelaire initially to Africa and its vicinity rather than the mere promise of the exotic. Consider Assia Djebar's notes on Delacroix's reminiscences of Algeria in 1832 following the French invasion in 1830:

> On June 25, 1832, Delacroix disembarked at Algiers for a short stopover. He had just spent a month in Morocco, immersed in an atmosphere of extraordinary visual richness (sumptuous costumes . . . the opulence of a royal court . . . lions, tigers . . .). That Orient, so near and with which he was contemporary, spread itself before him in total and excessive novelty. It was the Orient as he had dreamed of it for *The Death of Sardanapalus*. But here it was free from any trace of the notion of sin. . . . Morocco was thus the meeting place for the dream and the incarnation of the esthetic ideal, the site of a visual revolution. So much so that soon after Delacroix would write in his journal, "People and things appear to me in a new light since my trip."[8]

It is a time when all of Africa and much of Asia are colonized spaces. The search for fresh ways of perceiving the world for the European avant-garde is to already immerse oneself in the economy of the new, embodied by the colonial transaction. Its seductive avenues include the international trade in African artifacts, Oriental commodities, exotic human exhibits, and the increased militarization of the French, British, Portugese, and the Dutch in Indochina, Africa, South Asia, and Southeast Asia.[9]

Within this stranglehold of desire and power, Europe's sense of the social and aesthetic norm, and hence its cutting edge, is dramatically shaped by the collision with its colonies and their sensorial regimes. Again, Djebar: "Delacroix brought back souvenirs from his visit to this place—slippers, a scarf, a blouse, a pair of trousers, not as banal tourist trophies, but as tangible proof of a unique and fleeting experience. Traces of a dream." It is a dream that remains etched in his 1834 painting, *Women of Algiers in Their Apartment*, a document of "something

unbearable, something present here and now," writes Djebar.[10]

Beginning with Delacroix and Baudelaire, the circulation of slaves, tea, cocoa, perfumes, coffee, cardamom, cloves, opium, mahogany, and other tropical commodities transforms the modern European imagination. The hermetic spheres of avant-garde experience in cities like London, Paris, Berlin, Rome, and Moscow are interrupted by the ephemeral urban brushing alongside colonized peoples from Third World sites as Walter Rathau's celebratory film *Berlin: Symphony of a City* (1929) captures on screen. In Rathau's Berlin, a sarong-clad Asian man and a well-attired black man are part of the Weimar metropole of the late 1920s. Chance meetings interrupt any singular notion of who has purchase on modernity as the field of intimacies between Europe and its colonies deepens. Urban jostlings underscore the fundamental contradictions emerging in notions of self, freedom, and radical subjectivity. As Aimé Césaire unflinchingly observes in his 1953 treatise *Discourse on Colonialism*:

> First we must study how colonization works to decivilize the colonizer, to brutalize him in the true sense of the word, to degrade him, to awaken him to buried instincts, . . . we must show that each time a head is cut off or an eye put out in Vietnam and in France they accept the fact, each time a little girl is raped and in France they accept the fact, and each time a Madagascan is tortured and in France they accept the fact . . . a gangrene sets in, a center of infection begins to spread; and that at the end of . . . all these prisoners who have been tied up and "interrogated," all these patriots who have been tortured . . . all the boastfulness that has been displayed, a poison has been instilled into the veins of Europe . . . the continent proceeds toward savagery.[11]

Fraught exchanges between colonized and colonizer inflect the deeper implications of what it means to break new ground or be on the cutting edge of history. Social relationships in metropoles and colonized cities blast open, literally and metaphorically, a sphere of historically new experiences weaving the power differentials between perceptual vernaculars. Again, Césaire:

> And then one fine day the bourgeoisie is awakened by a terrific reverse shock: the gestapos are busy, the prisons fill up, the torturers around the racks invent, refine, discuss. People are surprised, they become

> indignant. They say: "How strange! But never mind—it's Nazism, it will
> pass!" And . . . they hide the truth . . . that it is barbarism . . . that . . .
> before they were its victims, they were its accomplices; . . . that they
> absolved it, shut their eyes to it, legitimized it, because, until then, it had
> been applied only to non-European peoples; that . . . they are respon-
> sible for it, and that . . . it oozes, seeps, and trickles from every crack.[12]

Under such violent conditions, self-improvisations for the colonial, and later the
postcolonial, do not translate as avant-garde in a formal sense, but they simultane-
ously unfold a distinctly emergent performative sphere that is ahead of its time in
its articulation as an aesthetic practice embedded in the social. As Frantz Fanon
observes in *Black Skin, White Masks*, to walk down a street in Marseille during the
1940s is an avant-garde act if the degree of shock it generates as a social experi-
ence, "Look, a Negro!" is any barometer to go by.[13] It is that petrifying moment
when Fanon's own cosmopolitan view of himself is shattered through the fear of
a little boy: "Mama, see the Negro! I'm frightened!"[14] Fanon writes, "My body
was given back to me sprawled out, distorted, recolored, clad in mourning in that
white winter day."[15]

 As these histories suggest, an oblique reconsideration of the early twenti-
eth century dislodges radical aesthetic developments eclipsed under the language
of the ocular. Such an approach allows for a distracted ethnography and fore-
grounds a non-ocular modernity. The language of the visual, however, obscures
the implications of the tactile as the sign of the modern. Homi Bhabha notes in
his introduction to *Black Skin, White Masks*:

> From within the metaphor of vision complicit with a Western meta-
> physic of Man emerges the displacement of the colonial relation. The
> Black presence ruins the representative narrative of Western person-
> hood: its past tethered to treacherous stereotypes of primitivism and
> degeneracy . . . its present, dismembered and dislocated. . . . The White
> man's eyes break up the Black man's body and in that act of epistemic
> violence its own frame of reference is transgressed, its field of vision
> disturbed.[16]

This disturbed vision signals a world that emerges between the snap of the photog-
rapher's fingers, the camera-eye's mise-en-scène, the performer's interest in move-

ment and touch, and the architect's vision for new kinds of spaces for people to traverse. Movement, largely relegated to the world of theater and dance, becomes a crucial urban reinvention of migrant colonials in the colonized cities of Algiers, Calcutta, and Dakar as well as in the metropoles of Paris, London, New York, and Amsterdam. It dissolves against the hardscape of the city for lack of a prism to translate its social practices into a historical narrative of modernity's emergence. Within the crucible of revolution and change, tactile movement emerges as a performative sensorium for dispossessed peoples across the North/South, East/West divide. It makes possible particular self-inventions of modernity not otherwise accessible in the more privileged spheres of the visual, in the already globalized world system of imperialism and slavery.

Dreamspace

> A Klee painting named "Angelus Novus" shows an angel looking as though he is about to move away from something he is fixedly contemplating. His eyes are staring, his mouth is open, his wings are spread. This is how one pictures the angel of history. His face is turned toward the past. Where we perceive a chain of events, he sees one single catastrophe which keeps piling wreckage upon wreckage and hurls it in front of his feet. The angel would like to stay, awaken the dead, and make whole what has been smashed. But a storm is blowing from Paradise; it has got caught in his wings with such violence that the angel can no longer close them. This storm irresistibly propels him into the future to which his back is turned, while the pile of debris before him grows skyward. This storm is what we call progress.
>
> —Walter Benjamin[17]

The neat categories of modernity and progress that frame the boundaries of modern subjectivity explode in Walter Benjamin's enigmatic image of the angel careening backward, mouth agape as if in shock. This mobile picture of a celestial messenger in free fall, suspended in mid-movement as the storm of progress propels him away, captures that space of the inarticulable within the modern, between the turned face and the plummeting body. It is the churning space of movement between knowledge systems, epistemes. Caught between the ocular and the aural, the petrified eyes and startled mouth, the structuring logics of progress lie

shadowed amidst the language of the visual and the literary. No one understood this epistemological quandary better than Benjamin, whose own inquiry into the nature of modernity in a time that "had lost all bodily and natural aids to remembrance" leads him to experiment with the "technique of awakening" through the prism of tactility. Awakening for Benjamin is "a process that goes on in the life of the individual as in the life of generations" and "sleep is its initial stage." Benjamin writes, "Its historical configuration is a dream configuration. Every epoch has such a side turned toward dreams, the child side."[18]

This Benjaminian dreamscape fuses multiple space/time configurations. For the colonized, this awakening takes the form of a nightmare from whose electrical spasms the waking is deferred painfully. Césaire writes from within this insomniac nightscape, "My only consolation is that periods of colonization pass, that nations sleep only for a time, and that peoples remain."[19] Sleep for Césaire is the space of a historic horror in which the colonized is forever banished from childhood, even as he is infantilized into a child state. Sleep is that convulsive shock of colonial brutality from which a technique of awakening has to be dreamt. It is the tormented wakefulness of the fearful in a world bereft of child-like innocence.[20]

From within this dismembered somatic space Fanon writes painfully: "Yesterday, awakening to the world, I saw the sky turn upon itself utterly and wholly. I wanted to rise, but the disemboweled silence fell back upon me, its wings paralyzed. Without responsibility, straddling Nothingness and Infinity, I began to weep."[21] Therein lies the epistemic tension between the self-conscious playfulness of the European psyche staged through the avant-garde and the more political reinventions of Surrealist possibility in the writings of colonial intellectuals such as Aimé Césaire, Leopold Senghor, and Frantz Fanon.

Benjamin's methodology of a distracted ethnography offers a historically dynamic method of translating this ambiguous epistemic wrangle between modernity and subjectivity. His elaboration of tactility intimately involves the body and the city. It is a fundamental shaping experience where the material, the imaginative, and the utopian converge to catalyze dramatic shifts of interiority: "The new, dialectical method of doing history presents itself as the art of experiencing the present as waking world, a world to which that dream we name the past refers in truth. To pass through and carry out *what has been* in remembering the dream!— Therefore: remembering and awakening are most intimately related."[22] This art of "experiencing the present as waking world" opens up that traumatic space of the "shock of the new" between colonialism and modernity. It transforms European

as well as non-European subjectivities, as Jean-Paul Sartre's impassioned introduction to Fanon's *Wretched of the Earth* acknowledges:

> For we in Europe too are being decolonized; that is to say that the settler which is in every one of us is being savagely rooted out. Let us look at ourselves, if we can bear to, and see what is becoming of us. First, we must face that unexpected revelation, the striptease of our humanism. There you can see it, quite naked, and it's not a pretty sight. It was nothing but an ideology of lies, a perfect justification for pillage; its honeyed words, its affectation of sensibility were only alibis for our aggressions.[23]

Benjaminian tactility interrupts the hermetic experiences of an initiated elite. It invites a perceptual reconsideration of syncretisms that shaped uneven notions of the cutting edge in the rapidly transnationalizing imaginary of the twentieth century.

Avant-Garde

> Modernity consists in working at the limits of what was thought to be generally accepted, in . . . the arts, in the sciences, in matters of technology, and in politics. . . . This work of testing limits also bears the name of the avant-garde. In the contemporary epoch, fashions often shield themselves with the title of the avant-garde. This is not always accurate. . . . It may well be the case that one has to wait a long time to find out whether the title of avant-garde is deserved.
> —Jean-Francois Lyotard[24]

The discourses of the avant-garde, grounded in Baudelairean preoccupations with synaesthesia and centered around André Breton, grapple contentiously with differing attitudes toward the visual. The tensions between Breton and Georges Bataille are a liminal marker of this crisis of the visual. Breton's rejection of Bataille, which he makes public in his *Second Manifesto of Surrealism* (1930), suggests his intolerance for the scatological and perverse phenomena that preoccupies Bataille.[25] Martin Jay points out that Bataille became a figure around whom other Surrealists who had a falling out with Breton gravitated. Roger Caillois, Michel Leiris,

and André Masson (all of whom had ethnological interests in Africa and Asia) are some. Antonin Artaud was also excommunicated by Breton.

Under the influence of the Dadaists and Surrealists, the notion of the avant-garde expands beyond the painterly frame and the theatrical proscenium. It impinges upon the fascia of the daily, as Marcel Duchamp's definition of art as something to "do" rather than "to make" emphasizes.[26] Duchamp's experiments with found and everyday objects such as the toilet bowl and the bicycle wheel redefine art as a practice of startling possibilities that disregards hierarchies, orthodoxies, and hermetic categories. His emphasis on the conjuncture of the unexpected addresses the everyday as surreal, a site of an emancipatory engagement.

Duchamp's interest in the quotidian addresses the social as an aesthetic enactment. One that Surrealists such as Bataille, Leiris, and Caillois elaborate upon through an interdisciplinary methodology of ethnology, sociology, history, and philosophy. This particular strain of Surrealism coheres around Bataille and the College of Sociology. It is indebted to Marcel Mauss for its interest in the social, and to Breton for its preoccupation with the aesthetic. Its interpretation of Surrealism as method and social practice permits the somatic space for Césaire, Senghor, Fanon, and other colonial subjects to pose the kinds of questions they do in their ruminations on the habitual.

Here, James Clifford's interpretation of the term "surrealism" is helpful. Clifford's indebtedness to Mauss and Bataille condenses this intellectual tradition to an ongoing critical practice. He uses surrealism in a broad sense to envelop an aesthetic that includes "fragments, curious collections, unexpected juxtapositions—that works to provoke the manifestation of extraordinary realities drawn from the domains of the erotic, the exotic, and the unconscious." For Clifford, surrealism is "a tangled disposition" whose overlapping boundaries of ethnography and surrealism produce a contested reality of past and future possibilites to be critically engaged with.[27] Clifford writes: "After Europe's collapse into barbarism and the manifest bankruptcy of the ideology of progress, after a deep fissure had opened between the experience of the trenches and the official language of heroism and victory . . . the world was permanently surrealist."[28] Clifford underscores that surrealism for Breton is not a body of doctrines but an activity.[29] It is an engagement that establishes the materiality of the tactile as a defining tool of the everyday.

Surrealist social practice demands an embodied and total consideration of the impact of the sensory upon the lived. It opens up the circuit between the visual and the technological. The resulting ideological projections that narrativize the

breakthroughs of European modernity (civilized/savage, modern/primitive) rub against the grain of emerging modernities located beyond the eye of the European imaginary. That which has been historically unavailable surfaces, as Senghor's poignant poems to the Senegalese shock troops of battle who fought and died for France in World War II portray:[30]

> There they lie stretched out by the captive roads along the
> routes of disaster
> Thin poplar trees, statues of dark gods draped with their
> Long, gold coats
> Senegalese prisoners lying gloomily on French soil[31]

Senghor's material groundedness allows for fragments and ruins of bodily crossings to surface with historic self-reflexivity across the geopolitical landscape: the Senegalese fighting for the French in Europe during World War II; the French in Algeria; the British in India and East Africa; Africans in Paris and New York; African Americans in Mexico City, Paris, and Amsterdam; Indians in London, Paris, South Africa, and Moscow. These transcontinental sojourns lead to transformations on either side of the encounter. As Sartre emphasizes in his introduction to *Wretched of the Earth*: "It came to an end; the mouths opened by themselves; the yellow and black voices still spoke of our humanism but only to reproach us with our inhumanity. . . . A new generation came on the scene. . . . With unbelievable patience, its writers and poets tried to explain to us that our values and . . . their lives did not hang together, and that they could neither reject them completely nor yet assimilate them."[32]

Sartre notes that itinerant colonial migrancy shifts avant-garde conversations about transnational collisions away from the enclosed spaces of the cafe, the prison, the salon, and the theater. Migrancy accosts the traveller with the uncontainability of the crowd, the unpredictability of the street, the delirium of colonial violence, and the hybridity of global flows. Its startling contacts impact modern subjectivity. Across an uneven international colonized sphere that includes the whole of Africa, South Asia, and Indo-China (Laos, Vietnam, Cambodia, Burma), a global avant-garde emerges. Again, Fanon, on a poem by Keita Fodeba:

> There is not a single colonized person who will not receive the message that this poem holds. Naman, the hero of the battlefields of

Europe, Naman who eternally ensures the power and perenniality of the mother country, Naman is machine-gunned by the police force at the very moment that he comes back to the country of his birth: and this is Setif in 1945, this is Fort-le-France, this is Saigon, Dakar, and Lagos. All those niggers, all those wogs who fought to defend the liberty of France or for British civilization recognize themselves in this poem by Keita Fodeba.[33]

Such surprising juxtapositions derail inquiry away from the formal toward the contextual. They highlight the impact of migrant bodies colliding in transnational locales. Césaire's friendship with Leiris concretizes this impact between ethnology, colonial discourse, and the avant-garde embedded in social contacts of the time. Consider Antonin Artaud among the Tarahumara in Mexico. Georges Bataille's interest in Islam and Tibetan Lamaism. Mahatma Gandhi in London and Durban. James Baldwin, Paul Robeson, Josephine Baker, Claude McKay, and Richard Wright in Paris. Peking Opera in Berlin and Balinese dancing in Paris. G. I. Gurdjieff in the Caucasus. Michel Foucault in Tunisia. Frantz Fanon in Marseille and Algiers. Michel Leiris in Dakar and Djibouti. Claude Lévi-Strauss in Brazil. Zora Neale Hurston and Katharine Dunham in Haiti. Andre Masson and Paul Rivet in Hanoi. Ho Chi Minh in Paris, Moscow, and New York. Conjunctures as these encapsulate the tremulous backdrop against which the interlocking experiences of modernity, globalization, and the avant-garde unfold.

Epistemic Bind

The nation is a bourgeois phenomenon. —Aimé Césaire[34]

The avant-garde is always a way of celebrating the death of the bourgeoisie, for its own death still belongs to the bourgeoisie; but further than this the avant-garde cannot go.

—Roland Barthes[35]

Despite contemporary assumptions that it is no longer possible to be "avant-garde" in the sense that Richard Kostelanetz defines it, as "those out front, forging a path that others will take," art that is "ahead of its time" poses an epistemological conundrum whose ambivalence continues in popular parlance.[36] It invokes a whole set of assumptions that are at once local, national, and global.

Underlying these assumptions is the perceived cultural time lag between the European avant-garde movements and "Third World" modernisms.[37] An apparent absence of innovations in Africa and Asia corresponding to those that the Futurists, Dadaists, and Surrealists were exploring around the body, text, performance, and movement foregrounds the epistemological dilemma. Striking discontinuities between the well-archived and researched terrain of the European avant-garde and the paucity of documentation on modern innovations outside the tribal and the folkloristic of African and Asian subjectivity prior to the decolonization movements of the 1940s and 1950s etch the dialectic.

This epistemic bind is embedded in what Theodor Adorno and Max Horkheimer describe as the delusional idea of teleological progression, whose end logic lay in the gas chambers of Auschwitz.[38] The linearity embedded in the narrative of the avant-garde contradicts the notion of a break with the past rooted in the practice of the avant-garde. It reiterates a conception of continuity in the preoccupation with the new. This epistemological knot of teleological progression whose barbarity Adorno and Horkheimer reject is further embedded in the history of colonialism, the rise of the nation, the emergence of cities, and the history of twentieth-century bourgeois individualism. Its undulating map is an interconnected one through the global history of colonial expansion connecting the French, British, Germans, Dutch, Belgians, Spanish, and Portugese to Asia, Africa, and the New World by the nineteenth century. It is an intricate global network of arrivals and departures, thefts and exchanges, influences and rejections, circulations and still points.

This trace of the modern begins with Baudelaire's travels to Mauritius in 1841 and his obsessions with Jeanne Duval, a mulatto actress who played roles at the Theatre de la Porte Sainte-Antoine in Paris in 1842.[39] A century later, it locates Artaud in Rodez in 1948 while Fanon studies psychoanalysis and the effects of French methods of torture on the Algerians in his groundbreaking exploration of the effects of colonial torture techniques on the colonizer and the colonized undertaken at Blida Joineville, Algeria.[40]

Transnational mapping impacts Continental thinking about notions of the new. Breton's numerous tracts, particularly "Freedom is a Vietnamese Word" (1947), consciously stage this epistemic rupture through his vociferous protests against French imperialist aggression in Indochina. Condemning the fierce repression perpetrated by the French under the name of democracy, Breton writes, "It is impossible to maintain freedom here while imposing slavery there. . . . Surreal-

ism . . . vigorously protests the imperialist aggression and addresses its fraternal salute to those who incarnate, at this very moment, the becoming of freedom."[41] Breton's deployment of Surrealist activity as a strategy for social transformation that includes decolonization as its sphere of engagement highlights the very interdependent scenario of abjection and emancipation moulding the avant-garde project. The "shock of the new" for Breton includes the barrel of the gun as well as conversations with intellectuals and political theorists such as the Martiniquan Aimé Césaire, the Mexican artists Diego Rivera and Frida Kahlo, the Senegalese Leopold Sedar Senghor, and the Haitians René Depestre, Jean Price-Mars, and Clément Magloire-Saint-Aude. Crossings such as these situate the aesthetic breakthroughs of the European avant-garde against the invention of modern sovereign states such as Vietnam, Senegal, Haiti, and Martinique, with their struggles for self-determination inspired by political surrealists such as Ho Chi Minh, Leopold Senghor, Rene Depestre, and Aimé Cesairé. Its transnational cartography underscores the intertwined landscapes of France, Indochina, the Caribbean, and North Africa.

Transnational consciousness percolates writing on the avant-garde. It is a writing that reflexively interrogates the paradox of inscribing from within the self-absorbed eye of Europe. It is conscious of its own narrative of modernity as a Western modernity. Working as a young journalist for Socialism or Barbarism, Lyotard gazes unnervingly into this epistemic quagmire. His experiences in Constantine, Algeria, from 1950 to 1952 shock him into wrestling with the uneven spaces of modernity. His later writings explore the inadequacy of the teleological model of development and progress that underlies the narrative of the modern, particularly that of the avant-garde:

> One can note a sort of decay in the confidence placed by the two last centuries in the idea of progress. This idea of progress as possible . . . was rooted in the certainty that the development of the arts, technology, knowledge, and liberty would be profitable to mankind as a whole. . . . After two centuries, we are more sensitive to signs that signify the contrary. Neither economic nor political liberalism . . . emerge from the sanguinary last two centuries free from the suspicion of crimes against mankind. . . . Following Theodor Adorno, I use the name of Auschwitz to point out the irrelevance of . . . the modern claim to help mankind to emancipate itself.[42]

For Lyotard, as for the Frankfurt School, the barbarity of the civilizing mission lay in the ruins of Auschwitz, a testament to the failure of the modern project of rationality and teleology.

Writing self-consciously from within this epistemological break, Césaire's *Discourse on Colonialism* spells out this double bind between the European avant-garde and its colonial and eventually postcolonial other, by responding to Caillois's ethnological blind spot. "Just think of it!" Césaire writes:

> M. Caillois has never eaten anyone! M. Caillois has never dreamed of finishing off an invalid! It has never occurred to M. Caillois to shorten the days of his aged parents! Well, there you have it, the superiority of the West . . . compared to the cannibal, the dismemberers, and other lesser breeds, Europe and the West are the incarnation of respect for human dignity. . . . But let us move on, and quickly, lest our thoughts wander to Algiers, Morocco, and other places where, as I write these very words, so many valiant sons of the West, in the semi-darkness of dungeons, are lavishing upon their inferior African brothers . . . those authentic marks of respect for human dignity . . . called . . . "electricity," "the bath-tub," and "the bottleneck."[43]

Here, Césaire draws out the ethnological and historical conditions that inform the very semantics of performing, collecting, producing, archiving, and recording within the French imagination. Writing in 1955, Césaire's scathing critique of Caillois suggests how the struggle for postcolonial sovereignty is the backdrop against which surrealist modernity unfolds. While the decadent bourgeoisie of the European avant-garde swing from chandeliers, as Phillipe Soupault does in the famed banquet for the Symbolist poet Saint-Pol-Roux, and slit cow eyes, as Buñuel and Dalí do in *Un Chien Andalou*, colonial subjectivity struggles to be humanized and recognized as modern. Even as European subjectivity ironically performs a stylized barbarity in *Un Chien Andalou*, colonial subjectivity contends with a biologically determined savagery imposed by Western scientific constructs.[44]

For a "native" from Africa or Indochina to emerge as an individual rather than merely as a native or *indigène* in Paris or in their colonized homelands requires an extraordinary amount of self-invention in the face of a debilitating effacement of subjecthood. To fashion modern subjecthood in the public sphere of the street, the marketplace, the café, and the French Communist Party becomes

an avant-gardist act par excellence for the colonized. This shock of the new escapes the radar of bourgeois Western codes. To walk down the streets of Marseille as Fanon does in the 1940s, to work as a photographer in the 1920s as Ho Chi Minh does, to interrogate the workings of seamen and longshoremen in the steaming coal hulls of the steamships of Marseille as Claude McKay does during the 1920s (see *Banjo*, 1929), to explore ritual and trance in Haiti as Zora Neale Hurston and Katharine Dunham do, suggest the wider social sphere of a corporeal avant-garde as social practice that coexists alongside the more visible stagings of Europe's avant-garde coterie.

Paul Robeson's plea in 1949 for self-determination during the World Peace Congress in Paris is a particularly evocative instance of how this aesthetic avant-garde shapes the political platform for change. Martin Duberman notes that W. E. B. DuBois headed the American delegation and Picasso and Louis Aragon were among the luminaries at the Congress. Robeson apparently sang to the gathering and spoke out for colonial peoples still denied their rights: "The wealth of America," he said, had been built "on the backs of the white workers from Europe . . . and on the backs of millions of blacks. . . . And we are resolved to share it equally among our children. And we shall not put up with any hysterical raving that urges us to make war on anyone. Our will to fight for peace is strong. We shall not make war on anyone."[45]

Robeson's speech stands out as a memorable gesture that encapsulates the epistemological dilemma of the avant-garde in all its pathos: that of the modern subject avant bourgeoisification that characterized a considerable portion of Africa and Asia by the first half of the twentieth century. To be modern yet not free, to be individualistic yet denied the rights to citizenship, to be globally mobile yet not part of a definable social class, this was Robeson's condition as much as it was that of other Third World subjects roaming Europe as exiles from the 1920s on. Claude McKay, Josephine Baker, Countee Cullen, Katharine Dunham, Suzanne Césaire, Mahatma Gandhi, Jomo Kenyatta, Julius Nyerere, the list continues. Embedded within the narrative of the avant-garde is its teleological limit. Discontinuous but preoccupied with the new. Non-linear yet historically sequential.

Tactility

Thus, insofar as the new form of vision, of tactile knowing, is like the surgeon's hand cutting into and entering the body of reality to palpate

the palpitating masses enclosed therein, insofar as it comes to share in those turbulent internal rhythms of surging intermittencies and peristaltic unwinding—rhythms inimical to harmonious dialectical flip-flops or allegories of knowing as graceful journeys along an untransgressed body of reality, moving from the nether regions below to the head above—then this tactile knowing of embodied knowledge is also the dangerous knowledge compounded of horror and desire dammed by the taboo.

—Michael Taussig[46]

In his groundbreaking 1934 essay "The Techniques of the Body," Mauss delineates tactility as the sphere of action, touch, sensation, encounter, exchange, and movement. He argues that the import of the tactile in the industrial era is far greater than its recognized significance as a link between the visual and technological modern suggests. Mauss proposes tactility as a technology of the body that is critical to gauging the modern. His observations about bodily techniques since 1895 are made in the wake of an ongoing preoccupation with the perceptual shifts of the non-ocular sensorium that emerges through nineteenth-century thought.

Mauss's theory of tactility opens up the space between movement, performance, and everyday social practices such as walking, running, training, marching, squatting, drinking, dancing. His treatise distinguishes between the tactility of the stage and the tactility of the everyday: "Technical action, physical action, magico-religious action are confused for the actor. These are the elements I had at my disposal."[47]

This liminal distinction between the tactility of the everyday and the semantics of movement on stage is crucial to an understanding of the communicative dimension of touch within the modern imaginary. Toward this broader historic understanding, Mauss offers a theory of action that is performative while also being located in what he calls "the total social fact: actions of a mechanical, physical, or physico-chemical order."[48] This socially embedded notion of tactility offers a provocative route into the debris of modernity. It fleshes out techniques of the self through which modern bodies are constituted.

Mauss's theory of tactility defines the modern sensibility and encompasses that great montage of manners and gestures that leads Baudelaire to observe in 1860 "that every age had its own gait, glance, and gesture."[49] Mauss's meditations on tactility follow in the wake of Baudelaire's intuitive ruminations on the nature of embodiment in the city. It makes available a methodology for translating these

itinerant, corporeal transferences between peoples across cultural chasms.

Baudelaire's notion of tactility is a critical interjection in the discourse on the avant-garde. For Baudelaire, the realm of the urban is the theater of modernity and its vernacular is tactile as well as ocular. It is amidst "the heart of the multitude, amid the ebb and flow of movement, in the midst of the fugitive and the infinite" that one experiences that sensation of being gripped by a surging present. The great landscape of the city generates "an immense reservoir of electrical energy" that inspires the spectator into a state of nervous shock.[50] Experienced between the spectacular street, the specular eye, and the pandemonious stage, shock captures what language fails to articulate: the phantasmagoria of the new. From within this inspirational shudder Baudelaire writes:

> By "modernity" I mean the ephemeral, the fugitive, the contingent, the half of art whose other half is the eternal and the immutable. Every old master has had his own modernity: the great generations are clothed in the costume of their own period. They are perfectly harmonious, because everything—from costume and coiffure down to gesture, glance, and smile (for each age has a deportment, a glance and a smile of its own)—everything, I say, combines to form a completely viable whole.[51]

This total work of art, the "viable whole" imagined by Baudelaire, is only possible outside the Wagnerian stage, out on the spectacular street, in the battlefields of the Crimea and the gifted ethnographic eye of Constantin Guys's mobile drawings.[52] In these spaces of the everyday, the chancing upon the Other (Turkey, India, Egypt) through travel, images, luxury commodities, and bodies on the street catalyzes a multiply layered sense of an evolving contemporaneity. As the vehicle of Baudelairean shock, the body and its sensation of the tactile pulls the experience of the avant-garde into the realm of the everyday and the street. This urban sensation of shock explodes the palimpsestic city into a site of performative distraction.

Shock

> Bardo is the death throes in which the ego falls in a puddle,
> and there is in electroshock a puddle state
> through which everyone traumatized passes . . .

it plunges the shocked into that rattle with which we leave life . . .
what the Tarahumaras of Mexico call the spittle of the grater, the
cinder of toothless coal

—Antonin Artaud[53]

Writing in Berlin, Georg Simmel in his 1908 essay "The Stranger" is nervous of
shock. Shock for Simmel is the increasing democratization of the urban public and
the consequent increase of strangers in the familiar streets of his city. For him, the
expansion of cities meant the demise of the folk worldview (the *volk-gemeinschaft*),
that distinctly local sensibility that made his Berlin neighborhoods of the late nine-
teenth and early twentieth century familiar and comforting.[54] Simmel's resistance
to the increasing heterogenizing of cities is a resistance to the speed of perceptual
shock embedded in the modern that is disconcertingly embodied by the foreigner,
the stranger, and most alarmingly, the immigrant.

This sense of shock is laid out programmatically by the Futurists by the
early 1900s. The Futurists were particularly interested in the relationship between
the body, technology, speed, the encounter with the Other, and perceptual shock
within the urban.[55] In F. T. Marinetti's writings, the collision with Africa and the
"Orient" through the urban grips his feverish vision of a technologized utopia. It is
a tremor that punctuates the opening of Marinetti's manifesto, a relentless erasure
of all else but a youthful masculinist self that is European: "We had stayed up all
night, my friends and I, under hanging mosque lamps with domes of filigreed
brass, domes starred like our spirits, shining like them with the prisoned radiance
of electric hearts. For hours we had trampled our atavistic ennui into rich oriental
rugs, arguing up to the last confines of logic and blackening many reams of paper
with our frenzied scribbling."[56] Perceptual shock for Marinetti is the heady dis-
connect of modernity's possibilities. It is a furious embrace of the future that is
expansionist and ultimately fascistic in its obsession with a technologized self that
glorifies the tactile machine:

We will sing of great crowds excited by work, by pleasure, and by riot:
we will sing of the multicoloured, polyphonic tides of revolution in the
modern capitals; we will sing of the vibrant nightly fervour of arsenals
and shipyards blazing with violent electric moons, greedy railway sta-
tions that devour smoke-plumed serpents; factories hung on clouds
by the crooked lines of their smoke; bridges that stride the rivers like

giant gymnasts, flashing in the sun with a glitter of knives . . . deep-chested locomotives whose wheels paw the tracks like the hooves of enormous steel horses bridled by tubing; and the sleek flight of planes whose propellers chatter in the wind like banners and seem to cheer like an enthusiastic crowd.[57]

This nihilistic sense of the modern leaves little accountability for the undulating space of modernity as a dialectical expression of history even as its intimately experienced multiplicity, "the tides of revolution in the modern capitals," is acknowledged through touch. Again, Marinetti: "O maternal ditch, almost full of muddy water! Fair factory drain! I gulped down your nourishing sludge; and I remembered the blessed black breast of my Sudanese nurse."[58]

Marinetti's recollection of his childhood offers the unconscious rupture to the falsely utopian sense that modernity can evolve without its catastrophic underbelly of imperialism and exploitation displaced to the periphery of Europe. Shock remains for the Futurists an exploration of sensation through formal movement, as in photodynamism or noise, while the messier technological forays of Italy into Sudan and Ethiopia remain the silent subtext in their manifestoes.

A temporal notion of shock is no longer of interest to us from our vantage point in history, as Lyotard observes. Referring to World War II, Lyotard argues that:

> After the recent conflict, revolt is now cut off from its occasion and its source, cut off from the possible. This is certainly the most serious crisis in expression for some time: expression is no longer able to surpass its material, no longer knows how to assign a "beyond" to the event. . . . There is no longer any delirium that can live up to our tidy violence. Chance and arbitrariness have entered our everyday life along with horror, and often it is no longer desire that produces surreality, but remorse.[59]

Shock under such conditions takes on a new intensity, a new urgency. What does it take to shock in our time? Is shock useful as an aesthetic and political strategy? Lyotard suggests (referring to his generation) that "what is new about this generation is its unconquerable appetite for the concrete."[60] This appetite for the concrete symptomizes the colonized's interruption through shock.

Writing in that gap between the technological and the visual as embodied subjects interrupting emerging metropolitan spaces, Césaire, Senghor, and Fanon articulate the tactile as the barometer of the new epistemological frame. It emerges as an amorphous but defining non-ocular sensation of modernity for these colonized subjects wandering through urban terrain. Tactility registers a modernity that exceeds the visual. Touch is the sublime convulsion marking its limits. This shock of the tactile is inscribed in Césaire's writings. It is Senghor's literal shock as a French prisoner of war in Germany in 1940, where he writes Black Hosts, poems mourning the Senegalese foot soldiers who literally fought as the shock troops of battle for the French during World War II. It is etched in Fanon's analysis of the impact of French methods of torture employing electrical shock that mutates the Algerian psyche, and his own.

Ricochet

> And now I ask: what else has bourgeois Europe done? It has undermined civilizations, destroyed countries, ruined nationalities, extripated "the root of diversity." . . . The hour of the barbarian is at hand. The modern barbarian. The American hour. Violence, excess, waste, mercantilism, bluff, gregariousness, stupidity, vulgarity, disorder.
>
> —Aimé Césaire[61]

The epigraph is taken from Aimé Césaire, *Discourse on Colonialism* (New York: Monthly Review Press, 1972), 32.

1. The Madrid bombings of 11 March 2004.

2. Walter Benjamin, *Theses on the Philosophy of History*, ed. Hannah Arendt (New York: Schocken Books, 1969), 257–58.

3. See Francois Lyotard, *Political Writings* (Minneapolis: University of Minnesota Press, 1993).

4. Martin Jay, *Downcast Eyes: The Denigration of Vision in Twentieth-Century French Thought* (Berkeley: University of California Press, 1993), 212.

5. Eric Hobsbawm, *Behind the Times: The Decline and Fall of the Twentieth-Century Avant-Gardes* (London: Thames and Hudson, 1999), 7.

6. Ibid.

7. Cornelius Castoriadis, "Socialism or Barbarism," in *Political and Social Writings: Volume 1, 1946-*

1955: From the Critique of Bureaucracy to the Positive Content of Socialism (Minneapolis: University of Minnesota Press, 1988).

8. Assia Djebar, "Forbidden Sight, Interrupted Sound," *Discourse* 8 (Winter 1986–87): 39.

9. See Coco Fusco, "The Other History of Intercultural Performance," in *English is Broken Here: Notes on Cultural Fusion in the Americas* (New York: The New Press, 1995), for the interconnections between performance, ethnography, and exhibiting.

10. Djebar, "Forbidden Sight," 41.

11. Césaire, *Discourse on Colonialism*, 13.

12. Ibid., 14.

13. Frantz Fanon, *Black Skin, White Masks* (London: Pluto Press, 1986), 109.

14. Ibid., 112.

15. Ibid., 113.

16. Homi Bhabha, "Introduction," in ibid., xii.

17. Benjamin, *Theses on the Philosophy of History*, 257–58.

18. Walter Benjamin, *The Arcades Project*, ed. Rolf Tiedermann (Cambridge, MA: Harvard University Press, 1999), 388.

19. Césaire, *Discourse on Colonialism*, 23.

20. Aimé Césaire refers here to the colonial Martinique of his childhood. Born in Martinique, Césaire studied in Paris in the 1930s. He initiated the Negritude movement along with Leopold Senghor and Leon Damas in Paris. Following Césaire's footsteps, Frantz Fanon studied medicine and psychiatry in France and later worked for the French in Algeria. He practiced psychiatry in Algeria, where he shifted sympathy from the French to the Algerians.

21. Fanon, *Black Skin, White Mask*, 140.

22. Benjamin, *Arcades Project*, 389.

23. Jean-Paul Sartre, "Preface," in Frantz Fanon, *The Wretched of the Earth*, trans. Richard Philcox (New York: Grove Press, 2004), 25.

24. Jean-Francois Lyotard, *Political Writings*, trans. Kevin Paul Geiman and Bill Readings (Minneapolis: University of Minnesota Press, 1993), 24.

25. Jay, *Downcast Eyes*, 233.

26. Marcel Duchamp, interview by Joan Bakewell, *Late Night Line Up*, BBC, 5 June 1968.

27. James Clifford, *The Predicament of Culture: Twentieth-Century Ethnography, Literature, and Art* (Cambridge, MA: Harvard University Press, 1988), 118–19.

28. Ibid., 119.

29. Ibid., 117.

30. The groundbreaking analysis by Edward Said on the structuring notions of Orientalism are critical to this literature. Also the seminal work of Frantz Fanon, Albert Memmi, and Malek Alloula

lay out the performative violence of the ethnographic gaze through which colonial desire operates. Fanon's analysis of the nature of identification on the part of the colonized as well as the colonizer draws out the embedded and interconnected relationships between power and desire that shaped colonial encounters. Alloula and Memmi's work, on the other hand, presents the staged and theatricalized nature of colonial violence through which the modern imaginary is constituted. Touch emerges in this archive of colonial desire as the terrifying place of non-language frozen in time as sanitized photographs of Europe's elsewhere.

31. Leopold Sedar Senghor, *Leopold Sedar Senghor: The Collected Poetry*, trans. Melvin Dixon (Charlottesville: The University of Virginia Press, 1998), 57.

32. Sartre, "Preface," 9.

33. Fanon, *Wretched of the Earth*, 233.

34. Césaire, *Discourse on Colonialism*, 57.

35. Roland Barthes, "Whose Theater? Whose Avant-Garde?," in *Critical Essays*, trans. Richard Howard (Evanston, IL: Northwestern University Press, 1972), 69.

36. Richard Kostelanetz, *Dictionary of the Avant-Gardes* (New York: Routledge, 2001), xix-xxiii.

37. Clifford, *Predicament of Culture*, 127. In "Ethnographic Surrealism," James Clifford points out that not enough work has been done on the interconnections between avant-garde movements, the social sciences, and Third World modernisms.

38. Theodor Adorno and Max Horkheimer, "The Culture Industry: Enlightenment as Mass Deception," in *Dialectic of Enlightenment* (New York: Continuum, 1972).

39. Charles Baudelaire, *Selected Poems*, trans. Joanna Richardson (New York: Penguin Press, 1975), 11.

40. See Frantz Fanon's "Colonial War and Mental Disorders," in *The Wretched of the Earth*, for case studies exploring the psychopathologies of the everyday under colonial violence.

41. André Breton, "Freedom is a Vietnamese Word," in *What is Surrealism?: Selected Writings*, ed. Franklin Rosemont (New York: Monad Press, 1978), 339–40.

42. Jean-Francois Lyotard, "Defining the Postmodern," in Hal Foster, *The Anti-Aesthetic: Essays on Postmodern Culture* (Port Townsend, WA: Bay Press, 1983), 172.

43. Césaire, *Discourse on Colonialism*, 52–53.

44. Clifford, "On Ethnographic Surrealism," in *Predicament of Culture*.

45. Martin Duberman, *Paul Robeson: A Biography* (New York: New Press, 1989), 342.

46. Michael Taussig, *Mimesis and Alterity: A Particular History of the Senses* (New York: Routledge, 1993), 31.

47. Marcel Mauss, *Sociology et Anthropologie* (Paris: Press Universitaires de France, 1968), 364–86.

48. Ibid. See also Michel Foucault's historical analysis of the emergence of technologies of the self

within the Western philosophical tradition in Huck Gutman et al., eds., *Technologies of the Self* (Amherst: University of Massachusetts Press, 1988).

49. Charles Baudelaire, *The Painter of Modern Life and Other Essays*, ed. and trans. Jonathan Mayne (New York: Phaidon, 1964), 14.

50. Ibid., 9.

51. Ibid., 13.

52. Ibid., 18.

53. Antonin Artaud, *Watchfields and Rack Screams: Works from the Final Period*, ed. and trans. C. Eshleman with B. Bador (Boston: Exact Change, 1995), 163–65.

54. Georg Simmel, *On Individuality and Social Forms*, ed. Donald N. Levine (Chicago: University of Chicago Press, 1971), 145.

55. See F. T. Marinetti's fascination for machines and cars in "The Founding and Manifesto of Futurism 1909," in *Futurist Manifestos*, ed. Umbro Apollonio, 19–24 (New York: The Viking Press, 1970).

56. Ibid., 19.

57. Ibid., 22.

58. Ibid., 21.

59. Lyotard, *Political Writings*, 87.

60. Ibid., 87.

61. Césaire, *Discourse on Colonialism*, 59.

PART TWO

DIALECTICS OF DISPLACEMENT

Migration, Law, and the Image: Beyond the Veil of Ignorance

W. J. T. Mitchell

The topic "Images of Illegalized Immigration" that provided the original occasion for this text demands a convergence of three fields: law, with its entire edifice of judicial practice and political philosophy; migration, as the movement and settlement of living things, especially humans, across the boundaries between distinct habitats; and iconology, the theory of images across media, including verbal and visual images, metaphors and figures of speech, as well as visual representations. Law and migration engage the realm of images as the location of both the sensuous and the fantasmatic: concrete, realistic representation of actuality, on the one hand, and idealized or demonized fantasies of migrants as heroic pioneers or invading hordes, on the other.

One peculiarity must immediately strike an image theorist in contemplating this array of problems. Images are "imitations of life" and they turn out to be, in a number of important senses, very similar to living things themselves.[1] It makes sense, therefore, to speak of a "migration of images," of images themselves as moving from one environment to another, sometimes taking root, sometimes infecting an entire population, sometimes moving on like rootless nomads.[2] The animated, lifelike character of images has been recognized since ancient times, which is why the first law concerning images is a prohibition on their creation, accompanied by a mandate to destroy them. If the relation of the law to migration is mainly negative, a mandate to block the movement of living things, the relation of the law to images is exactly analogous. The prohibition on images is grounded in an attempt to sequester a political and religious community from contamination by images, and to extirpate those alien forms of imagery commonly known as idols. The image is thus always involved with the other, with alien tribes, foreigners, invaders, or conversely with native inhabitants who must be expelled. Since other people, both kinfolk and strangers, can only be apprehended by way of images—stereotypes of gender, race, ethnicity, etc.—the problem of migration is structurally and necessarily bound up with images. Migration is not merely content to be represented through images, but is a constitutive feature of life, central to the ontology of images as such.

But there is an important limit to this analogy that we should note at the outset. The prohibition on images, especially dangerous images of others, is rarely successful. In contrast to real human bodies, images cross borders and flash around the planet at lightning speed in our time, and have always been "quick," in every sense of the word. Unlike real living bodies, images are very difficult, if not impossible to kill, and the effort to stamp them out often has the effect of making them even more virulent. The idea of a "plague of images" has become a commonplace since Baudrillard; the difficulty of containing or censoring the migration of images is a well-established fact. The laws that govern the migration of real bodies and borders are without question much better enforced than those against images. Images "go before" the immigrant in the sense that, before the immigrant arrives, his or her image comes first, in the form of stereotypes, search templates, tables of classification, and patterns of recognition. At the moment of first encounter, the immigrant arrives as an image-text whose documents go before him or her at the moment of crossing the border. This simple gesture of presentation is repeated millions of times every day throughout the world, and might be regarded as the "primal scene" of law and immigration in the face-to-face encounter.

Insofar as my topic is "illegalized" immigration, it engages the whole domain of law and the underlying foundations of political philosophy, a highly abstract and general field. In Western jurisprudence, the law is grounded in political philosophies, principally in liberalism, that insist on some form of primacy for the law, in its most abstract sense, as applying to equally abstract subjects or persons. The "legal subject" has to be an abstraction or the law is not the law, at least in liberalism. Notions of the equality of subjects before the law, the moral equality of persons quite apart from accidents of birth, race, or culture; the individual as a subject of rights and responsibilities, sovereign in its value—all these features of the liberal notions of law and politics remain very difficult to imagine or represent concretely. That is part of the point of liberalism: as a political and legal philosophy, it is deliberately abstract and schematic, employing an ascesis of images, most visibly represented in the image of Blind Justice with her scales.[3] One might even see it as an instance of the aniconism and iconophobia of Judeo-Christian and Muslim religious law and its grounding in an invisible, hidden personification of divine justice. "The principles of justice," as philosopher John Rawls put it, "are chosen behind a veil of ignorance" that eliminates all concrete contingencies and particularities—in other words, all sensuous images.[4]

Of course there are other notions of the law that are more concretely embodied and visible: the body and buildings associated with sovereignty; notions of cultural custom and communal authority that may clash markedly with liberal notions of individual freedom and equality. When the realm of images and the imaginary collides with the law, in other words, the abstract tends to become concrete, and liberalism's picture of a rational, legal, politically just framework for immigration begins to expose its contradictions. As Phillip Cole notes in his book, *Philosophies of Exclusion: Liberal Political Theory and Immigration*, "liberal political philosophy . . . comes to an end at the national border."[5] Rawls's "veil of ignorance" is rent by a revelation of flesh-and-blood human beings. The abstract legal subject takes on a human face, and the abstract notion of borders becomes a concrete site. Cole, in fact, opens his book with a meditation on the proper image for the cover of a book about liberal political theory and immigration, and immediately notes a reversal of expectation. He had been imagining:

> Something dramatic signifying exclusion—a painting of city walls with massive gates closed against besieging hordes, or a black-and-white photograph of barbed-wire fences and people with guns keeping out bedraggled travelers. I was searching for something spectacular or stark, which would signify one or other of the poles around which discussions of immigration gather—that liberal democratic states are justified in erecting firm barriers against teeming masses that would drain them dry, or that they are jealously guarding their privileges against the weak and helpless.[6]

But the image that Cole finally adopted was quite at odds with this imaginary scene, turning out to be a banal photograph of a man painting a white line down the middle of a street. (fig. 1). This 1947 photograph of a British official marking the boundary between the Soviet and British sectors of Berlin reveals to my eye two contradictory readings: on the one hand, it signifies (as Cole notes) the arbitrary, even imaginary and ephemeral character of a border, like a child drawing a line in the sand to claim a momentary territory; on the other hand, as we now know, it was a premonition of a global dividing line that was central to the Cold War for half a century. It became the frontier of clashing political philosophies and the site of numerous "legalized" murders and tragic separations that still linger, and not only in the consciousness of the German people, but across the world. The banality

Fig. 1. *Border Line*, 1947, Keystone, Hulton Archive, Getty Images. This image was featured on the cover of Phillip Cole, *Philosophies of Exclusion: Liberal Political Theory and Immigration* (Edinburgh, UK: Edinburgh University Press, 2000)

of this image of "illegalized" migration was matched by its fatefulness for the world order from 1945 to 1989.

Immigration at the level of the image, then, has to be seen as perhaps the most radically *dialectical* image available to us in the present moment. I'm using dialectical here in Walter Benjamin's sense of the image that captures "history at a standstill," but I'm also interested in the vernacular sense of the dialectical image as a site of visible, audible, palpable contradiction where the real and the imaginary suddenly crystallize in a symbolic form, epitomized by the merely imaginal character of the white line and its fateful realization. Migration as a topic engages all the inherent dialectics of the image and exacerbates them: figure and ground (the migrant's body and the physical border); immigration as an affair of bodies and spaces, living things and environments; the push and pull of movement and stasis, exile and return, expulsion and invasion. We might schematize the dialectics of migration with the following diagram (fig. 2).

In calling this a "dialectical" diagram I want to insist that its elements do not have the status of binary oppositions that remain in fixed positions. They are, rather, dynamic opposites that are manifested in times and places, events, narratives, and dramatic scenes, and above all in points of view. Every emigration is at least in principle an immigration somewhere (and to someone) else. Every departure implies an arrival, and perhaps a return. Every exile longs for a home; even the most radically rootless nomad requires an oasis as a temporary home. Invasions are almost invariably accompanied by expulsions, such as ethnic cleansing and the production of masses of refugees. And at every turn, the law is

MIGRATION

EMIGRATION IMMIGRATION

Exit Entrance

Departure Return
Exile, Nomad Settler, Colonist

Expulsion Invasion

Refugee Detainee

Borders
Frontiers
Checkpoints
Internment camps
Ghettoes

Fig. 2. The Dialectics of Migration

invoked to justify expulsion or confinement, exile or colonization. Every legalization is at the same time an illegalization, as the law of Manifest Destiny showed when it justified driving Native Americans from their ancestral homelands to make room for European settlers.

The dialectical image of "history at a standstill" is most often revealed when the image captures a figure or space of arrested motion or (what may come to the same thing) endless repetition. The most salient fact about migration in our time is the way it has become, not a transitional passage from one place to another, but a permanent condition in which people may live out their lives in a limbo of illegalized immigration, perpetual confinement in a refugee camp, or perpetual motion and rootlessness, driven from place to place.[7] We might call this, inverting Heidegger, immigration as *dasein*. This paradoxical condition is nicely captured in the Dustbowl ballad, "How Can You Keep on Moving?" collected and performed by Ry Cooder:

> How can you keep on moving, unless you migrate too?
> They tell you to keep on moving, but migrate you must not do.
> The only reason for moving, and the reason why I roam
> Is to move to a new location, and find myself a home.[8]

The balladeer wants to insist on the logical connection between moving and migrating, only to be told by the law that they are opposites: moving is mandated and migrating is forbidden. And this law was being applied, it should be noted, not to aliens arriving from another country, but to citizens of the United States, refugees from the Dustbowl in Oklahoma during the Great Depression. America is not only a "nation of immigrants," as is often said, with the Statue of Liberty welcoming "your tired, your poor, your huddled masses" from abroad, but a nation of *internal* migration in which whole populations surge across the borders between states and regions, sometimes voluntarily, as in the case of the nineteenth-century pioneers heading westward, sometimes involuntarily, as in the removal

and ethnic cleansing of the Cherokee nation on the notorious "Trail of Tears." The Great Migration that brought African Americans from the rural South to the industrial North was, at the level of the imaginary, a utopian reversal of the obscene parody of immigration that had been imposed upon them with their forced migration as slaves. The law showed its teeth at both ends, legalizing slavery as a Biblically sanctioned institution, supported further by the laws of property in the notorious Dred Scott decision of the United States Supreme Court, and enforced spatially in the long border between the slave-owning states of the South and the free states of the North. The Dred Scott decision had the effect of rendering African Americans *and their descendants* "resident aliens," ineligible for the rights of United States citizenship: "persons of African descent cannot be, nor were ever intended to be, citizens under the U.S. Constitution. Plaintiff is without standing to file a suit."[9]

Migration in search of freedom or as a compulsion to slavery might be taken as the absolute dialectical poles of the law of human movement. God tells Abraham: "Get thee out of thy country, and from thy kindred, and from thy father's house, unto a land that I will show thee: And I will make of thee a great nation." He later tells Moses to lead the Israelites out of captivity into their promised land. What is not generally noted is that these mandated, "legalized" immigrations are accompanied by conquest, colonization, and expulsion of the native inhabitants, as well as (not incidentally) their images and idols:

> When you cross the Jordan into Canaan, drive out all the inhabitants of the land before you. Destroy all their carved images and their cast idols, and demolish all their high places. Take possession of the land and settle in it, for I have given you the land to possess.[10]

If our goal is to make visible and ponder "images of illegalized immigration," we need to focus not only on images of the immigrant body—faces, genders, skin color, clothing, the data gathered on identification documents— but also images such as "the Jordan" to be crossed over. Images of immigration crucially involve the places, spaces, and landscapes of immigration, the borders, frontiers, crossings, bridges, demilitarized zones, and occupied territories that constitute the material and visible manifestations of immigration law in both its static and dynamic forms.[11] Above all, we should consider the detention camp as a new form of legal limbo where persons may be detained indefinitely, in a situation

that is de jure "temporary" but de facto "permanent." Illegalization of immigrants, and the spaces set aside for them, may be regarded as a more moderate version of the most militant form of illegalization in our time: the concept of the "unlawful combatant." What the illegalized immigrant and unlawful combatant share is a peculiar, paradoxical status in relation to the law—at one and the same time they are subject to the law and excluded from it. Illegalization places them outside legal resources such as due process, habeas corpus, and elementary human rights at the same time that it does so *in the name of the law* or "under the color of legality." The reliance of the Bush administration's extra-legal detention camps (Guantanamo the principal example) on elaborate legalistic justifications perfectly exemplifies the paradoxical lawful/lawless character of these institutions and their peculiar status as both temporary and permanent, visible and invisible.

As a mnemonic device, we might exemplify these two manifestations of the law in the phenomena of the immoveable wall, on the one hand, and the flying checkpoint, on the other. These two forms of interdictory legal space have been made famous by their emergence as fundamental structures of everyday life in the occupied territories of Palestine, but they instantiate a much more general dialectic that governs social space globally, from Tibet to the United States-Mexican border, the boundaries of Russia and Georgia, or the barrier that once divided Catholic and Protestant Belfast along the Falls Road. At one pole of this dialectic is the relatively permanent structure that may divide peoples and prevent any movement, much less immigration or emigration—for generations. At the other is the flying checkpoint, a regular feature of military occupations, in which a population is subjected to unpredictable and arbitrary blockages of movement. Routinely observed in failed states with insurgencies is the phenomenon of a paramilitary group establishing ad hoc checkpoints to extract tribute, intimidate populations, and exterminate enemies defined along racial, religious, or tribal lines. In such countries, everyone is a potential immigrant whenever they try to move anywhere, even within their own homeland. Thus the immigrant is a close cousin to the refugee.

The opposite of the refugee is, of course, the visitor, the guest who comes perhaps with the objective of settling among us, or perhaps to conquer us. It may thus be helpful to come at the question of immigration from the perspective of the *absolute immigrant*, the alien from outer space. Especially useful here are the kinds of science fiction stories that postulate the viewpoints of the aliens rather than the earthlings, as is the case in the wonderful novels of Octavia Butler.

Butler (an African American novelist who died in 2006) wrote a series of novels (the *Xenogenesis* series, also known as *Lilith's Brood*) based on the premise of an extra-terrestrial race, known as the *ooloi*, who travel the universe in search of interesting life-forms with which they can mate. The objective of this travel and cross-pollination is the enhancement of the diversity of life, the acceleration of evolutionary processes of hybridization and mutation. Needless to say, Butler's aliens have to encounter terrestrial human beings in order to get the story moving, and these encounters are invariably filled with ambivalence—fascination, horror, disgust—which thus almost inevitably lead to violence and, much more interestingly, sexual encounters and even marriage and the production of hybrid offspring. The *ooloi* in particular are erect bipeds whose bodies are completely enveloped in a "skin" consisting of thousands of tentacles (imagine a full-body Medusa) that are constantly in motion, expressing the mood of the alien, with each tentacle containing a tiny stinger capable of injecting death-dealing and painful poison or intensely pleasurable and ecstatic elixirs of sexual enjoyment into the body of anyone whom they embrace. One never gets over an *ooloi* hug.

From the standpoint of Butler's aliens, the universe is a vast field of life-forms in constant motion, awaiting visitation by other life-forms. Even fixed, static forms such as vegetative life are involved in micro-movements and growth, and they often spring into more dramatic forms of migration aided by animals (such as bees carrying pollen) or simply by the wind carrying their seeds abroad. The *ooloi* regard all life-forms, from the simplest microorganism to the virus, the fungus, the cactus, all the way up the ladder of creation to mammals and intelligent beings capable of complex symbolic behavior, as potential partners in the evolutionary saga.

A salient contrast with Butler's utopia of limitless migration is the recently released science fiction film, *District 9*.[12] Set in Johannesburg, South Africa against the backdrop of the history of apartheid, with its Bantustans and racial Pass Laws, this film concerns the arrival of an advanced species of bipedal crustaceans who have made a forced landing on earth and whose only wish is to return to their homeland. The damage to their ship, however, requires an extended stay, and they quickly achieve the status of undesirable and illegalized aliens, referred to contemptuously as "prawns." They are compelled to live in the shantytown of District 9, a place ruled by paramilitary gangs and government operatives with a license to kill, which strongly resembles the contemporary shantytown of Kai alecha ("beautiful place") outside Cape Town, as well as numerous other *favelas*

and slums from Brazil to India. The film centers on a hapless, well-intentioned mid-level bureaucrat who is saddled with the impossible task of removing the aliens to another detention camp, going from one shanty to the next with a clipboard and documents that the aliens are required to sign in order to certify the legalization of their removal and the illegalization of their continued stay in District 9. But the law quickly breaks down and violence erupts. The bureaucrat becomes infected with the bodily fluids of the aliens, and his body begins a gradual metamorphosis into alien form, a transformation reminiscent of Kafka's Gregor Samsa and the mutation of the human body rendered immortal in David Cronenberg's *The Fly*. Rumors spread that the bureaucrat has been having sex with the aliens, and he becomes the object of a ferocious manhunt with the secondary objective of using him as an experimental animal to analyze the aliens' biological character.

It is hard to imagine a more vivid dramatization of the collision of liberal notions of legality with the visceral reality of migration. *District 9* is destined, I suspect, to become for this decade what *The Matrix* was for the 1990s, an allegory of collective global anxieties about a rising flood of migrations spurred by the economic displacements of globalization and the literal disappearance of human habitats caused by global warming. It also makes explicit the contradiction built into liberal notions of immigration law, namely that the law is inherently lawless, ad hoc, and permeated by ideological prejudices that make it exactly the opposite of an instrument of justice. It is well known that American immigration law, from the Chinese Exclusion Act of 1882 to the present day, is a travesty of justice that merely systematizes institutional forms of racism. What *District 9* helps us to see is that, in practice, these forms of racism devolve quickly into a complete denial of the humanity of the alien; immigrants are treated as cattle to be herded from one pen to another. In the state of Texas, for instance, immigrants are confined in remote camps where it is difficult for lawyers to communicate with them. They have fewer rights than criminals and are generally despised by the judges who decide their fate.[13] Add to this the whole range of sexual anxieties focused on aliens—that they are reproducing too rapidly and that they are mating with the "native" population and polluting its racial purity—and one sees all the ingredients for a form of liberal jurisprudence that throws a veil of ignorance over de facto fascism.

What happens when the space of illegalized migration is not merely a camp, a detention center, or a shantytown, but an entire country? The answer is to be found in a country that I am going to refer to by a hyphenated name, Israel-Palestine, a place that concentrates all the contradictory images we have

been contemplating into a small region that, by all accounts, is at the center of the most important global political conflict in our time: the struggle between the West and the Middle East, European Judeo-Christian civilization and the Arab and Islamic world.[14] Space forbids a detailed consideration of this complex and deeply fraught region, so a few snapshots will have to suffice. Israel "proper" (which is in itself a deeply contested phrase) contains a sizeable minority of Palestinians who are denied many of the rights of Jewish citizens. In fact, as Saree Makdisi points out, "Israel lacks a written constitution that guarantees the right to equality and prohibits discrimination among citizens"[15] at the same time that it trumpets its status as "the only liberal democracy in the Middle East." It is a Jewish state, it "is not the state of its citizens, but rather . . . the state of a people,"[16] many of whom do not actually live in Israel but are invited, even encouraged to immigrate there; it is a polity defined by religion and ethnicity rather than by a secular or race-neutral concept of citizenship. The legalized, mandated migration of Jews to the homeland is enforced by the Law of Return, which is exclusively for Jews no matter where they come from. Palestinians who have been forced into exile since 1948, who have titles to land and property inside Israel have no right of return and no legal means of seeking compensation for their losses. The Palestinian diaspora lives, by definition, in a state of permanent illegalized immigration with respect to its homeland.

The Palestinians who live in Israel proper at least enjoy some of the minimal rights of citizenship while being denied the rights of nationality (though Avigdor Lieberman, the current Defence Minister, would like to compel all non-Jewish citizens of Israel to sign a loyalty oath or be subject to expulsion). Palestinians in the occupied territories of the West Bank and Gaza, by contrast, enjoy none of those rights and are subject to military rather than civil law. It is virtually impossible to describe the complexity of the occupation from a legal standpoint: the multitude of permits, licenses, passes, and identity papers required of Palestinians surpasses the ingenuity of the South African apartheid regime, to which it is often compared. Gaza has been described as the world's largest open-air detention camp, a densely populated strip of land whose inhabitants are mainly refugees living in appalling conditions, in a state of permanent humanitarian crisis, most of them prevented from leaving or threatened with no possibility of return should they manage to escape. This tiny territory is regularly subjected to ferocious military assaults that make only token attempts to discriminate between civilians and non-combatants. In the 2009 Israeli invasion of Gaza, about one-

Fig. 3. Miki Kratzman (Israeli, b. Argentina, 1959), *Abu Dis*, 2003. Digital print, 45 ³/₄ × 67 in. (116 × 170 cm). Courtesy of the artist

third of the casualties were civilians. Gaza is thus the epitome of the most extreme contemporary condition of the refugee internment camp, at the same time that it is treated by Israel as if it were a sovereign nation ruled by a rogue terrorist regime with whom no negotiation is possible. The news blackout and general censorship of all images coming out of Gaza constitute a Rawlsian veil of ignorance that allows Israel to maintain its own fictional status as a liberal democracy.

But it is in the West Bank that this veil is most dramatically torn away. The notorious "security wall" (known as the "apartheid wall" by Palestinians) is the most visible manifestation, a thirty-foot-high wall of concrete slabs that snakes its way through the West Bank (fig. 3), often plunging deep into the occupied territories to protect the illegal Israeli settlements or surround Palestinian villages such as Qalqilya and cut them off from the agricultural lands on which their economic life depends. I have discussed elsewhere some of the Israeli attempts to mend the veil by painting over the security wall with murals (fig. 4) that make it seem to disappear into depopulated Arabian pastoral landscapes, but these efforts seem only to make the veil more egregiously visible, exposing the fantastic

Fig. 4. Miki Kratzman (Israeli, b. Argentina, 1959), *Gilo No. 2*, 2001. Digital print, 27 $^1/_2$ × 39 $^3/_8$ in. (70 × 100 cm). Courtesy of the artist

contradiction between the imaginary peace the Israelis discuss and the actual state of permanent war in which they have chosen to live.[17]

Two recent documentary films, one Israeli, the other Palestinian, expose the nature of illegalized immigration when it is concentrated into a relatively tiny space and imposed on an indigenous population. The Israeli film, *Checkpoint*, by Yaav Shamir (2003), is a "fly-on-the-wall" documentary of the more than five hundred fixed and flying checkpoints that are sprinkled profusely throughout the West Bank. The film opens with a scene of one of the flying checkpoints and introduces the petty details of daily life under military occupation. Several things are worth noting about this scene. It is set in what might be called an "uglified" landscape with a pond in the foreground that is obviously not natural, a "borrow-pit" created by moving earth to create a roadway, leaving behind an infertile marshland that is marked by human footprints. Perhaps most notable is the banality of the scene, the sense that this is a boring ritual that is repeated so often that it is regarded as a routine performance by the Israelis and a numbing, daily humiliation to be endured with silent resentment by the Palestinians. It

has all the signs of a border crossing, with the inspection of belongings and the emptying of suitcases, but it is important to note that this is *not* taking place at any border between Palestine and Israel but is internal to the West Bank, on the road between Nablus (the second oldest city in Palestine) and Jericho (the oldest).

The second thing to note is the attitude of the soldiers, a mixture of cynical detachment, arrogance, and insolence as they smile and smirk self-consciously for the camera and swagger with their authority over the older people. They issue contradictory commands, one soldier telling the Palestinians to line up by the side of the road and then ordering them to remove their suitcases from the van (which requires them to return to the van), while the other is impatiently ordering them to line up by the roadside. The Palestinians register their feelings of being caught in a wedge between two arbitrary authorities by pointing out that the first soldier "told us to get our bags," while the driver tries to claim an exception for himself, both from the lineup and the removal of his belongings from the vehicle.

This is a scene of "illegalized immigration" in two senses. On the one hand, it imposes upon the lawful, native inhabitants of a country a ritual that reduces them to the status of immigrants in their own land, immigrants that are greeted under a cloud of suspicion as potential criminals or terrorists. On the other hand, the soldiers themselves, as representatives of an unlawful military occupation, are performing a kind of arbitrary and capricious authority that amounts to the lawlessness of mere force embodied in the automatic weapons that they carry so ostentatiously. The real illegal immigrants in this scene are the soldiers themselves and the over one quarter of a million settlers that Israel has illegally planted in the West Bank. Having traveled in the West Bank with Palestinians and been subjected to periodic stops at flying checkpoints, I can testify that this scene is absolutely typical and true to my own experience. On one stop the teenaged soldier who inspected my passport expressed surprise to find an American citizen in the West Bank. "What are you doing here?" he asked. My answer was, "I was about to ask you the same question." My Palestinian comrades immediately put their fingers to their lips and urged me to shut up. Later they told me that if it had not been for my presence, they would probably all have been beaten up by the soldiers.

If the soldiers at the flying checkpoint were acting out all the telltale signs of a fascist mentality, this mind-set is made explicit in another scene depicting the main permanent checkpoint between Ramallah and Jerusalem. A nice young soldier has completely gone over to the dark side. He calls the Palestinians animals,

denying their humanity. He is defiant and proud to be telling the truth about an attitude he knows that he shares with many of his countrymen: we are human beings, they are not. Racism resolves into a bio-racial picture. Ethnocide, ethnic cleansing, and extermination are the next logical step. Rafael Eitan, Chief of Staff of the Israeli Army, 1978–83, once put it in the clearest terms: "When we have settled the land, all the Arabs will be able to do about it will be to scurry around like drugged cockroaches in a bottle."[18]

The horrific irony of these scenes cannot be lost on anyone who has (as I do) a deep sympathy for and connection with Israel and the Jewish people. These soldiers are only a couple of generations away from the victims of the Holocaust and the whole fascist resolution of the Jewish question. Jews were "illegalized" in Nazi Germany, treated as racial foreigners in the midst of the German *Volk*, subject to dispossession, expropriation of their property, deportation, and of course, a Final Solution of industrialized genocide in which they were treated as animals, or more precisely, as vermin to be exterminated. All this was supported by a process of *legalization* justified by a state of emergency, what Nazi legal philosopher Carl Schmitt called a "state of exception."[19] Small wonder that, alongside the legalized immigration encouraged by the Law of Return, there is a significant tendency toward *emigration* of middle class Israeli Jews who cannot bear watching their children transformed into fascists by the occupation. As one Israeli father put it in another documentary film about this issue, "I would be willing to send my children to risk their lives in defense of this country. But to see them becoming morally corrupted as agents of this occupation is more than I can bear."[20]

Israelis with a sense of history and justice understand quite clearly that the security wall and the occupation and the checkpoints and the settlements have little to do with security. They are, as Israeli scholar Ilan Pappe has shown, instruments of a long process of ethnic cleansing that began in 1948 and continues to the present day, always hidden under the veil of legality on the one hand, and the exceptional demands of security on the other.[21] Key to this process is a double system of legalized immigration for Jews and the reduction of Palestinians to the status of illegal immigrants. The aim is to encourage all Palestinians to emigrate, not by direct violence but by a war of legal attrition that makes ordinary life and civil society impossible. But Palestinians constitute about fifty percent of the population of Israel-Palestine (or "Greater Israel," as the Right likes to call it). A disproportionate share of this population is under twenty-five years old, unemployed, and living in a state of constant rage and emotional mobilization.

The wonder is that there is not more violence. If Israeli fanatics manage to set off a bomb in the Dome of the Rock in Jerusalem, or Hamas and Hezbollah obtain rockets that can reach Tel Aviv, a fuse will be lit that could set off a holocaust of weapons of mass destruction throughout the Middle East and beyond.

A recent Palestinian film that shows the other perspective on this situation is *Journey 110*, by Khaled Jarrar (2010). It contrasts strikingly with the Israeli film in its strict economy of means (a single camera as opposed to many) and its restriction to one scene, an underpass filled with sewage that travels underneath one of the restricted highways accessible only to Israelis that connects Ramallah to Jerusalem. (Most Palestinians are forbidden from going to Jerusalem; the attempt to do so makes them illegal immigrants.) Much of the film, therefore, is shot in darkness, with only the faint outlines of the tunnel and the silhouettes of Palestinians—men, women, and children—slogging through the stagnant, boulder-strewn water. Some make the passage with plastic bags tied around their shoes, others are attempting the dark passage barefoot. The scenes are generally backlit by the distant "light at the end of the tunnel," which turns out to be obstructed by large boulders and the occasional appearance (off-camera) of Israeli soldiers, who send the Palestinians fleeing back.

This deceptively simple film captures in twelve excruciatingly long minutes one of the most fundamental experiences of everyday life in Palestine. Like Tania Bruguera's checkpoint installation at Documenta 11, it subjects the viewer to the ordeal that it represents, turning the darkened space of the theater into an analogue of the underpass. Its insistence on remaining confined to this space enacts the sense that Palestinians live in a "no exit" situation, with no outsides to their underground existence. Movement and obstruction, migration and internment, have become for them a way of life rather than a temporary passage. In this regard, the film reminds me of the structuralist films of Michael Snow in the 1960s with their obsessive exploration of single, confined spaces (especially corridors). But now the perceptual exploration has been given a specific human and political content. The details—the plastic bags, the bare feet, the voices, including occasional laughter—puncture the darkness and make it clear why the Palestinian people are so difficult for the Israelis to control, why every barrier they erect will be surmounted or undermined.

We could descend endlessly into the vortex of images, law, and immigration that constitutes the political culture of Israel-Palestine. I want to conclude, however, by returning to a more general and global view of this issue

by way of a brief meditation on the work of Cuban artist Tania Bruguera, who has made the question of immigration a central topic of her work. At Documenta 11 she installed a re-creation of an immigration checkpoint that could have been anywhere in the world. The spectator passed through a gauntlet of loud noises, shouting, and dazzling searchlights that induced an intense effect of anxiety, panic, and disorientation that almost invariably accompanies, in some degree, every passage through a border security checkpoint. I have to say that I found the work deeply unpleasant and resented it at the time as overly literal. But I have not forgotten it, and it is perhaps useful as a kind of shock treatment that provides some glimpse of the experience of illegalized immigration.

More interesting and successful is Bruguera's current long-term performance art project, which aims to create an "Immigrant's Party," a political organization based not on ethnicity, national origin, or identity but on the shared experience of immigration. This project is headquartered in Paris, which for centuries has been a significant recipient of immigration from all corners of the globe and is both the capital of secular, enlightened liberalism and the city in which some of the most despicable racial theories in Western pseudo-science have been developed. This same culture has produced Jean-Jacques Rousseau and the Comte de Gobineau, Jean-Paul Sartre and Jean-Marie Le Pen. Bruguera's staging of her project as an artistic performance is what has allowed it to attain funding from the French government; a non-artistic, directly political proposal of this sort would have had nowhere to go for support except the fragmented non-community of immigrants who are as suspicious of each other as they are of the government.

It is impossible to predict at this point what will become of Bruguera's project. As a work of conceptual performance art it may simply become part of the archives of contemporary art as an interesting idea whose time is, as Jacques Derrida put it, "to come." Whatever results, the process engages centrally the question of the image, especially the deconstruction of the racist and racializing images that are endemic to the representation of immigrants. The objective is not merely to change the way people see immigrants but the way they see themselves, enabling the production of new, self-generated images and words to articulate the common interests of immigrants, both legal and illegal. And to do so not just in order to create new icons but in order to generate new situations and performances, from the immediacy of the mass assembly to the staging of events for the mass media.

As representative of the fastest-growing population on the planet earth, the Immigrant's Party will have to create its own slogans and identity as an emergent public sphere, building on the blank space, or "place of negativity" that has been such a critical component of recent critiques of democracy.[22] It may even have to reinvent a new form of Rawls's veil of ignorance in order to suspend the divisive forces of identity politics, racial, ethnic, and religious schisms typified by that other veil, the one worn by women that has been so toxic within French political culture.

I'm aware that this will all sound impossibly utopian and imaginary, but that is surely another role that the image has to play in relation to illegalized immigration, namely to set out hypotheses, possibilities, and experimental scenarios for a world of open borders and universal human rights. The road of militarization and racist schemes of national security is a one-way street to global fascism and anarchy. There is one contemporary phenomenon at the level of the image that offers some hope. As you may know, the most powerful man in the world, the President of the United States, Barack Obama, has been declared by the leadership of the Republican Party to be an illegal immigrant. Obama's image has now gone through the entire cycle of demonization and idealization; merged with the visages of Jesus, Mao, Lenin, Bin Laden, and Hitler, he is now "revealed" to be an undocumented alien. When an African American man—who embodies all the characteristics of a multi-racial, multi-ethnic identity that both fulfills and defies racial categories and is the leader of the so-called "Free World"—is declared to be an illegal immigrant, perhaps an Immigrant's Party is not so very far behind. Obama's image, as distinct from his actual policies, has had the effect of rending the veil of liberalism, or (more precisely) of turning it into a screen for the projection of the most extremely antithetical fantasies. In order to secure any notion of legality with respect to migration we will continue to need the veil of ignorance; we will need to rend that veil and project new images on it in order to have any hope of justice.

This paper was originally written as the keynote address for "Images of Illegalized Immigration," an international conference at the University of Basel, Switzerland, 30 Aug. 2009.

1. See W. J. T. Mitchell, *What Do Pictures Want?* (Chicago: University of Chicago Press, 2005), for an extended discussion of this point.

2. See W. J. T. Mitchell, "Migrating Images: Totemism, Fetishism, Idolatry," in Petra Stegmann and Peter Seel, eds., *Migrating Images* (Berlin: Haus der Kulturen der Welt, 2004), 14–24.

3. See Martin Jay's masterful study of the iconography of Justice: "Must Justice be Blind? The Challenge of Images to the Law," in *Refractions of Violence* (New York: Routledge, 2003), 87–102.

4. John Rawls, *A Theory of Justice* (Cambridge, MA: Harvard University Press, 1971), 12.

5. Phillip Cole, *Philosophies of Exclusion: Liberal Political Theory and Immigration* (Edinburgh, UK: Edinburgh University Press, 2000), 13.

6. Ibid., ix.

7. One of the enduring scandals of the United States immigrant detention system is the number of detainees who die in custody, often without being counted and without any account of the manner of their deaths. See Nina Bernstein, "Officials Say Fatalities Of Detainees Were Missed," *New York Times*, 18 Aug. 2009.

8. Ry Cooder, vocal performance of "How Can You Keep on Moving," *The Ry Cooder Anthology* (Rhino Publishing, 2008).

9. See, by way of comparison, the notorious Art. 1, Sec. 9 of the United States Constitution: *"The migration or importation of such persons as any of the states now existing shall think proper to admit, shall not be prohibited by the Congress prior to the year one thousand eight hundred and eight, but a tax or duty may be imposed on such importation, not exceeding ten dollars for each person."* Congress prohibited the international slave trade in 1808, but treated it as taxable immigration prior to that.

10. Nm 33:52–53.

11. See Jacques Derrida, "The frontier turns out to be caught in a juridico-political turbulence, in the process of destructuration-restructuration, challenging existing law and established norms," in *Of Hospitality*, trans. Rachel Bowlby (Palo Alto, CA: Stanford University Press, 2000), 51. All this is as a result of the "mutation" (as deconstruction) brought on by new technologies of communication: e-mail, Internet porn, etc.

12. Neil Blonkamp (director), *District 9* (2009). This film was ranked second of ten thousand on MOVIEmeter in the final week of August 2009. MOVIEmeter is a ranking service available on IMDb (Internet Movie Data Base) Pro.

13. I am grateful to Anne Pinchak, who has shared with me her experiences as an immigration lawyer in the state of Texas.

14. For a familiar argument that immigration from the Middle East to Europe is threatening a "Moorish return" that will destroy Western civilization, see Christopher Caldwell, *Reflections on the Revolution in Europe: Immigration, Islam, and the West* (New York: Doubleday, 2009).

15. Saree Makdisi, *Palestine Inside Out: An Everyday Occupation* (New York: W. W. Norton, 2008), 146.

16. Ibid., 144.

17. For further discussion, see my essay, "Gilo's Wall and Christo's Gates," *Critical Inquiry* (Summer 2007).

18. *New York Times*, 14 April 1983.

19. Carl Schmitt, *Political Theology: Four Chapters on the Concept of Sovereignty*, trans. George Schwab (Chicago: University of Chicago Press, 1985).

20. Michal Ariad (director), *For My Children* (2006).

21. Ilan Pappe, *The Ethnic Cleansing of Palestine* (Oxford, UK: Oneworld Publications, 2006).

22. I'm thinking here particularly of Ernesto LaClau and Slavoj Žižek's debate over the role of negativity in contemporary democratic politics. Certainly immigrants in the United States occupy precisely the position of the negative in contemporary political polemics. Among the many lies being circulated about Obama's healthcare plan is the claim that it will provide insurance for illegal immigrants. See Judith Butler et al., *Contingency, Hegemony, Universality: Contemporary Dialogues on the Left* (New York: Verso, 2011).

From Diaspora to Exile: Black Women Artists in 1960s and 1970s Europe

Richard J. Powell

Writing about the concept of a far-flung, cultural diaspora among modern artists and intellectuals and their self-imposed condition of exile, the eminent art historian Linda Nochlin stated that what angered and disappointed her most about these conceptualizations was that, as a Jewish woman, she had been "exiled from Jewish exile by the mere fact of [her] sex; it is men," she continued, "who lay claim to the diasporist tradition of modernity."[1] Although Nochlin's frustration was specifically directed to the art and ideas of the late, longtime London-based, Jewish American painter R. B Kitaj, her observations about this seeming monopoly that men have on a willed migration and expatriation based on personal trajectories are valid and extend across historical periods and geographic territories.

One certainly senses this domination by men on diasporic and exilic matters in African, Caribbean, and African American arts and letters. The list of black male transatlantic artists/intellectuals is long and definitive: from Henry Ossawa Tanner to James Baldwin, from Frantz Fanon to Stuart Hall, and from Oluadah Equiano to Akon. The standard narratives engender these black sojourners as overwhelmingly male and largely self-driven to forge their respective identities and make their cultural impact on a cosmopolitan stage, beyond the narrow confines of a pre-circumscribed place.

The rare but most notable instances when black women enter the discussion of diaspora and exile—circus spectacle Saartjie Baartman in circa 1800s London and Paris, sculptor Edmonia Lewis in post-Unification era Rome, entertainer Josephine Baker in 1920s and 1930s Paris, and artist Elizabeth Catlett in post–World War II Mexico City—have been the occasions for a radical retelling of the typical "usurp-and-conquer" narratives of men. These four women's accounts of living and working in foreign localities, while varied and individual in their historical specificities, share Nochlin's sense of removal from the diasporic disentanglements of men who, while similarly removed from "home," found it abroad (or, rather, created new, serviceable bases of operation) with fewer societal impositions. In contrast, black women have often had to overcome either overwhelming cultural obstacles or near-insurmountable perceptions in order to lead productive lives, much less successful careers on alien soils.[2]

Fig. 1. Dick Tripp, photograph of Donyale Luna, Detroit, MI, 1966

In this essay I want to examine one black woman's diasporic and exilic experience in late 1960s and early 1970s Europe as a way of reconceptualizing and problematizing this largely male and triumphant experiential construct. The black woman under investigation is Donyale Luna (fig. 1), the first internationally renowned African American fashion model.[3] By 1966, Luna had already appeared on the covers of both *Harper's Bazaar* and *Vogue*, and was photographed in haute couture clothing by renowned fashion photographers like Richard Avedon and David Bailey.[4] Describing her in 1966 as "the completely new image of the Negro woman," a commentator further remarked that "fashion finds itself in an instrumental position for changing history, however slightly, for [in the industry's promotion of Donyale Luna] it is about to bring out into the open the veneration, the adoration, the idolization of the Negro. . . ." By the mid-1970s, Luna had also collaborated with and appeared in several experimental films and major motion pictures by Carmelo Bene, William Klein, and Andy Warhol, among others.[5]

Utilizing the visual record, historical documentation, cultural criticism, and commentaries by acquaintances, this essay cross-examines the parallel ideas of diaspora and exile and the black woman's entry into these theoretical constructs through the largely European-centered life and career of Donyale Luna. After

providing biographical details on Luna, I speculate on why she left the United States and settled in Europe. Although the relatively limitless career opportunities that many blacks experienced in the arts and letters there certainly explain her migration, I probe other possible factors—personal, social, and political—that might have caused Luna to seek a figurative and literal asylum abroad. Europe in the 1960s not only lured Luna, but a host of other black women artists, writers, and political dissidents, and I briefly speculate as well on what charms or safety nets Europe might have held for them.

Donyale Luna's face and figure move toward an expression of bodily and cultural independence, but a version specific to Civil Rights–era demonstrations and petitions. In the 1960s and 1970s, images of Luna loomed large, although retrieving them has been hampered by their mostly archive-based, European locus, or fugitive disposition. Interestingly, Luna herself is implicated partially in the disappearance of her own image, first through her decision to channel her energies toward film work and an essentially racist motion picture industry, secondly with her propensity to perform in alternative and relatively transitory experimental projects, and finally through her reluctance to participate in the race-centered body discourses that erupted in the United States in the late 1960s. At the height of the Black Power and Black is Beautiful movements, Luna was, at various moments, artistically aligned with Pop artist Andy Warhol and legendary rock and jazz album illustrator Mati Klarwein, appearing in films by directors ranging from Otto Preminger to Federico Fellini, and posing for nude photographs for *Playboy* magazine. It is within this contradictory framework—an African American woman who invariably conjures in her assorted personas the struggles and strivings of the Civil Rights movement while simultaneously rejecting that narrative in lieu of being a European novelty, an avant-garde marvel, and a counter-cultural outsider—that I examine her relationship to an at times exilic aloneness and exploitative "phallocentric" sense of diaspora.[6]

As to Luna's usefulness in interrogating the issue of a diasporic identity and its overtures toward states of isolation, as well as a disassociation from the larger modernist enterprise, an observation on a related topic by novelist and essayist James Baldwin possibly supports her example:

> The question of identity is a question involving the most profound panic—a terror as primary as the nightmare of the mortal fall. This question can scarcely be said to exist among the wretched, who know,

merely, that they are wretched and who bear it day by day—it is a mistake to suppose that the wretched do not know that they are wretched; nor does this question exist among the splendid, who know, merely, that they are splendid, and who flaunt it, day by day: it is a mistake to suppose that the splendid have any intention of surrendering their splendor. An identity is questioned only when it is menaced, as when the mighty begin to fall, or when the wretched begin to rise, or when the stranger enters the gates, never, thereafter, to be a stranger: the stranger's presence making you the stranger, less to the stranger than to yourself. Identity would seem to be the garment with which one covers the nakedness of the self: in which case, it is best that the garment be loose, a little like the robes of the desert, through which robes one's nakedness can always be felt, and, sometimes, discerned. This trust in one's nakedness is all that gives one the power to change one's robes.[7]

As rich, complicated, and nuanced as this well-known passage from Baldwin is, it proffers an important cautionary before embarking on this question of a diasporic identity, especially as related to cultural figures like Luna. Being (in Baldwin's parlance) the quintessential "splendid stranger," Luna's forays into the strange worlds of fashion and experimental filmmaking, circa 1966, not only initiated a profound reexamining of her status as a black female exile, but the challenge of constantly discerning that diasporic self—set against iconic representations ranging from the classical Aphrodite to the cinematic buxom blonde—under the already voluminous, ever-changing "robes" of identity sui generis.[8] The unique nature of that ontological reality for black women artists and intellectuals living and working abroad—in sharp contrast to the lived experiences of their black male counterparts—dictates entering a markedly different conceptual terrain: one that Luna's visible life and career might help illuminate.

The larger idea that issues from this meditation on Luna is the question of diaspora's relative usefulness for black women. In other words, within a celebrated history that points to migration and expatriation as the salvation for African American men of arts and letters in the mid-twentieth century, does this same account of artistic and personal deliverance hold true for black women artists? Or is it a more mixed bag that, as evidenced in Luna's meteoric ascent to fame and free fall into anonymity, frequently morphs from opportunity and freedom

into bodily speculation and social isolation or, as Nochlin states, renders her the penultimate exile from a wider brotherhood of exiles?[9]

Donyale Luna, born Peggy Anna Freeman on 31 August 1946, was the youngest of three children born in Detroit, Michigan, to a working-class black couple, Nathaniel A. Freeman and Peggy Hertzog Freeman. Peggy Anna Freeman began calling herself Donyale in high school (possibly a derivative of the French given name Danielle). Donyale's adopted surname, Luna, in all likelihood referred to what she and others considered her extraterrestrial looks and capitalized on media coverage about unmanned United States lunar explorations to probe and photograph the moon's surface. Both names took on symbolic dimensions, realizing this young woman's yearning for complete, far-flung autogeny.

In 1964, Luna met David McCabe, a London-born, New York–based photographer on assignment in Detroit with Ford Motor Company. While taking pictures near one of Detroit's famous architectural landmarks, McCabe noticed "a tall, incredibly striking young woman, walking down the street in a Catholic schoolgirl's plaid skirt. . . . She was so striking," he said, "that I couldn't let her pass without giving her one of my cards." He then suggested that, if she should ever consider pursuing a career as a fashion model, she should come to New York City and he would help her.[10]

After moving to New York City in October of 1964, Luna called McCabe and took him up on his offer. Within several months, she was featured in a series of drawings in the January 1965 issue of *Harper's Bazaar*, including an amazing cover drawing, and three months later, she appeared in *Harper's Bazaar's* legendary "What's Happening" issue, generally considered the American fashion scene's official heralding of the Swinging Sixties. Dramatically photographed by the famous fashion photographer Richard Avedon in an unprecedented three fashion editorials for that special issue, Luna immediately made fashion history.[11] "Rock music throbbed all day long in Avedon's studio," recalled sculptor Nancy Grossman about those fashion shoots and heady times, "while models like Penelope Tree and Donyale Luna traipsed through along with Revlon account executives and *Vogue* fashion editors."[12]

Well, not exactly. For all of Luna's celebrity status after being photographed by Richard Avedon, she quickly collided head-on with the American fashion industry's glass ceiling for women of color, and even a powerful fashion insider like Avedon admitted years later that "for reasons of racial prejudice and the economics of the fashion business, . . . I was never permitted to photograph

[Donyale Luna] for publication again."[13] When *American Vogue* decided to do an extensive fashion editorial on the radical designs of Luna's close friend and favorite couturier, Paco Rabanne, Avedon actually shot Luna, but ended up having his photographs of two white models wearing the same designs published.[14] Avedon's admission, coming from one of the most important and influential figures in the fashion industry, underscores just how insidious and powerful institutional racism was in the United States: pervasive enough to thwart the materialization of black people in certain media outlets and, when they were seen, influential enough to predetermine a particular image or emotional tenor. One of the entries in a "People are Talking About . . ." column in a 1965 issue of *Vogue* perhaps sums up this proscription against black visibility: "People are talking about *anything* to ease thinking about the two subjects on everyone's mind: Viet Nam and 'the Negro Revolution.'" From the dizzying heights of *Harper's Bazaar,* Luna's modeling assignments during the latter half of 1965 rapidly shifted in prestige to the secondary ("Negro") advertising market.[15]

It was around this time that the notion to live and work abroad was planted in Luna's mind. The lively axis of fashion activities between London, Paris, and Milan, as well as a reputation for being less corrupted by racial prejudice, recommended Europe as the ideal environment. Although McCabe's suggestion to pursue a career as a model came at an opportune moment, Luna had always aspired to become an actor and writer, and Europe now loomed as the place where these aspirations could be realized and where she might dismantle and retrofit the two identities—*Negro* and *fashion model*—that she felt particularly burdened by in America. She left for London in December of 1965.

"I felt that I had to go," confessed actress and singer Marsha Hunt, another African American woman who made a similar decision in 1966 to move to London. "Something seemed to be pulling, nudging me all the time. . . . What suddenly made [being black] an asset," Hunt continued, rhetorically asking herself, "was it the Civil Rights movement, Donyale Luna captivating the fashion world," or, as she half jokingly proposes, "being a 'spade chick,'" since "Spades were 'in' like a fashion . . . ?"[16]

That Luna, like Josephine Baker years earlier, suddenly became the symbol of African American female success in Europe was the buzz among African American dreamers like Hunt and other cultural commentators. For those Americans with access to European fashion periodicals and celebrity magazines, it appeared as if Luna was *omnipresent*, her stealth-like figure and angular, jarring

beauty inserting itself into what had historically been an overwhelmingly white and predictable fashion scene. Occasionally, news of this African American interloper within the European scene made its way into American media outlets, from the venerable *Time* magazine to television's routinely watched *Tonight Show Starring Johnny Carson.* "American fashion fotogs missed the boat (and we all know why)," dispatched Charles Sanders, a European-based correspondent for the African American weekly magazine *Jet,* "when they ignored the talents of Detroit's Donyale Luna. Maybe it was best that they did, since Donyale's now living in London and is probably the most photographed girl of 1966. . . ."[17]

As Luna had hoped for, she increasingly expanded her career options while living in Europe, first by performing in experimental theater projects and making cameo appearances in small experimental films and later by taking bigger and more sensational movie roles, most notably God's Mistress in Otto Preminger's 1968 film *Skidoo,* the part of Oenothea in Federico Fellini's 1969 film *Fellini Satyricon,* and the title role in Carmelo Bene's 1972 film *Salomé.* These path-breaking roles, unimaginable in the film resumes of most African Americans, would have assured many actors a solid future in the international film industry. These parts, along with Luna's spectacular modeling portfolio and tabloid-covered associations and liaisons with a virtual "Who's Who" of late 1960s and early 1970s "beautiful people" (including artists Andy Warhol and Salvador Dalí, film actors Maximillian Schell and Mia Farrow, writers Elsa Morante and Pier Paolo Passolini, and rock musicians Brian Jones of The Rolling Stones and Jimi Hendrix), should have catapulted her into greater stardom, or at least provided her with a few more years of continued film and theater work.

Despite Luna's creative potential in future acting and performance art projects, the remainder of the 1970s brought little more than run-of-the-mill modeling assignments and an existence consisting of being ogled from afar and propositioned on the streets. Although Luna's lack of sustained success in these years could be attributed as well to her own personal shortcomings and inabilities to reimagine herself beyond the narrow spheres of high fashion and the more conventional performing arts scene, the destructive nexus of sexism, social and cultural dissolution in her adopted Italian home base, and a peculiarly European brand of racism were all contributing factors to this tumultuous free fall. The other legendary 1960s fashion model, Veruschka, recounting a 1970s sighting of Luna, recalled that art critic Robert Hughes told her that Luna reminded him of "a living sculpture by Alberto Giacometti, walking alone and barefoot across an

empty Roman piazza." Revealingly, Hughes both *saw* and *could not see* Luna. The figure on the streets of Rome barely insinuated the life that had been filled a few years before with colors, originality, and complexity; instead, all that was there now was existential aloneness.[18]

In 1974, Luna returned to the United States for a brief, one-year stay. Apart from some runway modeling in New York and California, Luna's most noteworthy project was a series of photographs published the following year in *Playboy* magazine. Although fulfilling *Playboy*'s prerequisite for female nudity, the photographs were far from titillating or sexually explicit. Luna seemed not only at ease with her nudity, but completely beyond societal strictures and moral rectitude. Luna's linear body, antithetical to *Playboy*'s voluptuous prototype, functioned more like a cipher than a sentient object of desire, suggesting ancient deities and ascetic, ritualistic actions. "I have many visions of myself when I go through photographic trips," Luna is quoted as saying. "I've gone through periods [from] Nefertiti to Josephine Baker."[19]

Luna's referencing of these two paragons of a black female presence within the European context signaled her identification with them, and underscored the iconographic role such heroines and tropes played at the time, especially among black women expatriates. However, perhaps what Luna had not considered by placing herself in the same league as these European-based black beauties was this adulation's underside. The adoration directed toward the Berlin-installed bust of Nefertiti was countered by endless charges against the Germans of cultural and psychic theft. Josephine Baker's celebrity status was artistically answered by primitivizing, sexualizing, and ultimately dehumanizing her. From the metamorphosis of Saartjie Baartman into a circus freak and scientific specimen to Diana Ross's campy 1975 film *Mahogany*, that Luna no doubt winced at, about an objectified black fashion model in Italy, black women had limited repertoires in the European imagination: exotic or erotic roles that did not provide occupational transitions to more fulfilling, post-spectacle lives.

A prose piece titled *LUNAFLYLABY* was written by Luna during this period. Utilizing many of the motifs (i.e., mythological, visual, and planetary) cited in her published interviews and reveries, it disclosed self-awareness about her life and career, a raw talent for expository writing, and hinted at the disasters that marred her journey along the way. This part-fairy-tale, part-confessional alludes to an insular and at times stifling childhood, the excitement and challenges Luna experienced in the fashion world, her move to Europe, and other highs and lows.

But the most salient elements revolve around *perception*: Luna's succumbing to "VISUAL MISTAKES," as well as her generating "VISIONS" of her past and future. This preoccupation with sight, acumen, misrecognition, and, by association, an endless search for beauty placed Luna in a precarious position in that her image-conscious career was impeded, ironically, by her own blind faith in being an object of visual speculation, rather than differentiated as a complex human being with a particular lineage and legacy.[20]

While living in Europe eased the psychological wounds of American racial prejudice, it could not prevent the other proverbial slings and arrows—in the form of aesthetic conspicuousness and perverse isolation—that rendered Luna powerless. That these societal forces conspired to render black women *invisible* (even such manifest ones like Luna) was the paradox of her "VISIBLE LIFE." Caught between the insinuating effects of racial/cultural renunciation, sexual stereotype, and, to a great extent, the seduction of her own image, Luna's response, ironically, was to wear the mask and, in the manner of one of Giacometti's skeletal sculptures, to become a negligible component of life, hovering between existence and nothingness.[21]

But Luna's diasporic dilemma in 1960s and 1970s Europe wasn't paradigmatic of other black women's experiences abroad during this same period. African American novelist Carlene Hatcher Polite, who arrived in Paris in 1964, lived quietly in a modern Left Bank apartment, very much removed from the overwhelmingly male African American artists' colony there, and managed to publish her first novel, *Les Flagellants*, in French two years later. Comprised largely of an extended, highly introspective dialogue between an African American man and woman (who Polite prosaically names Jimson and Ideal), a 1967 *New York Times* review noted that these two characters "brilliantly and bitterly tear off layer after layer of rationalization and myth."[22] In the regional French newspaper *Est Éclair*, reviewer René Vigo noted that *Les Flagellants* was "a book so haunting, so rich in thoughts, sensations, so well located in a poetic chiaroscuro that one [could] savor its ineffaceable harshness."[23]

The English version of Polite's novel begins as follows:

The afternoon is white. The earth is as quiet as the snow. The few birds flying across the sky appear black and free. Smoke from both my cigarette and incense blow blue-gray forms into the silence. The lighting of another cigarette has become a sort of ritual, a necessary preface to

my every act and sentiment. A blue-gray haze may be mistaken for my aura. I may be mistaken for a fool. The laughter that just permeated the room may be mistaken for gaiety. It is hysteria. The laughter's volume eases down into the same tone as the silence.[24]

This opening passage, voiced by the female protagonist Ideal, initiates a meditation on the self that contains images of madness. Revealingly, selected European-based, African American female artists during this same period also employed gendered images that, through expressionistic devices, examined psychological displacement, objectification, and physical abuse. Mildred Thompson, a painter and printmaker based in Hamburg, Germany for much of the 1960s, created the etching *Love for Sale* in 1959, fusing sketchy, Dadaist overlays with a decidedly feminist rumination on prostitution. Painter and printmaker Emma Amos, who gained important art training at the London Central School of Art in the late 1950s, created a series of prints from the mid- to late 1960s that, reflecting on women's positionality between subjectivity and objectivity, interrogated these extremes in works like *The Ladies*. And Barbara Chase-Riboud, a sculptor who moved to Paris in 1961, produced figurative bronzes like *Plant Lady* that, while certainly understandable within the context of the prevailing existentialist aesthetic, grappled as well with a Simone de Beauvoir–like indictment of misogyny.[25]

Luna, as suggested in her autobiographical *LUNAFLYLABY*, was baffled by the lingering question of how she and other African American skeptics, operating from the European diasporic vantage point, could construct their own image. This inability to imagine herself in relationship to the social phenomena of difference, with a confidence that comes from negotiating one's exterior with one's constitutional distinctions, forever marked her (to use another 1960s metaphor) as a "soul on ice": an entity encased and obscured by its own false image, which only hinted at the naked power and creative potential that lay beneath the surface.

In addition to Polite, Thompson, Amos, and Chase-Riboud, the other African American artist to meaningfully interrogate the plight of black women expatriates in 1960s and 1970s Europe was author Maya Angelou. In Angelou's screenplay for the 1972 film *Georgia, Georgia*, the narrative revolves around Georgia Martin: an acclaimed, African American pop diva performing in Stockholm, Sweden. Accompanied on the Swedish tour by an older female personal assistant and a closeted gay male manager (both African American as well), Georgia vacillates between hateful outbursts and intimate actions toward the two, culminating

in a violent and Samuel Beckett–like absurdist ending. With parallel subtexts of interracial liaisons and political asylum, Angelou broached the psychological dynamic of African American expatriation to Europe with an unprecedented frankness and gender-informed specificity: scenarios that, in tandem with visual and literary explorations of these same themes, resonate with the biography and artistic career of a cosmopolitan, larger-than-life figure like Luna.[26]

Luna's move to Europe at the end of 1965 and her rapid-fire accomplishments in the fashion world provided a succession of photographic and cinematic cameos that underscored her embodied perusal of *subject agency* in black portraiture. By 1968, Luna's retrofitted career as a film actor, performer in experimental theater, and itinerate member of the rock music scene brought her idiosyncratic image into a collision course with an unfurled black and feminist consciousness. Consequently, being a "visible" black woman like Luna created an odd kind of discernment in the European context. Luna's was a perspicacity that, removed from the African American community and a politicized sisterhood, was only capable of seeing and comprehending her in the most *retardaire*, reactionary manner: a look through which one's deliberate exile from both homeland *and* a diasporic co-fraternity of exiles leaves that subject vulnerable to social collapse and eventual implosion, or what my Parisian colleague Florence Alexis calls "the mad, beautiful, black woman syndrome" in Europe.[27]

Joining the sorority of other black female objects of spectatorship in modern Europe, Luna was placed in an unenviable position: being an object of curious, mostly prurient interests, or merely a flat, one-dimensional cipher. In spite of wanting to do more serious acting and publish her creative writings, Luna was unable to move beyond the external and self-imposed limitations for someone of her idiosyncratic temperament and tenuous lifestyle. Although she had been a key player in the mid- to late 1960s fashion, film, and experimental theater scenes, none of this guaranteed the reimagining of herself in the broader cultural context of the 1970s, in which her gender and racial identity (like that of so many artists in that era) might have favorably informed her work and fortified her. These impediments united to diminish and obscure her once impressive figure, which then led to her public erasure and, tragically, her death from a drug overdose in 1979.

It could very well be that Luna was more ideally suited for the nascent cultural revolutions of the 1960s than the retrogressions and pluralities of the 1970s. In spite of her repudiation of the "role model" label, Luna is forever linked to those 1960s struggles for civil rights; her torso symbolically pushing beyond

America's "Whites Only" entryways and preferential seats. When black women's faces were mostly confined to pancake boxes and *Jet* magazine, her face, form, and name popped up in mainstream print media, in films, and on television, and always with a spectacular, simmering vengeance. Thus, Luna bears the dramaturgical reaffirmation of that moment in history when the Negro was not only becoming universally "beautiful" but reconstituted in the philosophy and political necessity of action. But framing her life and contributions within the idea of a modern European diaspora of black artists and intellectuals exposes that exilic context to its more exclusionary aspects: a scene where even emphatic black women like Donyale Luna faced elision and derogation from the mainstreams and the margins.

1. Linda Nochlin, "Art and the Conditions of Exile: Men/Women, Emigration/Expatriation," in Susan Rubin Suleiman, ed., *Exile and Creativity: Signposts, Travelers, Outsiders, Backward Glances* (Durham, NC: Duke University Press, 1998), 37–58.

2. Clifton Crais and Pamela Scully, *Sara Baartman and the Hottentot Venus: A Ghost Story and a Biography* (Princeton, NJ: Princeton University Press, 2008); Kirsten P. Buick, "The Ideal Works of Edmonia Lewis: Invoking and Inverting Autobiography," *American Art* 9 (Summer 1995): 5–19; Bennetta Jules-Rosette, *Josephine Baker in Art and Life: The Icon and the Image* (Urbana: University of Illinois Press, 2007); Melanie Ann Herzog, *Elizabeth Catlett: An American Artist in Mexico* (Seattle: University of Washington Press, 2000).

3. Cultural theorist Janice Cheddie discusses Luna's pioneering status in fashion and this benchmark's implications in "The Politics of the First: The Emergence of the Black Model in the Civil Rights Era," *Fashion Theory* 6 (March 2002): 61–81.

4. Unless otherwise noted, the biographical information and critical exegesis on Donyale Luna in this essay is culled from the chapter on this historic figure in Richard J. Powell, *Cutting a Figure: Fashioning Black Portraiture* (Chicago: University of Chicago Press, 2008).

5. Judy Stone, "Luna, Who Dreamed of Being Snow White," *New York Times*, 19 May 1968.

6. For a discussion about the black American cultural presence in Paris in the twentieth century, see Michel Fabre, *From Harlem to Paris: Black American Writers in France, 1840–1980* (Urbana: University of Illinois Press, 1991).

7. James Baldwin, *The Devil Finds Work* (1976; repr., New York: Dell Trade Paperbacks, 2000), 79–80.

8. For an examination of this topic within the context of European cinema, see Lola Young, *Fear of*

the Dark: "Race," Gender, and Sexuality in the Cinema (London: Routledge, 1996). For comparable discussions, but in the context of high fashion, see Barbara Summers, Skin Deep: Inside the World of Black Fashion Models (New York: Amistad, 1998); also see the special issue of Italian Vogue featuring black models (including Donyale Luna), "A Black Issue," Vogue Italia 695 (July 2008).

9. The literary possibilities of an African American female protagonist coming to terms with a life and career in contemporary Europe have been exploited, fairly recently, in two popular novels: Bonnie Greer, Hanging by Her Teeth (London: Serpent's Tail, 1995), and Shay Youngblood, Black Girl in Paris (New York: Riverhead Books, 2000).

10. David McCabe, interview with the author, 1 June 2001.

11. "Chic Proportions '65," Harper's Bazaar 98 (Jan. 1965) and "What's Happening," Harper's Bazaar 98 (Apr. 1965).

12. Nancy Grossman, as quoted by Patricia Bosworth, Diane Arbus: A Biography (New York: Knopf, 1984).

13. Richard Avedon, as quoted in "Luna," Playboy 22 (April 1975): 89.

14. "The Now and Future: Raco Rabanne," American Vogue 149 (1 March 1967): 204–7.

15. Richard Avedon, as quoted in Dennis Christopher, "Donyale Luna: Fly or Die," Andy Warhol's Interview 4 (Oct. 1974): 5–6.

16. Marsha Hunt, Real Life (London: Chatto and Windus, 1986), 82–90.

17. Charles L. Sanders, "Paris Scratchpad," Jet 30 (16 June 1966): 28.

18. Veruschka, interview with the author, 8 November 2001.

19. "Luna," Playboy 22 (Apr. 1975): 88–93.

20. Donyale Luna, LUNAFLYABY, unpublished manuscript, 1970s. I am grateful to Luigi and Dream Cazzaniga for sharing with me a copy of this prose work by Luna.

21. For an extended discussion of black female invisibility, see Michele Wallace, Invisibility Blues: From Pop to Theory (London: Verso, 1990).

22. Madhu Dubey, "Carlene Polite (1932–)," in Darlene Clark Hine, ed., Black Women in America: An Historical Encyclopedia (Brooklyn, NY: Carlson Publishing, 1993), 934–36.

23. René Vigo, "Les Franges du Romanesque," Est Éclair, 31 July 1967.

24. Carlene Hatcher Polite, The Flagellants (New York: Farrar, Strauss, and Giroux, 1967), 3–4.

25. For discussions of Mildred Thompson and Emma Amos's early work, see Richard J. Powell, Impressions/Expressions: Black American Graphics (New York: Studio Museum in Harlem, 1978). For information on Barbara Chase-Riboud, see Peter Selz and Anthony F. Janson, Barbara Chase-Riboud: Sculptor (New York: Harry N. Abrams, Inc., 1999).

26. Stig Björkman (director), Georgia, Georgia (1972; VHS reissue, Prism Entertainment 2854, 1986).

27. Florence Alexis, interview with the author, 23 Jan. 2001.

A Building with Many Speakers: Turkish "Guest Workers" and Alvaro Siza's Bonjour Tristesse Housing for IBA—Berlin

Esra Akcan

The Migrants

In the German newspaper *Mittelhessische Anzeigenzeitung*, an anonymous Hüseyin A. listed the following advertisement:

> Apartment wanted: Young Turkish family with four-year-old daughter seeks a three-or-four-room apartment. . . . Warning: . . . We have just one daughter now, but soon we will multiply like locusts. In a few years, we will have several loud, dirty children with bad manners who will raise hell in the building. These little urchins will run around screaming all day, and you won't understand a word they are saying. . . . The only time the laundry will not be there [in the yard] is when we invite our countless relatives and acquaintances to grill with us. By the way, we slaughter our lambs in the bathtub on principle. If we move in, the entryway will smell like garlic and exotic spices. Deafening Turkish Jada music will waft from our open windows all day. At least once a week, the woman of the house will be beaten to the point she needs hospitalization. For this reason, we will be a well-known address for the local police. . . . Knifings are normal to us.[1]

This Turkish-German apartment seeker's ironic words are not dissimilar to the spirit of German hip-hop in the late 1990s, or of the Kanak Attak migrant movement whose members included the prize-winning writer Feridun Zaimoğlu, among others. Embracing the common pejorative attribute *kanak* for Turkish immigrants and turning it into an empowering symbol, Kanak Attak expressed cynicism toward the "dialogue culture" that had become an over-used theme of multiculturalism, and criticized this supposed conversation for its expectation that Turkish immigrants simply assimilate into German culture without also expecting Germans to question their "own complicity to subordination."[2] As unidentifiable as he or she might seem, the writer of this advertisement was apparently responding in a similar way to the official and cultural housing discrimination that was undeniably visible in the 1970s and 1980s in Germany.

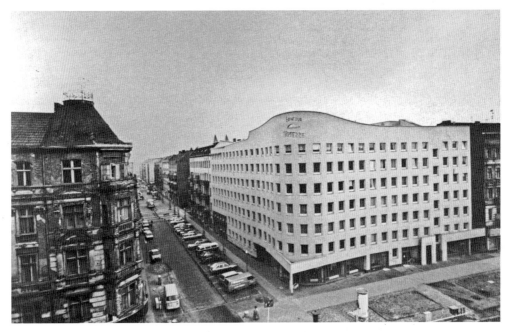

Fig. 1. Alvaro Siza (Portuguese, born 1933), Bonjour Tristesse, 1980–84. Photograph by Giovanni Chiaramonte, published in
Alvaro Siza, Poetic Profession (Milan: Electa, 1986)

It was these housing conditions that the civil society group IGI (Initia-tivkreis Gleichberechtigung Integration) challenged in their bilingual brochure, "What Foreigners Think About Foreign Politics," written in May 1981 by Turkish members, some of whom were working in the rarely publicized segments of the IBA—Berlin housing exhibition (Internationale Bauausstellung—Berlin).[3] Im-migration politics, integration debates, and naturalization and asylum norms took numerous turns in Germany, affecting the lives of the Turkish "guest workers" who filled West Germany's labor shortage after the first recruitment contract was signed between the two governments in 1961, the same year the Berlin Wall was constructed. By 1973, Turks formed the biggest portion of the noncitizen popula-tion in Germany (23 percent), followed by Yugoslavs (17 percent) and Italians (16 percent). Just before the Wall fell, 12.5 percent of West Berlin's population of two million was composed of what the Germans referred to as *Ausländer* (foreigner), half of whom were reportedly Turkish. The IGI group, which demanded to be a "discussant" in the German integration debates, not just the "object of discus-sion,"[4] reported that landlords and housing bureaus consistently turned down foreign families' rent applications, which subsequently pushed them to ghettos

made up of rundown buildings with substandard, small units. "The apartment will not be rented to foreigners" was a common newspaper advertisement.[5] Taking advantage of the lack of immigrant's rights, landlords also neglected legal maintenance measures, given that foreign families hardly could make official complaints about the decaying state of their apartments. There is a general consensus that the Turkish workers themselves did not invest much in improving their apartments during the early 1970s in order to save money for an early return back home. By the 1980s, however, many families had decided to stay permanently.

The IGI group also outlined a set of urban and architectural strategies to improve the housing situation of the migrant population. Rather than building new housing, they indicated that it would be more effective to repair existing units without a concurrent steep rent increase: this renovation (*Modernisierung* in German, *yenileme* in Turkish) should proceed with the authorization of renters presently living in the buildings and in compliance with their incomes; demolition of buildings should be pursued only in very urgent cases and with the approval of renters; and rental applications should be reviewed by municipalities together with renters' organizations that speak up for the rights of foreigners. These suggestions quite compellingly overlapped with the principles outlined by one of the two segments of IBA, albeit not the overly publicized one in which Alvaro Siza's Bonjour Tristesse housing was constructed (fig. 1).

The International Building Exhibition (IBA)

IBA—1984/87, a building exhibition that followed a German tradition with three notable precedents in Berlin (building exhibitions of 1910, 1931, and 1957), was arguably one of the most important architectural events of the 1980s, where the major aesthetic and intellectual shifts of the period found an opportunity to be manifested in built form. Although there were smaller construction sites in Tegel and Prager Platz, IBA's major area was the Kreuzberg borough, just along the Berlin Wall, heavily bombed during the war and left to decay. Building on land that belonged almost entirely to the city government, IBA constructed four thousand five hundred new apartments, renovated five thousand existing units, and supported seven hundred self-help projects by 1989.[6] For the construction of new buildings, IBA invited architects from all over the Western world, including Rob Krier, Aldo Rossi, and Oswald Mathias Ungers, whose theories shaped its urban renewal model, as well as others such as Giorgio Grassi, Vittorio Gregotti, Herman Hertzberger, Arata Isozaki, Hans Kollhoff, Daniel Libeskind, Gustav Peichl,

Alvaro Siza, and James Stirling. IBA also made history with visionary competition projects, included in exhibitions but never built, by Peter Eisenman, John Hejduk, and Rem Koolhaas (although they did receive commissions for built projects, after modifying their visions following IBA's principles). If nothing else, IBA's architectural directors, Hardt-Waltherr Hämer and Josef Paul Kleihues, achieved a miraculous and rare accomplishment in convincing the authorities to repair a working-class neighborhood and support subsidized housing designed by an astonishingly large number of cutting-edge architects.

IBA sought to align itself with the social housing tradition of Germany's heyday. The fact that its beginning year was Bruno Taut's hundredth anniversary was repeated on numerous occasions, while the world-famous Weimar *Siedlungen* that provided state-sponsored housing to thousands of lower and middle income families (such as Britz, Onkel Toms, and Siemensstadt) were exemplified as historical precedents in its ubiquitous self-promoting publications. Proponents of IBA opposed the postwar, large-scale urban interventions and planning values that they criticized for reducing the city to a function of vehicular transportation. They significantly distanced themselves from postwar housing projects of standardized massive blocks, such as Gropiusstadt and Märkischesviertel, and even from IBA—1957 in the Hansaviertel where existing buildings were unhesitatingly replaced with freestanding blocks. IBA—1984/87 started instead with the motto "the inner city as a place to live," an ideal that challenged not only modernist zoning principles that separated work and residential spaces, but also the tabula rasa dictum that built cities from scratch on empty or emptied lands. Instead of demolishing Berlin's nineteenth-century urban texture for the modernist cause, IBA proposed to repair and reconstruct it.[7] As Kleihues explained, urban rejuvenation without razing the old would be possible by preserving the "ground plan," defined as the "gene structure of the city." "It is the *ground plan* in particular that testifies to the spiritual and cultural idea behind the founding of a city," he stated.[8] The new buildings were thus conceived as infill projects complementing the existing periphery blocks that were half destroyed during the war and its aftermath. Established architects offered variations on the theme.

The Senate

When put in its historical context, IBA's fresh social and formal ideals, however noble in intention, were also complicated by the ambivalent immigration politics that characterized the event. With the support of the social democratic

senator Harry Ristock, the Senatorial Bill "Preparation and Implementation of an IBA—1984" (the exhibition date was later extended till 1987) was finally accepted in February 1979, after a few years of debate, appointing Kleihues and Hämer as the directors of the Neubau (New Building) and Altbau (Old Building) segments respectively.[9] The run-down Kreuzberg borough, just at the edge of the Berlin Wall, had made a name as a Turkish neighborhood—"the German Harlem" as some newspapers characterized it. Its population was composed of almost fifty percent foreigners, who were predominantly Turkish (although numbers fluctuate in different sources and in different streets of the borough), and German squatters who had moved illegally into the abandoned buildings.

Between 1975 and 1978, the Social Democrat-Liberal coalition in the Berlin Senate passed a series of housing laws and regulations that were meant to oversee the "foreigner problem." Among these, the *Zuzugssperre*, the "ban on entry and settlement" that took effect in 1975, and the desegregation regulations of 1978 had serious consequences for the immigrant population. While the former prohibited the movement of additional foreign families to the Kreuzberg, Wedding, and Tiergarten boroughs (three of the twelve boroughs), the latter suggested that only ten percent of residential units be rented to foreigners all over West Berlin. Justified as an "integration" of foreign workers into German society by their forced dispersal evenly throughout the city, the restrictions actually caused the fabrication of many fraudulent documents and was aimed at preventing Turkish families from inhabiting dwellings close to their relatives or ethnic groups, checking the construction of social and cultural networks.[10] To be precise, the Berlin Senate, IBA's employer, had assessed that there were too many Turks living in IBA's areas, and new housing laws would regulate what they believed to be desegregation, to be forced from above.

During the reign of the Christian Democrats in the mid-1980s, integration debates were further complicated by anti-immigration policies. In his Bundestag speech of 1982, Chancellor Helmut Kohl unambiguously declared that his political party would "first: . . . avoid an unbridled and uncontrolled immigration. Second: . . . restrict the number of new family members coming to West Germany . . . to avoid another immigration wave. Third: assist the foreigners who would like to go back to their homeland."[11] Ideas promoting anti-immigration measures not only filled the pages of the conservative press, but also some classrooms. In the Heidelberg Manifesto, for example, university professors united against the "education problem of foreigners" ("especially those from the so-called Third World")

wrote: "The integration of large masses of non-German foreigners is not possible without threatening the German people, language, culture, and religion. . . . What hope do our own children have when they are being educated predominantly in classes with foreigners? Only active and viable German families can preserve our people for the future."[12]

Outside the Senate, during the IBA years, it was only perhaps the Green Alternative group (which had not yet become a major political force) that was slowly formulating a third voice in between the forced integration and anti-immigration policies. In a pamphlet on immigration and asylum whose writers included the Turkish-German architect Cihan Arın from the IGI group and IBA's Altbau segment, the Green Alternative raised their objections against the Senate's discriminatory housing regulations (*Zuzugssperre*) and proposed measures that rejected displacement or rent increases (fig. 2).[13] These demands were not too dissimilar from those of the protesters who often filled the streets of Kreuzberg, in rallies initiated by German squatters. (Turkish immigrants, however, were usually reported to have a low participation rate in these rallies, most likely due to their insecure legal status).[14]

Fig. 2. Pamphlet in Turkish and German protesting the Senate's housing regulations, c. 1980. Courtesy Cihan Arın

Fig. 3. Josef Paul Kleihues (German, 1933–2004) and Hardt Waltherr Hämer (German, born 1922), IBA—City Plan, 1979–87. Newly built and renovated buildings are marked in darker color. Reproduced from promotional pamphlet

The Split Directors

The top-down integration regulations and anti-immigration policies of the period set up a context that calls for a different account of the IBA than that which has been traditionally found in the architectural literature.[15] From the outset, IBA was divided into two segments: the Neubau in West Kreuzberg, directed by Kleihues, where new buildings by European and North American architects would be situated (ironically, they were viewed as "international" architects, rather than "foreigners"); and the Altbau in East Kreuzberg, directed by Hämer, where existing run-down buildings would be renovated. To describe their positions, the directors proposed the concepts "critical reconstruction" (*kritischen Rekonstruktion*) and "careful city renewal" (*behutsame Stadtneuerung*), respectively. The fact that there were more empty plots and whole areas to be filled in with new buildings in West Kreuzberg justified this distinction (fig. 3).

However, this division also ended up being racial insofar as it was premised on a German/foreigner distinction. "Race" may not seem the most appropriate word here, but it was the category used by both Germans and Turks to connote the discrimination of the latter. While much more could be said about the similarities and differences between IBA's Neubau and Altbau segments in terms of their numerous contributions to architectural and urban debates, I focus here on the dissimilarity of their immigration policies for the purposes of this paper.

Kleihues is often remembered for his diplomatic maneuvers that enabled him to see IBA through both the Social Democrat-Liberal coalition and the Christian Democratic periods of Senate rule. While this gave a rare opportunity to the most successful architects to turn their ideas and visions into buildings, it also made it possible for the Senate to implement immigration regulations that were protested for constituting an ironically discriminatory "desegregation" policy, such as the ban on entry and settlement and the ten percent foreign resident rule. These restrictions unavoidably diminished Turkish families' chances to move into the new buildings in West Kreuzberg and consequently changed the percentage of the foreigner population in the area.

While reconstruction of the periphery block, ground plan, typology, and morphology were the terms most repeated by Kleihues's circle,[16] Hämer and his team offered a vocabulary that linked physical planning with social planning, participation, renters' rights, peace, and democracy.[17] Hämer objected to the original project considered at the Berlin Senate that would have demolished fifty percent of the buildings and displaced fifteen thousand residents. He also stated that he had to fight against the expectations of the politicians who wanted to turn Kreuzberg into an upper-middle-class neighborhood.[18] In contrast to conventional city planning implemented from above, Hämer openly promoted a participatory model, and insisted that the population directly affected by the renovation should themselves become the decision makers. Based on a pilot project he executed in Charlottenburg in 1976, he convinced the authorities that it was financially more feasible to renovate the units and update them to social housing standards than to displace the families, demolish the existing buildings, and construct new ones (the cost of the pilot renovation project was only sixty-two percent that of new construction).[19] Taking "city renewal without displacement" (*Stadterneuerung ohne Verdrängung*) as their motto, IBA's Altbau team, consisting of not only architects but also social workers and Turkish translators, organized renters' meetings for each and every building, sought the renters' democratic approval, and then renovated their units by putting in WCs, proper insulation, infrastructure, and heating, as well as additional measures based on the residents' own requirements and budgets. Mindful that over-renovation would displace the immigrants due to dramatic rent increases, modernization was handled on a unit-by-unit basis, repairs made based upon what current tenants could afford. During construction, the renters were temporarily moved to another apartment in the same building or down the block or street. Some liked their temporary apartments and stayed, others moved back

to their renovated units, but very few moved out of East Kreuzberg. As a result, the Senate's immigration regulations were courageously broken in IBA's Altbau segment, which refused to displace the Turkish families, most of whom had been living in the neighborhood since the mid-1960s.

The Architect

Alvaro Siza's building, commonly known as Bonjour Tristesse, has a peculiar place in the split of IBA. It was a new building, like those Kleihues was in charge of, but it was constructed in the very far corner of East Kreuzberg, next to the Schlesisches Tor train station, and thus under Hämer's directorship. It was Siza's first built structure outside his native Portugal; soon after he would be acknowledged as an accomplished international architect and win the Pritzker Prize in 1992.[20] Yet at the time, Siza's foreignness, in particular his identity as Portuguese, presented a problem in the conservative German media. An article appeared in *Berliner Stimme* supporting the reduction of funding for IBA and criticizing Siza's selection for his alleged inability to understand West Berlin.[21] After winning an invited architectural competition in 1980 over Group PSA (Aachen), Volker Theißen (Berlin), and Uli Boehme (Berlin), Siza designed not only the corner apartment building (Bonjour Tristesse), but also the overall concept of Block 121, as well as two additional buildings situated in the same block, a kindergarten and a seniors' club. The corner building, Bonjour Tristesse (1980–84), includes forty-six dwellings with seven distinct types of one- or two-bedroom apartments ranging from 64 to 85 square meters, ten units of housing for the elderly, five shops, and three shops with housing attached. Peter Brinkert worked with Siza as the contact architect.[22]

Siza had previously participated in two other competitions in the same area: his project for Görlitzer Swimming Pool (1979) with a large dome of 40 meters in diameter was rejected because the jury found its resemblance to a mosque inappropriate.[23] Tellingly, the Turkish residents' request to build a mosque also near the Görlitzer train station was rejected, signaling the limits of participation for Hämer and his group, an ideal that was otherwise enthusiastically advocated.[24]

Siza's other competition project at Frankelufer (1979) prepared the urban ideas for Block 121 at Schlesisches Tor. Adding six distinct buildings into the empty slots of the blocks along the canal, without touching the existing structures, Siza suggested an urban renewal strategy that was different from Kleihues's idea of a periphery block, and one that came out of his own peculiar interpretation of the Berlin block. Noting that Berlin had not been "systematically reconstructed"

Fig. 4. Alvaro Siza, site model and individual buildings for competition project for *Frankelufer*, 1979. Reproduced from Brigitte Fleck, *Alvaro Siza* (Berlin: Birkhäuser, 1992), 57

after the war, unlike many other European cities, Siza observed: "Thus the old city-new city duality does not exist in Berlin. We are obliged to slip our projects in between the old and new fragments which never complement each other, which never lend themselves to be reduced into a unity, but which exist as parallel realities."[25] Siza explained that he was very interested in the permeability of the Berlin box (the block), which allowed the public to use the courtyards at least during the day, and enabled surprising experiences through the encounters with a church, a school, or a nice garden inside.[26] "When we are on the street, we approach a portal and we find ourselves in an interior court, and then another portal, and we penetrate into another court. In this court, there is a public layout, and if we open another gate, we might find ourselves in a quite private garden."[27] In the Frankelufer project, Siza's additions took their rectangular, triangular, or L-shaped forms from the contingencies of their location, but they were always detached and set back from the street, and they often created surprise appearances in the courtyard behind (fig. 4). Rather than focusing on the public street side only, Siza proposed to enliven the semi-public life of the backyard, thus making the Berlin block more permeable. As Peter Testa noted, the ideological implications of this operation were quite substantial, given that the courtyards were traditionally associated with servants' quarters, tenements, and small-industry workshops.[28]

Siza followed this urban renewal strategy in Block 121 at Schlesisches Tor, even though the site, having been heavily built already, was not as convenient as

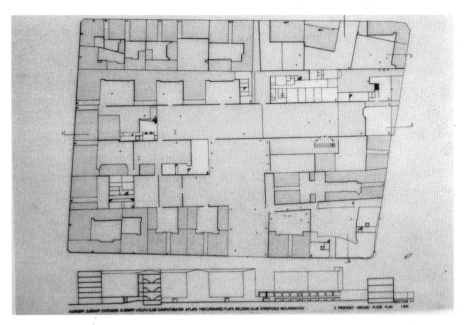

Fig. 5. Alvaro Siza, site plan for competition project for Block 121 at Schlesisches Tor, 1980

many others to express fully the idea of a permeable block (fig. 5). Both the corner building (what would come to be known as Bonjour Tristesse) and the kindergarten are detached from the adjacent structures on one end. The seniors' club is freestanding and set back, creating a small urban plaza in the front and allowing access to the irregular green space, playgrounds, and sports fields at the back. (In the competition, the building was slightly tilted, detached, and raised.) Following IBA—Altbau's principles, none of the existing buildings were demolished, not even the ad hoc single story line of buffets at the southeast corner of the block, or the U-shaped tall building with an unbelievably narrow passageway between its wings standing just next to Bonjour Tristesse. Interpreting the Berlin block in Kreuzberg, Siza had also taken interest in the monotonous height of the buildings, which are suddenly disrupted by an "explosion of imagination," a "fantastic tension" in the treatment of the corner.[29] Bonjour Tristesse re-creates this experience with its round and high corner façade (fig. 6).

While Kleihues and other architectural theorists behind IBA—Neubau, such as Rob Krier and Aldo Rossi, subordinated the new buildings into the "gene of the city," namely the nineteenth-century ground plan with periphery blocks, Siza's suggestions called for more tension, more discontinuity, and more juxtapo-

Fig. 6. Alvaro Siza, sketch for Bonjour Tristesse, n. d.

sition between the existing structures and new interventions. Hämer supported the idea of the permeable block as well, which, according to him, was another difference between IBA's Neubau and Altbau segments. Unlike the Neubau architects that prioritized the continuity of the street front, the Altbau team did not mind gaps and disturbances on the periphery block, since this provided more ventilation and greenery in an already congested area. Even the corner edges of the blocks that had historically remained open could be left unbuilt.[30]

Architectural critics often find Siza's forms "silent."[31] Nothing could be farther from the truth when one thinks about the process through which Bonjour Tristesse was produced and inhabited. Siza himself reinterpreted the terms "contextual" and "regionalist," so often attributed to his buildings, as the "absence of a pre-established language" to emphasize the transformations during the design process.[32] However, it may be that the architect's most unique contribution, at least during the 1970s and 1980s, came with his ideas on participation. Prior to his IBA experience, Siza had worked for the participatory social housing project SAAL (Servico Ambulatorio de Apoio Local), which came out of the revolutionary spirit in Portugal in 1974, something that admittedly caught Hämer's eye when he invited Siza for the IBA competitions soon after.[33] During the same period, Siza worked on another participatory project with a majority Muslim population in the Netherlands (De Punkt and De Komma Social Housing in Schilderswijk-West, 1983–88).[34]

While working on the Bouça (Porto, 1973–77) and São Victor Housing (Porto, 1974–79) for SAAL, Siza elaborated his ideas on participation, which did not imply surrendering architectural expertise under the demands of "what people want." In interviews and articles, he spoke appreciatively about his fre-

quent dialogues with the future residents over comfort, space, and color during construction.[35] While these "enriched the project," the approach of politicians and some technicians was "authoritarian," reducing the role of the architect to that of a "tool for people."[36] Rather than subordinating architectural expertise or giving up the participatory process entirely, Siza suggested a third option that involved confronting the tensions between architect and inhabitant. In his own words: "Consequently, to enter the real process of participation meant to accept the conflicts and not to hide them, but on the contrary to elaborate them. These exchanges then became very rich although hard and often difficult. . . . For me these participation procedures are above all critical processes for the transformation of thought, not only of the inhabitants' idea of themselves, but also of the concepts of the architect."[37]

In Berlin, Siza joined some of IBA's renters' meetings and explained his projects to the future users (fig. 7). As Hämer recalled, in a public meeting on Frankelufer in the winter of 1979, Siza talked for two hours to the residents, explaining to them Berlin's architectural history from Schinkel to Scharoun, as well as his own project's dialogue with the Berlin block. While many would think "the masses" would not understand, Siza knew they did; as Hämer said, "one could rediscover Berlin anew with him."[38] Siza was similarly attentive to safeguarding the Turkish immigrants' rights during the Kreuzberg project. Rather than blaming economic constraints of the Bonjour Tristesse building for impairing architectural quality, as many did in the case of social housing, he welcomed such constraints as

Fig. 7. Meeting of IBA participants in Berlin. Alvaro Siza can be seen at the far right. Reproduced from *IBA '84 '87: Projektuebersicht Stadterneuerung und Stadtneubau*, exh. cat. (Berlin: Internationale Bauausstellung-Stand, 1982), 11

a guarantee that his buildings would be inhabited by the lower-income immigrant population that they were intended to serve.[39]

In the Netherlands, the participants seem to have embraced Siza's architectural proposals more than the authorities and professionals.[40] In order to respond to the needs of the Muslim residents in this project, Siza worked together with a Turkish socialist; they communicated with the help of two interpreters who translated from English to Dutch, and Dutch to Turkish. According to Siza, during the process he realized that the conventional organization of council houses in Holland was not appropriate for immigrants who wanted a complete differentiation between the private section of the house and the semi-private space where men could greet visitors without women being seen. While not necessarily encouraging women's separation, Siza proposed a double distribution space that could be closed and opened based on user preference, something criticized by the architects for being anti-functional. Upon his visit to one of the units after construction, Siza was happy to discover that women had turned this second distribution space into an eating area—in his words, "proof that the idea works."[41]

Today, Siza finds it unfortunate that participation in social housing is considered a recipe for mediocrity, while dialogue with the client in a single house is accepted as a usual part of the design process.

> I know that many politicians want to take advantage of the civic participation for their own purposes. This can happen. Popular participation in architecture could be even a way to attract very dishonest opportunists. But participation itself is not dishonest, and it seems sad to me that after having shown such enthusiasm toward social subjects in architecture, these may suddenly become something shameful and provincial, which is of no interest to anybody. . . . Nevertheless, I still believe that participation is an irreplaceable instrument for a project.[42]

The Participants

In a handwritten poster to be distributed around the Schlesisches Tor neighborhood, IBA—Altbau invited residents to discuss the four competition projects designed for Block 121. "Come and tell us your opinion," it called: "Should a daycare center be built? Which houses should stay and which ones should be demolished? How should the space inside the block develop? What should happen to the businesses on Schlesisches street?" The meeting took place on 13 October 1980, with

fifteen residents and five representatives from IBA (Yalçın Çetin, Thörnig Keller) and other renters' organizations (Akdüzün from *Otur ve Yaşa*). The participants discussed the proposals for the corner building, voiced their concerns over hygiene in the existing school building as well as the decaying conditions of their own buildings, discussed the placement of the kindergarten in different competition projects, did not have a unified opinion about the existing buffets in the southeast corner, and criticized the current organization of the playgrounds inside the block.[43] On 3 and 4 November 1980, two other meetings were organized during which Hämer himself explained the four projects to the residents and answered their questions and concerns about the design and construction process. He reassured them that no one would be displaced and that the open areas in the block would be designed through a participatory process. In this meeting, the participants also voted almost unanimously for the building of a kindergarten and a seniors' club. Siza's building received affirmative support from nine participants, a negative reaction from three, and a neutral vote from one.[44]

The Turkish residents participated in the IBA process in matters that directly sought their approval, such as their own apartments and shops, but they were absent from the participatory meetings concerning the public spaces.[45] Reasons for this are hard to decipher: while many admittedly voiced their disinterest or skepticism, a few criticized IBA's participatory model for being geared toward the squatters rather than the Turkish population. Participation could have been recognized as a cultural issue, and different participation models for different groups could have been explored.[46] This seems confirmed in the attendance records from the public meetings for the common areas of Block 121 such as the overall design, open areas, the school, and the kindergarten. Nevertheless, as current renters of the existing Altbau buildings and owners of the businesses on the streets, the Turkish immigrants did take part in the renovation process. In Block 121, most of the buildings were renovated by Group 67, and Yalçın Çetin worked in the IBA team as the Turkish correspondent and translator. The process was initiated after the approval of the majority of renters in a building; protocols were signed ensuring that the renters would not be displaced; the renovation took place on a unit-by-unit basis following the requirements of current inhabitants; and the business owners in the street shops and buffets filled in questionnaires about the architectural problems in their spaces.[47] Still, the large Turkish families with up to nine children presented a challenge in the renovation process due to the small size of available units.

The Resident

Yüksel Karaçizmeli currently lives in the second floor corner apartment of the Bonjour Tristesse building with her husband and their two sons, who both grew up there. We spend time together in a most memorable round living room over-looking the crossing streets—a room she genuinely appreciates, and she asks me to thank the architect on her behalf. Yüksel had come to Germany with her husband in 1968 from Adana to work in Siemens, a job she found through the Turkish Labor Placement Office, like millions of others. Upon her arrival, she must have read the how-to-behave pamphlets or come across one of the official toilet decrees for foreigners (*Toilettenerlass für Ausländer*). The latter set of instructions, in particular, conveys some of the obscenities that structure the bureaucracies of immigration: "Sit (don't stand) on the toilet seat! . . . After purging the bowels, clean the anus carefully with at least two pieces of toilet paper, folded together, until the anus is completely clean. Use the left hand for this. . . ."[48]

In 1979, Yüksel and her husband moved to Berlin, and in 1983 to Siza's Bonjour Tristesse building, becoming one of the first tenants after construction was completed. They sent their kids to the local school, as they were legally obliged to. After realizing that classes were segregated into German and Turkish children, Yüksel complained. But when the principal sent her home claiming that the German parents had demanded this division, she later regretted that she did not follow up with her legal right to file a suit. Over the years, she had watched through her window the Berlin Wall being smashed into pieces and the area change from a relatively silent Turkish peripheral neighborhood into a culturally mixed central location. Yüksel does not feel like a "foreigner" after forty years of residence in Germany, and she criticizes those who live in isolation with their traditional Turkish customs. Her husband Mehmet is dreading the day of his retirement when they will have to move out of their apartment due to high rents. "Where else can we find such a bright living room with five windows?" he tells me.

Yüksel's family had not participated in the design process of Block 121, but they have inscribed their physical traces on the Bonjour Tristesse building. Like many Turkish immigrants, their unit is easily detectable outside from the satellite dishes attached to the windows, enabling them to watch the Turkish TV channels—a right the Turks won after a lawsuit in the 1990s. For each unit, Siza designed a non-identified void space accessed from the living room, which looks like a winter garden, but lends itself to flexible use. This void space is one of Siza's crucial architectural contributions in the name of participation, since it

Fig. 8. Additional kitchen of Yüksel Karaçizmeli's apartment in Bonjour Tristesse

prescribes a zone for residents' voices at the very stage of architectural design. Many families in the building have used it as a space for religious practice or a bedroom for their children. Yüksel turned it into an additional kitchen that can be well ventilated, and brought in her own oven and refrigerator that she obtained from her employer, Siemens. Finding the open kitchen in Siza's project inappropriate for Turkish cooking habits due to the heavy smells that infiltrate the house, she now has a two-part kitchen: an open section for washing, preparing, storing, and dining; and another divided by a moveable glass partition for cooking (fig. 8). Such a reinvention of the space was similar to the transformation processes that took place in Siza's social housing in the Netherlands, and it was enabled by the fact that he had designed a void space in each unit that can be filled in relation to residents' choices.

The Graffiti Artists

Siza's building gets its name from the graffiti on top of its round corner façade: "Bonjour Tristesse." The inscription, which was discovered when the scaffolding was taken down, looks like the spontaneous and hasty gesture of a dyslexic hand. It was not indicated in the architect's construction drawings, and multiple stories about its unidentified author add to its enigmatic content. Perhaps it refers to

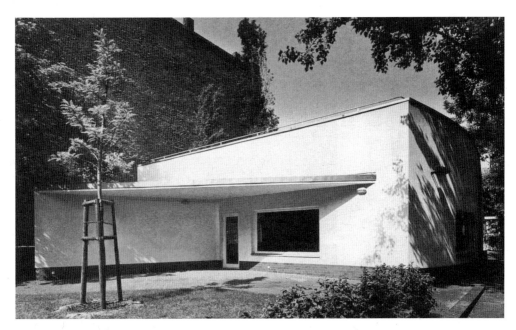

Fig. 9. Alvaro Siza, seniors' club, 1987–88. Façade as it appeared c. 1990. Reproduced from *Alvaro Siza: Works and Projects*, ed. José Paulo dos Santos (Barcelona: Gustavo Gilli, 1993), 104

Fig. 10. Alvaro Siza, seniors' club. Façade as it appeared in 2009

Otto Preminger's movie of 1958, based on Françoise Sagan's novel of the same title. In the movie, Juliette Greco sings "Bonjour Tristesse," while Jean Seberg, who plays practically the same character as her legendary role in Godard's *Breathless*, dances and explains to the audience the reasons for her aloof detachment: "I cannot feel anything he might be interested in, because I am surrounded by a wall, an invisible wall made of memories I cannot lose."[49] Perhaps this is Siza's gesture for implying that his building at the corner of the Berlin Wall would repair the city's urban texture, but not by forgetting the trauma of World War II or by denying the Wall—a theme that was also elaborated by Peter Eisenman and Daniel Libeskind in their IBA projects. Perhaps the graffiti belongs to one of the architects who lost the competition—a common rumor. Perhaps it was a protest against the profit-oriented developer who forced the architect to add one more floor to the building. Or perhaps it was the work of one of the arts initiatives that organized workshops during the IBA years near this site.

While "Bonjour Tristesse" has become a beloved graffiti on the building, inspiring many articles and a short film,[50] it has not remained the only one. The Schlesisches Tor neighborhood is famous for its ubiquitous graffiti to such an extent that householders moving into the area during the recent wave of gentrification are reported to be commissioning cutting-edge graffiti artists to tag their buildings so that "non-artists" will not. Yet much of the graffiti on Siza's buildings is anonymous and political in nature. As of the summer of 2009, the following inscriptions stood on the walls of Bonjour Tristesse's interior hallways: quite a few times "TGB" (Die Türkische Gemeinde zu Berlin [Turkish Community of Berlin], an activist organization founded in 1983), "Freiheit für Iran" (Freedom for Iran), "Fuck you boys," "Support Israel," "Nazis Raus" (Nazis get out), "CuCa Crew ♥," "KTC" (if a Turkish acronym, it would refer to "Republic of Turkish Cyprus"), "Killer Emine," "I love you," and the list goes on. The same is true for the façades of Siza's kindergarten and seniors' club. The latter has especially become a major attraction for graffiti enthusiasts, with no untouched white surfaces remaining today (figs. 9 and 10). Unlike the architectural critics who adore the serenity and silence of Siza's buildings, the city's inhabitants have evidently interpreted his modernist white façades as blank paper on which to write their own stories. But no need to take a lofty tone; this is to be expected. When there is no effective public sphere for the migrants to represent themselves, building walls host the unauthorized voice.

The research for this article was partly carried out in the archives of the Akademie der Künste (Berlin), Canadian Center for Architecture (Montreal), and Getty Research Institute (Los Angeles). It was facilitated by two fellowships from the Getty and CCA, and the granted leave from the University of Illinois at Chicago. I would like to thank the staff of all institutions for their helpful guidance.

1. Hüseyin A., "Mietgesuche," *Mittelhessische Anzeigenzeitung* (16 June 1996), trans. David Gramling, in *Germany in Transit: Nation and Migration, 1955–2005*, ed. Deniz Göktürk, David Gramling, and Anton Kaes (Berkeley: University of California Press, 2007), 358.

2. For Kanak Attak's manifesto in German, Turkish, and English, see http://www.kanak-attak.de/ka/down/pdf/textos.pdf. See also Feridun Zaimoğlu, *Kanak Sprak: 24 Misstöne vom Rande der Gesellschaft* (Hamburg: Rotbuch, 1995).

3. "Yabancıların Yabancılar Politikasına İlişkin Görüşleri/Stellungnahme der Ausländer zur Ausländerpolitik," (Berlin: IGI [Initiativkreis Gleichberechtigung Integration], May 1981). Prepared by Cihan Arın, Safter Çınar, Necati Gürbaca, Hakkı Keskin, M. Yaşar Öncü, and M. Niyazi Turgay (correspondence between Esra Akcan and Arın, 18 October 2009).

4. Ibid., 2.

5. Ibid., 24.

6. Eighty percent of land in Southern Friedrichstadt belonged to the city; the numbers were comparable in the other three sub-sections of the Kreuzberg borough (Southern Tiergarten, Luisenstadt, and SO 36). Gernot and Johanne Nalbach, eds., *Berlin Modern Architecture*, exh. cat. (Berlin: S.T.E.R.N., 1989).

7. IBA spent a considerable amount of its budget on publications, explaining its goals, research, and projects. For major volumes, see *In der Luisenstadt, Studien zur Stadtgeschichte von Berlin-Kreuzberg* (Berlin: IBA, 1983); *Idee, Prozess, Ergebnis: Die Reparatur und Rekonstruktion der Stadt*, exh. cat. (Berlin: IBA, 1984); Karl-Heinz Fiebig, Dieter Hoffmann-Axthelm, and E. Knödler-Bunte, eds., *Kreuzberger Mischung: Die innerstädtische Verflechtung von Architektur, Kultur, und Gewerbe*, exh. cat. (Berlin: IBA, 1984); Vittorio Magnago Lampugnani, ed., *Modelle für eine Stadt* (Berlin: IBA / Siedler, 1984); *Remisen in der Stadterneuerung* (Berlin: IBA, 1985); Heinrich Klotz and Josef Paul Kleihues, eds., *International Building Exhibition Berlin, 1987* (New York: Rizzoli, 1986); Josef Paul Kleihues, *Internationale Bauausstellung Berlin 1984/87 Die Neubaugebiete Dokumente Projekte*, 7 vols. (Stuttgart: Gerd Hatje, 1987–93); *Internationale Bauausstellung Berlin 1987: Projektübersicht* (Berlin: IBA, 1987); Dankwart Guratzsch, ed., *Das Neue Berlin: Für einen Städtebau mit Zukunft* (Berlin: Bebr. Mann, 1987); Dieter Hoffmann-Axthelm, *Baufluchten: Beiträge zur Rekonstruktion der Geschichte Berlin-Kreuzbergs* (Berlin: IBA/Transit Buchverlag, 1987); Gernot and Nalbach, *Berlin Modern Architecture*.

8. Josef Paul Kleihues, "Southern Friedrichstadt," in *International Building Exhibition Berlin, 1987*, 128.

9. There are competing accounts on the beginnings of IBA and the major agents behind its intellectual, architectural, and urban visions, which are beyond the scope of this article.

10. For more discussion, see Cihan Arın, "Analyse der Wohnverhältnisse ausländischer Arbeiter in der Bundesrepublik Deutschland—mit einer Fallstudie über türkische Arbeiterhaushalte in Berlin Kreuzberg" (Ph.D. diss., Technische Universität, 1979); Arın, "The Housing Market and the Housing Policies for the Migrant Labor Population in West Berlin," in *Urban Housing Segregation of Minorities in Western Europe and the United States*, ed. E. Huttman (Durham, NC, and London: Duke University Press, 1991).

11. Helmut Kohl, "Coalition of the Center: For a Politics of Renewal," trans. David Gramling, in *Germany in Transit*, 46.

12. Quotes 112 and 113 from the "Heidelberg Manifesto," trans. Tes Howell, in *Germany in Transit*, 111–13. Originally published in *Frankfurter Rundschau* (4 March 1982).

13. Grun Alternative Basusgruppen, *Immigraten- und Asylfragen* (Berlin, c. 1980). Cihan Arın would later describe the political milieu that prepared IBA as "authoritarian social-liberal politics." Arın et al., "Migration und Stadt," *Project Migration* (Cologne: DOMiT, 2005), 638–51.

14. Esra Akcan, interview with Cihan Arın, Berlin, 15 July 2009; Deniz Göktürk, "All Quiet on the Kreuzberg Front," interview with Wulf Eichstädt, *die tageszeitung*, 1 Nov. 1994. Reprinted in *Germany in Transit*, trans. Tes Howell, 354–56.

15. Once the first competitions were announced, the publications on IBA in the international press poured out. In addition to the German journals *Bauwelt*, *Arch Plus*, and *Deutsche Bauzeitung*, the English, Italian, and French journals *Architectural Design*, *Review*, *Record*, *Architecture AIA Journal*, *Lotus*, *Casabella*, and *Architecture d'Aujourd'hui* all had at least one IBA issue. Yet the international architectural community was astonishingly neglectful about IBA's impact on immigrant populations, while they were promoting the project as a committed and noble gift to the "workers," conceived only as an abstract economic category.

16. In addition to Kleihues's declarations in IBA publications referred to above, see Josef Paul Kleihues, "Architecture, as I wanted to say, needs the care and support of all of us," *AD* 53, no. 1–2 (1983): 5–9; "Josef Paul Kleihues interviewed by Lore Ditzen," *Arch Review* 176 (Sept. 1984): 42–44; Kleihues, "From the Destruction to the Critical Reconstruction of the City: Urban Design in Berlin after 1945," *Berlin–New York, Like and Unlike: Essays on Architecture and Art from 1870 to the Present*, ed. Kleihues and Christina Rathgeber (New York: Rizzoli, 1993), 395–409; *Josef Paul Kleihues im Gespräch* (Berlin: Ernst Wasmuth, 1996); Paul Kahlfeldt, Andres Lepik, and Andreas Schätzke, eds., *Josef Paul Kleihues: The Art of Urban Architecture*, exh. cat. (Berlin: Nicolai, 2003).

17. In addition to Hämer's declarations in IBA publications referred to above, see Hardt-Waltherr Hämer, "The Center City as a Place to Live," *Urban Design International* 2, no. 6 (Sept.–Oct. 1981): 18–20; Hämer, "Renovation urbaine: Pour des relations plus sensibles avec la ville," *Archithese* 6

(1984): 45–46; "Hardt-Waltherr Hämer interviewed by Lore Ditzen," *Architectural Review* 176 (Sept. 1984): 28–32; Hämer, "The other face of IBA: careful renewal in Kreuzberg," *Spazio e societa* 8, nos. 31–32 (Sept.–Dec. 1985): 79–86; Hämer, "Es gibt noch viel zu tun! Behutsame Stadtneurung der IBA," *Deutsche Bauzeitung* 122, no. 9 (Sept. 1988): 8–15.

18. "Hardt-Waltherr Hämer interviewed by Lore Ditzen," 29.

19. Hardt-Waltherr Hämer, "Stadterneuerung ohne Verdrängung—ein Versuch," *Arch Plus* 29, (Jan. 1976): 2–13; Hämer and Stefan Krätke, "Urban Renewal Without Displacement, Assessing an Experiment in Charlottenburg: The Prelude to IBA's Activities in SO 36," trans. Eileen Martin, *Architectural Design* 53, nos. 1–2 (1983): 27–30.

20. For general information on Siza's architecture, see the monographs *Poetic Profession: Lotus Documents* (New York: Rizzoli, 1986); Wilfred Wang and Jose Paolo dos Santos, eds., *Alvaro Siza, Figures and Configurations: Buildings and Projects 1986–1988* (Boston: Harvard University Graduate School of Design, 1988); Brigitte Fleck, *Alvaro Siza* (Berlin: Birkhäuser, 1992); Dos Santos, ed., *Alvaro Siza: Works and Projects* (Barcelona: Gustavo Gili, 1993); Pedro de Llano and Carlos Castanheira, eds., *Alvaro Siza: Works and Projects* (Madrid: Electa, 1995); Kenneth Frampton, *Alvaro Siza: Complete Works* (London: Phaidon, 2000), including "Foreword" by Francesco dal Co.

21. Leo Dronkers, "Gute Gründe für kurze Leine," *Berliner Stimme*, 20 March 1981.

22. Akademie der Künste, Baukunst Sammlung, Archiv IBA-ALT/STERN (1979–90) (Hereafter AdK-Archiv IBA), Folder A3 SO/58.

23. Fleck, *Alvaro Siza*, 52.

24. The documents over the request to build a mosque near Görlitzer station (including the correspondence between IBA and the Berlin Islamic Society) can be found in AdK-Archiv IBA, Folder A3 SO/15. Even though a small number of Turkish professionals working under IBA raised their voice against this rejection, they soon dropped their claims as they were committed secularists publicly distancing themselves from any association with Islam. Akcan, interview with Arın, 15 July 2009.

25. Quote 18 from "Un imeuble d'Angle a Berlin: Entretrien avec Alvaro Siza," in *Architecture, Mouvement, Continuité*, no. 2 (Oct. 1983): 16–21.

26. Alvaro Siza, videotape interview with Carsten Krohn, for the *Unbuilt Berlin* exhibition, on view 16 July–15 August 2010, Café Moskau, Berlin. The video records of the interview were provided by Krohn.

27. "Un imeuble d'Angle a Berlin," 20–21.

28. Peter Testa, *The Architecture of Alvaro Siza*, Thresholds Working Paper 4 (Cambridge, MA: MIT Press, 1984); Testa, "Unity of the Discontinuous: Alvaro Siza's Berlin Works," *Assemblage*, no. 2 (Feb. 1987): 47–61.

29. Siza, interview with Krohn; "Un imeuble d'Angle a Berlin," 20.

30. "Hardt-Waltherr Hämer, interviewed by Lore Ditzen."

31. Let me refer to only two newspaper articles as a testament to this general consensus: Nicolai Ouroussoff, "Modernist Master's Deceptively Simple World," *New York Times,* 5 Aug. 2007; Emmanuella Vieira, "É loge du silence et de la simplicité," *Le Devoir,* 4 Oct. 2003.

32. Quote 33 from "Entretien avec alvaro siza," *Architecture, Mouvement, Continuité* 26, no. 44 (Feb. 1978): 33–41.

33. Yoshio Futagawa, *Studio Talk: Interview with 15 Architects* (Tokyo: A.D.A. Edita, 2002), 200–234.

34. For articles that mention Siza's ideas on participation, see Bernard Huet, "Alvora Siza architetto 1954–79," in *Poetic Profession,* 176–81; Kenneth Frampton, "Poesis and transformation: The architecture of Alvaro Siza," in *Poetic Profession,* 10–24; Frampton, "Architecture as Critical Transformation: The Work of Alvaro Siza," in *Alvaro Siza: Complete Works,* 11–65.

35. See, for example: "Entretien avec siza."

36. Alvaro Siza, "Evora Malagueira," in *Alvaro Siza: Complete Works,* 160–62; see also ibid., 25.

37. Frampton, "Architecture as Critical Transformation," 25; Frampton, "Poesis and transformation," 12.

38. Hardt-Waltherr Hämer, "Vorwort," in *Alvaro Siza Vieira, Projekte fur Berlin 1978–1984: Ein Skizzenbuch* (Berlin: Aedes, 1985), no pagination.

39. "Un imeuble d'Angle a Berlin," 21.

40. Siza said: "I could not have defended many of my proposals without the support of the people who participated in these debates—the neighbors of the quarter affected by the project—because there were proposals which the administration, and in some cases even the architects, did not accept due to some preconceptions. If I was able to carry them out, it was thanks to the openness of the people who discussed them without the load of the cultural significance and who were, therefore, more open to reasoning." Quote 34 from "Fragments of an experience: Conversations with Pedro de Llano, Carlos Castanheira, Francisco Rei, Santiago Seara," in *Alvaro Siza: Works and Projects,* 27–55.

41. Quote 28 from "Getting through turbulence: Interview with Alvaro Siza by Alejandro Zaera," *Croquis,* nos. 68–69 (1994): 6–31.

42. "Fragments of an experience," 34.

43. Minutes of the meeting on 13 Oct. 1980, AdK-Archiv IBA, Folder A8 SO/30.

44. Minutes of the meetings on 3 and 4 Nov. 1980, AdK-Archiv IBA, Folder A8 SO/30.

45. Akcan, interview with Arın, 15 July 2009; Göktürk, "All Quiet on the Kreuzberg Front," interview with Eichstädt, in *Germany in Transit,* 354–56. This was confirmed by almost all Turkish residents I interviewed who lived in Kreuzberg during the 1980s.

46. Cihan Arın et al., "Migration und Stadt," *Project Migration* (Cologne: DOMiT, 2005), 641.

47. AdK-Archiv IBA, Folder A15 SO/52–57.

48. Baden-Württemberg Ministry of Social Services, "Toilet Decree for Foreigners," *Der Spiegel*, 10 Oct. 1979. Reprinted in *Germany in Transit*, trans. Tes Howell, 341–42.

49. *Bonjour tristesse*, directed by Otto Preminger (Los Angeles: Columbia Pictures, 1958).

50. "Alvaro Siza: 'Bonjour Tristesse' Apartment Building, Berlin," http://www.youtube.com/watch?v=noNDkNbV3IA.

Sea Dreams: Isaac Julien's *Western Union: Small Boats*

Jennifer A. González

A dark gated archway at the edge of the sea opens to a blue horizon. We approach the gate from the shadows of an echoing hallway, waves washing gently at the entrance, beckoning us toward the open space beyond. The voice of singer Oumou Sangaré announces the entrance of the graceful figure Vanessa Myrie. As Myrie walks slowly forward from the darkness to gaze into the light, her full profile is serene and statuesque, silhouetted against the sky (fig. 1). Flanked on both sides by gates that are closed and locked, she is free.

So opens Isaac Julien's large-scale video installation, *Western Union: Small Boats* (2007). From this first scene a host of associations comes to mind, from the Atlantic Middle Passage to the proliferating incarcerations of the present, historically framing the contemporary sea passage of African migrants to the southern shores of Italy that is the subject of this work. Thousands of migrants make the Mediterranean journey to Europe each year from the North African coast.

Fig. 1. Isaac Julien (English, b. 1960), *Western Union: Small Boats*, 2007. Film still from three-screen installation. Super 16mm color film, transferred to High Definition, 5.1 sound, 18'22"

About twenty-two thousand people reached Italy by boat in 2006. Many more travel to Spain. It is estimated that hundreds die each year attempting the crossing. In June of 2007, twenty-four Africans drowned after a dinghy capsized south of Malta.[1] *Western Union: Small Boats* was inspired in part by accounts of such crossings in the international news. One story attracted special attention due to a dispute about where the African migrants would be put ashore. "After weeks stranded in the Mediterranean, thirty-seven Africans were allowed to disem-

bark in Italy after officials bowed to international pressure and agreed to accept the asylum-seekers," wrote one newspaper, "but Italian authorities later arrested two German aid officials whose ship transported the immigrants to Sicily and said initial checks showed that the Africans were not predominantly Sudanese fleeing the crisis in Darfur, as they had been led to believe."[2] Instead, it appears the refugees were from Ghana and Nigeria. Being economic (rather that political) refugees, these migrants and their rights to protection were immediately in jeopardy, revealing the double standards used to articulate the logic of "asylum." As Didier Fassin has argued, "If the refugees occupy a crucial space in the biopolitics of Europe today, their collective treatment does not rest on the separation of the 'humanitarian' from the 'political,' but on the increasing confusion between the two."[3] Fassin suggests that it is precisely a shift in the conception of asylum that has transformed the contemporary politics of immigration in Europe. The expression "false refugees" has emerged as a new phrase to describe "economic immigrants."[4] The declaration that a person might be in a "false" relation to his or her own status as subject or citizen—with or without rights—echoes a long history of racially inflected arguments used against immigrant communities that appear to threaten a majority population. Julien's exploration of migratory experiences in *Western Union: Small Boats* reveals the degree to which a complex history of race discourse shapes the conditions of international migration today.

Isaac Julien's early films, such as *Looking for Langston* (1989), *Young Soul Rebels* (1991), and (with Mark Nash) *Frantz Fanon: Black Skin, White Mask* (1995–96), drew critical acclaim for examining repressed histories of racial and sexual politics through an experimental cinematic language. The films challenge the genre of documentary film production by exploring the psychological, interior states of his subjects without losing sight of their historical conditions and political contingencies. His recent large-scale video installations continue this approach by eschewing strictly linear editing, giving Julien the opportunity to explore a syncopated sound and image landscape more akin to the fragmentary nature of dreams. Like the stanzas of a poem or the verses of a song, his three-screen projections introduce slow conversations among images, inviting viewers to linger on one scene while anticipating the next. Our eyes travel across the space of the exhibition as if scanning a landscape. The scale of the projections places us in an environment where the subjects are life-size or larger, operating in a world that is itself frequently changing scale. The effect is to displace the viewer from a comfortable position of omniscience to one of immersion and identification. Close-up shots in-

vite us to imagine the lives of those depicted as part of a realist documentary, while long shots of landscapes and interiors work to position the viewer as an observer, outside the scene. Ultimately the environmental scale and shifting points of view allow the audience to occupy multiple and contradictory positions.

The opening scene of *Western Union: Small Boats* moves from the close-up of Myrie's profile, gazing offscreen, to water shimmering in symmetrical patterns suggesting two shores. In several of Julien's recent video installations, the figure of Myrie appears as both witness and actor: as one who observes, reveals, enacts, reflects. Her presence punctuates the work like a Greek chorus; she seems to hover, ever watchful, on the margins of historical events. Rather than a traditional protagonist, she embodies perhaps the passing of time, the wind of fate, or destiny. Her gaze is our gaze, her witnessing is our witnessing.

Part of an ongoing exploration of sea passage and transnational crossings that Julien calls his *Expedition* series, which includes *True North* (2004), *Fantôme Afrique* (2005), and *10,000 Waves* (2010) based on Chinese migrations to England, *Western Union: Small Boats* follows a loose narrative arc that operates simultaneously on the level of documentary realism and psychological lyricism. The documentary elements provide a sobering framework for the more breathtaking and disturbing interpretive gestures of the lyrical passages. Near the beginning of the video, the viewer is invited to engage in an intimate way with the contemporary condition of African sea migrants through photographs, short clips, and found sound elements. There is no authoritative voice (or voice-over) in the work, just carefully chosen juxtapositions of images that speak to each other. Closely cropped views of Italian fishermen winding their nylon fishing line, their boats rocking in the early morning sunshine, give a human face to those who are often on the front lines of sea rescues. Nautical details are accompanied by a shift in the aural landscape. Distant humming of high-pitched static and the clicks and tones of Morse code form the background to barely intelligible voices on a radio frequency. Snatches of English and Italian comment on the imperiled status of some forty refugees. We see the weathered faces of Italian fishermen, their paint-chipped boats in blue and white with names like *Massimo* bobbing in the port. Then the video cuts to a very different scene: a graveyard of small wooden boats painted with Arabic script with tattered makeshift sails of black plastic and torn fabric fluttering in the breeze. The ships are stacked and overturned, broken and bleached by the sun, and contain discarded shoes and crumpled clothing, empty life vests, dry water bottles (fig. 2). By now such vessels are so common in Spain (where they

Fig. 2. Isaac Julien, *Shipwreck–Sculpture for the New Millennium (Western Union Series no. 9)*, 2007. Fujitrans in lightbox, 47.25 × 118.10 in. (120 × 300 cm)

Fig. 3. Isaac Julien, *Western Union: Small Boats*, 2007. Film still from three-screen installation. Super 16mm color film, transferred to High Definition, 5.1 sound, 18'22"

are called *pateras*) that they have become an iconic sign and key metaphor for African migration in Spanish fiction and non-fiction.[5] Just a few of the scores of boats that have washed ashore or been abandoned by their owners on the coast of Italy, these skeletal remains have been gathered into heaps by the Italian authorities.[6]

Having thus set the stage, Julien shifts from the subtle realism of documentary images to the first movement of a thoroughly lyrical interpretation of the migrant's sea crossing. A magnificent barren hillside of white rock (the Turkish steps near Agrigento, Sicily) becomes the backdrop for a small group of dancers who walk in unison down to the shores of the coastline (fig. 3). Stunning striations and undulations of stone are repeated in the ripples of calm seawater. In an adjacent screen, Myrie wears a black dress and stoops to grasp a red T-shirt that floats gently in the surf. Its graceful undulations are as fluid as a sea creature until, lifted out of the water in a slow, deliberate gesture, it becomes a lifeless remnant of a lost human host. From the barren shoreline we cut again to the sound of crashing waves and a group of African men sailing in a small vessel under an unforgiving sun. We see a man dozing with eyes closed and another man staring blankly at the horizon in boredom or exhaustion. Memories of home cut across the multiple-screen array: parched earth, dusty roads, rural architecture, mosques, and sunlit trees. One man nods off, head drooping, and suddenly the roaring of the ocean ceases; we enter the strange silence of a dream.

A rectangular pattern of polished floor tile glistens in the center screen. The camera's gaze ascends slowly to reveal a crystal paradise, an eighteenth-century parlor of golden chandeliers and tasseled velvet divans bathed in a sparkling, jaundiced hue of greens and yellows across a reflected hall of mirrors. A space of fantasy, desire, and wealth, the sumptuous decor of the Palazzo Gangi in Palermo, Sicily—virtually unchanged for centuries—is nearly hallucinogenic when paired with the barren and uncertain situation of the migrants crossing the sea (fig. 4). Julien's unexpected editing device shifts our mode of attention. We grasp that we are now exploring the dreamscape of the migrating subject. The shimmering palace is the wished-for haven from hardship and strife, but also a mirage of luxury that is, finally, a site of refusal and unyielding power.

How does the materiality of race figure in the materialist histories we tell ourselves? Is the *coherence* of time (understood as abstract, mathematical, indisputable), as a support for the *coherence* of historical discourse (especially in its realist aspirations), not also racially overdetermined? How do artworks act out or reenact a changing perceptual relationship between the aesthetic past and

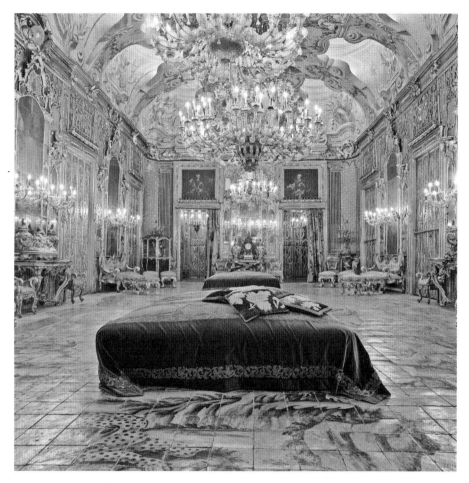

Fig. 4. Isaac Julien, *Western Union: Small Boats*, 2007. Film still from three-screen installation. Super 16mm color film, transferred to High Definition, 5.1 sound, 18'22"

the present through a kind of time travel? It is useful to recall Michel Foucault's distinction between a genealogical approach to the past—which develops a provisional account from fragments of always-partial evidence—and a more traditional historical approach to the past that produces overarching explanatory narratives or general characterizations of a historical epoch. He writes that a genealogical model of critical analysis is "no longer to be practiced in the search for formal structures with universal value, but rather as a historical investigation into the events that have led us to constitute ourselves and to recognize ourselves as subjects of what we are doing, thinking, saying. In that sense, this criticism is not transcendental . . . it is genealogical in its design and archeological in its method."[7] A genealogical

approach to the past might be said to follow an interlinking, capillary spread of facts without imposing a necessary or absolute order on things. For, despite the great efforts of traditional historians, the past is not something that can be kept in order—or kept in place. Genealogical methods reveal an effort to chart the relations of bodies to systems of power through which they have been marked and dominated. In this respect, Foucault's asserts, "The body is the inscribed surface of events. . . . Genealogy as an analysis of descent is thus situated within the articulation of the body and history. Its task is to expose a body totally imprinted by history and the process of history's destruction of the body."[8]

Referencing Luchino Visconti's *The Leopard*, the eponymous 1963 film adaptation of the 1958 novel by Prince Giuseppe Tomasi di Lampedusa, Julien returns us in his video to the original film location of the penultimate scene. During an elaborate staging of a formal ball, the protagonist, the Prince of Salina, worries to himself that aristocratic privilege and inbreeding may eventually lead to decadence and corruption, while a crowd of beautiful young women in silk gowns laugh and frolic together ("like monkeys," says the prince) in the same hall of mirrors. Some sprawl drunkenly on the velvet divans, while others circumnavigate the room, gracefully fanning their perspiring faces in the summer heat. Set in the 1860s during Garibaldi's red-shirt uprising (the so-called Expedition of the Thousands) that resulted in the unification of Italy, *The Leopard* explores the growing obsolescence of the aristocracy in the face of a rising bourgeois class. The prince struggles to come to terms with this transformation and what it means for himself and his family, and what his own role might be in the face of modernity. In one scene, a newly appointed bureaucratic official comments on the squalor and homelessness of the Sicilian poor: "Our modern administrative system will change everything." The prince replies, "All this shouldn't last, but it always will. The human 'always' that is: a century or two. After that, it may be different but it will be worse. We were the leopards, the lions. Those who will take our place will be jackals, hyenas. And all of us—leopards, lions, jackals, sheep—we'll go on thinking ourselves the salt of the earth." *The Leopard* is equivocal about class relations, suggesting that none of the solutions humans have yet developed are finally successful. In Julien's video, a woman dressed in ruffled pink enters the ornate interior of the palazzo and walks primly across the glistening hall of mirrors to gaze fixedly into the camera. Both desirable and unapproachable, she is eerily like a specter, and the whiteness of her skin is somehow uncanny. Her originally warm smile, prolonged by the shot, slowly and subtly transforms into a fixed

grimace and her echoing footsteps sound lonely in the empty cavernous space. As the current descendent of the original Prince and Princess Pietro and Marianna Valguarnera who occupied the Palazzo Gangi in the eighteenth century, she is also a sentinel of aristocratic privilege. The video cuts away from the face of the princess and focuses on Myrie who, in a surprisingly effective collapse of digetic space (since we have just seen her at the seashore), strolls regally into the mirrored hall, gracefully fanning herself like the young women at Visconti's ball. The sound landscape is complex: male and female voices reverberate against underwater sounds of the sea. An amazingly compelling effect is created by a vertical pan, projected simultaneously on the two side screens of the installation, inviting our eyes to scan asynchronously up and down, following the contours of the decorative baroque architecture. Myrie is both at home and ghostly, foreign, uninvited. What does her presence in this rarified palazzo mean for the migrant dreamers in the Mediterranean sun?

As if in answer, Julien returns us to the white undulating rocks of the Turkish steps where we see one young man carrying another over his shoulder. The race politics of the work become increasingly complicated, as the man who hangs down flaccidly like a corpse is white, and the man who carries him seems to be of African descent. The one who appears to have drowned, if that is the implication, is not from the small boat we have left behind. Instead, he is part of a dream, a dream of rescue, of human contact, of compassion or duty. Once more worlds collide in a cut reminiscent of Maya Deren's *Meshes of the Afternoon*: the two men are transposed from the rough shoreline of Agrigento into the silent Palazzo Gangi, entering as Myrie exits. One man is slung across the shoulders of the other; their bodies sway together, intimately entwined, evoking a homoeroticism that is shadowed by mourning and death. The intimacy of their bodies belies the hetero-normative space of fantasy held by the two women who previously occupied the mirrored hall. It also evokes the corporeality of rescue, the flesh-on-flesh materiality of bodies alive and dead.

The dancer of African descent, now alone, writhes sensually against the smooth surface of the floor to the sound of splashing water. Abruptly, a thrashing of muscular arms and legs creates trails of translucent white in the deep blue of the sea. The video cuts back to the Palazzo Gangi, but this time the floor of the mirrored hall is convincingly repositioned as a kind of impenetrable ceiling that takes the place of the surface of the water (fig. 5). Multiple screens articulate the relation between the seawater and the floor, while the dancer's body curves and

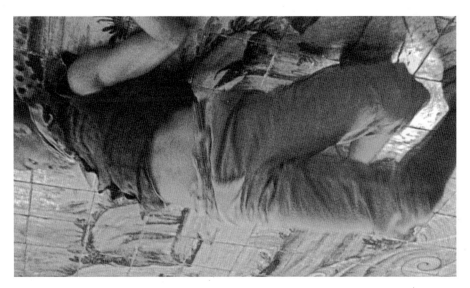

Fig. 5. Isaac Julien, *Western Union: Small Boats*, 2007. Film still from three-screen installation. Super 16mm color film, transferred to High Definition, 5.1 sound, 18'22"

rolls against this polished stone barrier in an ambivalently erotic intercourse with privilege, wealth, and power. Centuries of domination, perhaps the same centuries invoked by Visconti's prince, seem to suffocate those rising from below. The present always traffics in the past, and the histories of that past are as powerful when they are repressed as when they are revealed. Scholars Ian Chambers and Lidia Curti comment: "The colonial adventure is cancelled in the Italian imaginary; it is neither studied in school nor, until recently, has it been the object of research and reassessment."[9] The history of racial domination and colonial encounter is nevertheless etched into the architectural details of many Italian cultural monuments. Julien's camera zeros in on the face of a painted leopard, part of the exotic motif that decorates the floor of Palazzo Gangi's great hall. We see that its dark shining eyes are not feline, but human (fig. 6).

Julien has a long history of working with dancers and choreographers— Bebe Miller and Ralph Lemon in *Three* (1996–99) and Javier de Frutos in *Long Road to Mazatlán* (1999). From its inception, *Western Union: Small Boats* was a collaboration between Julien and British choreographer Russell Maliphant.[10] The choreographic elements can be incongruous to first-time viewers who may be uncertain about the status of the actors or dancers and their role in the video. The dancers look like dancers, not migrants, and they move with a casual poise more often seen on the stage than in everyday life. Their bodies are not starv-

Fig. 6. Isaac Julien, *Western Union: Small Boats*, 2007. Film still from three-screen installation. Super 16mm color film, transferred to High Definition, 5.1 sound, 18'22"

ing, their bodies are not injured, they are not burned by the sun. When they enter the domain of what appears to be documentary footage, the audience may feel uneasily caught between theater and reality, experiencing a cognitive tension that brings into question familiar strategies and politics of spectatorship. This uncertainty and tension productively disrupts what might otherwise be a merely familiar viewing experience.

Both documentary film and theatrical dance tend to invite or create a kind of visual distance, locating their spectators as outsiders looking in. Although both are modes of enunciation, they are nevertheless quite different; one traditionally presents itself as pedagogical and informative, the other as evocative, eliciting awe and affect. By experimenting within these two traditions, Julien also unsettles his viewers' habits of seeing such that uncertainties arise about how to read the work. It is in the space of this uncertainty that he inserts multiple rubrics of engagement—realist, lyrical, and surrealist filming; first person and omniscient points of view; racial ambiguity; spatial and diagetic compression—inviting the viewer to grasp not merely the contemporary situation of African migration to the shores of Italy but to see how this is but one instance of a larger human dilemma that includes the history of political struggle, the risks taken by the immigrant, the privilege of the wealthy, the despair of the dispossessed, the yearning for other worlds, and the psychological fantasies structuring this desire.[11] As viewers in the context of the installation—surrounded by unfolding tableaux, implicated in the scale, immersed in the landscape—our relation to the material tends to be more visceral, less distanced. Julien has stated, "I think the demands of a single-screen piece of work lead to a slightly conservative way of viewing. There is something about the three-screen version that allows a certain choreography that emphasizes movement and flexibility in narrative progression."[12] This movement and flexibility create an ambivalent identification in the viewer who is hearing and seeing multiple and parallel narrative threads and political subject positions along the way. The fragmentation of time and repetition of spaces in the work reveal

Fig. 7. Isaac Julien, *Western Union: Small Boats*, 2007. Film still from three-screen installation. Super 16mm color film, transferred to High Definition, 5.1 sound, 18'22"

the relentless, ongoing, hopeful—yet always inherently and involuntarily blind—experience of migration and culture contact.

The last three movements of *Western Union: Small Boats* are the most dramatic. An enormous baroque staircase of gray stone, symmetrical and solemn, becomes the stage for a strange underworld where dancers' prone bodies ascend and descend the steps like flowing water. The racial diversity of the dancers can be seen as a kind of ecumenical treatment of migration by Julien; this is not only about Italy and Africa, this is a work about migration more generally, and the broader history of the sea itself as a critical agent of social change and becoming, of death and disappearance. Moving gracefully and uncannily in reverse motion, the dancers seem to be freed from gravitational and temporal rules and the repetition of their falling bodies is echoed in the ringing of church bells, an aural motif that runs throughout *The Leopard* as well. We cut back to the sea, the African men on the boat, and tourists—real tourists—bathing on the Italian shore. Having regained what appears to be a documentary frame, we observe with mixed pleasure the light-skinned bodies leaping and diving into the waves from rugged outcroppings (a visual reference to Thomas Eakins's *The Swimming Hole* comes to mind) and hear the happy sounds of children playing in the surf (fig. 7). In a well-edited sequence of intersecting frames, we become aware that in the margins of this picturesque scene emerge tragic signs of death: five prone bodies wrapped

Fig. 8. Isaac Julien, *Western Union: Small Boats*, 2007. Film still from three-screen installation. Super 16mm color film, transferred to High Definition, 5.1 sound, 18'22"

in silver Mylar lie along the water's edge. If it wasn't already evident, Julien's critique of contemporary global economic relations lies in this simple juxtaposition. National boundaries, economic policies, and international law are shown to be effective forms of capital punishment, in practice if not in name. In a world of global migrations, "illegality" has become an ontological state that is defined by the "not-yet" or "not-quite" human. As Iain Chambers has commented, "Globalization not only concerns the migration of capital at a planetary level, but also of bodies, cultures, histories, and lives. While the former is considered inevitable, the latter is both fervently resisted and increasingly criminalized. It has been estimated that in the coming decades one sixth of the world's population will be migrants, and will almost certainly be criminalized for this."[13]

It is not the end, however, for Julien. To the sound of a rapid drumbeat we watch with a certain breathless anxiety as submerged dancers' bodies on all three screens struggle fiercely to stay alive. In the deep blue water punctuated by rays of light, they grasp the ocean with desperate gestures, gyrating in awkward arabesques (fig. 8). Floating to the surface or drifting to the bottom, their bodies' eventual stillness is almost a relief. Moments of this sequence are upside-down and in reverse motion so that the crystalline bubbles surrounding their bodies create a kind of eerie and morbid sense of suction. Radically different from the formal austerity of video artist Bill Viola's underwater bodies in *Five Angels for the Millen-*

nium (2001), Julien's bodies are not frozen archetypes but rather violent signifiers for invisible but horribly quotidian events.

Criticism of Julien's work sometimes returns us to the question of aesthetics and ethics, or even politics. What is the ethical relation of the artist to his subject matter? Is it unethical to build a body of expensive, lush, and sensually gripping work around the real-life tragedies of immigrants?[14] Julien's video installations garner accolades and economic success. Isn't Julien's current life of relative privilege rather far removed from the African migrant's struggle both at home and abroad? What gives him the right to pursue a fraught topic such as this, and offer it up to be consumed by collectors and art-world patrons? (Julien is not naïve: it may be precisely this community of wealth and privilege that is most directly interpellated by the unwavering gaze of the princess who occupies the Palazzo Gangi today.) To make something beautiful out of human relations that are truly ugly—how can this be a politically progressive gesture?

While these and similar questions have arisen in response to Julien's work, they seem to miss the point. A more interesting line of inquiry might be: why have so few visual artists addressed the politics of migration from the psychological, internal state of the migrant? How can contemporary concerns of international migration be given a broader historical frame that includes a long history of colonialism and domination? And what of the more lyrical artistic and cinematic tradition that has depicted tragedy and human suffering for centuries? Julien's work engages with this long tradition, but also speaks to a newer, media-saturated environment where all kinds of violence appear aestheticized and normalized. It is precisely this normalization of violence in popular culture that may function to mask the real world violence of international politics. By producing a nearly sculptural, excessive representation of the drowning body, the choreography of the dancers invites us to glimpse a violence we can only otherwise distantly imagine. It is all the more important, therefore, that we are immersed with their bodies in the projected video environment. Their asphyxiated corporeality dominates the space, replacing temporary fictions of nationality with the unforgiving sea, a substance that promises both life and death. Migration is shown not as a simple trajectory with a beginning and ending point, but rather as a series of intersecting and looping paths, flows, and currents that map non-contiguous spaces of economic, social, and historical difference. To cite Iain Chambers again: "In this disruptive geography it becomes both possible and necessary to rethink the limits of the world and the Mediterranean we have inherited; it becomes possible to

open a vista on another Mediterranean, on another modernity."[15]

Western Union: Small Boats is not merely an indictment of globalization and economic inequalities, although it is surely that. It poses a question about destiny and fate, about the desire to fulfill a fantasy that may be finally elusive, about the failed story of migration in which even returning home is impossible. The closing sequence shows shadowed ships sailing out to sea, witnessed by Myrie seated high on the cliffs above. Julien employs an effective sequencing of images to wrap the ships across all three screens. Finally, using the asynchronous parallel vertical pan on two screens, seen previously in the Palazzo Gangi, Julien films a male hand gracefully lifting a wet black shirt out of the seawater by the shore and silently dropping it back in. In this closing sequence, we return to Oumou Sangaré, whose repeated vocal refrain from her traditional Wassoulou hunting song, *Sabu*, intones: "Jasabu Ye Mogo Ye La, Mali denu Jasabu Ye Mogo Ye La, Mogo m'a Laadon" (There's a source behind everything that happens. Destiny is determined by our actions. No one knows when their time on earth will end).

1. Story from BBC NEWS, published online on 2 July 2007 at 21:05:13 GMT: http://news.bbc.co.uk/go/pr/fr/-/2/hi/europe/6228236.stm (accessed 16 Sept. 2009).

2. "Italy Accepts African Refugees," *Washington Times*, 13 July 2004.

3. Didier Fassin, "Compassion and Repression: The Moral Economy of Immigration Policies in France," in *Cultural Anthropology* 20, no. 3 (2005): 368.

4. Ibid. Fassin writes: "As a consequence of deep changes occurring in popular attitudes toward asylum, explicit orders had been given by the Ministries of the Interior and Foreign Affairs to their respective administrations, and police officers in the airports and bureaucrats of OFPRA have come to view asylum seekers with systematic suspicion: all candidates for refugee status are now considered, until there is evidence to the contrary, to be undocumented immigrants seeking to take advantage of the generosity of the European nations. Use of the expression 'false refugees' to refer to 'economic immigrants' who claim political asylum has become central to bureaucratic common sense."

5. Manuel Martín-Rodríguez, "Mapping the Trans/Hispanic Atlantic: Nuyol, Miami, Tenerife, Tangier," in *Border Transits: Literature and Culture Across the Line*, ed. Ann M. Manzanas (New York: Rodopi, 2007), 215.

6. David Frankel, "Isaac Julien: Metro Pictures," *Artforum* (Jan. 2008): 288–89.

7. Michel Foucault, "What is Enlightenment?" in *The Foucault Reader*, ed. Paul Rabinow

(New York: Pantheon Books, 1984), 46. Foucault's use of genealogy follows from that defined by Friedrich Nietzsche, who rejects any historical search for origins (*Ursprung*) in favor of an analysis that marks paths of descent (*Herkunft*) or emergence (*Entstehung*).

8. Foucault, "What is Enlightenment?" 83.

9. Iain Chambers and Lidia Curti, "Migrating Modernities in the Mediterranean," in *Postcolonial Studies* 11, no. 14 (2008): 387–99.

10. Roselee Goldberg, "The World is Flat: Isaac Julien," in *Art Asia Pacific*, no. 55 (Sept./Oct. 2007): 151–53.

11. Hendrik P. van Dalen, George Groenewold, and Jeannette J. Schoorl write: "It is interesting that in statistical studies of African migration, it appears that it is less the actual levels of poverty or the inhospitable political climate that motivate the migrant to leave Africa (specifically Ghana, Egypt, Senegal, Morocco) but rather the 'great expectations' of increased earning potential abroad." "Out of Africa: What Drives the Pressure to Emigrate?" *Journal of Population Economics* 18, no. 4 (Dec. 2005): 741–78.

12. Isaac Julien, "The Long Road: Isaac Julien in Conversation with B. Ruby Rich," *Art Journal* 61, no. 2 (Summer 2002): 51–67.

13. Iain Chambers, "Adrift and Exposed," in *Koncepcja I Redackcja: Isaac Julien, Western Union: Small Boats* (Warsaw: Colophon, 2009), 3–13.

14. Critic Alan Gilbert writes: "The work derives its structure from a series of fragmented and stylized tableau—so stylized in fact that certain moments approximate a fashion shoot, lending what is a gritty, harrowing, and sometimes fatal journey a slightly incongruous quality of slick sensuality." "Isaac Julien: Metro Pictures," *Modern Painters* 20, no. 1 (Fall 2008): 91.

15. Chambers, "Adrift and Exposed," 5.

Locating World Art

Stanley Abe

Over the past two decades, the migration of objects and knowledge, institutions and discourses has stimulated a range of desires to locate ways in which to transcend the Eurocentric limits of the fine art museum, art history, and related institutions, which have been categorized under the rubric "World Art." Some initiatives have been mounted from the discipline of art history and the institution of the art museum, others from anthropology and the ethnographic museum.[1] The entangled interests of the two disciplinary fields over art in general are, of course, not new, going back at least to the anthropologist Ernst Grosse's *Die Anfänge der Kunst* if not Kant's *Anthropologie in pragmatischer Hinsicht*.[2] World Art wishes to be global and universal, but the universal is deeply embedded in a European genealogy of *kunst* and *anthropologie* not easily disengaged from the Enlightenment concept of Man, the division between the raw and the cooked, or the idea of modern art. The multiplicity of objects that World Art would embrace cannot, in other words, erase the local character of its knowledge and the disciplinary tools deployed to produce an object as art. World Art has a problem.

One way into (but not necessarily out of) the problem of World Art is James Clifford's seminal graph of the "Art-Culture System" published in his 1988 book *The Predicament of Culture* (fig. 1).[3] The graph—from which the term "World Art" is absent—was produced on the heels of *"Primitivism" in 20th Century Art: Affinity of the Tribal and the Modern* of 1984 at the Museum of Modern Art and before *Magiciens de la Terre* of 1989 at the Centre Pompidou. Rejecting the concept of affinities between the primitive and the modern, Clifford astutely mapped the migration of objects collected from non-Western sources into two major categories: (scientific) cultural artifacts or (aesthetic) works of art.[4] His Art-Culture System, conceived as a set of four linked and permeable zones through which objects might move, was based on the semiotic square of Algirdas Greimas as elaborated by Fredric Jameson. A further exploration of the semiotic square, as we will see below, offers the opportunity to bring the operation of this square to bear on Clifford's square; to employ the square, in Jameson's words, as a tool that "maps the limits of a specific ideological consciousness and marks

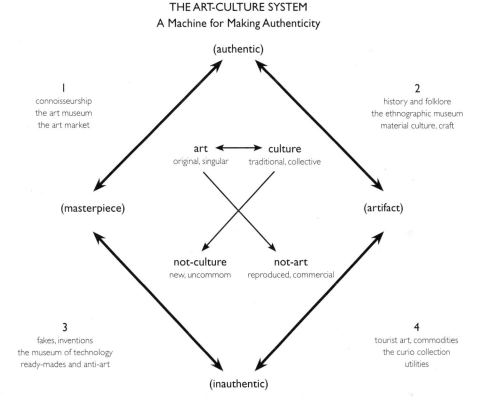

THE ART-CULTURE SYSTEM
A Machine for Making Authenticity

(authentic)

1
connoisseurship
the art museum
the art market

2
history and folklore
the ethnographic museum
material culture, craft

art ⟷ culture
original, singular traditional, collective

(masterpiece)

(artifact)

not-culture not-art
new, uncommom reproduced, commercial

3
fakes, inventions
the museum of technology
ready-mades and anti-art

4
tourist art, commodities
the curio collection
utilities

(inauthentic)

Fig. 1. The Art-Culture System. Reprinted by permission of the publisher from James Clifford, *The Predicament of Culture* (Cambridge, MA: Harvard University Press, 1988), 224. Copyright © 1988 by the President and Fellows of Harvard College

the conceptual points beyond which that consciousness cannot go, and between which it is condemned to oscillate."[5]

Greimas's semiotic square begins with two contrary semes, s_1 and s_2, and their contradictory terms, \bar{s}_1 and \bar{s}_2, which in turn represent a second pair of contraries (fig. 2). The relations along the sides are of implication. The large S at the top represents the synthesis that encompasses both s_1 and s_2; S is opposed below by \bar{S}, a synthesis that is neither \bar{s}_1 nor \bar{s}_2. The system is often described as one of binaries or negations but as you can see there are three distinct relations: between contraries, between contradictories, and of implication.

Turning to Clifford's graph, the terms "art" and "culture" have been inserted into the slots s_1 and s_2, which form the initial contrary relationship. The contradictories not-culture/not-art form their own contrary relationship. A

Fig. 2. Semiotic Square of Algirdas Greimas

second set of four synthetic terms is produced from the original four: "authentic–inauthentic" on the vertical axis and "masterpiece–artifact" on the horizontal. Finally, the complimentary relationship of these four terms produces four semantic zones: 1. the zone of authentic masterpieces; 2. the zone of authentic artifacts; 3. the zone of inauthentic masterpieces; 4. the zone of inauthentic artifacts. For Clifford most objects can be located within one of these zones or "ambiguously" in transit between two of them. The zones represent contexts through which value is assigned, with positive values acquired by movement from bottom to top and from the right side to the left side.

The privileged slot in a semiotic square (s_1), the first to be filled, is here occupied by art, the original and singular object of rarity and value. The insertion of its contrary, culture (s_2), makes visible the negative field (traditional, collective) with which the term "art" is opposed. The initial contrary relationship in the square is something like the relationships of dominant/subordinate, center/periphery, or self/other.[6] Clifford's selections for the original slot and its contrary are therefore quite telling, placing art in the position of privilege while casting culture in the role of its subordinate other.

The contradictory relationships generate a second pair of contrary terms in the lower register that represent more than simple negativity. "Not-art," for example, is a far broader category than "art." The fourth term, "not-culture," as the negation of the negation, is always the most critical and the one that remains open the longest; in Jameson's terms, "the place of novelty and of paradoxical emergence, for its identification completes the process and in that sense constitutes the most creative act of the construction . . . the place of the great leap, the

great deduction, the intuition that falls from the ceiling, or from heaven."[7] The fourth term (not-culture: new and uncommon) is indeed not easily specified in Clifford's adjacent zone 3 of Borges-like incommensurability: "fakes, inventions, the museum of technology, ready-mades, and anti-art."

Finally, we should note two contradictory terms (authentic and inauthentic) with which Clifford has filled the slots S and S̄ along the vertical axis of the square. These are the positive complex term (authentic), a synthesis of the art/culture contrary, and the negative complex term (inauthentic), a synthesis of the not-culture/not-art contrary. What is striking is how a frankly pedestrian set of oppositions breaks out into a different semantic register with the pair of complex terms, which underscores what is at stake in the work of the Art-Culture System. Jameson suggests treating the positive complex term (authentic) as a utopian term, a transcending of the art-culture opposition, and the negative complex term (inauthentic) below, which assembles all of the negations, as a neutral (or should we say abject?) term. These six slots form the core of the square according to Greimas, but Clifford adds a second pair of complex terms along the horizontal axis: masterpiece, a synthesis of art/not-culture; and artifact, a synthesis of culture/not-art. To these we will return.

The ideological consciousness of the Art-Culture System is marked by an architecture of closure and limits. His system, as Clifford notes, offers the collected object a stark option at best between an after-life as a work of art or as an ethnographic artifact: "It excludes and marginalizes various residual and emergent contexts."[8] But the closure of the square does much more. Following Jameson, it produces a relationship of tension between presence and absence that can be mapped according to the various dynamic possibilities of generation, projection, compensation, repression, and displacement, so that the "structure, far from being completely realized on any one of its levels, tilts powerfully into the underside or *impensé* or *non-dit*, in short, into the very political unconscious of the text."[9] Understood in this way, the semiotic square offers a way to access what has remained unrealized or failed to become manifest in the logic of the Art-Culture System: that which has been necessarily repressed. The square is more than a map of opposed categories, it offers up the structure of a particular political fantasy or "libidinal apparatus"—the vehicle for our experience of the real—in which the narrative of the Art-Culture System is invested.[10]

The point of a binary opposition in the square "is not its logical accuracy as a thought concerned to compare only comparable entities and oppose only terms of

the appropriate category, but, on the contrary, its existence as a symptom." Jameson goes on to argue that an opposition "is not so much a logical contradiction, as rather an antinomy for the mind, a dilemma, an aporia, which itself expresses—in the form of an ideological closure—a concrete social contradiction. Its existence as skewed thought, then, as a double bind and a conceptual scandal, is what accounts for the restless life of the system, its desperate attempts to square its own circles and to produce new terms out of itself which ultimately 'solve' the dilemma at hand."[11] Note the slippage of Jameson's language into an anthropomorphic mode: he gives the system a "life" and a will, a desire, which is crucial.

Thus appropriated, the semiotic square might function as a dialectical tool with which to force the narrative to "blurt out" its own secret. Yet, as we know, one who seeks to reveal secrets does so at one's own risk. Let us rethink Clifford's narrative with caution, squaring the square, so to speak, in order to suggest "the ideological service which the production of this narrative is ultimately intended to perform—in other words, the resolution of this particular determinate contradiction—or, more precisely, following Levi-Strauss's seminal characterization of mythic narrative, the imaginary resolution of this particular determinate real contradiction."[12] It is appropriate that we begin with anthropology.

Clifford offers the Art-Culture System as a straightforward map of four zones through which objects might move. The first examples are promotions from Zone 2 to Zone 1, such as African sculpture into the Metropolitan Museum of Art or Shaker crafts into the Whitney Museum of American Art. Clifford characterizes the difference as the result of protocols of display: a migration from "contextualist" ethnographic displays to the "aestheticized" protocols of the fine art museum.[13] For Clifford, "movement in the inverse direction occurs whenever art masterworks are culturally and historically 'contextualized,' something that has been occurring more and more explicitly."[14] One is hard-pressed, however, to find examples of a fine art masterwork being moved into a contextualized ethnographic display. Clifford's reference must be to what in the 1980s was the prominent project of the New Art History, with its rejection of formalism in favor of social, political, and economic contexts.[15] This was indeed an effort to promote contextualization, but wholly within the realm of art history and fine art museums. Clifford's view that contextualization would result in the demotion of a masterpiece into the realm of "culture" ironically aligned with the fears of many critics of the New Art History. In fact, the widespread contextualization of artworks over the last twenty-five years has had little impact on the aesthetic aura or singular value of the masterpiece.

As an example of a demotion from Zone 1 to Zone 2, Clifford refers to the relocation of Impressionist paintings from the Jeu de Paume in Paris to the renovated Gare d'Orsay train station, now the Musée d'Orsay, in 1986. Perhaps on the surface it appeared that the new Museum of the Nineteenth Century (the museum's first, short-lived name) represented a historical-cultural context in which masterpieces would be reduced to ordinary period objects undifferentiated from "bad" art. But nothing of the sort was ever envisioned: "In its design, its installation, and its presentation of objects, Orsay clearly places itself in the tradition of the museum as sacralised realm."[16] The status of long-established masterpieces was hardly in doubt in a "museum that comes down on the side only of quality and invention in art."[17]

Clifford's missteps might be read, in light of Jameson, as less a lack of cognitive attentiveness than a symptom. A prominent theme in the *Predicament of Culture* is "ethnographic surrealism," the figure of the ethnographer as artist. Labeled by Hal Foster as a kind of artist envy (or the flip side of what Foster critiques as the ethnographic turn in contemporary art and criticism), the ethnographer-artist is a figure for the desire of anthropology to be the antidote for the Eurocentrism of art.[18] However, the placement of art in the privileged first slot (s_1) of Clifford's square sits uneasily with any such claim or wish for equivalency between art <—> artifact, of which the proposed simultaneous traffic of objects between the two is meant to corroborate. We might therefore situate Clifford's inexplicable insistence on the movement of objects from the realm of art "down" to that of culture as a symptom of a double bind, a conceptual scandal, "an antinomy for the mind . . . which itself expresses . . . a concrete social contradiction."[19]

Viewing the Art-Culture System with historical distance, one can admire the protean effort exerted to hold the separate categories apart, to construct a system that respects autonomous zones of value even as it functions dynamically like a machine. For some, it may serve as a memory map with the effect of producing nostalgia for those days when art was art and ethnographic artifacts were obviously not. For others who have come of age with only global postmodernist pastiche, the graph may be largely incomprehensible, its oppositions untethered to historical experience or cognitive reality. The unconscious of Clifford's vision—caught in the 1980s patterns of collecting, paradigms of display, and disciplinary skirmishes—returns, however uncannily, in the shadow of World Art.

Any reconfiguration of Clifford's Art-Culture System must necessarily

Fig. 3. Zande hunting net, n.d. American Museum of Natural History Library, New York (90.1/5144)

engage the conditions of the present, in particular the irrepressible appetite for new objects in the art market and the challenges of new narratives of contemporary art.[20] More and more, objects from Clifford's Zone 2 as well as Zone 3 and even Zone 4 flow into Zone 1.

The aesthetics of difference also makes its contribution on a global scale. This is not to collapse or homogenize but simply to follow the paths of aesthetic-economic value formation in diversity. If ethnographic objects functioned largely as foils to modern Western art in the exhibitions of the 1980s, they have increasingly gained value and status as art objects themselves in the multicultural twenty-first century. This is not to say they no longer serve as foils. Rather, the tightly rolled Zande hunting net extolled by Alfred Gell may serve simultaneously as foil for a dominant modern aesthetic and a work of art in its own right (fig. 3).[21] Compared to the detritus of much contemporary art (fig. 4), the Zande hunting net might even be taken for a traditional, autonomous aesthetic object, a masterpiece.[22]

Meanwhile, the aestheticized protocols of Zone 1 have expanded into Zone 2 and beyond. Some ethnological museums now look more like art museums than many art museums. The recent reinstallation at the National Museum of Ethnology in Leiden is an example of this hyper-aestheticization of ethnographic objects (fig. 5). One does not wish to overstate the case. Some museums, such as the American Museum of Natural History in New York, have been forthright in their desire to maintain an older form of ethnographic presentation as a kind of ironic self-critique, but as Ken Lum has observed: "With a nudge and a wink, the irony is often so sly that there is [often] very little effective change in the way that the museum appears in its core epistemological operations."[23] In both cases, old values and modes of knowledge production remain intact, disavowed but not displaced.

Fig. 4. Heather Mekkelson (American, born 1975), *Debris Field: turned and said to her, no matter what hold onto this*, 2007. Mixed media. Courtesy of the artist

Fig. 5. Installation view of seated Buddhas. National Museum of Ethnology, Leiden

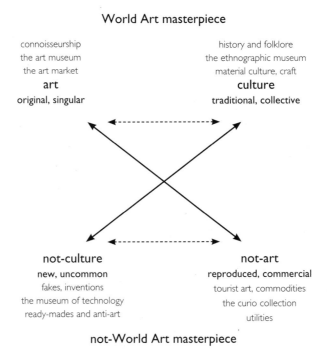

World Art masterpiece

connoisseurship
the art museum
the art market
art
original, singular

history and folklore
the ethnographic museum
material culture, craft
culture
traditional, collective

not-culture
new, uncommon
fakes, inventions
the museum of technology
ready-mades and anti-art

not-art
reproduced, commercial
tourist art, commodities
the curio collection
utilities

not-World Art masterpiece

Fig. 6. The World Art System

Still another form of self-transformation—to a museum of World Art—inscribes art directly across the ethnographic narrative itself, as in the Fowler Museum at the University of California, Los Angeles, which was established in 1963 as the Museum and Laboratories of Ethnic Arts and Technology. Still in the main an ethnographic and archaeological collection, its name was changed to the Museum of Cultural History, then the Fowler Museum of Cultural History, and finally the Fowler Museum at UCLA in 2006. The elimination of the term "cultural history," an interesting parallel to "art history," served a double function: it freed the museum from culture even as it placed it on an equal footing, at least in nomenclature, with the Hammer Museum, the university's similarly unclassified museum of art. From the Fowler's website and publicity materials, it appears that exhibitions and objects are, wherever possible, identified as art even though the curatorial narrative remains largely ethnographic in language and content.[24]

From the other side of the globe, the goal of World Art demands a radically different narrative. Established in 2006, the Beijing World Art Museum has no collection of its own but serves as a venue for exhibitions of mainly non-Chinese

art, often in conjunction with art museums abroad. Here, World Art mimics the programs of paradigmatic universal art museums such as the Metropolitan Museum of Art in New York, following a familiar schedule of exhibitions of Impressionists, Classical sculpture, Italian Renaissance art, French academic painting, and so on, along with Ancient Egyptian and Mesopotamian artifacts, a mixture of non-Western materials, and the occasional contemporary Western artist. The institution and its goals, display and presentation, curatorial strategies, and fiscal challenges appears indistinguishable from those of the modern, or Western art museum.[25]

The Fowler Museum and the Beijing Museum of World Art may seem to have little in common, but what is obvious in Beijing—that the Museum of World Art wishes to be the equivalent of a Western art museum—is no less true for the Fowler. The goal—to move from ethnographic to World Art museum— may be understood as a form of artist envy within the dynamics of the semiotic square.[26] The desire to occupy Zone 1 is represented as an intervention by culture (ethnography) in which native objects are raised to the status of the masterpiece, achieving what is denied to them by a Eurocentric art history. If we then return to Clifford's graph (fig. 6) and replace "authenticity" with "masterpiece" at the top position (the positive complex term S from the synthesis of "art <—> culture"), we might understand the goal of World Art as the formation of a transcendent (utopian) masterpiece beyond art or culture, rather like the inaccessible but necessary Lacanian Real: "what resists symbolization absolutely" and reaches "its high point in the pressing manifestation of an unreal, hallucinatory reality."[27] The desire for World Art depends on a double disavowal of the ineradicable historical and epistemological foundation of both art history and anthropology as contrary but interdependent forms of European knowledge.

The original pair of complex terms, "Authentic/inauthentic," has disappeared from the square. Authenticity—fundamental for the construction of the category of both art and artifact but a term openly abused in contemporary art practice—seems like a quaint effect of a pre-modern past long superseded. But if the contrary of art <—> culture today leads to a masterpiece of World Art instead of the "authentic," how are we to understand the negative complex term s̄: not-(World Art) masterpiece? If the World Art masterpiece is, like the art masterpiece, original and singular, the category of not-World Art masterpiece must comprise all the rest. Working through the square suggests that the ideology of World Art leads to a configuration that is indistinguishable from that of art.

World Art has emerged to answer contradictions in both disciplines. For a universal art history, resolution appears at hand. The corrective to charges of Eurocentrism is the simple addition of "world" to the unchallenged category of "art" and the continuation of the chore of determining which non-Western objects are to be included in the narrative of (World) art history.[28] The situation for anthropology may not be as simple. Culture may be synonymous with World, but everything can't be art.

In conclusion, let us reconfigure Clifford's square with one final injunction from Jameson: "The four primary terms are best conceived polysemically, each term carrying within it its own range of synonyms, and of the synonyms of its synonyms—none of them exactly coterminous with each other, such that large areas of relatively new or at least skewed conceptuality are thereby registered."[29] If we draw synonyms from the periphery of Clifford's graph—his four semantic zones—and fold these into the four terms at the center, we have four clusters of terms, uneven as sets of synonyms, with a range of possible juxtapositions. If we maintain Clifford's parallel terms, for example the art museum, the ethnographic museum, the curio collection, and the museum of technology, we have a neat relationship of physical sites of collecting. But if we follow a different set of terms—the art market, material culture and craft, utilities, ready-mades, and anti-art—we have a far slipperier set of oppositions with a radically "skewed conceptuality."[30]

The square is an invitation, a lure to test these terms against the logic of the contrary, contradictory, and synthetic forces of the semiotic and cultural field. But the square refuses sublation. We are faced with an antinomy, a dilemma, an aporia that is a symptom: the manifestation of a contradiction between what is imagined to be a new horizon (World Art) and old practices, both art historical and ethnographic. World Art, which is the expansion of the production, appreciation, and consumption of art objects globally, demands new instrumental practices of validation, if not criticism. So it comes as no surprise that the academic discipline of art history has recently been established in China and we now hear of the "anxieties and expediencies" raised by questions of how Chinese art is to be related to World Art.[31] As with the reproduction of the Western universal art museum in Beijing's World Art Museum, Western art history has been transplanted in China as not just Western art history but World Art history.[32] It is the Western concept of the universal—necessarily suppressed in Art but flaunted in World Art—that points to the unspoken underside of the Art-Culture System.

For Clifford, the fourth and final term of the square—the place of

novelty and paradoxical emergence—is occupied by the "not-culture" of new and uncommon objects. Among the synonyms for not-culture, however, ready-mades and anti-art have long been enshrined as masterpieces in the canon of modern art. Inventions and technology may not fall within the usual purview of anthropology, but they each have been subsumed by culture if Cultural Studies is allowed to serve as a measure. Little today, certainly not the new and the uncommon, qualifies as not-culture. The fourth term does yield one category of object that is not so easily assimilated: fakes. With the fake, the question of authenticity reappears in Clifford's Art-Culture System.

In the ethnographic realm, the question of authenticity (in African art, for example) has been the unique concern of Western scholars, dealers, and collectors.[33] The Western fetish of the authentic is expressed as an intense anxiety regarding the intent of the maker as well as the original purpose and use of the object. Only things made for use in local rituals or other tribal purposes and actually utilized for such are considered authentic. As verification, some objects are even labeled as having been used or "danced" on a certain date, the further in the past the better. Similar objects never used in a ritual or that have been explicitly produced for the art market cannot be authentic. This peculiar definition of authenticity arises from the culturally specific ways in which artistic intention, rarity, beauty, and antiquity have come to produce value in the Western art market. African makers and dealers have learned to exploit the anxieties of the marketplace to their own benefit. Objects such as an African mask are therefore found throughout Clifford's four zones: as art (Zone 1), material culture or craft (Zone 2), fake (Zone 3), or tourist art (Zone 4).

For art history and the canon of fine art, the fake is that hard kernel or unavoidable thing that can neither be absorbed nor expunged. Fakes "loosen our hold on reality, deform and falsify our understanding of the past."[34] Conventional wisdom has it that, as in the sleuth-mystery film genre, the perfect fake/crime is in the end never perfect enough. It is said that an authentic work is like a living entity, while fakes are like dead objects. The latter might fool their owners temporarily but would never provide lasting pleasure.[35] In other words, a fake would reveal itself over time; certainly a striking example of anthropomorphism worthy of ethnographic investigation. Since an undiscovered fake is an authentic work of art until it exposes itself, it is undeniable that fakes go undetected as authentic works of art, perhaps for extended periods of time. Furthermore, determining authenticity in a work of art is wholly comparative, that is, specialists

can only evaluate a work based on its consistency with similar works known to be authentic. What comprises the visual characteristics of works "known" to be authentic has shifted over time and will certainly change in the future. The doctrine of an authentic canon is fundamentally unstable. If even a single "known" authentic work is in fact a well-crafted fake, the fantasy of the authentic should collapse, but of course it does not. Here we are tilting toward the unconscious of the Art-Culture System, haunted by the specter of the fake.

Yet there is more. Nelson Goodman has argued that terms such as "authentic" or "genuine" are superfluous.[36] An authentic Zande hunting net is just a Zande hunting net, and an inauthentic Zande hunting net is just not a Zande hunting net, but rather something else. Every thing is an authentic something. That the language of authenticity persists in the narrative of art objects suggests an essential role for a narrative of authenticity, not for a Zande hunting net but for works that are supposed to be, or claim to be, or hope to be a Zande hunting net. The narrative of authenticity is therefore crucial to the art-culture market and the ideology of the market, which must repeatedly produce the authentic for consumption, circulation, and profit. The terms "authentic" or "genuine" are a supplement—a recognition of the inability of the object to be authentic on its own, hence the necessity of the narrative and the oscillation between the antithetical terms "authentic" and "inauthentic" that drives the narrative. Although the narrative of authenticity has ostensibly stabilized sets of art objects in modern categories and institutions such as the museum, the ongoing repetition of claims for authenticity suggests the limit/failure/impossibility of the narrative.

What is suggested again is something like Lacan's Real: "The essential object which isn't an object any longer, but this something faced with which all words cease and all categories fail, the object of anxiety *par excellance.*"[37] Understood in this way, the authentic returns as the positive complex term S (the synthesis of art <—> culture) in Clifford's Art-Culture System; in other words, as the double of the Real of the World Art masterpiece.

The desire to venture further and further outward to discover, gather, and promote new objects as World Art—surely the subtle repetition of an old paradigm of encounter and conquest—appears to be the anxious avoidance of the antinomies of the Art-Culture System. As more and more newly discovered "authentic" objects (how fleeting will be their authenticity?) flow into the market and enter various types of collections, only a select few will ever be displayed to the public. The rest join a vast corpus of objects hidden below in museum storage

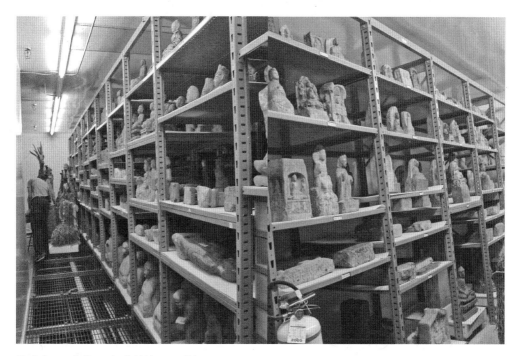

Fig. 7. Storage facility at the Field Museum, Chicago

(fig. 7). These works are the losers in the competition for singularity, for a prized place in the exhibition hall above. Here are the not-so-good, the duplicates, the fakes, the copies, the truly unexceptional. As objects that few will view closely (even in increasingly popular "visible" storage), they require no elaborate labels, no research, no justification for being an authentic anything. They may be tacitly acknowledged as art or artifact, but it is an easy acknowledgement because what they actually are—fake or simply not exceptional—is of little consequence for the museum, its public, or the art market. Such works are liminal, neither an authentic subject of value nor its negation. They represent an immense body of objects largely unseen or unknown: the unacknowledged, the unconscious of Clifford's Art-Culture System.

In the galleries above, spotlighted objects are arranged by a chronological narrative mapped onto a series of interlocked spaces meticulously planned and ordered. In the darkness below, there is no chronology and no narrative. In this heterotopic space, time is collapsed, genres mixed; Brazilian masks sit easily among Chinese sculpture (far left of fig. 7). Out of this ghostly realm of floating spirits and things rises the specter of the abject to haunt the global designs of World Art.

1. An example of the former is the conference "Compression vs. Expression: Containing and Explaining the World's Art" at the Sterling and Francine Clark Art Institute in 2000. A recent example of the latter is the conference "(World) Art?: Art History and Global Practice" in May 2008 at Northwestern University where the material in this essay was first presented. I am grateful to the organizer, Christopher Pinney, for his kind invitation to participate.

2. Ernst Grosse, *The Beginnings of Art* (New York: D. Appleton and Co., 1897), translation of *Die Anfänge der Kunst* (Freiburg im Baden, Leipzig: J. C. B. Mohr, 1894); Immanuel Kant, *Anthropology From a Pragmatic Point of View*, ed. Hans H. Rudnick, trans. Victor Lyle Dowdell (Carbondale: Southern Illinois University Press, 1978), translation of *Anthropologie in pragmatischer Hinsicht* (Königsberg: Bey Friedrich Nicolovius, 1798).

3. James Clifford, *The Predicament of Culture* (Cambridge, MA: Harvard University Press, 1988), 224.

4. Ibid., 222.

5. Fredric Jameson, *The Political Unconscious* (Ithaca, NY: Cornell University Press, 1981), 47.

6. Fredric Jameson, "Foreword," in Algirdas Greimas, ed., *On Meaning: Selected Writings in Semiotic Theory* (Minneapolis: University of Minnesota Press, 1976), xv.

7. Ibid., xvi.

8. Clifford, *Predicament of Culture*, 226.

9. Jameson, *Political Unconscious*, 49.

10. Ibid., 48.

11. Ibid., 254.

12. Ibid., 256.

13. Clifford, *Predicament of Culture*, 224, citing Michael M. Ames, *Museums, the Public, and Anthropology: A Study in the Anthropology of Anthropology* (Vancouver: University of British Columbia Press, 1986), 39–42.

14. Clifford, *Predicament of Culture*, 224.

15. See, for example, A. L. Rees and Frances Borzello, eds., *The New Art History* (London: Camden Press, 1986).

16. Daniel J. Sherman, "Art History and Art Politics: The Museum According to Orsay," *Oxford Art Journal* 13, no. 2 (1990): 56.

17. Françoise Cachin, first director of the Musée d'Orsay, in Sherman, "Art History and Art Politics," 62.

18. Hal Foster, *The Return of the Real: The Avant-Garde at the End of the Century* (Cambridge, MA: MIT Press, 1996), 180–81.

19. Jameson, *Political Unconscious*, 254.

20. For example, the attack on theoretical–political rigidity in contemporary art criticism and the

advocacy of "complicit formalism" in Johanna Drucker, *Sweet Dreams: Contemporary Art and Complicity* (Chicago: University of Chicago Press, 2005).

21. Alfred Gell, "Vogel's Net," *Journal of Material Culture* 1 (1996): 17–18.

22. James C. Faris, "'Art/Artifact': On the Museum and Anthropology," *Current Anthropology* 29, no. 5 (1988): 776.

23. Ken Lum, "Art and Ethnology: A Relationship in Ironies," *Last Call* 1, no. 3 (Spring 2002), accessed at http://www.belkin-gallery.ubc.ca/lastcall/index.html.

24. For example, see the press release for the exhibition *Intersections: World Arts, Local Lives*, http://www.fowler.ucla.edu/incEngine/sites/fowler/pdf/Intersections%20release%20on%20letterhead.pdfx (accessed 3 Jan. 2010).

25. Wang Limei, "The Beijing World Art Museum at the China Millennium Monument," *Museum International* 60, nos. 1–2 (2008): 140–47.

26. Foster, *Return of the Real*, 180.

27. Jacques Lacan, *Freud's Papers on Technique*, 1953–1954 (New York: W. W. Norton, 1991), 66–67.

28. For example, see David Summers, *Real Spaces: World Art History and the Rise of Western Modernism* (London and New York: Phaidon, 2003).

29. Jameson, "Foreword," xv–xvi.

30. Ibid.

31. Cao Yiqiang, "Anxiety and Expediency: Chinese Art History Seen in the Context of World Art," in John Onians, ed., *Compression vs. Expression: Containing and Explaining the World's Art* (Williamstown, MA: Sterling and Francine Clark Art Institute, 2006), 139–47.

32. There is no equivalent contrary role for culture or anthropology established in China in the 1930s. For the beginnings of anthropology in China, see Gregory Eliyu Guldin, *Anthropology in China: Defining the Discipline* (Armonk, NY: M. E. Sharpe, 1990), 6–8; Zhou Daming, "Anthropology in China Takes Practical Approach," trans. by Shao Da from *Guangming Ribao* (Guangming Daily), 16 May 2002, http://china.org.cn/english/2002/May/32689.htm (accessed on 10 Jan. 2009).

33. Christopher Burghard Steiner, *African Art in Transit* (Cambridge, UK, and New York: Cambridge University Press, 1994), 100–102.

34. Mark Jones, ed., *Fake?: The Art of Deception* (Berkeley: University of California Press, 1990), 16.

35. Attributed in my unreliable memory to Walter Pach; however, I have been unable to locate a source.

36. Nelson Goodman, "Authenticity," *Grove Art Online, Oxford Art Online*, http://www.oxfordartonline.com/subscriber/article/grove/art/T005210 (accessed 16 Sept. 2004).

37. Jacques Lacan, *The Ego in Freud's Theory and in the Technique of Psychoanalysis*, 1954–1955 (New York: W. W. Norton, 1988), 164.

PART THREE

MODES OF ENGAGEMENT

Cosmopolitanism Assemblages Art

Nikos Papastergiadis

Shortly after 9/11, at a time when politicians around the world were calling upon their people to prepare for the "clash of civilizations," Jimmie Durham claimed it an opportune moment to redefine the function of art. Drawing on Sarat Maharaj's comment that "artists produce knowledge," he suggested that the form of this knowledge is prompted by a change in the context of cross-cultural interactions:

> This is a time when we ask: "Who are we humans?" It's not the American invasive kind of globalization, but globalization where humans try to talk to each other. I think that humanity is trying to talk to itself now, for the first time in human history, maybe. We don't necessarily like each other, or like what we are trying to say to each other, but to me it looks like we are trying to see ourselves.[1]

For Durham, art is part of this historic dialogue between people from different backgrounds. Obviously such a conversation would require more than the congregation of people in a forum where they articulate their differences and negotiate over fixed boundaries. As has been often noted, it requires an ethics of hospitality toward the other and an attitude of openness toward the risks and benefits that may accrue in the exchange. In this process, Durham notes that art has the capacity to explore human bonds that are not reliant on an economic system of credit and debit or confined to nationalist categories of loyalty.

It is a matter of considerable significance that Durham suggests that this process commences with the question, "Who are we humans?" rather than yet another declaration such as, "As humans we should . . . !" This is expressive of a broader rethinking on the fundamental question of being and community in the context of radical mobility. A decade earlier, Giorgio Agamben posited a communal structure in which "humans co-belong without a representable condition of belonging."[2] Cosmopolitanism begins in such propositions. It also transpires in the myriad of mixtures that occur in everyday life. When Durham suggests that art is part of a global dialogue on the definition of "our" common but distinctive identity, he also suggests that everyone enters into this dialogue

as equals. These philosophical questions and social processes have profound consequences for understanding the place of art in everyday life. Let me illustrate this challenge with an account of what is by now a fairly typical art event.[3] In 2004, the curator Marina Fokidis and Lorenzo Romitto, an artist from the collective Stalker, invited me to participate in a "picnic" on the island of Makronisos that fellow artists were organizing along with the refugees from Lavrio, a camp just outside of Athens. In the evening after the event, I recorded the following notes:

> From the windows of Lavrio there is a view of a nearby island called Makronisos. This long island juts out of the sea like the spine of an ancient dolphin. Along the rocky thin line are clumps of green. Oregano grows wild among the thorns. It appears abandoned and lonely. Everyone who stares from the mainland knows that this was the most infamous prison where the political dissidents were confined and tortured into submission. Yet, to this island that no one else wants to go, there is the fantasy that, here, the refugee might come, build a home, stay, and no one will say "leave."

> Makronisos is the most dreaded name for a Greek island: it means exile, torture, and humiliation. And how much more cruel that the mainland is so close, so visible and punishingly at hand. Only children see this as an open playground. There are a couple of boys with shaved heads and eyes alert to any chance of a game. They are not orphans, for their parents entrusted the PKK (the Kurdistan Workers' Party) to smuggle them out of Turkey. The only inhabitants on the island are three Pakistani shepherds. Goats and sheep are everywhere, and wherever there is shelter, there are mounds of manure. The shepherds seem to have vanished. Only a rusty Datsun utility truck sits by the edge of the port. After we disembark, one of the artists, Nikos Tranos, and one of the leaders of the PKK make a speech in which they announce the self-evident purpose of this event. History needs few words among the ruins of abandoned theaters, a flattened prison, and fragments of walls. Nikos suggests that we announce our presence by clearing a space. He suggests that each person toss a few rocks on a communal mound. Marina mentions that her father, like all the prisoners, was allocated a heavy rock to carry. They carried these rocks all day, up

and down the Sisyphean hills. The rocks were numbered, and the prisoners were called by the numbers on their rocks. Soon it becomes almost impossible to distinguish the small pile from the rubble when the Kurds join in and the pace quickens, and more and more stones are flicked and clack on the mound. One smiling man finds a pile of larger rocks. The tossing and throwing builds like a crescendo. When it is over, another young man, Mafouz, invites me to walk to the peak of the hill. While ascending he tells me that Christians gathered rocks to define a place, and that Zoroastrians throw rocks to cast out the devil. We speculate whether this clearing and purging are just different ways to speak of heaven.

Assemblages

Such an event has no essence. There was no iconic moment, no gesture that captured the "spirit" of hospitality, or object that symbolized the experience of momentary solidarity. It was a day in which one incident was clipped to the next. The participating artists knew that their art was found in the whole of the day. There was no predetermined time or specified place that framed the ordinary flow of social activities. The journey to the island was neither the approach to nor exit from a scene: at no point could I distinguish a zone that would resemble a performance space.

The new toll highway to the international airport provides a direct axis that links the ancient port of Lavrio to Athens. Approaching Lavrio there are abandoned mines that resemble a weird hybrid of ancient and industrial ruins. This twisting of time repeats itself inside the architecture of Lavrio. The town now stands somewhere between the remnants of an Ottoman village and a new beach suburb, not quite certain of what to make of its combination of palm trees, pink disco signs, and the old gray *kafenia* with nicotine-stained walls and green Formica tables. Flags announce the civic center. Above the municipal building the Greek blue and white whirrs and whistles in the harbor breeze, while above the adjacent building troop Kurdish and Turkish Communist Party flags. In the absence of formal poles they use antennae to announce the rule of Ocelan. The refugee camp is a former army barracks. Its gates are

wide open and the interior holds a volleyball court. A match has just finished. Who wins? Who cares! The players and fans do. Every day there is a contest. Athens versus Lavrio. The men are now standing in the shaded cloisters. They smile as we enter. The women are above on the higher balconies, too busy with other things to notice us.

"We are here to meet Marina," I say.

I am trying to validate our entrance, but it does not seem necessary. It doesn't alter the greeting; their smile is the same. They point to the other side. Marina has been working with these refugees for many months. She stayed there overnight to finalize some discussions about the day's event.

As we enter the building it is clear that we are in the Kurdish PKK half. Homages to Ocelan, maps of the Kurdish homeland, portraits of martyrs adorn the walls. On the other side are the red flags of the Turkish Communist Party. In the following building there is a mixture of Azerbaijani, Afghani, and Iraqi refugees. On all balconies are satellite dishes.

Following on from Durham, we can now ask whether it is necessary for art to produce a kind of understanding that is distinctive from other social, creative, and critical encounters? In short, was my arrival an opportunity to witness the work that Marina does as a curator? Was the process of negotiation that she and the artists Lorenzo and Iacobo were involved in merely part of the preparatory stages for a subsequent event? The usual "lens" employed in art criticism would render such activity either a form of social welfare or as the necessary fieldwork to provide an artist with raw material to be subsequently transformed into an aesthetic product. At best, my role as critic would be to note the context from which the work is derived and then search for the influences that it exerts.

By focusing on the context of art one does not necessarily dissolve the boundary between art and other social activities. On the contrary, sociologists such as Janet Wolff and Howard Becker have critiqued the Romantic conception of the artist aloof from social connections, emphasizing the historical causality of creativity and the complexity of the cooperative networks and contexts through which art happens.[4] This materialist sociology of the production of art as work

moves by way of demystification and is largely concerned with enumerating the social factors that *affect* art's development. While Wolff, following Anthony Giddens's conception of the duality of structures,[5] argues that artistic practice is both socially determined and an arena for situated choices, this sociology of art remains tied to the Romantic model, which it worthily attempts to correct. I am interested in formulating a critical disposition that might engage more effectively with art production, which is avowedly, indeed tactically embedded in the context and sociability of its making. In the specific encounter between the artists from the collective Stalker and the refugees in the camp at Lavrio, it is impossible to distinguish between background, research, hospitality, and art. Art here is not simply rooted in social practice but is itself social praxis. What would previously have been seen as social context or a preparatory phase is now part of the materiality of the total experience.

> We find Marina and her friend Iacobo in a back room. As we enter we are immediately invited to join the table. A plastic plate with rice, chicken, salad, and yoghurt is placed before us. Some men are eating and talking with Marina and Iacobo while others prepare, serve, and clean. Every surface is rough, splintered, and chipped but clean. The leader of the PKK in Greece, the chief, is in the middle of a discussion about cultural politics with Iacobo. Iacobo's views on the significance of an imaginary as opposed to a territorial homeland, on fluid rather than fixed identities, on hybrid instead of essential cultural values are received with equanimity. Iacobo can talk and talk, but the chief patiently disagrees, qualifies, and explains in a manner that echoes his perfectly ironed shirt and immaculate fingernails. There are no wrinkles, doubts, or gaps in his authority. To the chief, an intellectual discussion is tolerable, but politically it must be understood: no culture without nation. Diaspora talk is only a shadow of armed struggle. The seed of the diaspora is not cut free to be something else, but only to reproduce the same tree in a foreign soil. Iacobo has his convictions. He is hanging on to the slivers of convergence, and repeats his questions. Marina walks out of the room and the chief drops his attention.
>
> Marina has already achieved her goal. The artists have arranged a boat and a meal for the refugees on the nearby island of Makronisos, and the

PKK has agreed that all the Kurdish refugees in Lavrio should attend. I follow Lorenzo and Mateo as they go next door to deliver a letter to an old man from Azerbaijan. He is incredulous. Not because a fellow countryman has written to him, but that it is from a sailor. How can a landlocked country produce sailors? Yet this sailor is now stranded on board a deserted ship in Naples. The crew abandoned the ship and he is unable to either depart or disembark. Lorenzo and Mateo tell him how they met the sailor. The conversation rattles through the corridors of six different languages. Lorenzo and Mateo speak in Italian and English, Theodoris and I translate into Greek. Through the words of an eleven-year-old Afghani boy, who translates into Turkish, the bedridden Azerbaijani listens. Tears well up from in the deep pockets below his eyes. The ship that will take us to Makronisos is sounding its horn. We scuttle around the corner and are among the last to board.

"It is just a short trip!" Marina shouts.

"You mean it is that island over there?" I interject.

"Yes, just over there. Come on, let's go."

I always thought Makronisos got its name because it was far from the mainland. The scene from Voulgaris's film *Stone Years* where two young lovers stare at each other from opposite ends of a ship, without their countenances yielding to reveal their embrace, suggested to me that the journey of their exile was toward the far side of Greece, like the winter. *Makro* also means long. It is also the island that Paris and Helen took refuge on before their escape to Troy.

The captain of our boat is counting heads and shouting for us to keep still. He can see the coast guard hovering at the mouth of the port. The boat is filled beyond its limit. But who will get off, artists or refugees? After a lot of pleading and the promise of a little more money, he agrees to make two trips.

This account of some of the details that surround an experience raises questions about the ambience of art, where it begins and ends? As artists are increasingly defining their field of practice as the domain of "existing social realities," it provokes a rethinking of the role of context in art.[6] I began by describing this as

a "fairly typical art event." However, it should be clear that this encounter was not quite an event and certainly unlike a Happening. I am not suggesting that the boundary between the organic totality of art and everyday life had suddenly dissolved; the artists were engaged with the social realities of the refugees, but they had not abandoned their aesthetic ambitions. What appears to have occurred is a more diffuse and unpredictable set of relationships between artists and refugees. I would prefer to describe the context of these encounters as an "assemblage."

Before unpacking this concept, I would like to take a sidestep and address the deep-seated ambivalence that artists have expressed about the definition of context. This ambivalence oscillates between the dread of decontextualization and the quest for an unbounded relationship between art and its context. In 1971, Daniel Buren observed that the spatial significance of "the studio as the unique space of production and the museum as the unique space of exposition" needed to be investigated as part of the "ossifying customs of art."[7] The following year, Robert Smithson decried the "cultural confinement that takes place when a curator imposes his own limits on an art exhibition" and results in art that is "politically lobotomized."[8] A couple of decades later, Rasheed Araeen renewed the desire to escape from prevailing attempts to define the context of art by railing against the theoretical "prisons" that were "predetermining and prescribing" the identity and value of non-Western artists within a "controlled space."[9]

For Buren the displacement of art from the unique space in which it is produced (the studio) to the museum marks the terms of an alienation complex. The location of art in its primal context—the home of the studio—is also the limit of the artist's economic and cultural survival. His work cannot remain there, yet when it leaves for the gallery/museum it not only loses meaning but also loses vitality, for in Buren's terms its fate is limited to being in either a "boutique" or a "cemetery." Buren places himself at the edges of this alienated context when he declares, "The art of yesterday and today is not only marked by the studio as an essential, often unique place of production. All my work proceeds from its extinction."[10] In a similar tone of disavowal, Araeen protests against the tendency to explain non-Western art by relying primarily on the artist's biographic details and cultural context. In both cases, the artists are seeking a context for art that does not remain bound by the primal home and that recognizes its status as an alienated object as a constitutive feature of its identity. Like Smithson, they uphold the view that as art enters the public domain its aim is neither to claim an

autonomous space nor find redemption within a ghetto, but rather to establish a direct relation "with the elements as they exist from day to day."[11]

By stressing the relationship with the ephemeral and dynamic elements of the contemporary context in which art is located, these artists sought to overcome the idea that the context could be defined within fixed conceptual, temporal, and spatial boundaries. The struggle against these definitions of context was largely influenced by the nationalist and formalist paradigms that dominated most of twentieth-century art history. According to Araeen, these same constrictions were evident in the postcolonial theories that putatively deflected attention away from the object of art and toward culturalist paradigms of hybridity.[12] However, my interest in the earlier disputes over the definition of the context of art is not confined to the utility of theory for critical appreciation or curatorial framing, but rather directed toward the artist's perception of culture as a process of radical mobility. In a context in which visual culture is mediated by a proliferation of digital communication technologies, crisscrossed by the paths of people from all corners of the globe, and reconfigured by the constant combination of traditional and contemporary modes of practice, it is no longer plausible to define context as a singular set of national traits forged in an exclusive setting over a sustained period of time, nor is it sufficient to identify the primacy of formal concerns. Rather, context becomes meaningful if it includes a multi-temporal engagement with the past and the present, a cosmopolitan vision of the cultural horizon, and a specific engagement with social realities.[13]

The encounters between the artists and the refugees, the experience of the picnic, and the events and performances on Makronisos are better grasped through the concept of assemblage. The Deleuzian account of assemblage has gained considerable purchase in recent debates on the virtual and causal processes of social transformation. George E. Marcus and Erkan Saka have argued that as a "concept/cluster" assemblage provides a useful "resource" for addressing the paradoxical but inextricable relationship between the dynamic flows that disrupt and the structural order that emerges in a reconfigured form.[14] It alludes to the multiplicity and heterogeneity of agents that intersect and interact within a social space without presuming that this collision of differences leads to either their assimilation into the preexisting hierarchy or the elimination of their differences. On the contrary, assemblage allows attention to focus on the critical and creative trajectories that arise from the incorporation of external agents. Hence, Marcus and Saka argue that assemblage can be used to refer to both the states of cognition and

the objective relations that emerge in the ephemeral temporality and evanescent reverberations of contemporary social formations.

It is from this perspective that I seek to rethink the status of art that defines its practice as within the domain of existing social realities, and the emergence of a significant trajectory in art practice that Mark Nash claims marks a "documentary turn."[15] I will argue, though, that the concept of assemblage enables an understanding of the significance of process in which the emergence of heterogeneous agents can be articulated without the requirement that their interactions be fixed into thingness or the trace of their interactions be captured into visual forms that can belatedly accrue value as commodifiable artworks. It is my contention that, once again, the field of practice has been expanded; this time the artist's cosmopolitan disposition has greater opportunity for articulation within the process of assemblage. Before looking closer at this "turn" and the "expanded field" of aesthetic practice, I will propose that it is also part of a paradigm shift in the understanding of mobility. Through this new prism it is possible to rethink the relations between local and global, the parameters of the nation and the networks of the diaspora: in short, to go beyond the mechanistic and nationalistic definitions of the concepts of place and context that have dominated the humanities and in which art criticism and art history have operated since the nineteenth century.

Mobility Paradigms

Since the late nineteenth century the sociological and political discourse on migration has followed the core assumptions of nationalist ideologies that defined sovereign states as comprising a population that was both settled within a defined territory and in possession of a unique cultural identity. This viewpoint was premised on a metaphysical claim that the abandonment of a nomadic lifestyle for fixed settlement was a developmental stage in human evolution. It was also framed by a mechanistic understanding of the negative relationship between movement and equilibrium: human movement was seen as a depletion of energy as well as a threat to the integrity of borders and the stability of social entities. Hence, migration was considered a deviation from the normal conventions of settled life, and migrants (or as Oscar Handlin termed them, the "uprooted ones") were at best seen as victims of external forces or at worst as suspect characters seeking unfair advantage over residents, thus representing a threat to the prevailing social order.[16] This tendency is also evident in sociological accounts of migration, which

express overt sympathy for the needs of migrants while describing them as "people with problems."[17] Even when migration was acknowledged as a crucial feature of modernization, it was usually framed as if the process were finite and adjustment a mere transitional phase.[18] Hence, the "problem with migrants" begins with the assumption that migration is a disruption to settled life, and that the desired destiny of a migrant is to become a citizen of the nation.[19] Given these negative assumptions on the effects of migration and the status of migrants, it comes as no surprise that public debates have tended to focus on the degree, rather than the legitimacy of the imposition of limitations on immigration, restrictions on political entitlement, and the subjection of migrants to additional tests in relation to their biological and cultural fitness.

In the past decade, a paradigm shift has enabled a new discourse on migration and migrants. State-centric views on belonging have been challenged by new transnational perspectives on the formation of social spaces and a redefinition of the universal definitions of human rights.[20] The teleological claims on social evolution that privileged what Harald Kleinschmidt calls "residentialism" have been discredited,[21] and there is now both a finer appreciation of the complex feedback systems that arise from cross-border movements and an affirmative valuation of the role of cross-cultural interaction in revitalizing and ensuring the viability of social structures.[22] From this perspective, migration is now seen as a dynamic and often ongoing feature of social life. Similarly, migrants are no longer typecast as either passive victims that are "pushed and pulled" by external forces or deviants that threaten social order. It is therefore more appropriate to consider the ways migrants plot their journeys and how they utilize extensive networks of information as part of the normal and conscientious efforts by which people dignify their lives. In Hardt and Negri's spirited defense of a new form of critical agency, migrants are pioneers of what they call the "multitude,"[23] and, as Kleinschmidt argues, the new discourse on migration has the potential to extend the notion of citizenship to "universalistic principles of human rights irrespective of loyalty to a particular institution of statehood."[24]

From Diasporic Differences

In visual studies and art criticism a new set of post-national categories has emerged to describe this context in which there is hyper-visibility of non-Western artists and collaborative art practices involving loose, tactical, international coalitions of artists and participants. In addition to mobility and heightened interactivity

between people, there is also the wider availability of information through digital technologies and the inclusion of the art market in global capital networks. As Kobena Mercer rightly observes, the signs of cultural difference, which were a matter of urgency and contention in previous decades, have become banal. He goes so far as to say that there is now a "widespread acknowledgement of multiple identities in public life," and the normative incorporation of multiculturalism has both "enriched our experiences of art and enlivened the entire setting."[25] This shift in the grounding of multiculturalism is confirmed by two key anthologies on contemporary art and culture. In the 1990 editorial introduction of *Out There: Marginalization and Contemporary Culture*, Russell Ferguson outlined three aims: first, to establish a relationship between cultural debates and critical theory; second, to explore representational strategies that affirm cultural identities in complex societies; and third, to challenge the terms of negotiation that would otherwise continue to make minority cultures invisible.[26]

Almost a decade and a half later, a sequel anthology, *Over Here: International Perspectives on Art and Culture*, appeared. While the editors Jean Fisher and Gerardo Mosquera expressed the intention of taking up the legacy of the critique of the condition of marginalization and the possibilities for transformation, they added the following bittersweet introductory remark: "In some respects, nothing has changed, but everything has changed."[27] They claim that despite the mobility of artists from every corner of the world, there is almost no change in the institutional structures of power. However, they also note the emergence of an unexpected level of cultural complexity: "Despite the accusations that globalization has led to artistic homogenization, there have been signs of shifts in the epistemological grounds of contemporary artistic discourses based not in differences but *from* differences."[28]

This slender switch in the use of prepositions is indicative of the broader paradigm shift on the conceptualization of mobility and difference. It recognizes that cultural development can no longer be represented by a teleological narrative that is linear and inevitably Eurocentric.[29] For instance, rather than assuming that the supposed origins of modernism in the West will shape in perpetuity the lineages of influence, they now claim that it is possible to discern a transversal vision of cultural development whereby the local manifestation of modernism carries within itself the possibility of establishing a distinctive inflection of the global process. This perspective abandons the Eurocentric hierarchy of cultural validation, and adopts an understanding of the horizontal process by which an idea

spreads and mutates as it connects with specific locales. Fisher and Mosquera use the metaphor of "cultural corridors" to describe both the formation of common links across diverse sites and to stress the multi-directionality of the traffic.

While *Out There* examines the extent to which the Other can appear in the center, and whether the center is capable of accepting difference, in the sequel *Over Here* the call for recognition moves beyond the framework of either a self-confirming mirror or a redemptive accommodation with Otherness, summoning an approach to an elsewhere that, like in the game of hide-and-seek, is both nearby and separate. Hence, the power of the metaphor of "cultural corridors" does not come from its one-way access to the center but from its facilitation of ongoing crisscrossings. The aim is not validation of the minority as a worthy equal within the center's cultural hierarchy, but the creation of networks *from* which cultural differences move and interact with each other.

When the artists in the Stalker collective redefine their practice as an open conversation and explore the ways in which strangers can meet, this expresses both the belief that art can make a social difference and a fascination with the conditions for cosmopolitan dialogue, or what Mica Nava describes as "performing mutuality."[30] This fascination occurs at both a semiotic level, in which there is the potential for art to contain both particularistic and universal meaning, and a social level, with the possibility of artists being simultaneously connected to local and global cultural networks. Ever since the Stoics in Ancient Greece, cosmopolitanism has been defined as an open outlook toward the world and a practice of relating ideas and materials that originate from elsewhere.[31] While philosophical discourses have generally defined cosmopolitanism as a necessary but impossible political ideal, I believe that it is worth examining as a constitutive feature of the artistic imaginary. Nava also attends to the unconscious factors that shape a cosmopolitan "disposition," going beyond conventional definitions that highlight an intellectual stance toward difference as she probes the "feelings of attraction for and identification with Otherness—on intimate and visceral cosmopolitanism."[32] This approach, which examines the deep levels of affection between different people in metropolitan life and the fascination with unfamiliar objects in modern consciousness, also stresses that this interest in Otherness only remains viable if it is translated into the practices of public life. Cosmopolitanism is not just about private consciousness, it is also a social activity of mutual respect and a shared commitment to developing inclusive and hybrid rituals.

My own role as a participant in the assemblage of artists and refugees at

Makronisos was also motivated by this kind of "visceral cosmopolitanism," but as a critic I am left struggling to give due form to the experience of that day. I am aware that the artists did not presume that their work would have a significant political impact: it was neither reported by the mass media nor noticed by the politicians who debate migration policies. Art criticism would normally gloss such activity as mere social activism, or relegate it to the fringe of "community art." However, part of my attraction to the work of collectives like Stalker is that success and failure are not registered within such conventional institutional markers, and their practice is not exclusively funneled by the imperatives of the art market. As a collective, they seem uninterested in populist media hype, and, most refreshingly, their interpersonal relations are not dominated by a self-promoting art personality. Their approach and conduct is, to use the critical phrase proposed by Charles Esche, "modest."[33] Attention is concentrated on the lived experiences of interaction, and what matters is the subtle transformation that occurs through these experiences. However, in the absence of a fixed object, is it sufficient for the critic to focus on the multiple documentary traces that trail in the wake of such assemblages? How does art criticism, which has its analytic skills tuned to interpreting images, suddenly instead address the temporality of an ephemeral spatial manifestation—what Pierre Huyghe recently called an "apparition"—or evaluate the humanistic values of generosity and conviviality?[34]

While art practices that aim to initiate social relationships in public spaces and explore cultural modes of exchange that resist capitalist codes have been a powerful presence in the contemporary art scene since the 1960s, critical discourse has been rather slow to respond. For instance, only in the last decade has the concept of the everyday been developed into a critical tool for addressing the "lure of the ordinary" in contemporary practice.[35] Similarly, while there is a long-standing tradition of monographs that explore the complex affiliations that artists develop with other people, novel symbols, and foreign ideas, the actualization of the lived forms of this cosmopolitan disposition has remained undertheorized. Cosmopolitanism, and the cultural elements that form an assemblage, when acknowledged, were invariably relegated to incidental or background information in the pursuit of formalist aesthetics or socio-political questions. Critical discourse continues to focus on the documentary traces or objects produced by the collaborative process. While criticism remains preoccupied with aesthetic objects, investigation into the social space and interpersonal relations that are indisputably part of the materiality of art is deferred, and the development of

new techniques of spatial observation and critical concepts for evaluating the subjective states of empathy, trust, and reciprocity is delayed. It is my contention that a closer examination of the sociological and philosophical theories that have influenced debates about the social context of art will only take us part of the way toward understanding the (albeit incomplete, but nevertheless generative) force of cosmopolitanism and its contestable relationship to the political.

Let me take another sidestep and examine some aspects of theories on art and its social context. Victor Burgin, Arthur C. Danto, and T. J. Clark, although they adopt different philosophical perspectives, all agree on the basic principle that art does not enjoy a privileged autonomy and detachment from the social. What remains under contention is the way it is dependent on and implicated within social forces. For instance, Burgin has argued that art can no longer be represented "outside of the complex of other representational practices and institutions."[36] He also acknowledges that the capacity for art to interact with these other social forces is never neutral or equal. Even within art historical accounts of the influence of art, he claims that this is often driven by a correlation between the artist's non-aesthetic qualities, that is their cultural status, political commitment, or spiritual sensitivity, and the aesthetic, rather than purely from the material effect alone. In short, he argues that there is always some level of appreciation of the relationship between a text and its context, and that utilizing an intertextual approach would facilitate greater attention toward the ways artistic production and interpretation are entangled within the multiple levels of social formations of knowledge and power. However, this analysis shifts away from the social mediation of knowledge and power and onto the interpretation of signs as expressive of the social complex. Therefore, it relies on texts to speak allegorically about the transformation in the social context.

Arthur C. Danto's account of the relationship between art and social change is framed by what he calls the "triple transformation in art"—the transfiguration of the ordinary, the popularization of the function of the museum, and the redistribution of authorial agency between artist and participant—as correlatives of the modern revolution in subjectivity, de-traditionalization, and authority structures.[37] Throughout this account there is the presumption that the main drivers of change occur outside the practice of art, the political appears as an external force, and the function of art is reduced to a visual manifestation of these forces that drive social change. A similar tension between artistic representation and political transformation is also evident in T. J. Clark's more recent description

of the artistic responses to neoconservative politics. At a crucial juncture of his analysis, Clark embraces the view expressed by Hardt and Negri that hope is to be found in a loose coalition of diverse communities, what they termed the "multitude." Clark is particularly attentive to the way the multitude offers a challenge in the struggle for mastery over the "realm of the image." He argues that this symbolic arena is the primary site for political contestation. However, he then qualifies its impact on existing social reality by describing it as a "premonition of a politics to come."[38] In short, while the multitude is contesting the symbolic realm and articulating an alternative set of meanings, Clark argues that lived politics is still not there: the political remains suspended in a state of intimation. The politics of the multitude hovers in a kind of imagined possibility rather than an actual existing form of active agency. This leaves the relationship between art and politics incomplete and detached, their connection deferred to an undefined point on the horizon of the future, with therefore the condition of both left in a state of lack and absence from the real. It also reintroduces an old revolutionary rhetoric: the fullness of art will come *after* society has been liberated from art's alienation.

While Clark sees great hope in the promise of a new political agenda that is based on the multitude's symbolic claims, there is a blind spot in his examination of the moments of its *actual* coming together. What are the attractions and affiliations that can generate such a diverse gathering? What occurs in the encounters and exchanges that produce a collective? How do these social events pose new questions for the relationship between art and politics? Clark is alive to the possibilities in the multitude, but the fullness of its meaning is not found in the constitutive role of mixing heterogeneous elements and their aspiration to be involved in living through models of change. For Clark, the possibilities of the multitude are tied to an imaginary in which emancipatory models arise from an alienated present. The analysis of the cosmopolitanism that emerges in the presence of the multitude is thus displaced by an ideological perspective that interprets the appearance of the multitude as the seeds of hope for a utopian politics of the future. From this perspective, the identity of the multitude and the assemblage is held within a category of being that defers the real to a later point in history.

Art and Its Relation to Others

It is my contention that these theoretical perspectives on art and politics acknowledge cosmopolitanism in the context of the everyday and address the

aspiration for a necessary relationship between that art and the everyday. However, they defer attention from both the constitutive role of a cosmopolitan imaginary and the role of art in the actualization of cosmopolitan social order. In Danto's analysis, art is embedded within a broader "revolution" of consciousness and social authority, but he fails to address the distinctive role that art can play in reconfiguring political boundaries. While Burgin distributes art into a "social complex" and directs attention toward the textual codification of knowledge and power, he also stops short of examining how these complex connections impact on agency. These debates played an important role in rethinking the relationship between art, the everyday, and politics. However, I would argue the approach for understanding these terms has now changed. It is no longer a necessity to start with an aesthetic object and then evaluate its place within the social context, but rather it is necessary to commence with the social conditions in which artists initiate communication with others.

Nicolas Bourriaud was among the first to identify the emergence of a new collective sensibility in artistic practices. In his two key texts, *Relational Aesthetics* and *Postproduction*, he has not only provided many astute observations of the tendencies that emerged in the 1990s, but also began to classify their characteristics within a conceptual framework that was derived from Deleuze's theory of subjectivity and social transformation. Both books focus on the artistic responses to the reconfiguration of public space and the emergence of new communication technologies. *Relational Aesthetics* focuses on artistic experiments with conviviality, while *Postproduction* examines the changing dimensions of mental space offered by digital navigational and combinative tools for accessing the hyper-information on the Internet. For Bourriaud the distinctive quality of art from the 1990s was not any stylistic or thematic preoccupation, it was not even the technological parameters introduced by the Internet, but the renewed attention to the "sphere of interhuman relations."[39]

In these texts, Bourriaud repeatedly defines the function of art in relation to its production of a "specific sociality" and stresses that the role of the artist is to create "relations between people and world, by way of aesthetic objects."[40] He argues that the approach toward issues of being and place, communication and technology was proceeding in ways that departed from past practices. In particular, he argues that the development of "process-related" events that initiate social encounters *through form* requires a new theoretical vocabulary and framework. At the time of his writing, work by artists like Lucy Orta and Thomas

Hirschhorn was being categorized as either community art or conceptual art. Bourriaud rejected the view that these artistic practices were either an extension of the oppositional spirit or a depoliticized version of the institutional critique developed in the 1960s. In the introduction to *Relational Aesthetics*, Bourriaud made a powerful case that globalization not only changed the terrain of culture, but also issued a radical challenge to the context of art.

In the 1990s, both the social conditions for conviviality and the media for interaction were increasingly privatized and commodified. Public space was shrinking and the State's control over the institutions for socialization was fragmenting. Bourriaud was aware that these changes in social circumstance neutralized many of the earlier artistic strategies for engaging with social practices in everyday life. His skepticism about the commercial trajectories of the new communication technologies has been confirmed by the spread of viral advertising, the use of branding as a form of lifestyle partnerships, the practice of cool hunting on social network sites, and the blurring of sport, entertainment, and art along a common spectrum of the cultural spectacle. In general, one can argue that the tactics used by global corporations to promote their "hard" commodities within increasingly sophisticated "fluid" symbolic fields could only be possible because the boundaries of public life and the forms of agency have become transnational. For art to intervene with the formation of a "mega-visual culture" and the transformation of public space there needed to be a radical shift in its utilization of the new technologies and techniques of mediation. Bourriaud was alert to the reconfiguration of the symbolic field and was among the first to explore how this had implications for both aesthetic and ethical practices adopted by artists.

During this period, artists were focusing their practice on the construction of scenes in places such as markets, clubs, schools, and roadways, or in the hosting of events such as dinner parties, live performances, public debates, and media interventions. By these means, artists sought to reroute social processes and behavioral patterns into what Bourriaud calls "hands-on utopias."[41] He notes that the aim of artists was not to construct an alternative social space in which people could seek refuge, nor were these sites selected because they were more "authentic" than conventional art institutions. The choice of site and the process of "co-habitation" was part of the materiality of the artwork and a resource that both the artist and the participants could utilize in their own "visual montage."[42] In this process, the radical or critical function of art was defined in relation to the capacity of individuals to simultaneously inhabit a form, but also to modify,

remix, and reclaim its utility. There are obvious precursors in art history that have demonstrated an interest in both the practice of reclaiming a site and the *détournement* of cultural symbols.[43] Although Bourriaud acknowledges that artists in the 1990s reactivated the general ambition to enhance communication by applying and extending previous strategies, he also insists that they articulated a new intervention in the present context:

> The form of an artwork issues from a negotiation with the intelligible, which is bequeathed to us. Through it, the artist embarks on a dialogue. The artistic practice thus resides in the invention of relations between consciousness. Each particular artwork is a proposal to live in a shared world, and the work of every artist is a bundle of relations with the world, giving rise to other relations.[44]

The extent of this point of distinction has been a matter of considerable debate.[45] In *Postproduction*, Bourriaud clarified the distinctive role played by artists in the 1990s as he compared their activity to that of a "semionaut who produces original pathways through signs."[46] Through this metaphor of the semionaut he also stressed the "original" capacity of the artist to select a site, combine heterogeneous elements, initiate a self-generative "critical mass," and direct a process of creative exchange. For instance, when describing Rirkrit Tiravanija's artworks, which involve the production and sharing of a meal, he notes in a rather mechanistic fashion that "the people are one of the components of the exhibition." He then compares the role played by the artist to that of a "movie director" who prompts and provokes his actors into improvised "modes of sociality that are partially unforeseeable."[47] Bourriaud is not making the grand claim that the artist already knows where the action will lead or how it will end. On the contrary, he hangs on to the claim that the artist shapes but does not control the multiple outcomes. Hence the resulting exhibition is always marked by its provisional and open-ended status, while also retaining the authorial imprint of the artist that organized the event.

In this overview of contemporary practice, Bourriaud claims that the "primary characteristic is mobility."[48] This attention to works that are either made in transit or involve the "hi-jacking" of communicational codes touches on the cosmopolitan disposition that I have claimed is central to the artistic imaginary and aesthetic production. However, the emphasis that he attributes to the artist

in organizing the scene in which strangers meet and the presentation of the artist as a catalyst in a process of creative intervention reintroduces the unresolved question over the boundary between individual and collective agency. At one level, Bourriaud pins the potency of art on an expanded notion of agency for both artists and participants: both expected to reroute the dominant codes, to treat each commodity or convention as an "open work," and to avoid the pitfalls of conformity. He makes a clear case about the distinction between relational aesthetics and earlier artistic practices, such as the Situationists and Conceptual art, on the grounds that the aim is neither to denounce from the outside nor to expose the metonymic links that bind the institutions of art to the repressive functions of capital. However, his argument about the ethical stance that emerges from the subversive power of "imitation" and its attendant process of critical reutilization is controversial, not just because he thinks it is more effective than what he calls the "discourse of frontal opposition that only make formal gestures of subversion," but for its emphasis on the belief that the ultimate power of change lies in the individual, in the micro-act of selection, comparison, and negotiation.[49]

Bourriaud's observation of the prevailing commodification of public interaction and his appreciation of the countervailing cosmopolitan dispositions in relational aesthetics can be positioned alongside some debates in political theory. Giorgio Agamben has also argued that the neoliberal colonization of everyday life has been most evident in the differential categorization of the value of human life.[50] How human life is valued and what sort of human responses will be permitted to shape the laws and practices that govern in life-or-death matters are never fixed and impermeable. Agamben presents a compelling argument in which he concludes that the power to decide in contemporary society is increasingly dominated by the sovereign. However, the concentration of powers in the sovereign is also increasingly crosscut by the dispersive effects of the new communication technologies. Relational aesthetics operates at the hinge of this tension. On one level, it extends the shift of power from the sovereign status of the artist and the artwork to the uncertain and "open" site of the decision made by each participant. However, for this aesthetic to actualize relations, it must go beyond a response and engage each participant as a fellow sovereign with equal authority to decide. For, as Derrida noted, a decision is not just the application of a body of preexisting knowledge that determines judgment over the relationship between causes and effects, but rather it is an entreaty with an outcome that may be other than what is already familiar or expected.[51] It therefore opens itself to

a process in which the artist is not in control of the social effects of his or her practice. In one sense there is nothing new in the claim that the meaning of an artwork only exists in the response of the beholder. However, response presumes a preexisting body. Relational aesthetics would have greater claim to breaking with avant-garde utopianism if the context of the artwork begins in the decisions made by others, rather than the propositions initiated by the artist. Bourriaud does not allow his theory to head in this direction. On the contrary, he concludes by reaffirming the status of the "beholders of art," who he reinvests with the authority to "judge artworks in terms of the relations they produce in the specific context they inhabit."[52]

Bourriaud's books provide some astute insights into shifts in artistic practice, and his use of Deleuzian concepts expands the framework for representing modes of cultural exchange, but the theoretical explanation of the cosmopolitan and political dimensions remains incomplete. This is not to say that the artistic practices themselves should be dismissed as mere mimics of emergent forms of flexible capital, or that they should be celebrated as the aesthetic triumph over alienation, but it does mark the point at which we must turn to another source in order to extend the understanding of the political and methodological implications of contemporary art. Gerald Raunig, in a bold rethinking of the relationship between revolution and art, takes the debate into a wider terrain as he rejects the prevailing orthodoxy in art theory that celebrated what he calls the "integrative conjunction of masses and art."[53] He suggests that the revolutionary aim of achieving a fusion of art and life, or even the diffusion of art into life, does not help bring the revolution closer to hand and it does not enliven the experience of art. Raunig claims that the revolutionary role of art is neither to capture the essence of the ordinary nor to merge with the complex web of everyday life.

He distinguishes the revolutionary function of art from the conventional assumptions that it must either be of service to a political agenda or be deferred until after successful takeover of state power, offering an alternative view that proceeds from the assumption that art always retains its emergent and distinctive self-presence as it moves through social spaces and interacts with other elements. Raunig presents a view of the relationship between art and politics as if they were incommensurable but inseparable partners—with the two elements constantly abutting and separately struggling to reshape their shared context. The identity of art remains unique not because it has a pure origin or fixed boundary, but because it retains the capacity to shape a distinct passage through space. Like Bourriaud,

he adopts Deleuze's conception of subjectivity and social transformation in order to demonstrate that while art and politics occupy discrete fields they are also in a constant state of interaction that is described as a sequence of "concatenations." This process of interaction between the aesthetic and the political does not result in a state in which one is subordinate to the other, or even a synthesis of the two, but in the formation of a complex structure that resembles what Marcus and Saka called an assemblage.

Raunig's present- rather than future-oriented vision of art and politics is also shaped by his conviction that the experience of participating with art collectives will frame the outlook on its aesthetic and political realities. His perspective bears closer alignment to the strategic utilization of social meanings and embodiment of existing realities expressed by collectives such as Stalker. Like my justification of the function of the "notes from my diary," with which I narrated my own presence in the assemblage at Makronisos, Raunig also insists that it is not possible to appreciate what happened without "being there." He claims that he only writes about collaborative art events in which he was an active participant.[54] This methodological principle is not elaborated upon in any detail. However, Raunig does suggest that the canonical art historical methodologies, which focus on "auratic" objects or on belated documentary traces, are likely to dismiss collaborative art projects as mere "activism" and thereby fail to register them as a worthy subject of study. Roland Barthes once claimed that the pleasure of the text is always short, you see it, you get it, and then you exclaim "is that all!"[55] This request for more is not to be confused with the complaint that there is not enough. It is suggestive of the need to make the ongoing effort to connect. As another small step in the ethnographic turn of art criticism, I conclude with a diaristic passage on the awkward and sometimes mute gestures that bring us closer to the task that Jimmie Durham described as "humanity . . . trying to talk to itself."[56]

Around the island we observe a variety of movements. Lorenzo and Matteo have gathered a small group and they find a spot behind the old theater to place a concrete plaque that had been inscribed by a former prisoner. Among the broken columns of the ruined church refugees and artists are being positioned for a performance. An artist suggests that some of the refugees join her in healing chant, but within a few minutes the levity of the gesture collapses as the refugees are

unable to suspend a sudden outburst of giggling. From above, the grid of the camp's foundations is barely visible. The one remaining wall is, for this day, converted into a table. All along the twenty meter wall a sheet of paper has been laid down, like a long tablecloth. The space is divided: bread, cheese, olives, tomatoes, cucumbers, water, and wine . . . bread, cheese, olives, tomatoes, cucumbers, water, and wine . . . bread, cheese, olives, tomatoes, cucumbers, water, and wine. . . . The men from Lavrio squat on their haunches. I stand on the lower side of the wall. We are facing each other at eye level. Quietly and jokingly, squinting in the sunlight and hungry from the sea, we eat together.

1. Jimmie Durham, "Stones Rejected by the Builder," in *Jimmie Durham*, ed. Anna Daneri, Giacinto Di Pietrantonio, and Roberto Pinto (Milan: CHARTA, 2004), 119.

2. Giorgio Agamben, *The Coming Community* (Minneapolis: University of Minnesota Press, 1993), 85.

3. Since the 1990s there has been a proliferation of art practices that aim to initiate social relationships in public spaces that challenge the object-based norms of the institutions of art and explore cultural modes of exchange that resist capitalist codes. Variously referred to as new genre art, littoral art, engaged art, community based art, dialogical art, social aesthetics, and relational aesthetics, this plurality of terms is indicative of both its mercurial characteristics and the diversity of sites in which it has simultaneously emerged. On the anxiety of giving a name to this practice that avoids doing violence to the creative flux, see Grant H. Kester, *Conversation Pieces* (Berkeley: University of California Press, 2004), 188.

4. See Janet Wolff, *The Social Production of Art* (London: Macmillan, 1981); Howard Becker, *Art Worlds* (Berkeley: University of California Press, 1982).

5. Anthony Giddens, *New Rules of Sociological Method* (London: Hutchinson, 1976).

6. Mark Nash, "Reality in the Age of Aesthetics," *Frieze* 114 (April 2008): 119–24.

7. Daniel Buren, "Function of the Studio," in *Museums by Artists*, ed. A. A. Bronson and Peggy Gale (Toronto: Art Metropole, 1983), 61.

8. Robert Smithson, "Cultural Confinement," in *The Writings of Robert Smithson*, ed. Nancy Holt (New York: New York University Press, 1979), 132.

9. Rasheed Araeen, "Re-thinking History and Some Other Things," *Third Text*, no. 54 (Spring 2001): 98.

10. Buren, "Function of the Studio," 67.

11. Smithson, "Cultural Confinement," 132.

12. Both Michael Zimmerman and Charles W. Haxthausen have argued that the structural limitations of national culture narratives and the contradictions within the universalist cultural discourse continue to constrict and distort contemporary discussions on the context of art. See Michael Zimmermann, ed., *The Art Historian* (Williamstown, MA: Sterling and Francine Clark Art Institute, 2003), vii–viii, 192. For a critique of Araeen's rejection of the postcolonial discourse, see Nikos Papastergiadis, "Cultural Identity and its Boredom, Transculturalism and its Ecstasy," in *Complex Entanglements: Art Globalization and Cultural Difference*, ed. Nikos Papastergiadis (London: Rivers Oram Press, 2003), 156–77.

13. Ticio Escobar, *El Arte Fuera de Sí* (Asunción: Fondec, 2004), 21–94.

14. George E. Marcus and Erkan Saka, "Assemblage," *Theory, Culture, and Society* 23, no. 2–3 (2006): 102.

15. Nash, "Reality in the Age of Aesthetics," 119–24.

16. Oscar Handlin, *The Uprooted: The Epic Story of the Great Migrations that Made the American People* (Boston: Little Brown, 1951). For a more recent survey of migration policies as mechanisms for ensuring national stability and regulation, see Andrew Geddes, *Immigration and European Integration: Towards Fortress Europe?* (Manchester, UK: Manchester University Press, 2000).

17. This is Jean Martin's summation of the governmental response to the presence of migrants. She also noted that during the 1960s, the perception of the migrant presence oscillated between being a burden and a threat, and the position on this issue shifted along a "complex disposition of invaders and invaded, regulars and reserves, official battle units and illegal guerillas." Jean Martin, *The Migrant Presence* (Sydney: Allen and Unwin, 1978), 209.

18. Raymond Williams, *The Country and the City* (London: Chatto and Windus, 1973).

19. Eugen Weber, *Peasants into Frenchmen: The Modernization of Rural France, 1870–1914* (Palo Alto, CA: Stanford University Press, 1976).

20. Nestor Garcia Canclini, *Hybrid Cultures: Strategies for Entering and Leaving Modernity* (Minneapolis: University of Minnesota Press, 1995); Thomas Faist, "Transnationalism in International Migration: Implications for the Study of Citizenship and Culture," *Ethnic and Racial Studies* 23 (2000): 189–222; Aihwa Ong, *Flexible Citizenship: The Cultural Logic of Transnationality* (Durham, NC: Duke University Press, 1999); Harald Kleinschmidt, *People on the Move* (Westport, CT: Praeger, 2003); Nikos Papastergiadis, *Dialogues in the Diaspora: Essays and Conversations on Cultural Identity* (London: Rivers Oram Press, 1998).

21. See Harald Kleinschmidt, "Migration, Regional Integration and Human Security: An Overview of Research Developments," in *Migration, Regional Integration and Human Security*, ed. Harald Kleinschmidt (Aldershot, UK: Ashgate, 2006), 61–102.

22. John Urry, *Global Complexity* (Cambridge, UK: Polity Press, 2003).

23. Michael Hardt and Antonio Negri, *Empire* (Cambridge, MA: Harvard University Press, 2000).

24. Kleinschmidt, "Migration, Regional Integration and Human Security," 65.

25. Kobena Mercer, "Introduction," in *Cosmopolitan Modernisms*, ed. Kobena Mercer (London: Institute of International Visual Arts; Cambridge, MA: MIT Press, 2005), 7.

26. Russell Ferguson, ed., *Out There: Marginalization and Contemporary Culture* (New York: New Museum of Contemporary Art; Cambridge, MA: MIT Press, 1990), 11.

27. Jean Fisher and Gerardo Mosquera, eds., *Over Here: International Perspectives on Art and Culture* (New York: New Museum of Contemporary Art; Cambridge, MA: MIT Press, 2004), 2.

28. Ibid.

29. Okwui Enwezor makes a similar observation in his "The Politics of Spectacle," in *Annual Report: A Year in Exhibitions*, ed. Okwui Enwezor (Gwangju: Gwangju Biennale Foundation, 2008), 128: "In the past, artists from the center or mainstream were eager to enter what was considered to be the center or mainstream. . . . However, as the idea of centers and mainstreams has become part of the anachronism of the cultural politics of the past, artists have oriented themselves not toward center and mainstreams, but toward a more transversal process of linkages, networks, and diverse communities of practice."

30. Mica Nava, *Visceral Cosmopolitanism: Gender, Culture, and the Normalisation of Difference* (Oxford, UK: Berg, 2007), 14.

31. Nikos Papastergiadis, "Glimpses of Cosmopolitanism in the Hospitality of Art," *European Journal of Social Theory* 10, no. 1 (2007).

32. Nava, *Visceral Cosmopolitanism*, 8.

33. Charles Esche, *Modest Proposals* (Istanbul: Baglam, 2005).

34. Pierre Huyghe (Artist's talk, Sydney Biennale, Museum of Contemporary Art, Sydney, 10 July 2008).

35. Stephen Johnstone, ed., *The Everyday* (London: The Whitechapel; Cambridge, MA: MIT Press, 2008).

36. Victor Burgin, *The End of Art Theory* (London: MacMillan, 1986), 204.

37. Arthur C. Danto, *Beyond the Brillo Box: The Visual Arts in Post Historical Perspectives* (New York: Farrar, Strauss, and Giroux, 1992), 12.

38. Retort (Iain Boal, T. J. Clark, Joseph Matthews, Michael Watts), *Afflicted Powers: Capital and Spectacle In a New Age of War* (London: Verso, 2006), 12.

39. Nicolas Bourriaud, *Relational Aesthetics*, trans. Simon Pleasance and Fronza Woods (Dijon: Les Presse du Reel, 2002), 8.

40. Ibid., 16, 42.

41. Ibid., 9.

42. Nicolas Bourriaud, *Postproduction: Culture as Screenplay: How Art Reprograms the World*, trans. Jeanine Herman (New York: Lukas and Sternberg, 2005), 69.

43. One can cite movements such as Fluxus, Situationist International, and feminist artists such as Martha Rosler, Adrian Piper, and Yoko Ono, as well as Joseph Beuys and Gordon Matta-Clark.

44. Bourriaud, *Relational Aesthetics*, 22.

45. In the journal *October* 110 (Fall 2004), Claire Bishop attacked the aesthetic merits of relational aesthetics (51–79), while in the same issue, Hal Foster (3–22) extended his political critique of its fetishization of the encounter and emptying out of sustainable communal relations that was raised in his review "Arty Party," *London Review of Books*, 2 December 2003. In the journal *Third Text* 21, no. 4 (2007), Stewart Martin described it as the "aestheticization of novel forms of capitalist exploitation" (371), while in the same issue, Rustom Bharucha went so far as to describe it as a "pseudo-democratic" neoliberal appropriation of the creative industries' rhetoric of vitality and autonomous performance (398).

46. Bourriaud, *Postproduction*, 18.

47. Ibid., 47.

48. Ibid., 48.

49. Ibid., 74.

50. Giorgio Agamben, *Homo Sacer: Sovereign Power and Bare Life*, trans. Daniel Heller-Roazen (Palo Alto, CA: Stanford University Press, 1998).

51. Jacques Derrida, *Negotiations* (Palo Alto, CA: Stanford University Press, 2002), 231–32.

52. Bourriaud, *Postproduction*, 94.

53. Gerald Raunig, *Art and Revolution: Transversal Activism in the Long Twentieth Century*, trans. Aileen Derieg (Los Angeles: Semiotext(e), 2007), 17.

54. This is a point also stressed by Brian Holmes in his overview of artist-activist collectives: "I preferred to stick as closely as possible to personal experience. What matters at the end of the last century and the beginning of this one, is the slow emergence of an experiential territory, where artistic practices that have gained autonomy from the gallery-magazine-museum system and from the advertising industry can be directly connected to attempts at social transformation." Brian Holmes, "Do-it-yourself Geopolitics," in *Collectivism after Modernism*, ed. Blake Stimson and Gregory Sholette (Minneapolis: University of Minnesota Press, 2007), 290.

55. Roland Barthes, *The Pleasure of the Text*, trans. Richard Miller (New York: Hill and Wang, 1975), 18.

56. Jimmie Durham, "Stones Rejected by the Builder," 119.

Zarina Hashmi and the Arts of Dispossession

Aamir R. Mufti

The modern state, as Hannah Arendt once noted, is a hyphenated entity. It is an articulation of impulses that are at the very least in tension with each other, if not outright opposing in tendency. On the one hand, the nation-state points to the realm of the state, of law, constitutionality, and citizenship. On the other, it asserts the claims of community and nation, of the people, produced as a set of normative practices, social imaginaries, and narratives of collective existence. Arendt was of course elaborating this idea in the context of her analysis of the Nazi state as a totalitarian state. The Third Reich, which handed over the realm of law entirely to the purported rights of the German people, was thus for Arendt the limit case that shone a sort of light on the constitutive instabilities of the nation-state itself as the normative state form of the modern era. As I have argued at length elsewhere, taking Arendt's formulation as a starting point, the nation-form, far from being a great settling of the relationship of people to place and to culture, must therefore be understood as a fundamental disruption and rearrangement of settled social relations.[1] Contrary, therefore, to the procedures of some of the most influential approaches to the study of nationalism—such as the works of Benedict Anderson and Partha Chatterjee—nationalization could be fruitfully examined from the perspective of the question of all that it renders non-national, those entire assemblages of practices and social imaginaries that it subjects to the possibility of uprooting and dispossession.

This essay represents a continuation of my ongoing exploration of the possibilities for thinking about dispossession and aesthetic form. I shall proceed here principally through an engagement with the work of the Indian-born artist Zarina Hashmi. Zarina (she often uses only her first name in her professional life) is a rather singular figure within the contemporary international reception of artists from India and South Asia. Her career appears to be at an angle to those of other contemporary artists receiving international attention in recent years. Belonging to an older generation than the crop of artists from the region that has blazed a brilliant streak of celebrity across the international art firmament and found their way into galleries, museums, and auction houses in New York, London, and throughout Europe, Zarina has displayed a distinct and quieter sensibil-

ity. Her work displays a critical historical imagination that distinguishes it from much of the new global art. In particular, she takes language—the Urdu language, to be precise—as a site for the exploration of society as sedimentation of the historical process. As I hope to show, she interweaves this historical imagination with personal memory and autobiography, thus exploring the shifting locations of artwork and practitioner within and between different and divergent ways of configuring our relation to the past.

What does it mean exactly to speak of an art of dispossession? If art and literature throughout the modern era have been inextricably tied to histories of national development, what does it mean to speak of certain works as being defined precisely by the lack of such frames of reference? If we take it seriously, there appears to be something paradoxical about this term, since as a psychic experience dispossession, understood as loss of an ancestral homeland, seems to consist precisely of a profound loss of frameworks of orientation. Can we assign stable attributes to experiences that imply the falling away of any permanent ground of signification and representation? Exile, alienation, and deracination have been pervasive themes in modern culture since at least the nineteenth century. Georg Lukács spoke of the modern condition itself as one of "transcendental homelessness," given form in such literary genres as the novel.[2] The presence of these themes in modern art and literature is not surprising for other, more mundane reasons as well, given the typically exilic, transnational, or cosmopolitan nature of movements and communities of artists and writers in the modern era, although we can never underestimate the ability of supremely national art institutions— from museums and academies of letters to official forms of art history and literary history—to reclaim such works for the national patrimony. But is it possible to speak of an art of dispossession in a more profound sense, an aesthetic practice concerned with the foundational unlivability of modes of modern life, with the dialectic of rooting and uprooting whose most emblematic and ubiquitous figure in our own times is the stateless refugee?

Zarina has lived and worked in New York for over three decades, and she was one of the few South Asian artists to be included in the major feminist exhibition *WACK! Art and the Feminist Revolution* in 2007, as well as the Guggenheim Museum's *The Third Mind: American Artists Contemplate Asia, 1860–1989* in 2010. While she has worked in a variety of different media and forms, at the core of her practice is printmaking, especially woodcut, but also etching.[3] Most of her works are line prints on handmade paper, often including calligraphic text in Urdu, one

of the two forms of the split northern Indian vernacular, of which Hindi is the other form. The prints often flirt with the indeterminate zone between representation and abstraction, and contain citations that range from architectural plans to maps and even the Indo-Buddhist mandala. Her work is often categorized as diasporic, feminist, Islamic, Indian, or Asian American—but although each of these rubrics captures an important element of her practice, none of them encompasses the full range of its complex significations. In fact, her work repeatedly escapes any such attempt to ground its social, regional, or civilizational identity and does not allow a settled filiation to any singular tradition. Her practice raises much broader issues concerning homelessness and dispossession in the modern world, issues that have major implications for contemporary art and critical thought today, inviting a new and compelling understanding of the history of uprooting in our times. While she evokes the violent partition of India in 1947—which was achieved through a massive rearrangement of populations, identities, and cultural and social imaginaries—in a series of remarkable elaborations of this distinctly modern "event" charged with the question of homeland and homelessness, the partition itself and its aftermath are placed in her work within larger and shifting constellations of planetary scope, the crisis of social fragmentation in modern India being shaken loose from its identitarian moorings.

While my focus in this essay will be on these preoccupations in Zarina's work, I begin by a brief detour through the work of Mona Hatoum, the London- and now Berlin-based artist of Palestinian origin. While the two share an interest in normalized forms of political violence, as well as a focus on exile and displacement, Zarina's work displays a formal sensibility dramatically different from that of Hatoum. Her woodcuts—made with roughly chiseled woodblocks, handmade paper, and rough, almost crude-looking lines—draw attention to the crafts elements of the work and to pre-capitalist forms of labor and modes of life as a whole, rather than the post-industrial and post-apocalyptic landscapes transplanted into intimate spaces that are the hallmark of some of Hatoum's most powerful installation work.

In Hatoum's iconic installation *Homebound* (fig. 1), for instance, a room is littered with domestic objects such as a table, chairs, bare metal bed frames, various kitchen implements like colanders and a meat grinder, a sewing machine, a table lamp, and more, all of which seem to be connected by the electrical wire snaking between, around, and over every horizontal surface and hanging over the sides of table and chairs. That at least some of the wires are live is indicated

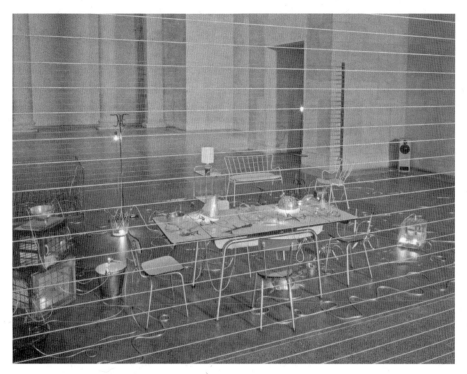

Fig. 1. Mona Hatoum (Palestinian, lives London and Berlin, b. Lebanon, 1952), *Homebound*, 2000. Kitchen utensils, electric wire, lightbulbs, computerized dimmer switch, amplifier, speakers, dimensions variable. Courtesy White Cube

by a number of flickering lightbulbs on the table and floor. Finally, the "room" is walled off from the viewer by a parallel series of exposed high-tension wires stretched across the entryway. The many objects and the details of their arrangement draw the viewer closer for a better view, while the wires—are they live with electrical current or not?—perform the reverse function by inducing vague physical anxiety. What kind of room is this? Is it currently inhabited or has it been hastily abandoned, and if the latter, by whom, and for what reason? The title of the work suggests an abiding habitation, but who could be at home in this space where objects seem denuded of their conventional symbolic accretions and every inch of motion would require an assessment of peril?

Hatoum was born and raised in Beirut in a Palestinian Christian family of 1948 refugees. Displaced by the outbreak of the Lebanese civil war in 1975, she went to London where she trained at the Byam Shaw and Slade schools of art and began exhibiting in the early 1980s. Her work has ranged widely across media and forms, from video and performance to sculpture, collage, found-object assemblage,

and conceptual objects and installations. As noted by Edward Said in his short but remarkable essay reprinted in this volume, perhaps the most persistent strategy of Hatoum's work throughout her career is disorientation—the subtle displacement of everyday objects and contexts into *unheimlich* and even threatening scenarios. The piece *Untitled* (*Wheelchair*, 1998; see page 13 in this volume) is still recognizable as the everyday object it evokes, but it is made strangely unfamiliar and uncomfortable by its hard metal seat, and the handles, which would normally invite us to engage our caring instincts and direct them toward the occupant of the chair, have been transformed into a pair of sharp knife-edges. The simultaneous feelings of anxiety and recoiling that this work seeks to produce in the viewer are a characteristic Hatoum gesture. In other works, ordinary objects are transformed through changes of scale. In *Paravent* (2008), a three-panel kitchen grater is blown up to resemble a screen or room divider, but our recollection of the sharp edges and jagged protrusions on a standard kitchen grater makes this a less-than-appealing piece of furniture. In *Mouli-Julienne* (2003), Hatoum achieves a different effect altogether. An old fashioned, hand-cranked food slicer and shredder, while utterly recognizable as an ordinary and familiar object, hovers over the viewer like a strange, menacing creature from some other world.

In Said's words, an "abiding locale is no longer possible in the world of Mona Hatoum's art which, like the strangely awry rooms she introduces us into, articulates so fundamental a dislocation as to assault not only one's memory of what once was, but how logical and possible, how close and yet so distant from the original abode, this new elaboration of familiar space and objects really is."[4] The title of the Hatoum show at the Tate Britain for which Said wrote the essay, *The Entire World as a Foreign Land*, is taken from Said's work, or, rather, from a quotation from Hugh of Saint Victor, the early twelfth-century theologian, philosopher, and mystic associated with the Abbey of Saint Victor in Paris, that appears in several places in Said's writings: "The person who finds his homeland sweet is still a tender beginner; he to whom every soil is as his native one is already strong; but he is perfect to whom the entire world is as a foreign place."[5] Said himself had encountered the passage in Erich Auerbach's famous essay "Philology of *Weltliteratur*," which Said had translated into English in the late 1960s.[6] It becomes in his writing a means to produce an account of critical practice and intellectual life more broadly as an unsettled and unsettling activity, refusing identitarian structures as its permanent abode. Hatoum's art, Said writes, embodies a "belligerent intelligence." It evokes a landscape that is "hard to bear . . . like the refugee's world,

which is full of grotesque structures that bespeak excess as well as paucity."[7]

Zarina's work too may be said to evoke devastated social landscapes, but these landscapes are dotted, we might say, with the ruins of historical monuments, unlike Hatoum's post-apocalyptic wastelands that are littered with the strangely deformed objects of everyday life. Although Hatoum's art also puts into play the work of memory, the recollection of the way things were, it is in her case the memory, housed in the individual body, of the experience of conventionalized and normative objects and spaces, as opposed to the historical memory that is jogged in Zarina's works. They recall for us the recurring instances of political violence across the planet in recent decades, from India's partition in the middle of the twentieth century to massacres in such places as Srebrenica and Jenin in more recent years. Her work provides a catalogue of ruined cities, frayed societies, fragmenting states. Her sensibility is an unapologetically exilic one, a quiet but persistent claiming of a homeland that has nevertheless been put profoundly in question. She provides a critical perspective on nation-states as the universal political form of our times, the social crises and conflicts they seem to repeatedly generate, and their marginalization and victimization of those social groups that are deemed to be non-national peoples.

Arendt argued over six decades ago that the emergence of stateless populations as a mass phenomenon in the twentieth century was a highly symptomatic political event, the stateless demonstrating in their very material existence the alienability of those "human" rights that had been the charter of (Western) modernity since the eighteenth century. Arendt's analysis was perspicacious about the outlines of the new world, the global system of nation-states, that was only beginning to emerge from the ashes of the European genocide and the coming collapse of the colonial empires, and highlighted the paradox at the heart of this emergence:

> After the war it turned out that the Jewish question, which was considered the only insoluble one, was indeed solved—namely, by means of a colonized and then conquered territory—but this solved neither the problem of the minorities nor of the stateless. On the contrary, like virtually all other events of our century, the solution of the Jewish question merely produced a new category of refugees, the Arabs, thereby increasing the number of the stateless and rightless by another 700,000 to 800,000 people. And what happened in Palestine

within the smallest of territory and in terms of hundreds of thousands was then repeated in India on a large scale involving many millions of people. Since the Peace Treaties of 1919 and 1920 the refugees and the stateless have attached themselves like a curse to all the newly established states on earth which were created in the image of the nation-state. . . . For these new states this curse bears the germs of a deadly sickness.[8]

Arendt thus placed the destruction of Palestinian society, and the installation of the logic of majoritarianism in Palestine, within a larger, global frame, identifying a structural link between this event and the resulting dissolution of society in the subcontinent that is known as the partition of India. Arendt's analysis of statelessness leads us to confront the paradox that dispossession is a feature of the putting into practice of what we may term possessive or proprietary theories of culture and language—precisely those ideological forms that coalesce in the nation-state and that have acquired worldwide dissemination as the nation-state has become the normative political form of the modern era. It is these slippages between home and homeland—slippages that are canonical to politics and culture in the modern era—that I am concerned with here.

I have argued at length in *Enlightenment in the Colony* that the so-called Jewish question of post-Enlightenment society in the metropolis must be understood as an early and in fact *exemplary* emergence of this familiar, ubiquitous, and "symptomatic" crisis of modern society, which I have called the crisis of minority, and that the "Muslim" question in late colonial India is an instance of its colonial reemergence and transformation. The two artists whose work I am examining here allow an extension of this set of concerns into the contemporary, postcolonial moment. Each had her formation in a social group affected by the ultimate manner of "resolution" of these historical "questions." The partition of India and the disappearance of Palestine, which took place within a few months of each other late in the fifth decade of the twentieth century, are contemporaneous events in more than a merely chronological sense. Together they can be seen as marking the inability of the modern system of nation-states to establish the nation as the universal form of political community except through massive upheavals and uprooting: the partitioning of a country and an entire social fabric, accompanied by communal violence of holocaust proportions in the former instance (that is, in India); and organized genocide and displacement of survivors to a foreign land, with the con-

Fig. 2. Zarina Hashmi (Indian, lives New York, b. 1937), *Father's House 1898–1994*, 1994. Etching printed in black on Arches cover buff paper, Chine collé on handmade Nepalese paper, sheet: 30 × 22 in. (76.2 × 55.9 cm); image: 22 ¹/₂ × 15 ¹/₂ in. (57.2 × 39.4 cm). Courtesy of the artist and Luhring Augustine, New York

sequent uprooting of its own native population, in the latter (that is, in Europe and Palestine). We might say that these enormous and unprecedented upheavals of the mid-twentieth century are never too far from either artist's concerns.

Dwellings have been a major theme in Zarina's work over the last three decades. Even the word "home" itself appears repeatedly in both the titles of individual pieces and in exhibitions of her work, as in *Homes* (1981), a piece of molded paper that depicts a haunting series of identical houselike cavities on what appear to be stilts (or are they legs?), and *Roofs* (1982), also in molded paper, a grid of pyramidal forms that evoke the roofs of a cluttered old city shimmering in the blazing sun. In recent years, she has explored this concern with dwellings in woodcut prints, including various experiments in imaging houses she herself, or members of her family, have inhabited at various points in their lives. This is the case with *Father's House 1898–1994* (fig. 2), which takes the form of an informal plan of a house, in which each of the rooms, spaces, and even plants and trees around the perimeter are identified in Urdu: "Mother's room," "Father's room," "the long room," "bougainvillea vine," "kitchen," "storage room," "boundary wall," "lime tree," "henna bush," "guava tree," etc. In a large number of prints, such architectural plans are reduced to nearly abstract geometric forms (see fig. 3, *My House 1937–1958*)—nearly, because the representational element of the architectural drawing continues to be operative, however attenuated it may have become through the formal reduction that is also a reduction of function.

Fig. 3. Zarina Hashmi, *My House 1937–1958*, 1994. Etching printed in black on Arches cover buff paper, Chine collé on handmade Nepalese paper, sheet: 30 x 22 in. (76.2 x 55.9 cm); image: 22 ¹/₂ x 15 ¹/₂ in. (57.2 x 39.4 cm). Courtesy of the artist and Luhring Augustine, New York

It may be that this is a visual equivalent of reductio ad absurdum, the syllogistic process by which a familiar, seemingly logical proposition is shown to be its opposite, self-contradictory, or an absurdity. More certainly, however, we might say that this tension between abstraction and representation seems to function as a means to highlight the unfamiliar always lurking in the midst of the familiar, the uncanny or *unheimlich* in the midst of the *heimlich*. And this movement toward abstraction leads this exploration of literal places for dwelling and not-dwelling toward abstract notions of home, dwelling, displacement, belonging, and not-belonging. Her work expands the meanings of house and home to an exploration of the nature of modes of collective and historical habitation and the meanings of homeland itself. As we have seen, these are homes stripped bare of the symbolic appurtenances of comfort and belonging, or homelands that are denuded of dominant ideologies of hearth and home, devoid of any trace of *Gemütlichkeit*.

So far as I am aware, all of Zarina's "architectural" prints are "plans"—there seem to be none that reference elevations, for instance.[9] What the plan as a form makes available is the footprint of the dwelling and its internal organization. It is a sort of map of a building. In a large body of recent work, she uses the map itself as a visual form in order to explore concerns that may be said to be geographical, territorial, and social at the same time. This is true of a portfolio of prints, *Countries* (2003). Another series of six prints, *Atlas of My World* (2001), consists of minimal line-image "maps" of countries and regions of the world that have in one way or another been significant in the artist's life. In one, the outlines of Western European countries are clearly delineated, their names written in Urdu. Another

Fig. 4. Zarina Hashmi, *Atlas of My World IV*, from the portfolio *Atlas of My World*, 2001. Woodcut with Urdu text, printed in black on handmade Indian paper, mounted on Arches cover white paper, sheet: 25 ¹/₂ × 19 ¹/₂ in. (64.8 × 49.5 cm); image: 16 ³/₄ × 13 ¹/₂ in. (42.6 × 34.3 cm). Courtesy of the artist and Luhring Augustine, New York

(fig. 4, *Atlas of My World IV*) draws our attention to the tortuous, conflicted history of India and Pakistan and to the border separating the two countries by the layering of an enlargement of the border line on top of a map of the post-Partition subcontinent, creating what almost appears to be a twisted umbilical cord both separating and connecting these two supposedly distinct nations. Its existence in the larger image seems a mystery. Is it above or below the image of the two countries? Is it tied down somehow or free-floating, both physically and in its significations? It appears to have no definite beginning or end, or at the very least seems to continue beyond the nation-state frame that tries to contain it.

Another print from 2001 evokes this second print, though it is not formally a part of the same portfolio. Called *Dividing Line* (fig. 5), it consists simply of this winding and twisted line, without any explicit reference to the distinct national geographies it instantiates—a historically and socially dense geography brought to the brink of abstraction. The territorial line evoked here is of course known historically as the Radcliffe Award, named for Sir Cyril Radcliffe, the English barrister who was, we might say, its "draftsman." The story of this cartographic event has repeatedly been told, including by W. H. Auden, in a remarkable poem from 1964 titled, simply, "Partition." This "dividing line" was initially conjured up in an isolated and locked room in the (Armed) Services Club in the hill station of Simla, the Viceroy's summer capital, in the summer of 1947, away from the stifling heat of the plains. But its implementation on the social and territorial bodies of an entire subcontinent in the following weeks and months meant the uprooting of perhaps as many as fifteen million people and the death,

Fig. 5. Zarina Hashmi, *Dividing Line*, 2001. Woodcut printed in black on handmade Indian paper, mounted on Arches cover white paper, sheet: 25 ¹/₂ × 19 ¹/₂ in. (64.8 × 49.5 cm); image: 17 × 12 in. (43.2 × 30.5 cm). Courtesy of the artist and Luhring Augustine, New York

in the midst of a communal holocaust, of as many as three million.

Zarina's image is a gesture of staggering economy. This density of historical experience and of human suffering at all levels of society—ongoing human suffering over six decades after the fact, we might add—is condensed to a knotty and undulating line twisting its way across a blank surface. What exactly does the line divide? What manner of space, what kinds of habitation, lie on its either side? When and by whom can it be said to have been drawn? It is questions such as these concerning the identitarian logics that are foundational to the modern world, colonial as well as postcolonial, that are raised by this quiet yet powerful image.

In the series . . . *these cities blotted into the wilderness* (2003) we find another sort of highly stylized exercise in mapmaking, or more precisely, a series of spatial attempts to engage with the fate of a number of cities around the world that have been ravaged in recent decades by war, mass violence, and social dismemberment. Each image is quite distinct in its procedures, once again flirting in various ways with abstraction but drawing attentively from the particular historical situation of the city that is its subject. In *Baghdad* (fig. 6), the city appears as an arrangement of fluid black forms, like a collage of cutouts laid out adjacent to each other in an abstract pattern on a yellow ground. Is it the silhouette form—*hāshīa* in Urdu—that is being mimicked here, or the urban master plan, or perhaps the aerial photograph? This last possibility of course is the most ominous one, given the historical context of the Anglo-American invasion of 2003. Does the print represent the city coming into view, for instance, of an ap-

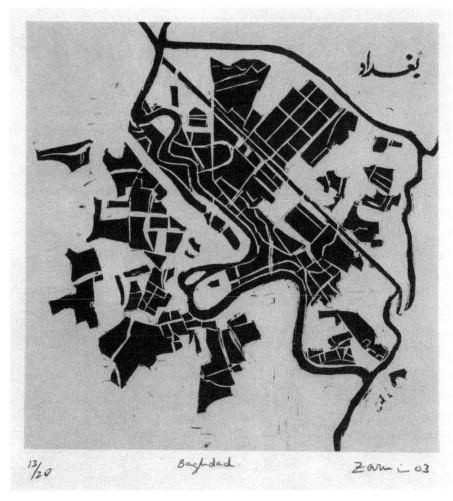

بغداد

13/20 Baghdad Zarin 03

Fig. 6. Zarina Hashmi, *Baghdad*, from the portfolio *. . . these cities blotted into the wilderness (Adrienne Rich after Ghalib)*, 2003. Woodblock printed in black on Okawara paper and mounted on Somerset paper, sheet: 16 × 14 in. (40.6 × 34.6 cm); image: 7 1/4 × 7 in. (18.4 × 17.8 cm). Courtesy of the artist and Luhring Augustine, New York

proaching Coalition bomber? If so, the image would evoke a suspended moment of calm before the inevitable devastation. As viewers, are we being made to share the viewpoint of the bomber? Judith Butler has shown that during the first Gulf War the ocular abilities of the then-novel "smart-bomb" technology, extended through live feeds into the television sets in our living rooms, helped reproduce and reinforce the phantasm of the all-powerful, "surgically" effective, imperial subject.[10] The spectacular callousness of the attacks of 9/11, as I have argued elsewhere, could be viewed as a mimicking of the monumentality of this impe-

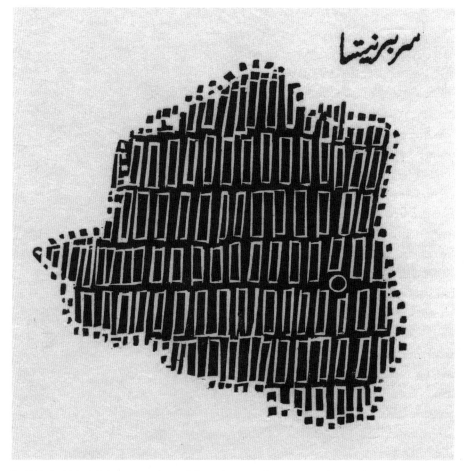

Fig. 7. Zarina Hashmi, *Srebrinica*, from the portfolio . . . *these cities blotted into the wilderness (Adrienne Rich after Ghalib)*, 2003. Woodblock printed in black on Okawara paper and mounted on Somerset paper, sheet: 16 × 14 in. (40.6 × 34.6 cm); image: 7 × 6 in. (17.8 × 15.2 cm). Courtesy of the artist and Luhring Augustine, New York

rial spectacle and an attempt to punch a hole through that phantasm.[11] Zarina's image can be seen as an invitation to consider this entangled set of possibilities in the production of imperial war-as-event as well as our own insertion into the event as (viewing) subject.

In another print in this series, *Srebrenica* (fig. 7), we encounter a very different set of visual strategies. The relationship to the map here seems even more tenuous. We encounter an organic black shape, edged by what looks like a dotted line. Inside this form row upon row of small rectangular shapes are packed in. Is this a stylization of a remarkably orderly urban grid or, given what we know

about Srebrenica's fate during the Yugoslavian wars, a huge hole in the ground full of coffins laid out in neat rows going on seemingly forever? The city had been declared a "safe zone" for refugees by the United Nations when, in July 1995, the so-called Srebrenica massacre of about eight thousand Bosnian Muslim men and boys occurred at the hands of Serbian and Bosnian Serb forces, while a contingent of four hundred Dutch United Nations troops was present in the city. Is the dotted perimeter a reference to the porousness and failure of this protective cordon? In *Jenin*, another print from the series, the perimeter, consisting of a series of thick and impermeable lines, seems the very opposite of that in *Srebrenica*. The enclosed space gives the impression of being under erasure, like a piece of fraying burlap or fabric with deep gashes. It is a depiction of a tightly enclosed city whose boundary becomes more and more defined and impermeable as its interior undergoes a process of dissolution. Is this a reference to the Israeli use of aerial bombing and bulldozers to level broad stretches of Jenin city and its overcrowded refugee camp during the so-called Battle of Jenin in April 2002 in order to create access for Israeli armor?

A final image from this series is titled *New York* (fig. 8). The least detailed image in this series and also the most recognizable, it is nevertheless perhaps the most elusive. Two narrow yellow lines bisect the image from top to bottom—the unmitigated darkness of the black ground broken by the thin parallel lines of light. The fate of downtown Manhattan on 9/11, which the artist experienced firsthand, is therefore included in this series of prints cataloging devastated cities, their populations subject to the ravages

Fig. 8. Zarina Hashmi, *New York,* from the portfolio . . . *these cities blotted into the wilderness (Adrienne Rich after Ghalib),* 2003. Woodblock printed in black on Okawara paper and mounted on Somerset paper, sheet: 16 × 14 in. (40.6 × 34.6 cm); image: 7 1/4 × 5 1/2 in. (18.4 × 14 cm). Courtesy of the artist and Luhring Augustine, New York

of mass violence motivated by imperialism, militarism, genocidal nationalism, religious fundamentalism, and terrorism.

While her prints retain a subtle and tenuous representational quality, often they verge on abstraction. In fact, the interplay between these two possibilities, and the tension between them, is a characteristic feature of the work. And while this interplay of abstraction and representation implies, on the one hand, the absence of any *explicit* narrative element, on the other it leads, in the words of an interviewer, to repeated "*invitation* to create interpretive narratives."[12] There is something of the quality of the verbal riddle to these visual exercises, but a riddle stood on its head. This is a riddle to which we already know the answer, which has been provided by the artist—for instance, in titles or in Urdu text in the images themselves—but which we must now laboriously work at in order to uncover the links that connect the visual clues to the already known secret they contain. In Zarina's work, mapmaking is employed in an aesthetic practice directed against the claims to totality embodied in the modern state, exposing and foregrounding the residue of the state: that which is necessarily left over as a result of its totalizing projects. How, then, are we to understand the range of these works, citing as they do such visual practices as architectural plans, maps, and aerial photographs? They are works about image-making, first of all, about image practices of various sorts. To be more precise, they are place-images, in a double sense, images of "places" of certain sorts but also images about the imaging of these places. In short, they are concerned with the symbolic fabrication of place, the production of the places of human life.

A final set of prints we may consider here is the 1991 series titled *Letters from Home*, which contains a strong autobiographical element. These images are based on handwritten letters from her sister in Pakistan, letters that were written at moments of personal grief, such as the deaths of their parents, but given to Zarina only later, during visits to her family.[13] Most of these prints have undergone a double printing process: a relief print from a metalcut of the letter is overprinted with a woodcut image or frame. *Letters from Home* explores the repeated experience of loss inherent in that impossible commonplace of Indian and Pakistani Muslim experience—families split between two rival and enemy nation-states. Zarina was born in India before Partition into a family of middle-class Muslims. Her family was of Punjabi origin but had settled in the town of Aligarh in the Hindi-Urdu heartland in the early decades of the century. (The town is itself of some significance in *Letters*, and I return to it below.) Segments of the Muslim middle

class and elites of this region have historically been linked to the demand for a separate Muslim homeland in the subcontinent. The partition of India, however, which had been imagined as a final settling of the place of these Muslim *ashrāf* (or "noble" elites), as they are called—and of the social and cultural practices associated with them, above all the Urdu language and literature—resulted instead in their homelessness on both sides of the border: as an increasingly marginalized minority in India and as migrants and refugees in Pakistan, where large numbers had resettled during the massive violence that accompanied Partition.

Zarina's own family history diverges from this larger narrative, because her family remained in India, only leaving for Pakistan a decade later, in the late 1950s. Thus her conception of herself as a displaced, overseas, or "diasporic" Indian is complicated by the fact that soon after her departure from India, her familial link to the country was broken altogether when her family was transformed into Pakistanis. Unlike much art that may be said to have a "diasporic" relation to India, therefore, the point of her work is not displacement to the United States or the West more broadly. Instead, this more familiar "diasporic" dimension becomes simply the occasion or means for a perception and understanding of that other, more foundational experience of dispossession. It is this strange disappearance of the homeland, an acutely experienced dispossession at the individual level, that links up repeatedly in her practice with dispossession as an uncanny and constantly repeated experience in the modern world.

Fig. 9. Zarina Hashmi, *Letter II*, from the portfolio *Letters From Home*, 1991. Woodblock and metalcut print, metalcut made from original letters in Urdu, printed on handmade Kozo paper and mounted on Somerset paper, sheet: 22 × 15 in. (55.9 × 38.1 cm); image: 12 × 9 in. (30.5 × 22.9 cm). Courtesy of the artist and Luhring Augustine, New York

The two prints from *Letters from Home* I examine in some detail, nos. II and III (figs. 9 and 10), take as their basis the first and

Fig. 10. Zarina Hashmi, Zarina Hashmi, *Letter III*, from the portfolio *Letters From Home*, 1991. Woodblock and metalcut print, metalcut made from original letters in Urdu, printed on handmade Kozo paper and mounted on Somerset paper, sheet: 22 × 15 in. (55.9 × 38.1 cm); image: 12 × 9 in. (30.5 × 22.9 cm). Courtesy of the artist and Luhring Augustine, New York

second pages, respectively, of a letter from her sister in Pakistan informing the artist of the passing of their father. In the first, the print of the letter has been overlaid with a second image, a black-line frame with a profusion of squiggly lines suggestive of a map of some sort. Urdu text in the bottom right-hand corner of the frame identifies this as a map of the town of Aligarh; the artist has said that this image is based on a nineteenth-century map of the city.[14] This dense layering of both historical and autobiographical allusions requires some disentangling. Aligarh is, first of all, the city in which Zarina was born and raised and lived through her college years—and it would likely be a small and provincial town in a forgotten corner of northern India except for the presence of the Aligarh Muslim University. The name Aligarh, of the town and the university, is one of the most overdetermined signs in modern Indian history. The institution was founded in 1867 as the Anglo-Mohammedan Oriental College, with the explicitly stated goal of dragging the Muslim *ashrāf* of north India reluctantly into the modern world by giving their sons a modern, colonial education. In the wake of the British suppression of the Great Uprising of 1857, known to colonial historiography as the Sepoy Mutiny, the aim was to transform this now seemingly decadent and stagnant culture, obsessed with memories of its former status as the social elite of the long-defunct Mughal Empire, into a modern service elite for the British colonial government in India. Sir Syed Ahmed Khan, the founder of Aligarh the institution and of the larger social and cultural movement for reform that surrounds it, can be credited more than any other thinker and public figure

with a redefinition of Indian Muslim identity to the exclusion of Indian nationalism.[15] He is a complex and contradictory historical figure, admired and even revered for his progressive attempt to revive and modernize a seemingly dying culture yet reviled for introducing the religious factor into the emerging discourse of Indian national identity.[16] In the decades following its founder's death, the university outgrew the (colonial) loyalism to which he had tied it, becoming a seat of opposition to British rule, but also, at the same time, a site for the production of a separatist Indian Muslim identity and a center for the demand for Pakistan.

Which brings us to the next print in this series, and Zarina's personal link to this complex cultural, social, and political history: the artist grew up on the campus of Aligarh Muslim University, where her father, Sheikh Abdur Rashid, was a professor of history and the provost of one of its residential colleges, Sir Syed Hall, named for its founder. The woodcut print overlaid on this second page of the letter from home is in fact a depiction of the grounds and buildings of Sir Syed Hall, including the main quad of the campus and the rectangular structure that encloses it. The perimeter buildings are reproduced in the print as elevations, showing the double-arched length of the façade. On a deeply subjective level, the prints perform the work of mourning occasioned by the news of the loss of her father, but it is a belated performance, given the letter's own displaced epistolary function. (The letter was never sent.) They are an attempt to recall the world that the father had been led to abandon decades earlier. But the very semiotic force of "Aligarh" as a historically meaningful constellation brings in another, more collective register, which does not so much intrude on this performance of personal grief and mourning as fit alongside it in some sort of pattern, like those visual riddles where an image may be interpreted in two very different ways. The father's uprooting from the homeland echoes the slow dispossession of "the Muslim," both persons and problematics—including the entire cultural heritage produced in the Urdu language—from its historical moorings, in a series of what may be described as synaptic exchanges in these works between individual and collective circuits and registers. The letters from home are thus from a place that has never been the artist's home; in the prints the letter from Pakistan is overlain with traces of a place of more originary filiation.

This is part of the significance of the ubiquitous use of Urdu calligraphy in Zarina's printmaking. The Urdu text, inserted and interwoven into the images, produces a powerful sense of loss—linguistic, literary, and cultural. As I have argued at length elsewhere, the overall social condition of Urdu as a linguistic and

literary formation is one of homelessness, even in Pakistan, where, despite being long established as the official national language, it fails the test of indigenousness to which it is subjected from to time, since it can be said to be the "native" language of only a small minority of north Indian origin, whose social base is entirely middle-class and urban in nature.[17] And in India, of course, a self-described community of speakers and readers has long been in decline, with the language carrying the taint—and of course nostalgic aura—of an "aristocratic" and "feudal" Muslim past. Zarina's use of Urdu text highlights this condition of homelessness, the unsettled nature of its place in the world. As linguistic signs these calligraphic elements are at the same time seemingly transparent—naming certain elements in the images (as in *Father's House*) or the images as a whole (as in the portfolio . . . *these cities blotted into the wilderness*)—and highly cryptic and elusive, not simply for the non-Urdu reading viewer. In what art-historical framework should we place this exercise in the articulation of visual artwork with written language? Should it be considered alongside the Orientalist use of Asian writing systems, or is it an exercise, pure and simple, in the traditions of "Islamic" calligraphic art?

For art publics in the West, this use of Urdu text must of necessity recall the Orientalist tradition of rendering Middle-Eastern writing forms as arabesque, coding them as non-code and thus placing them forever beyond the possibility of decoding. Some of the post-Said debate about the claim to descriptive realism that attaches traditionally to the Orientalist canon has focused precisely on this rendering of writing as arabesque—conventions that are still very much in use in a degraded form in such popular visual media as the political cartoon.[18] In Zarina's prints, contrary to this Orientalist practice, the calligraphy enables a dense double text, simultaneously historical and autobiographical—coded as the relation to the father's life, which intersected in illuminating ways with the larger currents of a nation's history. The Urdu calligraphic elements of Zarina's prints thus function as a repudiation of the Orientalist conventions, where incommensurability is reduced to an absence of meaning. Zarina's prints invite exploration of the mutual translatability of heterogeneous cultural positions within the now globalized circuits of culture and power. More concretely, they draw our attention to the complex and twisted (but by no means unique) history of a culture, a historical intelligence and imagination produced in a specific language that is now permanently on the verge of disappearance in its historical homeland.

In conclusion, let us return briefly to Hatoum in order to pose once again the question about art and dispossession. Hatoum has long resisted being typecast

as a "Palestinian artist," rejecting a search for political messages linking her work to the Palestinian national struggle for collective rights. She speaks instead of formal concerns and an interest in defamiliarization. And with few exceptions, (dispossessed) Palestine seems to be missing from her works entirely. In what sense, then, may we speak of her work as a treatment of dispossession, and of the dispossession of Palestine specifically? Hatoum takes as her medium the psycho-physical disorientations that threaten to turn the commonplace objects of every-day life into phantasms. Objects typically appear in her work removed from their habitual social environments and inherited, conventional contexts. In *Marrow*, for instance (see page II in this volume) the viewer is led to wonder from what social environment this strange yet familiar object has been removed. What macabre transformation has it undergone in this process of extraction? What kind of physi-cal force might have reduced the object, which we would expect to be made of hard substances such as steel and wood, to a tangled mass that gives to the slightest touch? This menacing vulnerability draws our attention to the missing persons who may have lived their daily lives with and around these everyday objects. We might say that Hatoum's work is a phenomenology of objects as well as bodies under duress, even if the bodies are, strictly speaking, missing from the artworks. In this transformation, if (dispossessed) Palestine survives or exists at all, it is not as a *single* or particular place on the earth, but potentially *every* place.

The horizon of Zarina's work too may be said to be the entire planet. But, unlike Hatoum, Zarina appears to be drawn to the historical contours of language—to the question of textuality. She seems concerned with the slow ac-cretion of meaning in language and therefore with a history of a longer *durée*, viewing dispossession as deeply connected to, and performed in, language. In the midst of the frenzied and much celebrated arrival of India (and Indian art) into globalization, her work quietly invokes a lost India, as well as lost *possible* Indias and their relation, which remains subterranean and counterintuitive for the most part, to a catalogue of other places, moments, and constellations of dispossession in the world. Her work expresses a minoritarian and exilic relation to society and the world, staging a series of affiliations with similarly fraught social and political events and situations worldwide. It thus stages a critique of the structure of feeling that Said has referred to as the "quasi-religious authority of being at home among one's people."[19] We might say of Zarina and Hatoum that each produces a dis-tinct visual language for an unredeemed, secular, and *damaged* life, a life lived on the verge of disappearance but with a strange resolve and repudiation of oblivion.

This paper originated as my Clark Lecture at the Sterling and Francine Clark Art Institute in spring 2009. I am deeply grateful to colleagues at the Clark for providing me with that energizing research atmosphere and to Michael Ann Holly, Keith Moxey, and Marc Gottlieb for asking probing questions on that occasion. My thanks also to Andrea Gyorody for her capable and uncomplaining research assistance. Finally, I am humbled by Zarina Hashmi's generosity—many thanks to her for correcting my mistakes, and for a lovely afternoon and evening in her studio spent poring over her prints.

1. See Aamir R. Mufti, *Enlightenment in the Colony: The Jewish Question and the Crisis of Postcolonial Culture* (Princeton: Princeton University Press, 2007). For Arendt, see Hannah Arendt, *The Origins of Totalitarianism*, 3rd ed. (1951; repr., New York: Harcourt, Brace and Company, 1979).

2. See Georg Lukács, *The Theory of the Novel: A Historico-Philosophical Essay on the Forms of Great Epic Literature*, trans. Anna Bostock (1920; Cambridge, MA.: MIT Press, 1989); and Linda Nochlin, "Art and the Conditions of Exile: Men/Women, Emigration/Expatriation," *Poetics Today* 17, no. 13 (Autumn 1996): 317–37.

3. Zarina trained in the 1960s and 1970s at Stanley William Hayter's renowned Atelier-17 in Paris and with Toshi Yoshida in Tokyo.

4. Edward W. Said, "The Art of Displacement: Mona Hatoum's Logic of Irreconcilables," *Mona Hatoum: The Entire World as a Foreign Land* (London: Tate Gallery Publishing, 2000), 15. Republished in this volume, see pp. 10–16.

5. Edward W. Said, *Culture and Imperialism* (New York: Knopf, 1993), 335.

6. See Erich Auerbach, "Philology and *Weltliteratur*," trans. Maire Said and Edward W. Said, *Centennial Review* 13, no. 1 (Winter 1969 [1952]): 1–17.

7. Said, "The Art of Displacement," 17.

8. Arendt, *The Origins of Totalitarianism*, 290.

9. I shall return below to an important exception to this rule.

10. See Judith Butler, "Contingent Foundations," in *Feminist Contentions: A Philosophical Exchange*, ed. Seyla Benhabib et al. (New York: Routledge, 1995).

11. See Aamir R. Mufti, "Reading Jacques Rancière's 'Ten Theses on Politics': After September 11th," *Theory and Event* 6, no. 31 (2003).

12. Ranu Samantrai, "Cosmopolitan Cartographies: Art in a Divided World," *Meridians: Feminism, Race, Transnationalism* 4, no. 2 (2004): 168. Emphasis added.

13. See "Letters from Home," in *Zarina Hashmi: Counting 1977–2005*, exh. cat. (New York: Bose Pacia, 2005).

14. Ibid.

15. See David Lelyveld, *Aligarh's First Generation: Muslim Solidarity in British India* (Princeton, NJ: Princeton University Press, 1978).

16. Both attitudes toward him are expressed, for instance, by Jawaharlal Nehru in his canonical account of the rise of Indian national consciousness out of the long sweep of Indian history, The *Discovery of India* (Delhi: Oxford University Press, 1985), 343–48.

17. See Mufti, *Enlightenment in the Colony.*

18. See, for instance, the pioneering study by Linda Nochlin, "The Imaginary Orient," in *The Politics of Vision: Essays on Nineteenth-Century Art and Society* (Boulder, CO: Westview, 1991), 33–59.

19. See Edward W. Said, "Introduction: Secular Criticism," *The World, the Text and the Critic* (Cambridge, MA: Harvard University Press, 1983), 16.

Flash in the East, Flash in the West
동에 번쩍, 서에 번쩍

Miwon Kwon

Visible from the very busy Wilshire Boulevard and not too far from Koreatown in Los Angeles, Choi Jeong-Hwa's colorful ribbon wrapping of a museum building (*Welcome*, 2009; fig. 1) and Bahc Yiso's cheerful, if ambiguous banner declaring "우리는 행복해요" ["We Are Happy"], announced the arrival of *Your Bright Future: 12 Contemporary Artists from Korea* at the Los Angeles County Museum of Art (LACMA) in summer of 2009. These two outdoor artworks, in conjunction with the bright yellow advertisements displayed around town with the exhibition title written in Korean, 당신의 밝은 미래, called out to Korean Angelenos in particular to visit the museum, some perhaps for the first time. This unprecedented convergence of Koreans at LACMA in an event mediated by contemporary art, which according to one of the curators is a global language that transcends national boundaries, set up a complex and at times frustrating meeting of different

Fig. 1. Choi Jeong-Hwa (Korean, b. 1961), *Welcome*, 2009. Colored fabric, dimensions variable. Courtesy of the artist

Fig. 2. Do Ho Suh (Korean, b. 1962), *Fallen Star ¹/₁₅*, 2008–9. ABS, basswood, beech, ceramic, enamel paint, glass, honeycomb board, lacquer paint, latex paint, LED lights, pinewood, plywood, resin, spruce, styrene, polycarbonate sheets, and PVC sheets, 10 ft. 11 in. × 12 ft. 1 in. × 10 ft. (332.7 × 368.3 × 304.8 cm). Photography courtesy of The Museum of Fine Arts, Houston

expectations, competencies, and access to contemporary art, on the one hand, and Korean cultural history and language, on the other.

Clearly an exhibition of Korean contemporary art of this scale at a major North American museum, taking up the entire second floor of the Broad Contemporary Art Museum on the campus of LACMA, is a significant cultural event that accomplishes several things. First, it positions LACMA as an institution sensitive to and savvy about its local Korean demographics. (The timing of *Your Bright Future* coincided with the reopening of the traditional Korean art gallery at the museum, around which numerous community events were programmed including Korean barbeques, brush painting workshops, traditional dance performances, and pop music concerts.) Second, this kind of exhibition elevates the reputation of the museum and Los Angeles as a globally minded cultural institution and city, a reputation all institutions and cities covet. Third, it confirms both the strength of Korean financial capital (Hanjin Shipping sponsored the exhibition) and its growing interest in cultural investments in

Fig. 3. Yang Haegue (Korean, active in Germany, b. 1971), *Storage Piece*, 2003–9. Mixed media installation and performances. Haubrok Collection. Photography courtesy of The Museum of Fine Arts, Houston

Korea and abroad, as well as foreign interest in this strength. Finally, and most obviously, the exhibition validates the work of twelve artists as exemplary of contemporary Korean art, and by extension as models of "success" in the broader art world.

Co-organized by Lynn Zelevansky, LACMA curator of contemporary art (now the director at the Carnegie Museum of Art in Pittsburgh), and Christine Starkman, curator of Asian art at the Museum of Fine Arts in Houston, to which the show traveled after Los Angeles (figs. 2 and 3), *Your Bright Future* also reflected the contribution of Sunjung Kim, director and curator at Artsonje Center in Seoul, who provided much guidance in the preparation of the exhibition and the accompanying catalogue. As a whole, the exhibition was an eclectic showcase of some strong and some not so strong recent works by twelve artists who share very little in common beyond their Korean origin. In fact, given the diversity of formal and material preferences, and methods of production, presentation, and distribution, as well as content, the Korean identity of these artists seemed more like an accident of birth than a viable organizing principle for a show. Moreover,

given that all artists with the exception of Choi Jeong-Hwa left Korea in the 1980s or 1990s, some not to return, it was unclear what being "from Korea" really meant. With undergraduate degrees from prestigious Korean universities, primarily Hong-Ik and Seoul National, almost all the artists pursued their graduate degrees in the West, variously in England, France, Germany, and the United States. Thus, the eclecticism of *Your Bright Future* resulted in part from each artist's intersection with different artistic conversations occurring in these "foreign," Western educational contexts during their formative years.

The curators seemed to have purposefully undermined the implication of a nation-defining art by overemphasizing the individuality and biography of each artist. This may have been in response to the popular assumption that "national identity" is an outmoded category through which to define cultural production. It may also have been a way to work against the myth of Koreans as predisposed to nationalistic group-think and mob rule. What they sacrificed in this approach, however, was a rare opportunity to cut through the fragmented *and* homogenized terrain of contemporary art, which is propelled by the hegemony of the market, to delineate for their audiences specific lines of artistic inquiry developing in and through Korea in recent years. Rather than providing a broader picture or a more pointed perspective on what is at stake for this generation of Korean artists—artistically, politically, historically, socially, and otherwise—the exhibition affirmed the personal accomplishments of artists whose credentials are more or less already established.

Similarly, despite their participation many of the participating artists refuse the "Korean" label and express deep ambivalence about an exhibition that frames their work in terms of national identity. Young-hae Chang of Young-hae Chang Heavy Industries (a collaboration with the American artist Mark Voge), for instance, has stated that this exhibition will be the last in which they will participate that foregrounds nationality as an organizing principle. "It's a very popular thing to talk about identity, Korean identity, but I have never thought that I am a Korean artist," Chang has said. "I am just an artist, that's all."[1] It seems "artist" here refers to a role or identity that is invested with the presumption of transcending location, national identification, and cultural specificity, a process that is seemingly hampered if you are linked to a particular place or tradition, like Korea. Artist Lee Bul, conspicuously absent from this exhibition, apparently declined the invitation to participate similarly on the grounds that she does not want to be pigeonholed as a "Korean artist."

I am familiar and sympathetic with these sentiments, for they are precisely the reasons why I consciously avoided being identified as a Korean/Korean American or even Asian/Asian American art historian/critic in the 1990s. Within the context of multiculturalism and identity politics debates of the period (especially in New York City), it was politically important for me not to be cast by the dominant culture as an expert on a "minority community," or a spokesperson for "my people." It felt imperative, in other words, to challenge the presumption—equally held by many of my American/Western friends and colleagues as well as Korean/Asian ones—that simply because I was born Korean I would have a unique relationship to and an innate and natural affinity with Korean/Asian art, or that I would promote and advocate for Korean artists. I wanted to escape not only the West's trap of stereotyping but also the self-marginalizing traps that often look like opportunities to join or change the terms of a larger cultural conversation. I was hypersensitive to the kinds of experiences that Korean American artist Michael Joo described at the time—you think you get out of the ghetto only to realize that you're in another one.[2]

At a time when many disenfranchised minority groups were fighting for greater visibility and inclusion in mainstream institutions and discourses (such as the academy, museums, or art market) and getting it at least for a little while (the 1993 Whitney Biennial is a paradigmatic example), I had the ambition to engage a broader horizon for my work. Or maybe my position was more an act of cowardice. Whichever the case, I did not simply want to be seen or heard or included as a Korean or Asian art historian/critic to perform or speak or occupy a position that felt totally predetermined, if not managed for me, including the position of a "resistant other." I wanted to be an art historian/critic/writer whose Korean identification would not matter. Just as the artists Young-Hae Chang and Lee Bul want to be considered foremost as artists rather than as Korean artists, I wanted my cultural identity to be invisible in the same manner that white, Western, male, and heterosexual function (still) as invisible centers in the organization of power in and beyond the art world.

Thus, I was acutely aware in the 1990s of how I could gain visibility and establish a reputation if I strategically played my identity card just right. But the problem was that I didn't even want to be at the game table. I was equally conscious of the fact that as much as the struggles of minority groups opened up critical spaces to challenge the hierarchical and exclusionary social and institutional norms, the foregrounding of cultural difference or national or racial

identity could also serve as a new kind of realism, novelty, and exoticism that were used by that same dominant culture for its entertainment and renewal. If the universalizing Eurocentrism of modernism was oppressive and troubling, then so was the diversity-happy nature of pluralist postmodernism.

So here we are in 2009. I do not know for sure if the power dynamics of 1990s identity politics has fundamentally changed or if the same fault lines I have described are still in place, just in different guises on a bigger playing field. But something has changed enough for me to feel less reticent about being identified as a Korean, to speak specifically about a Korean art exhibition, although I am still unwilling to be a spokesperson. Admittedly, I do not have a clear view as to why this shift in attitude makes sense for me now, but I think it is undeniable that at a historical moment of geography-defying coordination of markets and economies as well as boundary-defying technologies of communication, exchange, and contact, the meaning of being from a particular somewhere, identified with a specific nation as origin, could have a different significance than before. What could this difference be?

In viewing *Your Bright Future* at LACMA this summer as both a Korean immigrant and as a contemporary art specialist, I felt the need to reapproach if not reembrace the issue of cultural politics of national identity. For clearly, despite the curatorial projection of contemporary art as a "global language" that exceeds national boundaries, and despite most artists' rejection of Korea as an identifying aspect of their work, and despite my own past resistances regarding the matter, the specter of "Korea" has a newly important role to play today. For instance, what kind of value accrues or is lost within today's contemporary art world system when a work of art or an artist is identified as being from somewhere specific, like "from Korea?" What kind of presumption attaches to the adjective "Korean?" Is it a pejorative that marginalizes or pigeonholes as Chang and Lee feel? Or is it a mark of positive distinction against a homogenized field of contemporary art (as this exhibition is promoting)? Is it a diminishment, a narrowing down of potential meaning of a work, or is it an opening up of its meaning? Is it better for the Korean identity of a work of art (or the artist)—imagery, signs, characteristics, qualities—to be visible or invisible, legible or illegible, accessible or inaccessible, apparent or hidden, in order to secure legitimacy in the broader contemporary art world as "relevant" and "interesting?" (It is perhaps no surprise that the front cover of the exhibition catalogue for *Your Bright Future* features a cropped close-up view of Do Ho Suh's sculpture highlighting only the part that is identifiable as

a traditional Korean house. This is one of the only works in the exhibition that offers an obvious visual clue instead of textual or linguistic mediation to non-Koreans that the content of the show is Asian.)

For the curator, Zelevansky, all the works in *Your Bright Future* inject "something local" (Korean) into a vocabulary that "belongs to the art world that we all inhabit," thus can speak to a wider audience (global) without becoming "generic, pallid, and weak."[3] That is, the works in the show are successful because they contrive an unfamiliar familiarity or a familiar unfamiliarity for those who inhabit the contemporary art world. For Christopher Knight, the art critic of the *Los Angeles Times*, however, *Your Bright Future* was simply too familiar. In his acerbic words: "Despite the forward-looking title, the new exhibition at the Los Angeles County Museum of Art seems locked in a wheezing, pre-millennial artistic frame of mind."[4] His negative evaluation was predicated on the fact that the exhibition champions a kind of art—conceptually oriented installations and large-scale video projections demanding too much space and time—that intensified the convergence of art with mass media, consumer culture, tourism, and the entertainment industry at a global scale in the 1990s. Thus, he bemoans what he sees as the continuing affirmation of tired "festival art," a term borrowed from art critic Peter Schjeldahl of the *New Yorker Magazine*.[5]

Although Knight's casting of *Your Bright Future* as behind the times reeks of an ethnocentric attitude in which the cultural production of other countries is seen as belated and derivative in relation to one's own, I do not totally disagree with Knight's criticisms. I also missed, like him, other types of art in the exhibition, including straightforward painting, drawing, or photography, for instance, that is not incorporated into elaborate multi-media installations or overlaid with labyrinthine and convoluted narratives. Along with art that utilizes new technologies and formats (digital animation, video projection, relational aesthetics, conceptual performance, and installations), I would have liked to see how so-called traditional mediums from the East and West are being reinvented today by artists whose outlook and formation refuse those binaries. In general, in privileging media-based art, the exhibition indirectly positioned art that engages with traditional mediums as not contemporary or not contemporary enough, which, I think, is a mistake. Just as the term "Korean" is an unstable construction, so is "contemporary," and an exhibition of this kind could have done more to explore the strange temporality of the contemporary along with the peculiar spatiality that constitutes Korean.

(re)naming oneself

When I was eleven years old, freshly arrived to America from Korea, I had to get used to a new way of referring to myself: instead of 권미원 (phonetically Gwon Mee One), I was now Miwon Kwon. Even as a child, I knew that this simple flip of first and last name with a harder "K" for Kwon was loaded with a great deal of meaning. For a very short time, my parents even considered changing my name to Mary. I could have been Mary Kwon. The rationale behind adopting a new Western name was to minimize my difference from other American schoolchildren in Alexandria, Virginia, to not stand out so much as a foreigner, outsider, Asian immigrant, "other." But the possibility of changing my name to Mary, embracing the new personhood that awaited me in the United States, felt tantamount to breaking from, if not denying, my Korean past, and a kind of betrayal. In other words, to assimilate into my new cultural context by calling myself by a different name felt like a partial erasure of self. At the time, in the early 1970s, this erasure seemed acceptable, a reasonable price to pay for a smoother and easier cultural transition. But in the end, I remained Miwon (a name that is not too hard to pronounce for Americans). However, a mark of difference remained in the written form of my name for a long time: a hyphen between Mi and Won, with the capitalization of the W in Won. Then it all became one word around the time I was in high school, I think, which was yet another moment of contending with similar issues and other crises.

I recount this episode from my childhood because, ultimately, the most meaningful aspect of *Your Bright Future* for me was hidden on the back cover of the exhibition catalogue, where the twelve artists' names are listed (fig. 4). LACMA, expressing its cultural sensitivity and perhaps predicting confusion

Fig. 4. Back cover of exhibition catalogue *Your Bright Future: 12 Contemporary Artists from Korea* (Houston: Museum of Fine Arts, Houston; Los Angeles: Los Angeles County Museum of Art, 2009)

on the part of the audience, expended a lot of effort to explain the convention of writing a Korean name. In the gallery brochure, for instance, the visitors were told the following:

> In East Asia, family names are written first, followed by the given name. Sometimes names are written as two separate words; other times they run together. Some of the artists in *Your Bright Future* follow East Asian conventions [Bahc Yiso, Choi Jeong-Hwa, Gimhongsok, Jeon Joonho, Kim Beom, Kimsooja, Koo Jeong-A]. Two also run their last and first names together [Gimhongsok, Kimsooja]. Others adopt Western conventions when they show their work in the West [Minouk Lim, Jooyeon Park, Do Ho Suh, Haegue Yang, Young-hae Chang]. We have capitalized the family name of each artist at the beginning of the section about his or her work.[6]

The eclectic spelling and stylization of each artist's name, more so than the eclecticism of the art on view, reflected the reality of what it means to circulate in body and name in the international art world today. To do so in today's international art world (the more you circulate, the more successful you are) requires an adoption of a Romanization of one's name. Of course, in itself this condition announces the dominance of Western (English-speaking) powers in structuring the field of contemporary art practice and discourse. That's a well-established fact. What I want to point to in addition is how the stylization and spelling of one's name reflects the self-positioning decision (conscious or not) of each artist in relation to that field. Whether to put one's surname or given name first; whether to run your two-syllable given name as one or two words; if two, then whether to put a hyphen or a space in between; whether to run the entire name as one word; whether to spell 박 as Park or Bahc, or 김 as Kim or Gim? Each artist, I am sure, has confronted this issue, weighing the extent to which the stylization and spelling of his or her name can signify degrees of Koreanness, or in contrast signify degrees of international cosmopolitanism, or somehow capture both.

The questions and choices that Korean artists inevitably confront regarding their names is an experience (and maybe a dilemma) that Western artists do not confront as a given. This fact highlights the uneven grounds of the contemporary art field that non-Western participants in general cannot ignore and must navigate quite differently than their Western counterparts. But what may

seem perhaps unfair—that the field belongs to the West so one must transform/ translate one's name from one's native language into English—itself captures a mutability, mobility, and flow that can be an asset in contemporary art: foreignness that is intelligible as a familiar unfamiliarity—the global touched by the local. It is in this roster of names on the back cover of the exhibition catalogue, suffering from the lack of a shared standard of translation or perhaps too many standards colliding at once, that I see far more clearly than in the artworks in the galleries the convergence of "a vocabulary that belongs to the art world that we all inhabit . . . and something of the local."[7] In this collection of names is the cultural evidence of how the locally specific is incorporated into the global system. And in the hyphens and spaces, the flips and capitalizations, are embedded the politics and history of this negotiation. Here is something for the world, specifically from Korea.

This text is adapted from a lecture given at the Los Angeles County Museum of Art on 8 Sept. 2009. The title, "Flash in the East, Flash in the West," is my translation of a commonly used phrase in Korean, 동에 번쩍 서에 번쩍, when something someone says or does reflects an extreme discontinuity in thought or position. The phrase also has spatial or geographical implication: to pop up here one minute and then to pop up somewhere totally random and unexpected the next. Flash here and flash there without any logic of continuity or connection. It's a phrase that can describe a condition of having no roots, lacking a grounding foundation, not inappropriate as the description of the peripatetic lifestyles of many contemporary artists "from Korea" and elsewhere as well as the overall quality of the *Your Bright Future* exhibition at LACMA.

1. Young-hae Chang in Suzanne Muchnic, review of *Your Bright Future* in *Los Angeles Times*, 21 June 2009, http://articles.latimes.com/2009/jun/21/entertainment/ca-korea21 (accessed 7 May 2010).

2. Conversation with the author, early 1990s.

3. Zelevansky in Muchnic, review of *Your Bright Future.*

4. Christopher Knight, comment on "Review: *Your Bright Future*," in *Los Angeles Times Blog*, posted 28 June 2009, http://latimesblogs.latimes.com/culturemonster/2009/06/korean-lacma.html (accessed 11 May 2010).

5. Ibid. The only exception was Do Ho Suh's *Home Within a Home*, which Knight admired as "flatly beautiful" and "post-festival art."

6. *Your Bright Future*, brochure (Los Angeles: Los Angeles County Museum of Art, 2009).

7. Zelevansky in Muchnic, review of *Your Bright Future.*

Running the Earth: Jun Nguyen-Hatsushiba's *Breathing is Free:* *12,756.3*

Nora A. Taylor

An Artist of the World

If art is supposed to speak of where and when it was made, then what do we make of an artist who no longer lives where he was born, whose nationality is not the same as his parents, who doesn't exhibit his work where he lives, and whose work appears in Biennales under the national flag not of his passport but of his place of residence yet shares little with the other artists living there? What is the critical framework for an artist who challenges the national and temporal parameters of contemporary art discourse, whose work transcends conventional notions of place, and who is literally constantly on the run—a misfit in a global art world that values and "curates" according to the local? This essay presents the case of an artist of mixed heritage whose practice has been to simultaneously engage and erase the boundaries of his nationality, his place of residence, and the medium with which he works. Jun Nguyen-Hatsushiba was born in Tokyo in 1968 of a Japanese mother and a Vietnamese father. His parents, who met in Vietnam, left before the end of the war and settled in Tokyo. After they separated some years later, his father moved to Texas, where Nguyen-Hatsushiba joined him as a teenager. Nguyen-Hatsushiba graduated from the School of the Art Institute of Chicago in 1992 and went on to get an MFA from the Maryland Institute College of Art. Although he had visited Vietnam once as a child in the mid-1970s, after his graduation from Maryland he made his first trip as a tourist. There, he made contact with a few artists and showed some of his work in a local art space. I encountered his work at that exhibition toward the end of my second extended research stay in Vietnam,[1] where I overheard what some of the local artists were saying about it. Because half his name happens to be the most common name in Vietnam, Nguyen, he was presumed to be a "Viet Kieu," or a diasporic Vietnamese, both foreign and familiar.

The term "Viet Kieu" often carries a negative association in Vietnam. A Viet Kieu is someone who left Vietnam during or after the war and settled elsewhere, usually with family. A Viet Kieu retains his or her Vietnamese identity, though one that is somewhat altered. The pejorative sense of the word comes both

from post-war nationalist discourse condemning those who left as betrayers and from a kind of jealousy from those who remained behind under less favorable conditions. The term is associated with a stereotype: a Vietnamese who does not know what it was like to live in poverty, a Vietnamese who knows nothing about Vietnam.

Nguyen-Hatsushiba's appearance in the Vietnamese art world drew my attention because his work did not quite correspond to what was being exhibited in the local galleries.[2] The artists and friends who attended the show discussed his work in ways that indicated that his presence was disruptive. It forced them to rethink the national boundaries of their own art production, because previously no international Vietnamese or hyphenated Vietnamese had exhibited in Vietnam. Although it seemed the only term that could apply to him at the time, Viet Kieu was not a term with which Nguyen-Hatsushiba identified: he had never lived in Vietnam, he did not speak Vietnamese, and he had never carried a Vietnamese passport.[3]

Following that first tourist visit, he later chose to settle in Ho Chi Minh City, which encompasses the greater metropolitan areas of Saigon, Gia Dinh, and Cho Lon, and is now divided into some fourteen districts and growing every day. Like other transnational artists, such as Francis Alÿs, a Belgian who resides in Mexico, Nguyen-Hatsushiba has been labeled by art writers and curators a "Vietnamese" artist. For instance, when he arrived in São Paulo for the Biennial in 2002, he noticed the Vietnamese flag flying among the other flags representing the nationalities of the participating artists; it took him a while to figure out that the flag stood for him.[4] Yet, unlike Alÿs, Nguyen-Hatsushiba is neither an artist in exile nor an expatriated artist, for it is not clear where his "homeland" lies. Like other "Third Culture citizens," as they might be called, he has grown accustomed to his in-between status. His case may not be surprising to those familiar with the politics of displacement; indeed, nomadism is fashionable in art circles these days. But his situation is unusual in Vietnam where artistic success is traditionally linked to an artist's ties to the homeland. Furthermore, outside of Vietnam, curatorial trends that place value on ethno-national identity in the name of diversity tend to locate Nguyen-Hatsushiba's work firmly within Vietnam, disregarding the complexities of his sense of self. Curators and art institutions continue to assume that his work "represents" Vietnam, when in fact it is entangled in the politics of national discourse within Vietnam in ways that are not recognized by certain international audiences. His case points to some of the contradictions, or as

Homi Bhabha has called them, the "disjunctures and ambivalences" present in any attempt to value locality and ethnic heritage in the work of an artist.[5] More importantly, it serves to demonstrate how artists often defy the expectations of their audiences by refusing to follow a certain set of prescribed conditions relative to "nation" and "identity." Nguyen-Hatsushiba has opted deliberately not to resolve the complexities of place, thus leaving curators guessing about where he belongs. This strategy has evolved and become particularly salient in his latest and most ambitious project: running a distance equivalent to the diameter of the earth over the course of one decade. *Breathing is Free: 12,756.3* is also his most powerful personal statement about human peregrinations and his trajectory as an artist.

Migrating to Vietnam

In 1995, when Nguyen-Hatsushiba first exhibited in Vietnam, the Vietnamese contemporary art world was at a pivotal stage in its history. For decades, since independence in 1954 in the northern part of the country, and since the end of the war in 1975 in the south, the country's artists were isolated from international art movements. Contact with foreign artists was restricted to encounters with those from Soviet-bloc countries on cultural exchange trips, and access to art books was limited. The situation began to change in the early to mid-1990s. Foreign students and tourists were granted visas to visit Vietnam and the government opened its doors to international trade following the institution of economic reforms known as *Đổi Mới*. Tourism increased after the United States–led embargo was lifted in 1994. By 1995, artists in both Hanoi and Ho Chi Minh City were receiving a steady stream of international visitors to their studios and participating in regional exhibitions. That year also saw the Singapore Art Museum open its doors to the public, and its curators embarked on several research trips to Vietnam intending to add Vietnamese art to their growing collection of contemporary Southeast Asian art. In 1996, Nguyen Xuan Tiep became the first Vietnamese artist to participate in an international biennale, the second Asia Pacific Triennial in Brisbane, Australia. In 1997, Sotheby's sold its first painting by a Vietnamese artist at auction in Singapore. By 2000, Vietnamese artists were beginning to engage in conversations about contemporary art through Internet forums and as participants in international symposia.

I witnessed many of the dramatic transformations that took place over the next decade in the contemporary Vietnamese art world. Artists grew increasingly familiar with art trends from around the world and experimented

with different media such as installation, performance, film, and video. What had once been a homogeneous group of individuals from similar backgrounds—the educated cultural elite whose parents and grandparents had been writers, artists, or musicians—was now made up of various groups with different interests and different backgrounds. A younger generation of artists attended art school not because their parents had done so but because they wanted to rebel against their parents' more conventional proletariat upbringing by choosing a creative profession. Some produced works that sold well commercially, landscapes and city scenes that appealed to tourists, while others were experimenting with different genres and going against the popular market. Still, the art community has remained relatively small, and most artists are familiar with one another. Thus the arrival of an artist such as Nguyen-Hatsushiba, with a foreign art education and no ties to the community, presents a challenge.

"Where are you from?" a common question that is asked in casual introductory conversations in the United States, does not have an equivalent translation in Vietnamese. In Vietnam, one asks "Bạn ở đâu?" or, literally, "where are you?" It means not "where are you from" but "where do you live?" The elimination of the word "from" should not be mistaken for a lack of value placed on origins or an indication that Vietnamese merely take origins for granted. Rather, it demands a consideration for the here and now by stating the place where one currently resides. A resident of Hanoi would answer, "Hanoi," or the street where he or she lives; a Viet Kieu visiting Vietnam would reply, "California" or "New York." In America, the same Viet Kieu would say, "Vietnam."

This linguistic anecdote illustrates how Vietnamese view what Americans call identity. There is a gap between the way in which Vietnamese and Americans situate themselves vis-à-vis an interlocutor. In the Vietnamese version, since one locates oneself in the present, the answer is relative and varies, a kind of self-professed identity, whereas in America it is more of an unchangeable and fixed identity linked to one's past. This can lead to fabricated narratives designed to satisfy the curiosity of the interrogator. The need to understand where one is "from" as opposed to where one "is" applies to situations in the art world. Nguyen-Hatsushiba is often asked to answer to where he lives, Vietnam, as if it were where he is from, thus enforcing an identification with Vietnam that is confused with identity.

In conversations with me over the past five years, Nguyen-Hatsushiba has offered varying explanations for his move to Vietnam. Initially, he said that he was attracted to the dynamism of Ho Chi Minh City, which appeared focused

on the future. Yet he was also drawn to it by a personal connection to the city and his heritage, sharing a desire to honor his father and pay respects to his father's country. In the rapidly changing environment of contemporary Vietnam, wartime memories are receding. The younger generation, some eighty percent of the population, all of whom were born after the war, are more focused on the new image of Vietnam as a "rising economic tiger." Today, Nguyen-Hatsushiba is not the only international artist living in Ho Chi Minh City. Since 2000, a growing number of second-generation Viet Kieu artists have chosen to "return," literally for some and metaphorically for others. Most have settled in Ho Chi Minh City where the majority of their parents grew up and where their relatives still reside. (I know only of one, Nguyen Oanh Phi Phi, who opted for Hanoi.) There, artists such as Dinh Q. Le, Tiffany Chung, Sandrine Llouquet, Tuan Andrew Nguyen, Erin O'Brien, and Rich Streitmatter-Tran have created their own community of expatriated—or, rather, repatriated—artists who have been gradually altering the landscape of the local art scene.

Some have described Ho Chi Minh City itself as a giant studio, a source of inspiration for their artistic production.[6] Nguyen-Hatsushiba has talked about how Vietnam gives him material for his work that he may not be able to find elsewhere.[7] This partly occurs because Viet Kieu artists did not find themselves immediately accepted or understood by the local artistic community, so they had to find creative ways to adapt their work to the local vernacular. And the foreign influence they have introduced has also forced the Vietnamese artists to adapt. Over time, this dialogue will attract the attention of increasing numbers of curators from around the world, and doors will open for both local and Viet Kieu artists. Eventually, the distinction between a Viet Kieu and a Vietnamese artist will dissolve, and the former's increased visibility in international exhibitions will transform, in turn, their relationship to Vietnam and the way this theme is articulated in their work.

Nguyen-Hatsushiba's first works made in Vietnam were not necessarily about Vietnam, but in them he used local materials and began to reflect on Ho Chi Minh City's spaces for viewing and making art. In 1999, for example, he created an installation for Blue Space, an alternative art space operating out of the Ho Chi Minh City Museum of Art, which drew attention to the courtyard. The museum is housed in a former colonial building, a catholic school consisting of four wings surrounding an open interior space. On repeated visits, he noticed that the courtyard was not used as an exhibition space, but was only used in the

mornings by the staff for their badminton games. He proposed installing there a large tentlike swath of mosquito netting on which he stitched a mazelike pattern. The finished piece hung above the courtyard and fluttered in the wind. In an article written by Joe Fyfe for *Art in America*, the installation was associated with post-Vietnam war narratives; Fyfe suggests that the maze, a recurring theme in Nguyen-Hatsushiba's work, is a metaphor for the displaced and "the complex paths taken by individuals buffeted by political forces."[8] He did not discuss the mosquito netting. The artist said that he was drawn to the space of the courtyard as both an enclosed and open space. "It is an architectural structure that is both inside and outside or neither."[9] The maze pattern created a drawing in space, highlighting this previously overlooked location, an action that he repeated later in the *Breathing is Free* project on a much larger scale.

Like other "foreign" artists living in Vietnam, Nguyen-Hatsushiba began to reflect on elements of local culture; in 2000 he focused on the cyclo—xich-lo in Vietnamese—the colonial hybrid of a bicycle and a rickshaw. For his contribution to the 2001 Yokohama Triennial, he originally planned a site-specific work related to the cyclo: a cyclo museum or a memorial to the cyclo. However, due to a number of reasons including lack of space, and at the suggestion of the curators, he instead produced a film made in Vietnam. Rather than a cyclo memorial, the artist invited fishermen from the coast to ride cyclos underwater. *Memorial Project Nha Trang, Vietnam: Towards the Complex—For the Courageous, the Curious, and the Cowards* (fig. 1) created a sensation at the Triennial, in part because of its title and the seductive symbolism of the cyclo, and more so because it was shot entirely underwater off the coast of Nha Trang, the site where thousands of boat people fled the country because of their economic and political despair.

Memorial Project Vietnam became an overnight sensation and was exhibited, along with three other films shot underwater in what became a series of *Memorial Project Vietnams*, at thirteen biennales and triennales around the world, making Nguyen-Hatsushiba one of the most represented Asian artists to exhibit at biennales.[10] Films from the series were exhibited at the New Museum in New York and the Berkeley Museum in California in 2003, and at biennales in São Paulo and Sydney (2002), Venice and Istanbul (2003), Seville and Shanghai (2004), Moscow and Lyon (2005), and Gwangju and Singapore (2006). The films *Memorial Project Vietnam* and *Happy New Year: Memorial Project Vietnam II* (2003), *Ho!Ho!Ho! Merry Christmas: Battle of Easel Point—Memorial Project* (2004), and *Memorial Project Minamata: Neither Either nor Neither—A Love Story* (2005) resonated

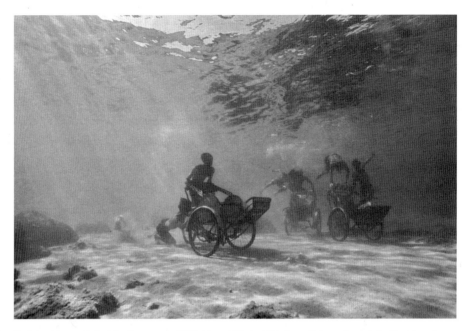

Fig. 1. Jun Nguyen-Hatsushiba (Japanese, b. 1968), *Memorial Project Nha Trang, Vietnam: Towards the Complex—For the Courageous, the Curious, and the Cowards*, 2001. Still from single-channel DVD, 13 min. Courtesy of Yokohama Triennale 2001, Lehmann Maupin, New York, and Mizuma Art Gallery, Tokyo

profoundly with international audiences who shared a compassion toward the plight of war victims and those who suffered under colonial oppression. Holland Cotter, in his review of the show at the New Museum in New York, described the "dream-like quality of the films." He also suggested that they belonged in the American Museum of Natural History's exhibition on Vietnamese culture and religion.[11] Like Fyfe's comments in relation to the maze suggest, Cotter's reading of these films as ethnographic added a burden on the artist to become a spokesperson for displacement and the politics of migration. The popularity of the work shows that Nguyen-Hatsushiba satisfied a need in the art community to bear witness to the politics of war, and that he did so in a way that no other artist had. For him, cyclos carried yet another significance, perhaps lost to the Yokohama audience or to those who have never traveled to Vietnam: in the 1990s cyclos were the only source of income for would-be refugees, those whose attempts to leave the country were unsuccessful. He recounted conversations with cyclo drivers, and how for him the cyclo was a metaphor for failing to leave Vietnam, rather than a symbol for success.[12]

Lee Weng Choy has cleverly noted that, "we—enlightened postmoderns,

postcolonials, cosmopolitans—immediately recognize local individual political identity [but] we have also placed a burden on contemporary art to represent culture, place, and identity. . . . Because of the inadequacies of our discourses in Southeast Asia, identity politics, by default, is the predominant frame for contemporary art, and, at the expense of a fuller understanding of both the possibilities for art's publics, and the individuality of artists and their works."[13] *Memorial Project Vietnam* resonated with publics at biennales and triennial because it appeared to represent Vietnam, or at least provide a view of Vietnam that spoke to the needs of the West. Yet elsewhere Nguyen-Hatsushiba has expressed unequivocally his reluctance "to speak for Vietnam."[14] His silence on the issue communicates his ambivalence about the complex nature of associating one's work with a nation. This conscious detachment from Vietnam has led him to take a different approach to his work, developing a unique artistic strategy aimed at avoiding interpretations of his work as Vietnamese and which speaks personally about the complex relations in which humans engage with the world.

Before discussing the project that is specifically associated with this strategy, let me return to how Vietnamese art historians have articulated these issues, for Nguyen-Hatsushiba is not just part of the global art world, he also plays an essential role in the reception of Vietnamese artists around the world. Although here I shall not go into lengthy discussion of the debates surrounding the issue of national identity in Vietnamese art and the contradictory ways in which the State has applied the term "national" or "Vietnamese" to works of art, it is worth recalling that the concept of Vietnameseness in Vietnam is not simply a matter of identity politics.[15] When applied to art, Vietnamese does not reflect the artist only, but also the work he or she creates. Under the strict regulations advocated by the Communist party in the 1950s, which lasted until the 1980s and the onset of economic reforms under *Đổi Mới*, artists were encouraged to portray Vietnam in idyllic landscapes or portraits of peasants, soldiers, and workers. The current generation of Vietnamese artists, as much as it tries to break away from State ideals, continues to feel the pressure to continue to produce officially sanctioned work or appeal to vague popular nationalistic concerns.

Viet Kieu artists come with their own sense of Vietnameseness, one that is no less influenced by ideology. Growing up in families and communities that rejected the Hanoi regime, they learned to believe in a "good Vietnam" and a "bad Vietnam": a Vietnam that is more democratic and prosperous, what they imagined it would have looked like had the South won the war, versus a Vietnam

that is corrupt and destitute. The contrast between these two types of Vietnamese is most apparent to the Vietnamese themselves, and not so evident to outsiders who are not as emotionally connected to the geo-politics of Vietnamese history. What appears to be a case of insiders versus outsiders is rather competing versions of a single identity, not merely of two competing definitions of identity.

Since the 1990s, artists in Vietnam have received a fair amount of attention from international curators, perhaps, as stated above, because of the strong visual associations that connect Vietnam to war and exile in the popular imagination. As with the focus of the acclaim that Nguyen-Hatsushiba's underwater cyclo films received, there has been a problematic conflation between an artist's ethno-nationality and his or her work. This creates a quagmire for artists, a rut out of which they find it difficult to emerge. They are included in exhibitions because of their nationality, but also excluded from the Western art historical canon because of it. As I have argued elsewhere, artists from a marginal place like Vietnam rarely receive attention in international art circles without being identified by their ethno-nationality because the powers that dictate which artists circulate in the global art community ensure Western hegemony.[16] Scholars such as Xiaoping Lin and John Clark have argued that this is achieved partly by further segregating artists from outside of the West through stressing their non-Western origins.[17] An American or a French artist will be identified by name, while an artist from Iceland, China, or Brazil will be labeled by his or her ethno-nationality. In the case of Vietnam, artistic identity is heavily overdetermined by images of the modern nation's history and geography, and it has become increasingly difficult for Vietnamese artists or Vietnamese American artists to detach their work from viewers' associations of their country. From the first exhibitions of Vietnamese art in America, such as *As Seen by Both Sides*, an exhibition that toured from 1990 to 1995 in nineteen cities, including Boston, Atlanta, Springfield (MO), Hanoi, and Ho Chi Minh City; or *An Ocean Apart*, organized in 1995 by the Smithsonian Institution Traveling Exhibition Service (SITES); or even *A Winding River*, organized by the Meridian International Center in Washington, D.C. in 1998, and shown in 1999 amid protests at the Bowers Museum in Santa Ana, California, the burden has been placed on artists to narrate their country's events, even to push for peace or changing perspectives.[18] It is an ongoing struggle for artists, particularly from Vietnam, to disentangle their work from their ethno-nationality.

In my research on painters in Hanoi, I demonstrated that Vietnamese artists have been studied for their contributions to social history, for their contributions

to the imaging of the Vietnamese nation, and for their connections to the artistic community. Artists traditionally belong to families of artists, to the intellectual middle class and the educated elite. Since the founding of the Indochina art school by the French colonial administration in 1925, artists have been integrated into a canon of painters that are seen as corresponding to nationalist representations of the country. In Vietnam, as elsewhere, the act of selecting artists and locating them in a historical framework is part of a process of writing an art history for the nation. Such a nationalist art historiography has involved classifying artists along the lines of twentieth-century Vietnamese history rather than by artistic style. Artists who studied under colonialism, for example, are considered colonial painters, artists who participated in the revolution are considered revolutionary painters, and so forth. This process has continued through the war years and the *Đổi Mới* and continues today. The struggle for contemporary artists has not been one of wanting recognition as contemporary artists but wanting to be treated as individuals rather than part of a collective. As Wu Hung noted in the case of China, the shift from modern to contemporary art took place when artists broke away from a collective identity to an individual one.[19] Similarly, Viet Kieu artists have had to forge their own path within the Vietnamese art world and avoid being grouped under a collective label.

Breathing is Free: A Work of Global Proportions

In what appears to be an effort to transcend the seemingly endless associations made between artists' identities and their work, or perhaps an effort to move beyond the concept of a single place, in 2007 Nguyen-Hatsushiba developed a project that explores the idea of transnationalism physically and literally. For the project, titled *Breathing is Free*, he proposes to run 12,756.3 kilometers, equivalent to the diameter of the earth. The "running drawing," as he calls it, is performed in increments, in cities in which he happens to be exhibiting. The routes are traced on Google Earth maps. Each of the "drawings," realized with the aid of a GPS wristwatch that the artist wears while he runs, takes a distinctive shape determined by chance and circumstance: a water hyacinth (Ho Chi Minh City;), a fern (Manchester), a root (Luang Prabang), the Chinese character for the number ten (Taichung), imaginary plants (Tokyo), and a microscope (Chicago). He is accompanied by a cameraman and a photographer who document the run in footage that is later exhibited as projections on flat screens, alongside previous runs and prints of the Google Earth maps with the drawings outlined and enhanced digitally.

The project is a work in progress that evolves with each subsequent run. The inaugural run occurred, symbolically, in Geneva, Switzerland: the site where the Geneva Convention was signed in 1954, which divided Vietnam into North and South, and the home of the United Nations and the United Nations High Commission for Refugees (UNHCR). The Geneva itinerary led him past the United States Embassy and the seat of the UNHCR, as if drawing a direct line between the two. Since then, he has run in Lucerne, 2007 (21.3 km); Ho Chi Minh City, 2007 (118.3 km); Karlsruhe, 2007 (32.4 km); Tokyo, 2007 (68 km); Taichung, 2007 (127.2 km); Luang Prabang, 2007 (89.6 km); Singapore, 2008 (70.6 km); Manchester, 2008 (92.6 km); Taipei, 2008 (84 km); and Chicago, 2009 (88.5 km). He conceived of the project while watching a movie on a transpacific flight. The idea that he could traverse the globe on a more human scale than that afforded by air travel came to him as he watched scenes in the film *Blood Diamond* of people running for their lives during the ransacking of local villages in search of potential slave labor for the diamond mines.[20] He felt uneasy, sitting comfortably in his seat, traveling great distances effortlessly, while in the film locals had to run on the ground and suffer under terrible conditions. He wanted to experience for himself that kind of exertion and pain.[21]

The preliminary press material for *Breathing is Free* describes it as a continuation of *Memorial Project Vietnam* in that it is a partial homage to the plight of those who have to "run" away. As the project website states: "*Breathing is Free: 12,756.3* is [a] culmination of artist's memorial projects to-date to challenge his own mind and physique to discuss layers of ideas through the action of repetitive foot strikes, running. As a form of memorial, as so many refugees had and are running away from their homes for [a] better life and sometimes for mere survival, the artist's running, his experience and struggle, sets the backdrop for this long-term project."[22] Nguyen-Hatsushiba explains in his own words: "It is my reflection and offering to the refugees whose lives are to run or to perish. And this is what I see as the desire of refugees running from their circumstances; they want to be on the 'other side' instead."[23] In running, he is trying to simulate or empathize with the physical pain endured by refugees in flight. Running is a natural function of the body, but in this project it carries a deeper meaning: it becomes a metaphor for fleeing and for deportation. The title of the project is equally laden with symbolism. Breathing is a necessary human function. Adding the word "free" to the title suggests it is also an entitlement, a condition to which all human beings are privy. There is no cost to breathing. Further, it alludes to freedom in the sense

of human rights, but it could be interpreted in more ambiguous ways, as both a reference to its use in the West to signify democracy and its use in Vietnam in the national motto "Độc lập—Tự do—Hạnh phúc" (Independence—Freedom—Happiness). But it may also be an illustration of what Homi Bhabha calls "identity as a kind of authorization."[24] Nguyen-Hatsushiba may be referring to the need and entitlement for human beings to be free of an overburdened identity.

Although the project requires the artist to subject his body to rigorous physical training and endurance, Nguyen-Hatsushiba does not entirely submit that the piece is a performance, and remains unsure how to define it. In the statement on his website, he calls it "conceptual yet physical; a real struggle, not a performance."[25] And yet he concedes that "the word performance can also refer to athletic performance and the achievement of a personal goal. Like an athlete, I would like to be recognized for this feat."[26] Although he may not call it an artistic performance, the work does show the artist in action presenting and representing himself "in the process of being and doing . . . in a cultural context for a public to witness," as Kristine Stiles has sought to define performance in *Critical Terms for Art History*.[27] At the very least, the work eludes conventional definitions of performance and defies the notion of a fixed, end result: it is not object based, it is in process and in progress, and like his earlier video performance under water, it involves bodies in space (figs. 2–6). It is durational and empathic, components that are closely related to engaged performances by other artists.

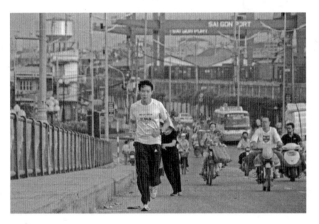

Fig. 2. Jun Nguyen-Hatsushiba, *Ho Chi Minh City 118.3 km*, from *Breathing is Free: 12,756.3*, 2007–. Ongoing running project. Courtesy of the artist and Mizuma Art Gallery, Tokyo

Performances that involve travel and long distance as emblems of human suffering are not uncommon. For example, there is Kim Sooja's eleven day, 2,727 kilometer performance-travel through Korean cities for the 1997–99 touring exhibition *Cities on the Move: Urban Chaos and Global Change, East Asian Art, Architecture, and Films Now*, cocurated by Hou Hanru and Hans-Ulrich Obrist.[28] In that performance, the artist traveled with bundles of cloth

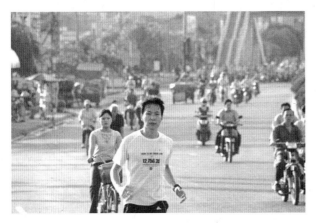

Fig. 3. Jun Nguyen-Hatsushiba, *Ho Chi Minh City 118.3 km*, from *Breathing is Free: 12,756.3, 2007–*. Ongoing running project. Courtesy of the artist and Mizuma Art Gallery, Tokyo

Fig. 4. Jun Nguyen-Hatsushiba, *Luang Prabang 89.6 km*, from *Breathing is Free: 12,756.3, 2007–*. Ongoing running project. Courtesy of the artist and Mizuma Art Gallery, Tokyo

as luggage, called Bottari in Korean, in reference to the items carried by women and as a "metaphor for movement."[29] In 1998, the Chinese artist Ma Liuming walked naked a substantial length of the Great Wall in a piece titled *Walking on the Great Wall*, highlighting China's authoritarian rule, its isolation from the West, and internal human rights abuses. Marina Abramovic and Ulay made a piece at the same location in 1989, *The Great Wall Walk*, which entailed the artists walking toward each other from opposite ends of the Wall, two thousand kilometers apart, until they met in the middle, as a test of their relationship. These works do more than test the limits of human endurance, they comment on the politics of separation, movement, and their effects on the human mind, body, and spirit; ideas that are captured convincingly in the art of performance.

The documentation of *Breathing is Free* also recalls the itinerant work of the Thai artist Manit Sriwanichpoom and his Pink Man performances, which he began in 1997, in which he travels the world dressed in pink and pushing a shopping cart in order to comment on global capitalism and tourism.[30] These travels are photographed and then exhibited as large-format prints, much as Tseng Kwong Chi does in his series *Ambiguous Ambassador*, which shows the artist dressed in a Chinese worker's outfit, shutter release in hand, in front of various American monuments, or the Singaporean artist Lee Wen, in his *Journey of Yellow Man*,

Fig. 5. Jun Nguyen-Hatsushiba, *Taipei 84 km*, from *Breathing is Free: 12,756.3, 2007–*. Ongoing running project. Courtesy of the artist and Mizuma Art Gallery, Tokyo

Fig. 6. Jun Nguyen-Hatsushiba, *Taipei 84 km*, from *Breathing is Free: 12,756.3, 2007–*. Ongoing running project. Courtesy of the artist and Mizuma Art Gallery, Tokyo

in which he appears in various cities around the world covered with a full-body coat of yellow paint as a commentary on race and Asian Identity.[31] But, unlike those performances and actions, Nguyen-Hatsushiba is not interested in portraying himself as a visitor, a traveler, or a tourist. He doesn't remark on the strange juxtaposition between himself and the backdrop of the city in which he runs. He is not interested in drawing attention to his Otherness. Rather, he seeks to simply be himself and blend in. However, his conscious act serves as both background and foreground. The footage shows him running as if he were any other ordinary jogger in a city, and yet, as the camera follows him, Nguyen-Hatsushiba also stands out. He is the only one running in the picture, for example; at times he is the only Asian, at others, the only person period. While he may not call it a performance, in subjecting his body to strain in front of a camera, he becomes a performance artist of sorts.

His earlier projects shot under water also pointed to human suffering, presented in an aestheticized manner. In *Memorial Project Vietnam*, the cyclo drivers held their breaths while riding, rising to the surface to breathe before returning underwater, thus communicating the pain of gasping for air and the discomfort of the body struggling for oxygen. Nguyen-Hatsushiba explained that he had not wanted to choreograph the riders, but had wanted to allow them to

choose when to rise to the surface and when to swim back underwater in order to capture the natural human need to breathe.[32] Similarly, in *Breathing is Free* the films document Nguyen-Hatsushiba's rhythmic breathing, the physical strain of running, sweating, inhaling, and exhaling. In her essay "A Punch in the Gut: Empathy and Meaning in Performance Art," Lynn Charlotte Lu explains the need for humans to know something through direct experience. "Identification with others in similar situations," she states, "is grounded in physical and psychological sensation, and is reciprocal and interactive."[33]

Lu relates performance art practices to Buddhist meditation as acts of empathy for the suffering of others. The rhythm of breathing in and out, apparent in Nguyen-Hatsushiba's rhythmic breathing, also recalls this idea. Nguyen-Hatsushiba has not stated an interest in Buddhism per se, although in 2006 he did make a film shot in Luang Prabang, Laos, that made more explicit references to Buddhism. Titled *The Ground, The Root and The Air: The Passing of the Bodhi Tree*, it was commissioned by the Quiet in the Land project under the curatorial direction of France Morin.[34] In the film, art students stand facing their easels in motorized river boats. They travel upstream until they reach a Bodhi tree on the side of the river, the boats dock facing the tree, and a few of the students jump in the water. The artist explained that he was trying to convey the idea of impermanence. "As locations and moments are left behind by the flow of the river, so will this symbol of Buddhism gradually fade away from the view of the painters, leaving them with some measure of doubt about the journey they have started."[35] The footage is interspersed with scenes of other students exercising in a run-down stadium and of the lighting of lanterns along the river, which refer to the Communist past and the traditional festival of Boun Ok Phansa, respectively, or the pursuit of modernity versus the preservation of tradition. Nguyen-Hatsushiba says, "images of revolution—the youths running around the perimeter of the stadium, the lanterns revolving in darkness, a whirlpool in the river—suggest that this journey, seemingly linear, is actually a cycle, in which tradition and modernity constitute a dialectical rather than a binary opposition that is subject to continuous synthesis."[36]

Nguyen-Hatsushiba ran a portion of *Breathing is Free* in Luang Prabang. His run through the treacherous terrain of the Laotian jungle contrasts sharply with the orderly calisthenics performed by the students in the dilapidated stadium. I asked him if he saw a connection between his run and the students' athletic activities during a conversation in Chicago.[37] He replied that they were meant

to stand in contrast to one another. The latter was a collaboration, a community project, whereas the former was a solitary endeavor. This difference between his individual "performance" and the group project points to a fundamental aspect of the *Breathing is Free* project, namely, that the artist is running alone. The distance that he plans to travel on this solo voyage is daunting and his ambition to complete it articulates a kind of need for him to be alone, to be detached from others, to isolate himself from the rest of the world. And yet the irony is that he is traversing cities at a relatively slow pace, slow enough to soak in the environment, to witness what others are doing, to catch the gaze of pedestrians and automobile drivers, but too fast to engage in conversation or interact with his surrounding. When he describes running through a city, he speaks of obstacles, of rugged terrain, of streets to cross, vehicles to avoid, and crowds to avoid. He is not interested in stopping to absorb his environment, to learn the language, or to buy a souvenir. However, he is interested in the scenery. At one point, he spoke of projecting the films in stop-action motion. When he showed me a preliminary cut of the Tokyo run edited in this manner, he was excited about the possibility of the buildings coming to a near standstill as opposed to the fleeting glances that define his runs.[38] It is as if he enjoys the sensation of simultaneously belonging and not belonging to his surroundings, a feeling that simulates perhaps the peculiarities of his relationship to the world.

In spite of its measured distance and calculated dimension, it is hard to predict what the piece will look like when completed. So far, the thousand-some kilometers that he has executed have amounted to eleven films, several prints of drawings over Google Earth maps, an overhead projected map (Taipei), and a digitally animated drawing over a map (Chicago). The scope of the project is made visible only through these filmic segments and linear prints. The end of the project, when the 12,756.3 kilometers are completed, will presumably add at least one hundred more films and drawings. Even then, will these images capture what the artist has accomplished or will they become an entirely different event? In addition, there is the question of time. If the work will take over a decade to finish, things will have undoubtedly changed. Most notably, the artist will have aged, technology may have advanced, and the landscape of some of the places where he has run will also have been transformed. Nguyen-Hatsushiba has admitted to me that he had not considered the permutations of the piece over time but that he enjoyed the unpredictability of it.[39]

The scale and scope of the piece have been equally difficult for curators

to grasp, and are a challenge to the conventions of curation and exhibition. The locations of the runs have been determined by the invitations that Nguyen-Hatsushiba has received to exhibit his other works, mostly the *Memorial Project* videos. The institutions then agree to sponsor the runs as part of the exhibition process, including several visits by the artist beforehand to prepare and realize the run. In e-mail exchanges with me, Tim Wilcox, curator at the Manchester Art Gallery at the time that Nguyen-Hatsushiba exhibited and ran there in 2008,[40] explained the difficulties in organizing the logistics of the run in his city. "We had not anticipated the complexities of navigating the run, nor how the adverse weather conditions might affect it. He wanted to run alone, but we were worried about his safety."[41] In Chicago, besides questions of insurance, the School of the Art Institute, which had funded the run, had to seek permission from the city, which requested that the artist be followed by a police escort. "Curating" *Breathing is Free*, then, is not simply a matter of hanging works in a gallery, but entails securing necessary permissions from municipal authorities and mediating communication between the artist and public institutions. This process is not a hassle for the artist; on the contrary, he has expressed its appeal. It becomes part of the draw, part of the challenge, a simulation of what refugees have to endure. Most recently, in an e-mail, he became interested in the Luanda Triennial in Angola and wondered what it would be like for an Asian to run through an impoverished African city.[42]

Conclusion

In running the diameter of the earth, Nguyen-Hatsushiba wants to feel what it would be like to traverse the globe lengthwise, to cut through the center of the earth, to see the world from the other side, to challenge the way in which humans travel by air by actually running on the ground in patterns determined by chance and circumstance. In choosing to run through the earth rather than over it, he has also challenged the way in which artists have been presented in global art exhibitions as belonging to one world, one universe, for no human can actually experience the world that he is presenting. The privilege of the artist is to imagine what cannot be imagined, and I would add, in his case, to turn things inside out and upside down. His project might be conceptualized as critiquing the utopian models of globalization that imagine a world of equal players on an even field. By breaking up the globe and replotting its coordinates according to his own imaginary patterns and drawings, he is subverting the very premise of global art.

Where his fellow Vietnamese artists have been trying to find a location in the world of contemporary art, a place where they can feel at home, and as art writers, curators, and art historians have been trying to chart paths and trajectories for artists from this place to that, from one location to another, and claiming their epistemological and theoretical territories, Nguyen-Hatsushiba has been drafting his own path along a world that only he knows and experiences. That might be the prerogative of the artist more generally, but few have addressed the issues of cosmopolitanism, transnationalism, dislocation, and exile in such a way as to both mark and erase them. His runs are recorded with his GPS, but they disappear just as quickly as they appear, while he simultaneously manipulates the mediums of video and performance. Neither ethnographic nor conceptual (or both), *Breathing is Free* refuses to be a metaphor for the displaced: it is a kind of reality that only the artist can experience. In the process of making the work and calling it art, he is drawing on his viewer to contemplate not the complex paths of individuals in the collective sense, but rather the complex paths of the artist himself, both as an artist and a global citizen, through this world and out of it. The world that he has created in his art is a world in flux in which the concepts of "Vietnam," "Performance," and "the World" are multiple, complex, and fluid.

1. My fieldwork in Vietnam included an initial extended stay from 1992 to 1994 and again from 1995 to 1996 for doctoral dissertation work. See Nora Annesley Taylor, "The Artist and the State: Painting and National Identity in Hanoi, 1925–1995" (Ph.D. diss., 1997, Cornell University). Additional fieldwork included stays in 1998, 2000, and 2004–5. Research from 2004–5 was funded by a Fulbright Scholar Grant. I would also like to acknowledge the generous support of the Getty Foundation for a collaborative research grant conducted with Dr. Barley Norton, Goldsmith's College, University of London, titled "Experimental Vietnamese Contemporary Performance," in 2008–9.

2. Nora Annesley Taylor, *Painters in Hanoi: An Ethnography of Vietnamese Art* (Honolulu: University of Hawaii Press, 2004).

3. I am grateful to Jun Nguyen-Hatsushiba for his trust and confidence in generously agreeing to share details of his life and work with me these past five years. I also thank Saloni Mathur for her editorial guidance and comments on an earlier draft of this essay. I also thank Barley Norton, Lisa Drummond, Pamela Corey, Heather Sealey Lineberry, Mary Jane Jacob, Rich Streitmatter-Tran, Dinh Q. Le, Diem Nguyen, and Jun's Studio for helpful ideas and intellectual support.

4. Jun Nguyen-Hatsushiba, interview with Hou Hanru, *Tema Celeste* 104 (July 2004).

5. Homi Bhabha, "Guggenheim Museum's Asian Art Council Symposium, Part 3: What is the Mission of Asian Art Curators in the Age of Globalization?" *Yishu* 7, no. 3 (May/June 2008): 78

6. Tuan Andrew Nguyen, conversation with the author, 2007.

7. Jun Nguyen-Hatsushiba, conversation with the author, 2005.

8. Joe Fyfe, "In deep water: In his ambitious films and installations, Jun Nguyen-Hatsushiba addresses the complexities of modern Vietnam, and of being an international artist who negotiates between East and West," *Art in America* (Sept. 2008).

9. Jun Nguyen-Hatsushiba, conversation with the author, 2007.

10. This statistic is according to the Asia Art Archives's Internet biennale forum, http://www.aaa.org. hk/onlineprojects/bitri/en/didyouknow.aspx (accessed 7 March 2010).

11. Holland Cotter, review of "Jun Nguyen-Hatsushiba—'Memorial Project, Vietnam,'" *New York Times*, 20 June 2003, sec. E, col. 1.

12. Jun Nguyen-Hatsushiba, conversation with the author, Chicago, 2008.

13. Lee Weng Choy, "The Assumption of Love: Friendship and the Search for Discursive Density," in Nora A. Taylor and Boreth Ly, eds., *Modern and Contemporary Southeast Asian Art: An Anthology* (Ithaca, NY: SEAP, Cornell University Press, forthcoming).

14. Jun Nguyen-Hatsushiba, conversation with the author, Chicago, 2008.

15. For more on the discussion of national identity in Vietnamese art, see Nora A. Taylor, "Framing the National Spirit: Viewing and Reviewing Painting Under the Revolution," in Hue Tam Ho Tai, ed., *The Country of Memory: Remaking the Past in Late Socialist Vietnam* (Berkeley: University of California Press, 2001), 109–34; and "Raindrops on Red Flags: Tran Trong Vu and the Roots of Vietnamese Painting Abroad," in Jane Winston and Leakthina Ollier, eds., *Of Vietnam: Identities in Dialogue* (London: St. Martin's Press, 2001), 112–25.

16. Nora A. Taylor, "Why Have There Been no Great Vietnamese Artists?" *Michigan Quarterly Review* 44, no. 1: 149–65; the title of this essay is a reference to Linda Nochlin, "Why Have There Been no Great Women Artists?" in Linda Nochlin, *Women, Art, and Power and Other Essays* (Boulder, CO: Westview Press, 1988) in which she discusses similar ideas of art historical prejudice.

17. Xiaoping Lin, "Globalism or Nationalism? Cai Guoqiang, Zhang Huan, and Xu Bing in New York," *Third Text* 18, no. 4 (2004): 279–95; John Clark, "What Modern and Contemporary Asian Art is [or is Not]: The View from MoMA and the View from Asia," in John Clark, Maurizio Peleggi, and T. K. Sabapathy, eds., *Eye of the Beholder: Reception, Audience, and Practice of Modern Asian Art* (Sydney: Wild Peony, 2006).

18. *As Seen by Both Sides*, organized by the Indochina Arts Project (traveled 1990–95); *An Ocean Apart*, organized by the Smithsonian Institution Traveling Exhibition Service, Washington, D.C. (traveled 1995–97); *A Winding River*, organized by the Meridian International Center, Washington, D.C. (traveled 1997–99).

19. Wu Hung, "How Chinese Art became Contemporary" (lecture, Art Institute of Chicago, 11 Feb. 2010).

20. *Blood Diamond*, directed by Edward Zwick (Warner Brothers, 2006).

21. Jun Nguyen-Hatsushiba, conversation with the author, 2010.

22. "Concept," http://www.breathingisfree.net/ (accessed 12 Feb. 2010).

23. Ibid. (accessed 10 Feb. 2010).

24. Homi Bhabha, "Guggenheim Museum's Asian Art Council Symposium," 76.

25. http://www.breathingisfree.net/ (accessed 10 Feb. 2010).

26. Jun Nguyen-Hatsushiba, e-mail conversation with the author, Sept. 2009.

27. Kristine Stiles, "Performance," in Robert S. Nelson and Richard Shiff, eds., *Critical Terms for Art History* (Chicago: University of Chicago Press, 2003), 75.

28. The exhibition traveled to the CAPC, Musée d'Art Contemporain de Bordeaux; the Hayward Gallery, London; the Vienna Secession; and PS1, New York.

29. Friedemann Malsch, "The Bottari as Time Capsule, Thoughts accompanying the exhibition, "Kimsooja-Bottari Cologne 2005," Kewenig Galerie, Cologne 29.1-23.4, 2005," in, http://www.kimsooja.com/texts/malsch.html (accessed 10 Feb. 2010).

30. Manit Sriwanichpoom conceived of the persona of the Pink Man during the 1998 Amazing Thailand tourism campaign. He states: "The Pink Man, a symbol of conspicuous consumption and vulgarity, trundles along with his pink supermarket cart, chewing up the scenery, shopping for tourist attractions. Like most tourists today, he travels not to learn but to consume: to collect exotic destinations, to shop, to show off, to stay in resource. . . ." See http://www.rama9art.org/manit_s/ (accessed 5 Apr. 2010). Documented initially as *Pink Man I, II, III, Soi Lalaisap, Silom Road, Bangkok*, 1998, but continued with such photographic series as *Pink Man on Tour*, 1998; *Pink Man on European Tour*, 2000; and *Pink Man—The Icon of Consumerism*, 2007–8.

31. See Tseng Kwong Chi, *Ambiguous Ambassador* (London: Nazraeli Press, 2005), with essay by Dan Cameron; Lee Wen has been performing *Yellow Man* in various performance festivals since 1992. See http://www.biotechnics.org/2leewen.html (accessed 5 Apr. 2010).

32. Jun Nguyen-Hatsushiba, conversation with the author, October 2009.

33. Lynn Charlotte Lu, "A Punch in the Gut: Empathy and Meaning in Performance Art," Lee Wen, ed., *Future of Imagination 4*, Singapore: National Arts Council, exhibition catalogue 27–30 Sept. 2007, p. 25

34. For futher information, see Carol Becker et al., *The Quiet in the Land, Luang Prabang, Laos* (New York: The Quiet in the Land, Inc., 2009).

35. Ibid., 138.

36. Ibid.

37. Jun Nguyen-Hatsushiba, conversation with the author, in *Breathing is Free: 12,756.3*, brochure

published on the occasion of the exhibition of the same name (Chicago: School of the Art Institute of Chicago, 30 Jan.–26 March 2010).

38. Jun Nguyen-Hatsushiba, conversation with the author, 2009.

39. Ibid.

40. The exhibition ran at the Manchester Art Gallery, 23 Feb.–1 June 2008.

41. Tim Wilcox, e-mail communication with the author, Sept. 2008.

42. Jun Nguyen-Hatsushiba, e-mail communication with the author, Feb. 2010.

Transaesthetics in the Photographs of Shirin Neshat

Iftikhar Dadi

Western obsession with the figure of the veiled Muslim woman has been foundational to Orientalism since at least the nineteenth century,[1] although the veiled figure was characterized earlier by a passive eroticism.[2] Despite the correlation between terrorism and the covered female Muslim body that was explored in films such as *The Battle of Algiers* (1966),[3] it wasn't until the Islamic revolution in Iran that this connection was brought to the attention of the Western public. Since the late 1970s, the media (especially photojournalists) has frequently depicted masses of Iranian women in black chador participating in the revolution.[4] With the advent of the Iran-Iraq war in the 1980s, images of Iranian women armed with rifles in regimented formations also became prevalent, both in the West and in Iranian propaganda (fig. 1). The crisis in which American hostages were held in Iran for 444 days from 1979 to 1981 was given prominent play by the U.S. media. Melani McAlister has argued that the media reception of developments in Iran between 1979 and 1989 decisively transformed popular understanding of the Middle East

Fig. 1. Zaynab's Sisters commemorate the eighth anniversary of the holy defense against Iraq. (Note the presence of red carnations in the rifles.) Reproduced from Faegheh Shirazi, *The Veil Unveiled: The Hijab in Modern Culture* (Gainesville: University Press of Florida, 2001), 129, fig. 5.7

and its relationship to terrorism: "'Islam' became highlighted as the dominant signifier of the region, rather than oil wealth, Arabs, or Christian Holy Lands. None of these other constructs disappeared, of course, but they were augmented and transformed by a reframing of the entire region in terms of proximity to or distance from 'Islam,' which became conflated with 'terrorism.'"[5] Moreover, McAlister has claimed that it was during this period that terrorism itself became understood more narrowly as primarily a mediated visual phenomenon.[6] Developments since 9/11 have further consolidated these conceptions.

I argue that the photographic work made by the Iranian American artist Shirin Neshat beginning in the mid-1990s intervenes in the ongoing Orientalist obsession with the trope of the veiled woman and its reformulation in political debates about the role of the veil in contemporary society, as well as in contemporary visualizations of the United States–led global war on terror. This body of photographic work is important for understanding the post-9/11 scenario in two ways: articulating the relationship between terrorism and the gendered body and foregrounding the threat of terrorism in its current globally imminent and dispersed reach, rather than as an experience localized to a nation such as Iran proper. In an important essay, Hamid Dabashi has compellingly argued for a "transaesthetics" at work, especially in Neshat's later videos, stating that "her art is no longer Iranian, Islamic, Western, Eastern, or indeed divided along any such national, regional, or bipolar dichotomies or set of sensibilities."[7] I further argue that transaesthetics is also present in Neshat's earlier photographic work, provided we interpret the term to index an imminent yet unnameable global visual sphere. By considering Neshat's photographs through the contexts and strategies of diaspora, and in dialogue with the concepts of nation and allegory, I develop a postcolonial reading that demonstrates their renewed relevance for understanding the imagery of terror in the post-9/11 context.

From Realism to Allegory

Between 1993 and 1997, Neshat produced a series of photographs titled *Women of Allah* that brought her international fame and clearly shaped the subsequent trajectory of her film- and video-based work.[8] In 1996, Neshat began to make video installations, and since 1998 has worked mostly in video and film. The earlier photographs, while forceful and well-executed, are less refined than her later more aesthetically accomplished videos. Many critics, including Neshat herself, have characterized her earlier photographs as literal and didactic.[9] However, these very

qualities are what allow the photographs more visibly to reveal Neshat's ongoing concerns. It can be argued that the video works feel safer to a Western viewer because they largely avoid dealing with the tensions and conflicts between the West and the Muslim world, focusing instead on an aesthetic examination of the dilemma faced by Muslim women within Muslim society with which the Western observer can empathize while maintaining a comfortable distance. By contrast, the photographs threaten the Western viewer, delineating terrorism and gender as key contemporary geopolitical fault lines, thus investing them with renewed significance.

Neshat's work is instructive because it draws attention to complex questions of cultural translation between two seemingly incommensurable entities: the West and Muslim women. She is arguably the most prominent artist of Muslim background exhibiting internationally; because her work directly references the visual representation of Muslim women, it ends up bearing an inordinately heavy critical burden and is frequently taken to index the status of all women in Islam.[10] While her work initially refers to the media image of the revolutionary Iranian woman, this is only a point of departure to a less literal, more complex trajectory of meaning enacted in her photographs.

Rather than seeing Neshat's photographs as Orientalist fictional depictions of harem interiors and veiled women or as documentary portrayals of the actual conditions of Iranian or Muslim women, it is more productive to understand them as allegorical.[11] The allegorical mode is profoundly ambivalent and complex, and mediates meaning between realism and fiction in a manner analogous to the effect that the ornamental and calligraphic screen in her photographs creates between the work and the observer. Such a reading of Neshat's photographs allows one to venture beyond the purely Iranian referent in favor of an unlocatable yet immanent site. The work also refuses to choose between the subject positions supposedly available to the modern Muslim woman—either traditional (subjugated) or Westernized (liberated)—instead marking Muslim women's instability, untranslatability, and incommensurability in the representational media strategies of the contemporary world.

Neshat's photographic work continuously references the veiled woman whose unsettling and overdetermined effect on Western audiences can be gauged from accounts by various observers.[12] The subject focuses centrally upon the Iranian postrevolutionary woman in the public sphere, or more accurately, her figure as representation.[13] On the surface, Neshat's photographs appear to abide

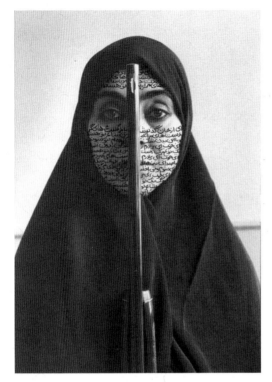

by contemporary Iranian legal strictures regarding the public display of the female body.[14] By seeming to conform to Islamic-Iranian codes of public conduct, there can be no immediate and simplistic reading equating freedom with unveiling. Rather than simply providing windows into the sociological reality of Muslim women's lives, Neshat subtly alters her photographs, orienting them toward an allegorical reading. Contingent props and temporal elements are carefully absent from the minimalist frames, allowing for a fruitful ambiguity in their interpretation. Two other important aspects produce a further distancing effect (figs. 2 and 3): the calligraphic and ornamental screen that is overlaid on the exposed body parts of the majority of the images, and the repositioning of the female figure from that of an anonymous element in a crowd to individualized placement in a frame. But to understand the specific modes of allegory deployed, an intervention in contemporary theories of allegory is necessary.

Allegory and Difference

Recent theoretical work has recovered allegory as an explanatory framework for (post)modernism, allowing the allegorical mode of reference to oscillate between metonymic and mimetic realism, on the one hand, and the metaphoric and poetic imaginary, on the other.[15] Of specific interest for this essay is the work on postmodern allegory in relation to visual arts by Craig Owens, while Aijaz Ahmad, Rey Chow, and Frederic Jameson have contributed important insights into the work that allegory is seen to perform in the Third World and in a postcolonial context.

Jameson controversially asserted in 1986 that all Third World texts are necessarily national allegories. This claim has been thoroughly critiqued, yet it remains useful in understanding how the idea of allegory is implicated in postco-

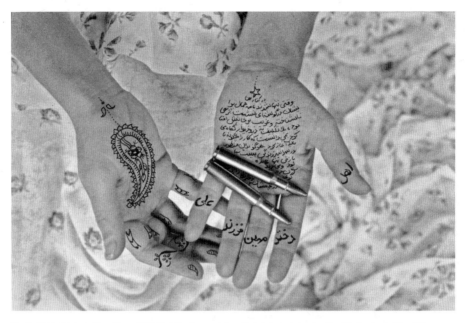

Fig. 3. Shirin Neshat, *Moon Song*, 1995. Gelatin silver print and ink (photo taken by Cynthia Preston), 40 × 60 in. (101.6 × 152.4 cm). Courtesy Gladstone Gallery, New York

lonial readings.[16] He suggested that Third World literature cannot be analyzed as purely libidinal or private, as it always engages with larger social questions and thus produces political texts even if seemingly personal. In contrast, literature and other cultural forms in the West have lost their social and political character and remain purely private, invested with an individuated libidinal charge. Jameson's formulation depends upon an oppositional relationship between the First and the Third Worlds, in which he discerns real differences, even while acknowledging the danger of orientalizing the Third World.[17] A consequence of his formulation is that both the First World and Third World are assumed to be distinct and unified entities. Jameson's schema also enacts a hierarchy that is both temporal and spatial. The Third World, located in a separate geographical space, is seen to lag decades behind culturally as it is able to narrate only political and realist texts. For the First World reader, Third World literature is not unlike bitter medicine—unpalatable but good for the patient in that it induces the realization that community-based social reality has completely withered and vanished in the West.

Aijaz Ahmad's forceful critique covers a wide range of problematic issues in Jameson's formulation. Of immediate relevance to this essay is Ahmad's suggestion that in the West a process of selective incorporation canonizes certain types of

texts and a small number of non-Western writers—such as Jorge Luis Borges or Salman Rushdie—while it excludes the heterogeneity of the remainder. Based on these highly selective examples, Ahmad argues that Jameson grossly overgeneralizes his case and produces an idealization of a singular ideological motivation for all Third World texts.[18]

However, one needs to attend not simply to the production of cultural artifacts but also to their afterlife, which includes their circulation. Moreover, the production of much cultural work that subsequently becomes prominent in the West is, in fact, greatly influenced at the moment of its creation by the perceived reaction of Western audiences; thus much of this work is partially or entirely made for the West. Neither Jameson nor Ahmad accounts for the fact that those more prominent Third World authors and artists, many of whom reside in the West and create work for a primarily Western audience, are seen as representative of their originary cultures. Would Jameson consider Rushdie's writings Third-World texts? Although Rushdie left South Asia decades ago, he is still widely considered an authority on South Asian literature.[19] Or is it perversely more accurate to state that Rushdie is expected to represent South Asia as an authentic translator precisely because he left South Asia decades ago? Similarly, Neshat's photographic work, whose primary audience has always been the Western art world, is unclassifiable in Jameson's schema because she left Iran a long time ago, just before the 1979 Iranian revolution. Clearly this situation also places Third World artists in the impossible position of having to negotiate a personal vision while standing in as fully representative of their communities—the "burden of representation" theorized by Kobena Mercer.[20] This scenario is especially difficult for the diasporic artist, who has no native public that functions as an already constituted interpretive community. What are the strategies a diasporic artist might deploy to avoid producing old-fashioned, obsolete work yet still refer to the longed-for social community? The diasporic artist's work needs to be at least partially addressed to a Western audience but also to self-reflexively attend to the problems inherent in the process in which realism is translated into something more palatable for Western taste. Before analyzing Neshat's photographs in this light, however, allegory needs to be further theorized in the context of the nation.

Allegory and the Nation

Rey Chow and Imre Szeman have pointed out that a major problem in Jameson's formulation is that the nation in his national allegory remains untheorized.[21] Un-

less the nation is understood in its complexity, the charge that it can be represented only by mimetic realism will continue to be leveled, with the assumption that it is a coherent and self-evident entity. In light of this critique, the term "national allegory" now appears strangely incongruous, a tension that is, in fact, visible in Jameson's own definition of "allegory": "If allegory has once again become somehow congenial for us today, as over against the massive and monumental unifications of an older modernist symbolism or even realism itself, it is because the allegorical spirit is profoundly discontinuous, a matter of breaks and heterogeneities, of the multiple polysemia of the dream rather than the homogeneous representation of the symbol."[22] The very idea of national allegory appears to conjoin a delimited representational mode with one that is multiply polysemic. Yet, if the national is to be characterized by realism, allegory cannot simply be a matter of discontinuity. Rather, according to Owens, the very polysemic modality of allegory also incorporates realism within itself.[23]

Jameson's positioning of the Third World cultural artifact as allegory provides an opening to consider the works beyond their emblematic status simply as realist/national/social/political artifacts.[24] Szeman has maintained that, in the context of Jameson's more recent observations on globalization, "the nation" does not simply refer to a space or a community delineated by the nation-state but rather includes at least two expanded meanings: first, the possibility of other forms of social life that are different from American mass culture, forms that have accommodated themselves to modernity while remaining separate from American social and cultural modes;[25] and second, a utopian space imagined by social and cultural movements as a "truly progressive and innovative political response to globalization."[26]

This reformulated understanding of the nation, which no longer bases itself on realism and geographic specificity, is more suited to understanding diasporic postcolonial art. Reading this in relation to gender and globalization, one can posit the following with reference to Neshat's photographs: they point toward irreducible social differences between a universalized and globalized commodified order in which the figure of the woman carries a charge as a consumer and object of spectacle and an Iranian/Islamic order where she symbolically threatens the imagined global order while remaining an object of (veiled) spectacle. In fact, this symbolic threat has spread to become global in scope, with significant sectors of urbanized and educated women (re)turning to the veil in the Muslim world and the West. Whether the veil is a coercive and compulsory mandate, as in Iran,

or a choice that is in many cases resisted by the state, as in Turkey or France, it becomes a spectacular marker of imagining a new utopian/dystopian community.[27] In this respect, the older geographic spatialization of difference by national borders is now fractured and imminently reproduced at a microscopic level across the globe. The veil identifies the problem of identity and difference as an intimate, lived, bodily relationship marked by the figure of woman, yet her subject position cannot be resolved either as a fully autonomous self or as an anonymous subjugated figure in a premodern or mass collective. Instead it is detached from geographic and temporal referents, suspended in menacing and immediate space-time proximity.

The Displaced Referent

Now we can finally turn to Neshat's photographs themselves. In order to reference a documented body of work, this essay cites the collection published in Italy

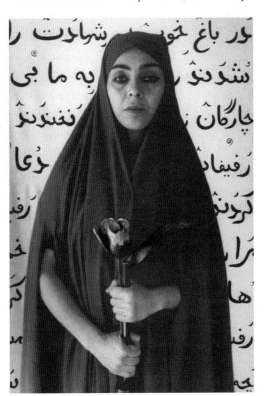

in 1997. The *Women of Allah* series contains thirty-eight photographs, taken between 1993 and 1997, as well as essays by various scholars. Interspersed among the images are translations of the poems by Forough Farokhzad and Tahereh Saffarzadeh that provide the Persian letters, verses, and ornamental patterns that are inscribed on as many as thirty of the photographs.[28] Four of the works are untitled, and the rest bear loaded allegorical titles such as *I Am Its Secret, Rebellious Silence* (see fig. 2), *Allegiance with Wakefulness, Face to Face with God,* and *Seeking Martyrdom* (figs. 4 and 5).

It is important to note that Neshat herself did not shoot any of the photographs in the se-

Fig. 4. Shirin Neshat, *Seeking Martyrdom* #2, 1995. Gelatin silver print and ink (photo taken by Cynthia Preston), 50 1/8 × 33 7/8 in. (127.3 × 86 cm). Courtesy Gladstone Gallery, New York

Fig. 5. Detail of *Seeking Martyrdom #2,* 1995

ries but that she collaborated with a number of photographers in realizing the images. However, she did inscribe the painstaking calligraphy and ornamental patterns inspired by South Asian and North African henna and tattoo practices. The photographs are technically of varying quality and generally cannot be characterized by the sort of aesthetic mastery found in the influential tradition of American black-and-white photography practiced since the days of the Pictorialists, Edward Weston, and Ansel Adams. Neshat's calligraphy, while carefully done, compares unfavorably with the work of master calligraphers of Arabic and Persian. Similarly, the ornamental patterns are beautifully drawn but do not stand up to some of the intricate accomplishments of henna artists. Neshat's refusal of aesthetic mastery also orients the photographs allegorically.[29]

How do Neshat's photographs differ from realist, documentary photographs or self-portraits in which the artist practices ethnography of the self? While poetry, revolutionary politics, and photojournalism might remain abiding reference points for her artistic process, they begin to be displaced by the allegorical mode enacted by the finished photograph. As argued by Owens, this is because of photography's inherent capacity for such a reading.[30] Further, she employs a number of formal devices that lead to such a reading, of which the most important are their titles and their calligraphic/ornamental overlay. Before discussing these devices, it is worthwhile to point out some of their more subtle aspects, such as the .seemingly random production of images that engage repeatedly with the same issues but lack any temporal or narrative link with subsequent images. The avoidance of narrative and temporality is critical to Neshat's spatialization of the

problem of the veil and her insistence on its coevalness with the present rather than its firm relegation to the past through a stagist view of history. This could not be achieved with a single image, as Owens made clear in his vital essays on postmodern allegory:[31]

> Roman Jakobson . . . associate[d] metaphor with poetry and romanticism, and metonymy with prose and realism. Allegory, however, implicates both metaphor and metonymy; it therefore tends to "cut across and subtend all such stylistic categorizations, being equally possible in either verse or prose, and quite capable of transforming the most objective naturalism into the most subjective expressionism, or the most determined realism into the most surrealistically ornamental baroque." This blatant disregard for aesthetic categories is nowhere more apparent than in the reciprocity which allegory proposes between the visual and the verbal: words are often treated as purely visual phenomena, while visual images are offered as script to be deciphered.[32]

By projecting her concerns in a series of random, successive images, Neshat references realist photojournalistic visualization while problematizing this mode by suggesting that its tropes are shared by poetic and fragmentary modes.

The allegorical charge of the photographs is effected through multiple registers. Imagine looking at all the photographs without the inscribed text and ornament. A feature shared by practically all the figures in the photographs—with or without calligraphic overlay—is their lack of affect and depth. Their faces betray few emotions, and the photographs are rendered in a flat and staged manner. Though they participate in many of the conventions of studio and portrait photography, they do not function as expressive fine-art portrait photographs because of their lighting, exposure, and printing, which realize a deflated, collage-like aesthetic effect.

Moreover, Neshat's appropriation of the postrevolutionary dress codes is subtle but unmistakable. At this juncture, it is instructive to compare Neshat's photographs with the infamous film *Submission*, made by the Somali-Dutch politician Ayaan Hirsi Ali, who has been militantly opposed to traditional Islamic strictures regarding gender.[33] The women in *Submission* have Quranic passages inscribed on their transparently clad bodies, an inflammatory depiction of Islamic strictures and a motif superficially similar to Neshat's use of text overlay in her

photographs. The differences between Ali's and Neshat's projects, however, are crucial. Unlike the female characters in *Submission* (and unlike works by other artists who represent the female Muslim body in various states of unveiling), Neshat does not unveil her figures. Moreover, she never inscribes Quranic text on her figures, choosing to use Persian poetry instead.[34]

By deftly avoiding the crude and inflammatory dichotomies that *Submission* revels in, Neshat's photographs enact a latent and proleptic confrontation between the Western viewer and the menacing Muslim woman depicted, a confrontation in which the subject and object are both ensnared.[35] In a number of the photographs, the veil is not the one commonly used in Iran but instead is a strange garment resembling a nun's habit more than the Iranian chador (see fig. 4).[36] Thus, while seemingly staying within Iranian veiling practices and not showing forbidden flesh, Neshat subtly estranges her figures from conventional depictions of Iranian women.

Unlike Cindy Sherman's *Untitled Film Stills*, which place the character in an architectural setting or interior that creates a sense of the photo as a single frame from a continuous and legible narrative, producing a "condensation of narrative,"[37] Neshat's photos contain static characters, thus remaining resolutely non-narrative.[38] Despite their apparent references to militant women in the Iranian revolution, their overall effect is as distant from revolutionary fervor as possible. With her deft use of minimalist formal compositional devices, Neshat has seized the codes of revolutionary documentary and propaganda imagery to construct photographs open to new readings.[39] Again, Owens's comments on the nature of allegory are apposite in this regard. He writes: "Allegorical imagery is appropriated imagery; the allegorist does not invent images but confiscates them. He lays claim to the culturally significant, poses as its interpreter. . . . He does not restore an original meaning that may have been lost or obscured; allegory is not hermeneutics. Rather, he adds another meaning to the image. If he adds, however, he does so only to replace: the allegorical meaning supplants an antecedent one; it is a supplement." He continues: "Allegory concerns itself, then, with the projection—either spatial or temporal or both—of structure as sequence; the result, however, is not dynamic, but static, ritualistic, repetitive."[40]

In the context of Owens's observations, it is worth stressing that the seriality of Neshat's photographs is spatial in character since all traces of temporality are carefully absent. The only modern objects in these photographs are guns and bullets, but these objects could have been present in photographs exposed decades

earlier. Unlike images of revolutionary Iranian women in the media, who are usually shown as massed in Iranian streets, Neshat's minimalist photographs are not specific to a particular time and are therefore always-already in the ever present. As shown later, this has important ramifications for how the photographic allegories comment on contemporary global issues, especially the notion of community, which is also a central concern of Jameson's Third World essay.

Allegory, Supplement, Labor

> If allegory is identified as a supplement, then it is also aligned with writing, insofar as writing is conceived as supplementary to speech. It is of course within the same philosophic tradition which subordinates writing to speech that allegory is subordinated to the symbol. It might be demonstrated, from another perspective, that the suppression of allegory is identical with the suppression of writing. For allegory, whether visual or verbal, is essentially a form of script.[41]

The most significant markers of the photographs' allegorical mode are manifested outside the works (their titles) or on their surfaces (the inscribed ornamentation and calligraphy), and are therefore supplemental.[42] As noted earlier, the titles are overdetermined and suggestive (in sharp contrast, for example, with Sherman's *Untitled Film Stills*, which are simply sequentially numbered). The textual inscriptions, which appear to be of immense significance to the reading of Neshat's photographs, are drawn from the rebellious, sexually liberated poetry of the feminist modernist poet Farokhzad and the postrevolutionary poetry of Saffarzadeh, which, in contrast to Farokhzad's work, is largely sympathetic to the aims of the revolution.

However, of far greater significance is the fact that the texts, written with much patience and care by Neshat, are completely unreadable to her immediate primary audience, the Western viewer. Neshat resolutely refuses to provide translations, so that deciphering the poetry is clearly impossible for a non-Persian reader (fig. 2). Thus the calligraphy doubles as ornament, as well as functioning as undecipherable text, reiterating the cliché of oriental inscrutability. The ornamental and calligraphic writing is secondary, a logical and procedural afterthought to the primacy of the photograph. Any supplemental translation may or may not be forthcoming.

Neshat's photographs go even further in their allegorical import by inscribing the "third world difference,"[43] as ornament in the photographs, as if mimicking alienated hand labor. The spectacular irruption of ornamental patterns (fig. 3) and calligraphy (fig. 2) on the surface of the photograph can also be read as enacting the duality between hand labor and mechanical reproduction, highlighting the reality of globalization in which the sophisticated automatic manufacturing of industrialized countries is in stark contrast to the expansive growth of sweatshop labor in developing nations, where commodities are produced by patient handwork, mostly by women. Arindam Dutta has pointed out that the artisan functioned as a supplement to organized factory labor during the nineteenth century and that the obsessions of British aestheticians with flat, nonprojective oriental design intersected with the unfolding of a flexible, empirical imperialism in the British colonial project.[44] Neshat's designs might well point toward a continuation and intensification of tendencies identified by Dutta and, with respect to economic exploitation, the increase of hand-calligraphed oriental design in postmodern art alerts us to the problem of economic disparity in neoliberalism today, which relies on the flexible, supplemental labor of female sweatshop workers. Neshat's photographs are thus multiply supplemental: as a privileged medium for allegory, as the bearers of ornament, and as emblems of labor and value.

Neshat has stated that she was inspired by South Asian and African henna and tattoo patterns, traditions that are not indigenous to Iran or even Islamic practice. Rather, they are seen as part of the generic Orient, coming from "Indian cultures," which are not necessarily Muslim: "I was . . . struck by the tradition of tattoo in the Middle Eastern and Indian cultures. Later, when I was composing my images that dealt with the body of a Muslim woman, inscription on her skin seemed appropriate."[45] Notice how Neshat's statement underscores a lack of a precise geographic and sociological motivation for the texts and patterns. Because the designs are not traceable to Iran proper, the patterns function as generic oriental signifiers, referencing the Islamic Orient as well as South Asia and Africa, where henna body decoration is prevalent. While the photographic medium is generally understood to freeze moments in time, Neshat's figures hold static postures and bear a surface cover of ahistorical oriental design, arresting any sense of narrative movement. In this connection, Dutta's comment on the nineteenth-century ahistorical understanding of ornament by British aestheticians retains its validity: "The immediate understanding of non-figural patterns was seen as free from the encumbrances of either conceptual canonization or historical periodization. The

pattern is *of* history, not *in* history."[46] It is precisely this ahistorical utopian/dystopian space indexed by oriental henna designs circulating within a fully commodified postmodern consumer society that has allowed performers like Madonna to appropriate this aesthetic, but these appropriations characteristically emphasize only the utopia of the orient.[47]

The Trans-Subject

Neshat's work questions Western portrayals of the figure that emphasize the autonomous individual, as well as the Western media's representations of the Iranian revolutionary woman as an anonymous, massed silhouette, a clichéd trope since the beginning of the revolution. Her work moves away from the mass subject back to the singular—from the nonindividuated collective to the individual, though an individual decontextualized and reframed in a studio setting. Insightful portrait photography is generally understood to reveal something of the character of the subject. Neshat's photographs, however, offer up only a subject drained of affect and depth (figs. 2 and 3), emptied of the interiority ascribed to the Western(ized) subject.

Her use of specific details serves to displace and subsume realist referents in favor of allegorical ones. For instance, consider the motif of the red tulip, which in Iranian revolutionary imagery symbolizes martyrdom and sacrifice. An image of a woman holding a rifle with a red tulip inserted in its barrel is common, and often seen in Iranian posters, magazines, postage stamps, and other media (fig. 6).[48] Neshat makes subtle interventions to this motif by placing the woman holding the rifle and flower in a studio setting, rather than in a public space (see fig. 4). In this image, it is significant that the decorative calligraphy does not cover the woman's body but provides a flat screen behind her, the mediation function here being performed by the flower.[49] Moreover, the stem of the flower has not been inserted in the muzzle of the gun but is held alongside it, literally displaced; nor is the flower fully red, but turns yellow along its top half (fig. 5).[50] The right arm and neck of the female figure are also impermissibly exposed, even while she appears to be in *hijab* that resembles a nun's habit. The image is clearly catachrestic, lacking proper reference to the public dress code of revolutionary Iran.[51] This misappropriation of the image from its original Iranian context helps in resituating the armed female protagonist well beyond realist media depictions or the Jamesonian national to an unnamed and thus potentially global context.

Neshat offers a critique of the mass Iranian-Islamic female subject, but

Fig. 6. Red flowers as symbols of love and sacrifice on postage stamps of Iran, issued between 1979 and 1986

also points to her nonarrival as a properly individualized Western subject.[52] Her photographs index the impasse of available subject positions in contemporary globalization for Muslim women, many of whom have apparently refused the promise of autonomous Westernized subjectivity, as indicated by their outward appearance. Neshat's figure of allegory—neither individuated (free) nor collective (enslaved), belonging neither to Iran nor to any other locatable site—bears the charge of being both the supposedly subjugated silent Muslim woman and the menacing global terrorist.

Neshat completed the *Women of Allah* series in 1997, well before 9/11, yet its current relevance in addressing the perceived global threat of Islam is striking in articulating the link between gender and terrorism. While Neshat draws upon the repertoire of classic Orientalist images of the veiled figure, she displaces their

charge from passive object of the erotic gaze to a confrontational modality. The photographs emphasize flatness, affectlessness, cotemporality, and veiled threats, enacting a mode of spatial allegory. By deploying a minimalist aesthetic, Neshat removes temporality from her photographic frames and avoids possible references to a stagist and developmental judgment regarding modernization, one in which the West is seen as temporally ahead of Islam. Instead, the photographs insist on the contemporary salience of Islamic Iran and, by extension, the entire Muslim world as fully global and coeval with modernity, permitting no safe escape by being relegated to the premodern. With their juxtaposition of mechanical reproduction overlaid with painstaking ornamental and textual handwork, the photographs also index the condition of commodity production in contemporary globalization that relies increasingly on the skills of female workers in the informal sector. And, because the veiled woman is increasingly visible in the West and a source of contention in its public sphere, the spatial allegorization of this terrorist difference is now freed from its geographic moorings and reenacted immanently at dispersed sites throughout the global public space.

I would like to express my sincere thanks to Susan Buck-Morss, Salah Hassan, Kaja McGowan, and Shirley Samuels for their helpful comments. A version of this essay was published in *Signs: Journal of Women in Culture and Society* 34, no. 1 (2008). I am grateful for the perceptive remarks by Senior Editor Karen Alexander and the two anonymous reviewers for *Signs*.

1. Malek Alloula, *The Colonial Harem*, trans. Myrna Godzich and Wlad Godzich (Minneapolis: University of Minnesota Press, 1986); Meyda Yeğenoğlu, *Colonial Fantasies: Towards a Feminist Reading of Orientalism* (New York: Cambridge University Press, 1998).

2. I use the word *veil* throughout this article with the awareness that it now functions as a visual marker of Muslim women's practices of subjecthood as differing from Western liberalism and individuation, rather than as a marker of the sociological accuracy of specific and diverse practices of body covering by Muslim women, such as burqa, chador, dupatta, hijab, niqab, etc.

3. *La battaglia di Algeri* [The Battle of Algiers], directed by Gillo Pontecorvo (Rome: Igor Film, 1966).

4. An example can be seen in the works by the photographer Abbas, who is associated with the famous Magnum Photos agency. Abbas, *Allah o Akbar: A Journey through Militant Islam* (London: Phaidon, 1994). His work is also online at the Magnum Web site: http://www.magnumphotos. com/c/htm/TreePf_MAG.aspx?Stat=Photographers_Portfolio&E=29YL53UHPG4. Other images

of the revolution can be seen in Shiva Balaghi and Lynn Gumpert, eds., *Picturing Iran: Art, Society, and Revolution* (New York: I. B. Tauris, 2002).

5. Melani McAlister, *Epic Encounters: Culture, Media, and U.S. Interests in the Middle East since 1945* (Berkeley: University of California Press, 2005), 200.

6. Ibid., 201.

7. Hamid Dabashi, "Transcending the Boundaries of an Imaginative Geography," in Shirin Neshat and Hamid Dabashi, *Shirin Neshat: La última palabra/The Last Word*, ed. Octavio Zaya (Milan: Charta, 2005), 53, 79.

8. For an informative interview with Shirin Neshat about these photographs, see Shadi Sheybani, "Women of Allah: A Conversation with Shirin Neshat," *Michigan Quarterly Review* 38, no. 3 (1999): 204–16.

9. Leslie Camhi, "Lifting the Veil," *ArtNews* 99, no. 2 (2000): 150.

10. For an example of Neshat's public role as the aesthetic voice of Muslim women, see Deborah Solomon, "Arteurs: Romance of the Chador," *New York Times Sunday Magazine*, 25 March 2001.

11. For example, Wendy Meryem K. Shaw, in her thoughtful essay, carefully levels the charge of reifying Orientalism against Neshat's video works: "[Neshat] ends up constructing texts of gender as totems rather than as complex participants in a discussion of the historical and social construction of global gender identities." Wendy Meryem K. Shaw, "Ambiguity and Audience in the Films of Shirin Neshat," *Third Text* 57 (Winter 2001–2): 52.

12. Farzaneh Milani, Shirin Neshat, exh. cat. (Milan: Charta, 2001); Igor Zabel, "Women in Black," *Art Journal* 60, no. 4 (2001): 16–25.

13. See Neshat's insightful comments on *Women of Allah* in an interview in which she situates her diasporic location in relation to revolutionary Iran. Shirin Neshat, "Women without Men: A Conversation with Shirin Neshat," in *My Sister, Guard Your Veil; My Brother, Guard Your Eyes: Uncensored Iranian Voices*, ed. Lila Azam Zanganeh (Boston: Beacon, 2006), 44–54.

14. For accounts of the complex history of public visibility of the female body in Iran, see Nima Naghibi, "Bad Feminist or *Bad-Hejabi*? Moving outside the *Hejab* Debate," *Interventions* 1, no. 4 (1999): 555–71; Homa Hoodfar, "The Veil in Their Minds and on Our Heads: The Persistence of Colonial Images of Muslim Women," *Resources for Feminist Research* 22, no. 3/4 (1993): 5–18; Afsaneh Najmabadi, *Women with Mustaches and Men without Beards: Gender and Sexual Anxieties of Iranian Modernity* (Berkeley: University of California Press, 2005).

15. The resuscitation of allegory in twentieth-century thought was pioneered by Walter Benjamin and has been further explored by Aijaz Ahmad, Susan Buck-Morss, Rey Chow, Paul de Man, Hal Foster, Fredric Jameson, Craig Owens, Jenny Sharpe, Gayatri Spivak, Imre Szeman, and other thinkers influenced by critical theory and poststructuralism. Jameson provides an important distinction between metaphor and allegory, "From Metaphor to Allegory," in *Anything*, ed. Cynthia C. David-

son (Cambridge, MA: MIT Press, 2001), 24–36. Also of considerable interest is Linda Nochlin's extended discussion of allegory in her two-part essay on Courbet, "Courbet's Real Allegory: Rereading 'The Painter's Studio,'" in *Courbet Reconsidered*, ed. Sarah Faunce and Linda Nochlin (Brooklyn, NY: Brooklyn Museum; New Haven, CT: Yale University Press, 1988), 17–41.

16. Fredric Jameson, "Third World Literature in the Era of Multinational Capitalism," *Social Text* 15 (Autumn 1986): 69.

17. Ibid., 77.

18. Aijaz Ahmad, "Jameson's Rhetoric of Otherness and the 'National Allegory'," in *In Theory: Classes, Nations, Literatures* (London: Verso, 1992).

19. For example, Rushdie coedited a major anthology of South Asian literature for the fiftieth independence anniversary of India and Pakistan. Salman Rushdie and Elizabeth West, eds., *The Vintage Book of Indian Writing, 1947–1997* (London: Vintage, 1997).

20. Kobena Mercer, "Black Art and the Burden of Representation," *Third Text* 10 (Spring 1990): 61–78.

21. Rey Chow, *Primitive Passions: Visuality, Sexuality, Ethnography, and Contemporary Chinese Cinema* (New York: Columbia University Press, 1995), 57, 82; Imre Szeman, "Who's Afraid of National Allegory? Jameson, Literary Criticism, Globalization," *South Atlantic Quarterly* 100, no. 3 (2001): 814. According to Chow, Jameson's failure to interrogate the meaning of nation leads him to read the situation of the Third-World protagonist as "semiologically transparent" within larger social conditions.

22. Jameson "Third World Literature in the Era of Multinational Capitalism," 73.

23. Craig Owens, "The Allegorical Impulse: Towards a Theory of Postmodernism," *October* 12 (Spring 1980): 72–74.

24. Szeman, "Who's Afraid of National Allegory?" 821.

25. For Jameson, French cinema has furnished an important case and a contemporary example might well be Iranian cinema, which has greatly influenced Neshat's own video work.

26. Szeman, "Who's Afraid of National Allegory?" 821.

27. On the question of the veil in Turkey, see Nilüfer Göle, *The Forbidden Modern: Civilization and Veiling* (Ann Arbor: University of Michigan Press, 1996).

28. On the life and works of Farokhzad and Saffarzadeh, see Farzaneh Milani, *Veils and Words: The Emerging Voices of Iranian Women Writers* (Syracuse, NY: Syracuse University Press, 1992).

29. A comparison with Martha Rosler's *Bowery* photographs is instructive here. Rosler's 1981 project also attempts to juxtapose the signifying practices of text and image in problematizing realist documentary. Benjamin Buchloh, writing on the deployment of allegory in Rosler's *Bowery* photographs notes a similar deadpan, affectless, and nonaesthetic strategy analogous to that of Neshat: "Rosler's crude attempts to try her photographic hand at mimicking the great urban 'documentarians' style

is of course . . . thoroughly disappointing to the cultivated photographic eye." Benjamin Buchloh, "Allegorical Procedures: Appropriation and Montage in Contemporary Art," *Artforum* 21 (September 1982): 53. Buchloh is not denigrating Rosler's work, but pointing out how Rosler's allegorical mode differs from the work of other photographers who strive for a documentary or poetic aesthetic excellence.

30. Owens has noted the strong "allegorical potential of photography." Owens, "The Allegorical Impulse," 71.

31. Ibid., 67–86; Craig Owens, "The Allegorical Impulse: Towards a Theory of Postmodernism (Part 2)," *October* 13 (Summer 1980): 59–80. For a critique, see Hal Foster, *The Return of the Real: The Avant-Garde at the End of the Century* (Cambridge, MA: MIT Press, 1996), 86–91.

32. Owens, "The Allegorical Impulse," 72–74.

33. The bad faith of the film is evident from the fact that many practices such as incest and rape decried in *Submission* as Islamic practices are not sanctioned by even the most conservative interpretations of Islamic law. *Submission* is currently available online on Google Video at http://video.google.com. Peter van der Veer has perceptively analyzed the crisis of Dutch multiculturalism in the context of this film and its aftermath, Peter van der Veer, "Pim Fortuyn, Theo van Gogh, and the Politics of Tolerance in the Netherlands," *Public Culture* 18, no. 1 (2006): 111–24.

34. See, for example, the work of the artist Jananne Al-Ani, "Acting Out," in *Veil: Veiling, Representation and Contemporary Art*, ed. David A. Bailey and Gilane Tawadros (London: Institute of International Visual Art, 2003), 88–107.

35. This work is proleptic about terrorism as an imminent and global threat, having been produced in the mid-1990s, before 9/11.

36. Sharon L. Parker, a graduate student at the University of Arizona, pointed out this and other incongruities in a conference paper. Parker showed Neshat's photographs to Iranian women living in Iranian diasporic communities in the United States. Rather than affirming recognition of the images of the photographs, because of their displaced references the women expressed bewilderment as to their possible meaning or import. Sharon L. Parker, "Between Speech and Silence: Framing Women's Experience of Revolution in the Art of Haleh Niazmand, Sonia Ballassanian and Shirin Neshat: Dialogues on the Politics of Culture" (paper presented at *Looking Out: Representing the "Other"* conference, Cornell University Department of History of Art, 20 Feb. 1999).

37. Peggy Phelan, *Unmarked: The Politics of Performance* (London: Routledge, 1993), 62.

38. Mitra Abbaspour, "Trans-national, Cultural, and Corporeal Spaces: The Territory of the Body in the Artwork of Shirin Neshat and Mona Hatoum" (master's thesis, University of California, Riverside, 2001), 80. Abbaspour also compares Neshat with Sherman, but her interpretation differs from the one advanced here. Ibid., 82–83.

39. Among numerous critical essays on Neshat's work, Igor Zabel's comes closest to recognizing this

appropriation: "The 'woman in black'—so heavily laden with stereotypes and fantasies—is the figure Shirin Neshat uses as the central motif in her photographs. She does not try to purify the image of its role as signifier for the otherness of the Muslim world. Such an attempt would necessarily fail, since the image itself is inseparable from this connotation. She does quite the opposite: she simulates it, making us aware of its constructed, artificial nature." Zabel, "Women in Black," 17.

40. Owens, "The Allegorical Impulse," 69, 72.

41. Ibid., 84.

42. Although some photographs might lack the inscriptions while others might lack titles, the supplemental, allegorical function across the whole body of the work is enacted by the embeddedness of each in the entire series.

43. Chandra Talpade Mohanty, "Under Western Eyes: Feminist Scholarship and Colonial Discourses," in *Third World Women and the Politics of Feminism*, ed. Chandra Talpade Mohanty, Ann Russo, and Lourdes Torres (Bloomington: Indiana University Press, 1991), 72.

44. Arindam Dutta, "Designing the Present: The Cole Circle and the Architecture of an Imperial Bureaucracy, 1851–1901" (Ph.D. diss., Princeton University, 2001), chaps. 3, 4.

45. Lina Bertucci, "Shirin Neshat: Eastern Values," *Flash Art* 197 (Nov./Dec. 1997): 84–87.

46. Dutta, "Designing the Present, 297.

47. On African henna practices and their appropriation by Western avant-garde fashion and media, see Salah Hassan, "Henna Mania: Body Painting as a Fashion Statement, from Tradition to Madonna," in *The Art of African Fashion*, ed. Els van der Plas and Marlous Willensen (Trenton, NJ: Africa World Press; The Hague: Prince Claus Fund 1998;), 103–29.

48. See William Hanaway, "The Symbolism of the Persian Revolutionary Posters," in *Iran since the Revolution: Internal Dynamics, Regional Conflict, and the Superpowers*, ed. Barry M. Rosen (New York: Columbia University Press, 1985), 31–50; Michael M. J. Fischer and Mehdi Abedi, *Debating Muslims: Cultural Dialogues in Postmodernity and Tradition* (Madison: University of Wisconsin Press, 1990), 341–79; Peter Chelkowski and Hamid Dabashi, *Staging a Revolution: The Art of Persuasion in the Islamic Republic of Iran* (New York: New York University Press, 1999), figures 13.6–13.9, 13.24; Faegheh Shirazi, *The Veil Unveiled: The Hijab in Modern Culture* (Gainesville: University Press of Florida, 2001), figures 5.6, 5.7; Kishwar Rizvi, "Religious Icon and National Symbol: The Tomb of Ayatollah Khomeini in Iran," *Muqarnas: An Annual on Islamic Art and Architecture* 20 (2003): 209–24.

49. This photograph is also presented with slight color variations and different calligraphic backgrounds in two other catalogues: Susan Edelstein, ed., *Shirin Neshat "Women of Allah"* (Vancouver: Artspeak Gallery, 1997), 19; Hamid Dabashi et al., *Shirin Neshat* (Milan: Charta, 2002), 88.

50. The meaning here is quite different from that of the activities of American peace protesters during the Vietnam war, who popularized the act of inserting flowers in the guns of soldiers.

51. An alternative reading of this image that references Iranian symbols is offered by an Iranian writing under the pseudonym of "Ahmad T" in *Shirin Neshat "Women of Allah"*, 19.

52. Ruth Noack has perceptively noted Neshat's critique of the Western subject in her video works: "This type of representation can and must, in my opinion, be seen as an attack on Western culture, which would be unthinkable without the myth of individual, autonomous subjectivity." Ruth Noack, "Productive Dualism," in *Shirin Neshat*, ed. Gerald Matt (Vienna: Kunsthalle, 2000), 39.

Contributors

Stanley Abe is Associate Professor of Chinese Art at Duke University. His book *Ordinary Images* (2002) received the 2003 Shimada Prize for distinguished scholarship in the history of East Asian art. Abe has published "To Avoid the Inscrutable: Abstract Expressionism and the 'Oriental Mode,'" in *Discrepant Abstraction*, edited by Kobena Mercer, and most recently "Rockefeller Home Decorating and Objects from China," in *Collecting China*, edited by Vimalin Rujivacharakul. He is writing a book on how Chinese Buddhist sculpture became a category of fine art at the turn of the twentieth century.

Esra Akcan is an Assistant Professor at the University of Illinois at Chicago. She received her architecture degree from Middle East Technical University, and her Ph.D. and postdoctoral degrees from Columbia University. She has taught at Columbia University, New School, Pratt Institute, METU, and Humboldt University, and has received awards and fellowships from the Institute for Advanced Studies in Berlin, Sterling and Francine Clark Art Institute, Graham Foundation, Getty Research Institute, Canadian Center for Architecture, Mellon Foundation, DAAD, Kinne, and KRESS/ARIT. She is the author of *(Land)Fill Istanbul* (2004), *Çeviride Modern Olan* (2009), *Architecture in Translation* (forthcoming), and *Turkey: Modern Architectures in History* (with Sibel Bozdoğan, forthcoming)

Iftikhar Dadi is Associate Professor in the Department of History of Art, and Chair of the Department of Art at Cornell University. Research interests include postcolonial theory, and modern and contemporary art with an emphasis on South and West Asia. His most recent book is *Modernism and the Art of Muslim South Asia* (2010). Curated exhibitions include *Calligraphic Abstraction: Anwar Jalal Shemza* (2009) and *Tarjama/Translation* (2008–10), which showcased numerous artists from the Middle East, Central Asia, and their diasporas. As an artist he collaborates with Elizabeth Dadi and has shown widely internationally.

Jennifer A. González is Associate Professor and Chair of the History of Art and Visual Culture department at the University of California, Santa Cruz. Her critical writings have appeared in numerous periodicals and journals, including *Frieze*, *Bomb*, and *Art Journal*. She has contributed essays to anthologies such as *The Cyborg Handbook* (1995), *Race in Cyberspace* (2000), and *With Other Eyes: Looking at Race and Gender in Visual Culture* (1999). Her book *Subject to Display: Reframing Race in Contemporary Installation Art* (2008) was a finalist for the Charles Rufus Morey Book Award.

Ranajit Guha is a renowned historian of South Asia, who taught in India, Europe, the United States and Australia before his retirement in 1988. He is founder of the Subaltern Studies project and author of over a dozen books and edited volumes that have been seminal to directions in Indian historiography and postcolonial studies. He currently lives in Vienna, Austria.

May Joseph is Founder of Harmattan Theater, an environmental theater company based in New York City. Joseph's directorial work includes working with islands, piers, rivers, and waterfronts. Joseph is also Professor of Social Science at Pratt Institute, where she teaches urbanism, cinema and visual studies. She is the author of *Nomadic Identities* (1999) and co-editor of the following volumes: *Performing Hybridity* (1999); *New Hybrid Identities* (1995); *Bodywork* (1999); *City Corps* (2006); and is currently working on the problem of metropolitanism in New York City.

Miwon Kwon is Professor of Contemporary Art History at University of California, Los Angeles. She is the author of *One Place after Another: Site-Specific Art and Locational Identity* (2002) as well as numerous essays on an international roster of contemporary artists' works. She is currently co-curating a major historical survey exhibition with Philipp Kaiser entitled *Ends of the Earth: Art of the Land to 1974*, scheduled to open at LAMOCA in April 2012.

Saloni Mathur is Associate Professor of Art History at the University of California, Los Angeles. She is the author of *India by Design: Colonial History and Cultural Display* (2007) and co-editor (with Kavita Singh) of the forthcoming novel *No Touching, Spitting, Praying: Modalities of the Museum in South Asia*. Her current book-in-progress constructs a genealogy of modern and contemporary art in India.

Kobena Mercer is an independent scholar based in the UK and an inaugural recipient of the 2006 Clark Prize for Excellence in Arts Writing. He was Reader in Art History and Diaspora Studies at Middlesex University, London, and previously taught at New York University and the University of California at Santa Cruz. He is series editor of Annotating Art's Histories, whose titles include *Cosmopolitan Modernisms* (2005), *Discrepant Abstraction* (2006), *Pop Art and Vernacular Cultures* (2007), and *Exiles, Diasporas & Strangers* (2008).

W. J. T. Mitchell is Professor of English and Art History at the University of Chicago, and editor of *Critical Inquiry*. He has published numerous books and articles on topics in image theory, art history, visual studies, and media theory. Recent books include *The Last Dinosaur Book* (1998), *What Do Pictures Want?* (2005), *Edward Said: Continuing the Conversation* (2005; with Homi Bhabha), *The Late Derrida* (2007; with Arnold Davidson), and *Cloning Terror: The War of Images, 9-11 to the Present* (2011).

Aamir R. Mufti teaches comparative literature at the University of California, Los Angeles. His work has undertaken a reconsideration of the secularization thesis in a comparative frame. He is the author of *Enlightenment in the Colony: The Jewish Question and the Crisis of Postcolonial Culture* (2007) and editor of three collections, including *Dangerous Liaisons: Gender, Nation and Postcolonial Perspectives* (1997) and "Critical Secularism," a special issue of the journal *boundary 2*, of which he is an editorial collective member.

Nikos Papastergiadis is Professor at the School of Culture and Communication at the University of Melbourne. Throughout his career, he has provided strategic consultancies for government agencies on issues relating to cultural identity and worked on collaborative projects with artists and theorists of international repute, such as John Berger, Jimmie Durham, and Sonya Boyce. His current research focuses on the investigation of the historical transformation of contemporary art and cultural institutions by digital technology. His published works include *Spatial Aesthetics: Art Place and the Everyday* (2006) and *Empires Ruins and Networks* (2005; co-edited with Scott McQuire).

Richard J. Powell is the John Spencer Bassett Professor of Art and Art History at Duke University. Powell has written on topics ranging from primitivism to postmodernism, including such titles as *Homecoming: The Art and Life of William H. Johnson* (1991) and *Black Art: A Cultural History* (2002). His latest book is *Cutting a Figure: Fashioning Black Portraiture* (2008). Powell has also helped organize numerous exhibitions, most notably: *Rhapsodies in Black: Art of the Harlem Renaissance* (1997); *To Conserve A Legacy: American Art at Historically Black Colleges and Universities* (1999); and *Back to Black: Art, Cinema, and the Racial Imaginary* (2005). From 2007 until 2010, Powell was Editor-in-Chief of *The Art Bulletin*.

Edward Said (1935–2003) was a literary theorist, cultural critic, and political activist for Palestinian rights. He wrote dozens of books, lectures, and essays, including most famously *Orientalism* (1978), which inaugurated the field of postcolonial studies and transformed the humanities and social sciences in its wake. At the time of his death, Said was University Professor of English and Comparative Literature at Columbia University, where he had taught for forty years.

Nora A. Taylor is the Alsdorf Professor of South and Southeast Asian Art at the School of the Art Institute of Chicago. Her research centers on artists living in Vietnam, with a recent focus on performance artists. She is the author of *Painters in Hanoi: An Ethnography of Vietnamese Art* (2004) as well as numerous articles on modern and contemporary Vietnamese art. She also curated *Changing Identity: Recent Work by Women Artists from Vietnam* (2007–9) and co-curated *Breathing is Free: 12,756.3* (2009–10) with Heather Lineberry.

Photography Credits